Knossos and the Prophets of Modernism

CATHY GERE

KNOSSOS

&

THE PROPHETS OF
MODERNISM

THE UNIVERSITY OF CHICAGO PRESS

Chicago & London

Cathy Gere is assistant professor in the history of science and medicine at the University of California, San Diego. She is the author of *The Tomb of Agamemnon*.

The University of Chicago Press, Chicago 60637
The University of Chicago Press, Ltd., London
© 2009 by The University of Chicago
All rights reserved. Published 2009
Printed in the United States of America

18 17 16 15 14 13 12 11 10 09 1 2 3 4 5

ISBN-13: 978-0-226-28953-3 (cloth)
ISBN-10: 0-226-28953-2 (cloth)

Library of Congress Cataloging-in-Publication Data

Gere, Cathy, 1964–
 Knossos and the prophets of modernism / Cathy Gere.
 p. cm.
 Includes bibliographical references and index.
 ISBN-13: 978-0-226-28953-3 (cloth : alk. paper)
 ISBN-10: 0-226-28953-2 (cloth : alk. paper)
 1. Palace of Knossos (Knossos). 2. Evans, Arthur, Sir, 1851–1941. 3. Arts—20th century—Greek influences. 4. Modernism (Aesthetics). 5. Archaeology and art. 6. Archaeology—Political aspects. I. Title.
 DF261.K55G47 2009
 939'.18—dc22

 2008053986

♾ The paper used in this publication meets the minimum requirements of the American National Standard for Information Sciences—Permanence of Paper for Printed Library Materials, ANSI Z39.48-1992.

To the memory of my father

❦ CONTENTS ❧

❦ ACKNOWLEDGMENTS ❦

My greatest intellectual debts were incurred in the History and Philosophy of Science Department at Cambridge University. Jim Secord untangled the more tortuous knots of my labyrinthine research with his characteristic combination of geniality and rigor. Nick Jardine—a polymath whose profound grasp of the history of history of science gives his feedback the reassuring authority of the longer view—read drafts of every chapter and managed to deliver his criticisms in such a way that I came away encouraged. John Forrester provided unparalleled depths of insight into the history of psychoanalysis. On a couple of memorable occasions Simon Schaffer read drafts and summarized my argument, adding his own dazzling interpretations of the material under the guise of paraphrasing mine.

My thanks to the curators of the Arthur and John Evans archives at the Ashmolean Museum, Oxford, and the librarians at the Beinecke Library at Yale, for granting access to the manuscript sources I have used in this book. Archaeologist and historian of archaeology Nicoletta Momigliano reviewed a previous version of the manuscript

for a publisher and provided many invaluable suggestions and essential corrections. Conversations with the participants in the conference that she subsequently organized on the history and politics of Minoan archaeology were inspiring and informative, especially those with Yannis Hamilakis, Kenneth Lapatin, David Roessel, Susan Sherratt, and the late Andrew Sherratt. Talking with John Tresch about the prophets of modernism has always sent me back to them refreshed and restored, and my thanks to him for providing such constructive feedback on parts of the manuscript. My editor Karen Darling has expertly shepherded this work to completion, and I count myself lucky to be among her first authors at the University of Chicago Press. This book was much improved by the criticisms and suggestions of three anonymous reviewers for the press.

On a more personal note, I thank my brother Charlie Gere for blazing the trail with such generosity, and my mother Charlotte Gere for all her support—material, psychological, and intellectual. I am grateful to Anandi, Anjan, Jim, Krister and Pam for the gift of friendship during what could otherwise have been a lonely first draft. Finally, my thanks to my partner Hildie Kraus, for accompanying me to Psyche's Cave, for having brilliant insights into reconstruction, for sending me ridiculous verses about H.D., for proof-reading an unconscionable number of different versions of this book, and, above all, for always wearing Zarathustra's rose-chaplet crown of laughter.

{ INTRODUCTION }

Crete's premier tourist attraction, the fabled Bronze Age Palace of Knossos, enjoys the dubious distinction of being one of the first reinforced concrete buildings ever erected on the island. Reconstructed by the English archaeologist Arthur Evans between 1905 and 1930, the walls of the palace are built of square concrete beams filled with limestone rubble masonry. Gray concrete floors, their edges molded in imitation of broken stone, are supported by squat, downward-tapering red pillars. Parts of Knossos are pure modernism: the throne room complex comprises three stories of unadorned square concrete pillars that rear up from the central court like a flimsy Le Corbusier exercise; a photograph of the west façade taken right after its completion in 1930 looks eerily similar to Alexei Shchusev's Lenin Mausoleum in Moscow of the same date; the south flank of the palace is dominated by a sub–Barbara Hepworth sculpture known as the *Horns of Consecration*.

A little north of the palace stands the Villa Ariadne, a lavish colonial bungalow that Evans commissioned in 1905 to serve as his headquarters. Named for Evans's favorite character in Cretan mythology, the

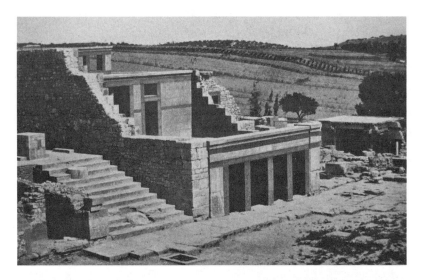

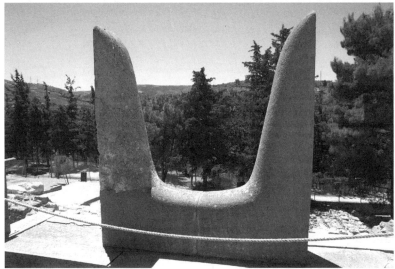

FIGURE 1. *Top*, the throne room complex at Knossos, completed 1930. Arthur Evans, *The Palace of Minos*, vol. 4, fig. 897. By permission of the Ashmolean Museum, Oxford. *Below*, the "Horns of Consecration." Istock Photo.

villa has a long garden wall running along the road that leads to Crete's capital city, Iraklion. Only a couple of undulating fields farther along, the postwar urban sprawl appears on the hills, threatening to engulf the palace and its environs and turn Knossos into a suburb. It will fit in well. Nearly eighty years after the completion of the concrete

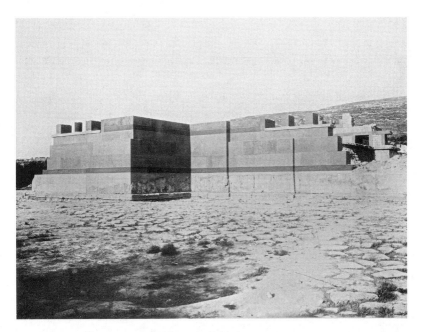

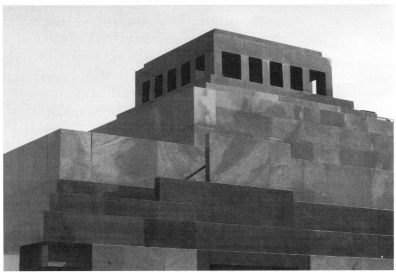

FIGURE 2. *Above*, the west façade of Knossos, circa 1930. Evans Archive. By permission of the Ashmolean Museum, Oxford. *Below*, the Lenin Mausoleum, Moscow, 1930. Istock Photo.

reconstructions and the rest of the country has caught up: today all of Greece is liberally studded with half-built, low-rise, skeletal modernist ruins, stairs climbing to nowhere, roofs bristling with rusting iron rebar.

Evans did not set out to reconstruct a Bronze Age palace using reinforced concrete. His excavation of the site began in the early spring of 1900. A few short weeks into the dig his workmen uncovered "the oldest throne in Europe," a carved gypsum chair flanked by frescos. The chair—its back plastered right into the wall behind—could not be moved off-site, and so the following season a bit of scaffolding was run up to support a protective shelter over it. Desiring a more artistic effect, Evans then substituted wood-and-plaster columns for the scaffolding, their downward-tapering shape and red color based on the painting of a building on a fresco fragment. As the dig went on, more squat red columns were constructed to prop up the crumbling walls of other parts of the building. In 1905, work began on the Villa Ariadne, and as soon as Evans saw how quickly its reinforced concrete shell went up, he realized that he had stumbled upon the most practical solution to the problem of protecting and supporting the remains of the ancient palace. Inspired by the plasticity, indestructibility, and relative cheapness of the material, he eventually undertook the wholesale and highly speculative reconstruction of large areas of the building. By the end of 1930, modernist Knossos was complete.

According to Evans, Knossos was the true Cretan Labyrinth, the historical reality behind the myth of the virgin-devouring Minotaur. The excavations, however, seemed to belie the bloodthirsty legends. "The ogre's den turns out to be a peaceful abode of priest-kings, in some respects more modern in its equipments than anything produced by Classical Greece,"[1] he announced in the introduction to his four-volume excavation report, *The Palace of Minos*. In this epic work, Evans bequeathed to his war-torn age a scientific vision of life before the Fall—Minoan society reconstructed as Western civilization's earliest blossoming, a gilded infancy suckled by a benevolent mother goddess, a time of peace and plenty on a beautiful island protected by the sea.

For archaeologists, Evan's reconstructions and interpretations have always presented a profoundly ambiguous bequest. Although, in most places, the modern fabric of Knossos is easy to spot, the relationship between the forms that the concrete takes, and the shape of any Bronze Age building, is still far from resolved. Not only do the concrete recon-

structions cover up the stones of the original buildings, but the paper reconstructions of the palace, in watercolor, pen and ink, and text, do not easily allow a perspective on the problem uncolored by the prejudices of Evans and his team.[2] The aim of this book is the opposite of archaeological. Instead of searching beneath the modern reconstructions in pursuit of the limestone and gypsum temples built by the people of the Bronze Age, the present narrative attempts to understand the temple builders of the age of concrete—the archaeologists, architects, artists, classicists, writers, and poets of the twentieth century A.D. who reconstructed Minoan Crete in modernist materials.

Concrete Knossos may be the most eccentric archaeological reconstruction ever to achieve scholarly acceptance. Evans's romanticism was made possible by his family's industrial fortune. He bought the land and paid for the excavation out of the proceeds of his father's paper mill, and he supervised the dig in a fine aristocratic fashion, floating down to the site in the evening to bestow mythological titles on the rooms and objects that had emerged that day. His methods were distinguished by a delirious interpretative incontinence that seemed to owe more to spiritualism than to science, and his self-fashioning—as an archaeological prophet and magician—was correspondingly grandiose. Evans embodied all the contradictions of modernism. He used industrial methods and materials to reinvent the myths of antiquity; he was a racist who argued for the African origins of Western civilization, an ageing Boy Scout who championed the theory of matriarchy. At the actual site of Knossos, the reconstructions proceeded in an absurdist counterpoint to the romantic rhythms of his prose, his utopian vision translating into a dystopia of "garages and public lavatories," in the biting verdict of one eminent visitor.[3]

But despite, or perhaps because of, their paradoxes and delinquencies, Evans's Minoans left their footprints all over the wilder shores of modernist thought. The Labyrinth of Minos was one of the sensations of the age and became (especially for those devotees who never experienced firsthand its concrete reality) a site across which some of the most urgent political, spiritual, and aesthetic questions of the early twentieth century were asked and answered. Modernist Knossos ties together fascism, feminism, and pacifism; it appears in experimental literature and psychoanalysis; it unites Nietzsche and Freud, James Joyce and Giorgio de Chirico. Certain twentieth-century poets—Hilda Doolittle, Robert Graves—cannot be properly understood without

knowing the Cretan archaeology through which they worked out their oracular neopaganism.

"Modernism" is, of course, a highly contested term. Some of its difficulties inhere in the very act of naming a past era with a word that means "of the present time." There is certainly no consensus as to its chronological boundaries. For some architectural historians, modernism has its roots in the abandonment of the classical ideal by early nineteenth-century Romantics. For many literary scholars, the term denotes a movement restricted to a few decades in the beginning of the twentieth century. In the history of the visual arts its reach extends well beyond 1945. When we turn to the history of the human sciences, however, a consensus seems to have emerged that modernism denotes a distinctive and often self-conscious sense of generational crisis, beginning around 1870 and persisting until just before the Second World War. This was distinguished, above all, by a profound loss of confidence in the Enlightenment legacy of rationalism.[4]

On the political front, this crisis comprised a rejection of the liberal tradition that privileged the rational, autonomous subject as the main unit of political and moral reasoning—modernism setting its face against modernity, so to speak. Denunciations of the bureaucratic, democratic, liberal state as a soulless dystopia were often accompanied by an "archaizing" impulse—a frantic search through the annals of the deep past for neoprimitive solutions to the problems of industrial capitalism. This book is centrally concerned with that impulse, as the archaeology of Bronze Age Greece provided much of the material from which the archaizing project drew its inspiration. From the fascist emulation of Homeric heroes to the feminist adulation of Minoan priestesses, the archaeology of Greek myth provided the blueprints for a series of future utopias.

On the philosophical front, the modernist crisis took the form of an acute anxiety about the relation of the external world with the individual's internal perception of it. Arthur Evans played a key, if orthogonal, role in this crisis of knowledge. For the most part untroubled by deeper epistemological questions, he and his celebrated predecessor Heinrich Schliemann blithely projected the spiritual and philosophical concerns of their own times onto the deep past. Their very lack of self-awareness made the archaeology of Bronze Age Greece particularly important for modernism. By denying its own florid subjectivity, archaeology seemed

to provide objective confirmation of some of the most irrationalist strains of modernist thought. Two important architects of modernist cognitive anxiety, Nietzsche and Freud, appear in these pages, and the narrative attempts to demonstrate the extent to which the archaeology of preclassical Greece provided their common cultural frame of reference.

Perhaps most pivotal for the present work, however, is the theological crisis of modernism—the death of the Christian God and the accompanying search for an alternative account of human origins. Minoan archaeology contributed a significant chapter to the scientific rewriting of the Old Testament, suggesting that European civilization had pagan roots in the island of Crete. Science, in this case, did not entail secularization. One of the most striking aspects of Evans's prose is how infused and animated it is with a sense of spiritual hunger. His project was not the disenchantment of the Christian world but rather the pagan reenchantment of secular modernity.

The contribution of the present work to the history of the modernist human sciences is the gathering of all the themes discussed above under a single rubric. Without exception, all the archaeologists, psychoarchaeologists, and assorted archaeological devotees who appear in these pages fashioned themselves as *prophets*. Modernist prophecy was at once a neoarchaic device for utopian world making, a visionary and intuitive way of knowing, and a rhetorical strategy through which to dismantle and reconstruct the Christian narrative of human origins. The historical sciences as a whole—cosmology, geology, paleontology, archaeology—pieced together a secular narrative after the Biblical chronology lost its credibility; here I investigate the way in which various Minoan "books of genesis" attempted to take over that chronology's prophetic as well as its historical role.

"Prophecy," never the easiest of words to define, was an extremely complex notion at the turn of the twentieth century. The archaeologist him- or herself was an exemplar of the scientist as prophet, the wielder of an epistemological method first formally characterized by that great apostle of the historical sciences Thomas Henry Huxley, in his 1880 essay "The Method of Zadig: Retrospective Prophecy as a Function of Science." Huxley presented the story of Zadig, a Babylonian philosopher famous for his deployment of a method of divination relying on the decipherment of tiny clues. Asked if he had seen the queen's

lost dog, Zadig was able to give an accurate description of the animal, despite the fact that he had never laid eyes on it. When he was arrested on the grounds that he must have stolen the royal pet, he protested that he had built up the image from her tracks in the sand:

> Long faint streaks upon the little elevations of sand between the footmarks convinced me that it was a she dog with pendent dugs, showing that she must have had puppies not many days since. Other scrapings of the sand, which always lay close to the marks of the forepaws, indicated that she had very long ears; and, as the imprint of one foot was always fainter than those of the other three, I judged that the lady dog of our august Queen was, if I may venture to say so, a little lame.[5]

The effect was magical, but the method was eminently rational. In order to underscore the wonder-working effect, Huxley gave the name "retrospective prophecy" to this technique, asserting that "it is obvious that the essence of the prophetic operation does not lie in its backward or forward relation to the course of time, but in the fact that it is the apprehension of that which lies out of the sphere of immediate knowledge."[6] To justify his terminology, Huxley explains that while the "foreteller" informs the listener about the future and the "clairvoyant" informs the listener about events at a distance, the retrospective prophet bears witness to events in the deep past. What unites them all is "the seeing of that which, to the natural sense of the seer, is invisible."[7] Huxley's essay was included in a collection subtitled *Science and Hebrew Tradition,* which explicitly advocated retrospective prophecy as the proper method for calibrating and revising the Old Testament narrative.

In his 1983 article "Clues: Morelli, Freud, and Sherlock Holmes," the historian Carlo Ginzburg makes the case that the method of Zadig was the defining epistemology of the late nineteenth-century human sciences, an interpretative technique immortalized by the wizardry of Sherlock Holmes and shared by Freudian psychoanalysis, Francis Galton's new method of identification through fingerprinting, and the connoisseurial technique of the art historian Giovanni Morelli.[8] The literary critic Gillian Beer offers an explanation for the predominance of this epistemology in "Origins and Oblivion in Victorian Narrative," arguing that it represented an effort to come to terms with the im-

mense vistas of prehistory implied by nineteenth-century geology and Darwinian natural selection: "No longer held in by the Mosaic time order, that history became a mosaic of another sort, a piecing together of subsets into an interpretable picture. Words like *traces* and *decipherment* became central."[9]

For Huxley, the rationalism of the historical sciences was secured with respect to the arrow of time. In his Zadig essay, he explicitly repudiated "fore-telling" and lamented that there was no such term as "back-telling" to capture what he meant by retrospective prophecy. Huxley's Zadig was a rationalist whose divinatory powers consisted of interpreting the physical traces of events that had already taken place. The past was in principle knowable; the future—with the notable exception of the rigorously law-like movements of the planets—was not. For his pains, Zadig was condemned to death by the Babylonian Magi: "If his method was good for the divination of the course of events ten hours old . . . might it not extend ten thousand years and justify the impious in meddling with . . . the sacred foundations of Babylonian cosmogony?"[10] Similarly, the retrospective prophets of the late nineteenth century threatened to rewrite the Biblical narrative according to the canons of scientific rationality.

Zadig was actually a proxy for Voltaire, who had published a biography of the Babylonian sage in 1747, extolling him as the embodiment of all Enlightenment virtues. As Huxley admits:

> Our only real interest in Zadig lies in the conceptions of which he is the putative father; and his biographer has stated these with so much clearness and vivacious illustration, that we need hardly feel a pang, even if critical research should prove King Moabdar and all the rest of the story to be unhistorical, and to reduce Zadig himself to the shadowy condition of a solar myth.[11]

Huxley seemed unruffled by the conundrum that retrospective prophecy itself—"critical research"—might reveal its inventor to be no more than a "solar myth." For the archaeologists, anthropologists, and ancient historians of this period, however, mythology constituted a sinkhole that sometimes threatened to swallow their Voltairean rationalism altogether.

Evans's prophetic archaeology was certainly consumed by its own founding stories. He united Zadig's method with a visionary tendency

that betrayed a passionate identification with the mythic exploits of
the ancient Cretans. The reconstruction of Minoan religion, in par-
ticular, called upon an epistemology that combined the methods of
the detective with the inspiration of the nature-worshipping mystic.[12]
In this, he was not alone. As the great tide of Christian faith gradually
receded, scholarly investigations of non-Christian and pre-Christian
religion took on a new status as suppliers of a pagan alternative to the
disenchantments of modernity. Archaeologists, anthropologists, and
armchair compilers of catalogs of religion like *The Golden Bough* became
the de facto theologians of modernist paganism, and they brought to
their task a mixture of irony and enthusiasm, skepticism and passion.
Evans, one of the least ambivalent of these scholars, took to his priestly
role with gusto, producing long, elegiac passages about the Great Cre-
tan Mother Goddess that read more like prayers or invocations than
archaeological analyses.[13]

Along with the destabilizing effects of mythological subject mat-
ter, a further difficulty presented itself to the archaeologist desirous of
following the method of Zadig. The premise that grounded Huxley's
rational divination was that all worldly phenomena were law-like. The
laws of gravity enabled astronomers to reconstruct and predict the
movements of the planets over millennia. The laws of "co-ordination
of structures" enabled the paleontologist Georges Cuvier to deduce
the form of a pelvis of an extinct marsupial from the shape of its jaw.
The absolute consistency of the operations of "water, heat, gravitation,
friction, animal and vegetable life" made the geological record intelligi-
ble to the modern paleontologist. Huxley extended the same principle
to archaeology, declaring that the discipline "could have no existence,
except for our well-grounded confidence that monuments and other
works of art and artifice, have never been produced by causes different
in kind from which they now owe their origin."[14]

But what exactly were the inexorable laws of human life whose con-
sistent operation enabled the retrospective prophet to ply his divina-
tory art? By the time Huxley was writing in the 1880s, these laws were
increasingly defined in racial terms. Despite being grounded in the his-
torical sciences, this discourse showed scant respect for chronology,
deploying instead a network of interlocking agreements between the
human sciences to rearrange past, present, and future into another grid
based on a racial hierarchy. The ancient Greeks (the "chosen people"
of secular modernity) were at the top of this ladder, indigenous Aus-

tralians usually languished at the bottom, and each rung represented a unit of cultural and physical evolution. As the armchair anthropologist Sir Edward Tylor, foremost proponent of the "doctrine of survivals," remarked: "the condition of modern savages illustrates the condition of ancient stone age peoples."[15] While the word "savage" was employed to make connections between the past and present, terms like "atavistic" and "degenerate" were mobilized to proclaim doom-laden prophecies of the future. An oracular system of correspondences emerged that collapsed the primitive past of Europe, the primordial savagery of the non-European periphery, and an onrushing modernity that seemed about to throw overboard the achievements of the Enlightenment.

According to this scheme, European explorers, missionaries, and anthropologists were engaged in a sort of living archaeology. To take just one example among many, Bronislaw Malinowski pleaded for the preservation of the culture of the Trobriand islanders on the grounds that it represented "antiquities more destructible than a papyrus and more exposed than an exposed column and more valuable for our real knowledge of history than all the excavations in the world."[16] The actual archaeology of Bronze Age Greece engaged in this same temporal reasoning in reverse order: as the racial forebears of modern Europeans, the pre-Hellenic Greeks were hailed as protomoderns. Indeed, enthusiasm for the "first Europeans" sometimes exceeded the strict terms of the doctrine of survivals, when they were extolled as models to be emulated for the sake of the future vitality of the white race.

In an earlier book on the ruins of the ancient city of Mycenae, I sketched how Heinrich Schliemann's archaeological exploits set the tone for this exuberant celebration of the Greek Bronze Age. His avid pursuit of the material truth behind the Homeric epics led him to pour his considerable fortune into excavating the legendary cities of Mycenae and Troy. Partly as a result of Schliemann's spectacular discoveries and his knack for publicity, the *Iliad* began to assume a new significance as an alternative, pagan origin story for Western civilization. The warrior ethic of the Homeric poems resonated with the social Darwinism and nationalism that was beginning to define post-Christian Europe, and the archaeology of Greek myth took on a futuristic cast. This took many different forms, but the most politically explosive appropriation of Homeric archaeology was in the newly unified Germany, where Schliemann's admirers claimed that the Bronze Age Greeks were fair-skinned, fair-haired Aryans, ancestors of the modern "Nordic

type." From there it was but a short step to reason from Agamemnon's victory over the Trojans to modern Prussian conquest of their racial inferiors.[17]

When the excavation of mythology moved from the Greek mainland to the island of Crete, however, the politics of European origins underwent a decisive shift. Far from being recreated in the image of Aryan military victory, Minoan society was reconstructed as Semitic and North African, matriarchal and unfortified, prosperous, peaceful, and law-abiding. Much of this change is attributable to the individual into whose hands Knossos fell. Although Evans was as instinctively racist as any of his contemporaries, he was also extremely politically liberal and had no truck with Aryan theory. His Minoans were immigrants from Libya, Egypt, and Anatolia, the lands to the east and the south of Crete. He was certainly an "unspeakable of the Oscar Wilde sort,"[18] with sexual politics that were correspondingly androgynous, and he recreated Minoan Crete as an inverts' paradise of female deities, cross-dressing priests, and girl athletes.[19] Above all, he was a pacifist, prepared to sacrifice even his scholarly integrity for the cause of peace.

The famous prelapsarian pacifism of the Minoan world started out as a deliberate political decision on Evans's part. The excavation of Knossos could only proceed after Crete had won its independence from the Ottoman Empire in the Greco-Turkish War of 1897. Horrified by the devastation wrought by the fighting, Evans organized his dig as a site of Christian-Muslim reconciliation, employing workers from both sides of the political divide and offering them their shared pagan heritage as a way to heal their religious strife. He also suppressed the evidence he had already amassed for Minoan military installations and set about resurrecting Bronze Age Crete as an unfortified idyll in the best British style—internally peaceful under the benign administration of the Palace of Knossos, and protected from its enemies without by the "wooden walls" of King Minos's legendary navy.

That the "first Europeans" were unwarlike quickly became a cherished myth. As the twentieth century launched conflicts of ever greater reach and ferocity, the Minoan epoch came increasingly to be celebrated as the pacifist precursor to Homer's militaristic age of heroes, a luminous, feminine, fairy-tale exception to an otherwise lamentable human record of violence and hatred. The crisis of rationalism that began to gather steam in the 1870s turned into a full-blown repudiation of scientific progress in the face of the spectacle of the "civilized nations"

systematically slaughtering each other's young.[20] There arose a divinatory alternative epistemology, allied to avant-garde artistic practice, in which the line between fact and fiction was crossed and recrossed in the pursuit of archetypes that straddled the civilized and the savage worlds. Evans's visionary reconstruction of Knossos was the product of a time and place in which poets—charged with the task of making sense of a culture-annihilating descent into violence—became for a fleeting, fragile moment the acknowledged legislators of truth.

Knossos and the Prophets of Modernism chronicles how Europe's traumatic experience of modern warfare produced its false memory of a peaceful Cretan childhood. The book divides the history of Knossos into four periods, each structured around a war and its aftermath. From the Franco-Prussian War to the Cold War, it examines how each of these conflicts required a different Bronze Age to serve as its prehistory or its antithesis. Set during the period in which archaeology and mythology were so energetically deployed in the service of fascism, this book recreates a sometimes poignant and often absurd parallel world: that of the pagans, prophets, and new tragedians who mobilized mythical archaeology in the service of pacifism and feminism.

Chapter 1, "The Birth of Tragedy," takes the story back to the aftermath of the German victory in the Franco-Prussian War (1871) and introduces the two great prophets of Minoan modernism, Friedrich Nietzsche and Heinrich Schliemann. It explores the way in which Nietzsche's heroic, aristocratic creed for a godless age, based on his passionate reading of Homer, became entangled with Schliemann's exhumation of the Homeric heroes from the shaft graves of Mycenae. The section then considers how the work of the two men was taken up by racial theorists in Germany, who assigned a German origin to Mycenaean civilization and transformed the Homeric protagonists into swastika-wielding Teutonic warriors. I conclude the prologue by sketching the way in which Knossos was reconstructed as an antithesis to the celebratory militarism of Mycenae, emerging as an equally Nietzschean site but one that was indebted to the philosopher's earlier work, his reanimation of the cult of Dionysus in *The Birth of Tragedy*.

Introducing Arthur Evans, chapter 2, "Stand-up Tragedy," examines the idiosyncratic mixture of political passions and psychological imperatives that shaped Knossos as the quintessential temple of Dionysian modernism. His early exposure to the antiquarian methods pioneered by his father, together with the death of his beloved mother

when he was only seven, formed Evans into an archaeological visionary who would project onto the prehistoric past his most intimate sorrows and desires. His particular brand of romantic antiquarianism developed in his young adulthood, when he was swept up in the 1875 Bosnian uprising against the Ottomans, and began to reconstruct the past of the region in the shape of his most optimistic hopes for its democratic future. Twenty years later, when he first went to the island of Crete, he explored a network of fortifications in the eastern part of the island and reveled in a description of a warlike society constantly feuding with itself. But his horror at the aftermath of the ignominious war that won Crete her independence caused Evans to turn his back on this evidence for Minoan belligerence and to reconstruct their world as a pacifist paradise.

Chapter 3, "Ariadne's Lament," examines the inextricability of Minoan archaeology from the politics of post-Ottoman reconstruction. In response to the terrible Christian-Muslim massacres that had occurred in the recent war, Evans made sure to employ workmen from both sides of the religious divide. As part of his agenda for political reconciliation in the new nation, he arranged for them to dance the labyrinth dance together every year on what he claimed was the original location of Ariadne's famous "dancing floor." Ariadne thus came to stand for a certain vision of the past and the future—neopagan, peaceful, and presided over by a Great Mother Goddess. The section concludes by analyzing some of the wider cultural significance of Evans's Ariadne, examining her appropriation by the devout Nietzschean and feminist classicist Jane Ellen Harrison, and finally, her prophetic appearance, frozen and melancholy, in the work of Giorgio de Chirico, during the Balkan Wars of 1912–13.

After the First World War came Cretan archaeology's strangest, most irrational and haunted chapter, divided into two overlapping sections for the purposes of this narrative. Chapter 4, "The Concrete Labyrinth," considers the construction of Evans's modernist "peace memorial" and the writing of his *Palace of Minos,* detailing the process by which his interpretations and reconstructions became increasingly extravagant and controversial. Various reconstructions are analyzed for their modernist aesthetics and politics, including his rebuilding of the throne room complex and his reconstruction of the so-called "Captain of the Blacks" fresco. Taking a close look at the steady trickle of Minoan fakes that appeared in the museums of the new world in the

1920s and 1930s, this section asks why Evans accepted so many of them as authentic artifacts and analyzes his narcissistic recreation of the cult of the divine son. It closes with a consideration of the gold "Ring of Nestor" (also possibly a fake), which inspired Evans's reconstruction of the Minoan "Psyche," an ancient cult of the immortal soul symbolized by a butterfly.

Chapter 5, "Psyche's Labyrinth," continues the focus on the interwar period, looking at Evans's work in relation to modernist art, literature, and psychoanalysis, taking as its central motif his reconstruction of the cult of the butterfly soul. This section culminates with one of the odder episodes in the reception of Minoan archaeology: its role in the psychoanalytic encounter between Sigmund Freud and the writer Hilda Doolittle, known as H.D., in the spring of 1933. Poet and psychoanalyst were equally obsessed with Evans's work, and they indulged in a psycho-archaeological *folie-à-deux* that displays all the excesses of Minoan modernism. "You have discovered for yourself," Freud told her, "what I discovered for the race," whereupon he proceeded to diagnose her poetic obsession with Greek islands as a mother-fixated regression to the earliest pre-Oedipal/Minoan stratum of the brain. H.D. resisted the terms of Freud's analysis by confronting his diagnosis of Minoan hysteria with her Minoan psyche, an archetype of the soul's transformations borrowed from Evans. The section ends with the outbreak of the Second World War, the 1941 Battle of Crete, and Evans's death back in England only a few months later.

The penultimate chapter, "The Rebirth of Comedy," chronicles the Minoan adventures of the two poets—H.D. and Robert Graves—during and immediately after the Second World War. The chapter begins by following H.D. through the London Blitz, joining her at the séances in which she visited various previous lives connected with Bronze Age Crete. The story continues in 1946, in the immediate aftermath of the conflict, when the spiritual comfort that she had derived from Evans's pagan theology proved to be perilously fragile. The focus then moves to the archaeologically inflected pacifism of Robert Graves, examining his utopian, antiwar novel *Seven Days in New Crete* and his passionate defense of Minoan religion in *The White Goddess*. Between them, H.D. and Graves reinvented modernist Knossos in terms that anticipated by twenty years the exact temper of the pacifist counterculture.

The book ends with a brief survey of the postwar period, examining some of what happened to the peaceful Minoans as Cold War

replaced World War, postcolonial relativism usurped classical elitism, and neo-Greek tragedy made way for neoprimitive farce. The Minoans flourished in the 1950s–1960s in Jungian archaeology and beatnik art history, before emerging in the summer of love as the exemplary hippies of the ancient world—drug-taking, sexually uninhibited pacifists, enjoying the endless sunshine of their island paradise. Starting in the 1980s, this neo-Dionysian Crete was retooled for the nuclear age, metamorphosing into an embattled refuge of Amazonian Bronze Age peaceniks holding out against war-loving, male chauvinist Caucasians. The pacifist-feminist version coexisted uneasily with the simultaneous appearance of a highly contentious Afrocentric reinvention of the Minoans dubbed the "Black Athena thesis."

The book concludes with the gradual scholarly dismantling of the pacifist vision of ancient Crete, culminating in the "Minoan Roads Program" of the 1980s and 1990s during which archaeologists explored and analyzed a network of fortifications in eastern Crete. With this the story comes full circle: the Minoan Roads Program explored the very same evidence for Minoan belligerence that was discovered by Evans in 1895, only to be suppressed by him in the aftermath of the Greco-Turkish War and then rendered invisible for nearly the whole of the troubled century that followed.

Knossos itself stands at the center of this text, the little Cretan mound that was stripped away layer by layer, every bucket of soil sifted for the detritus of human occupation, while the buildings were reconstructed in the materials of modernist architecture. Around the site is arrayed an eccentric cast of individuals for whom the Minoan world provided a displaced enactment of the psychic, spiritual, and political dramas of modernity. Reconstructed as a vestige of the great age of matriarchy, Knossos was a site where the relations between men and women could be radically reimagined. Celebrated as the "childhood of Europe," Minoan Crete's melting pot of Egyptian, Libyan, and Anatolian cultures undermined the ideology of Aryan supremacy. Above all, because the concrete labyrinth was rebuilt as a lost pacifist paradise, the drama of modernism played out against its backdrop as a Euripidean tragedy of prophecy unheeded and the bitter inexorability of war.

{ I }

THE BIRTH OF TRAGEDY,
1822–1897

Evans's style of archaeology was invented by a businessman: the fabu-
lously wealthy, astonishingly polyglot merchant Heinrich Schliemann,
who, at the age of forty-six, decided to trade the balance sheet for the
trowel, thinking that he had located the ruins of the legendary city of
Troy. Boastful, lonely, ferociously ambitious, and possessed of a pecu-
liarly nineteenth-century combination of ruthlessness and sentimen-
tality, Schliemann was an opportunist who happily misrepresented his
activities and findings for the sake of dramatic effect and monetary
gain. The result was an archaeology of depthless popular appeal, and
his successes at Troy and Mycenae launched a frenzied search for other
sites associated with Greek legend. Schliemann's story provides the es-
sential background to the reconstruction of Knossos. He established
the very existence of pre-Hellenic civilization and inspired a school of
archaeology that gave material shape to mythical locations. Evans can-
not be understood without Schliemann, and in histories of archaeology
the two men's names are always coupled.

Where this account deviates from the usual narrative is in the introduction of another famous name. In the same year as Schliemann began to dig at Troy, the young classics professor Friedrich Nietzsche began to compose his first book, an exhortation to Germany's artists to embrace their historical destiny and inaugurate a new age of creative achievement to rival that of ancient Greece. This prologue links Nietzsche and Schliemann, sketching one little-explored route by which Nietzsche's heady mixture of irrationalism, poetry, and mythology found its way into Anglo-American modernism: irresistibly carried in by the archaeological artifacts that gave material shape to Nietzsche's pagan gods.

An Archaeology of Heroes

Heinrich Schliemann introduced to the practice of archaeology an entirely new note. At a crucial juncture in his archaeological career, in order to erase his intellectual debts and paper over his duplicities, he confected a childhood scene in which he prophesied to his father that he would one day excavate the walls of Troy. This enduringly popular autobiographical fable breathed into the nascent discipline of archaeology a fairy-tale atmosphere of childhood longing and quasi-supernatural wish-fulfillment that would become one of Schliemann's most powerful cultural bequests.[1] With the self-mythologizing of this self-made man, the archaeology of Greek legend acquired an aura of pagan predestination, a prophetic grandiosity that Arthur Evans would inherit and exploit in his own pursuit of archaeological enchantment.

Schliemann's childhood was overshadowed by a tragedy that brought disgrace and poverty in its wake. He was born in 1822 in a tiny village in northeastern Germany, near the border with Poland. His father, Ernst Schliemann, was a Lutheran pastor whose indiscreet affair with one of the household maids became the scandal of the village. When Heinrich was ten years old his mother died giving birth to her ninth child. After his wife's death, Ernst Schliemann's parishioners demonstrated their disgust by assembling in front of the house every Sunday, banging pots and pans and throwing things at the windows. Their offspring were forbidden to play with the Schliemann children. Heinrich was sent to stay with his uncle. There he joined his cousins' lessons with a private tutor, and at the age of eleven went to a local gymnasium. Family financial

troubles—Schliemann senior was suspended without pay pending the outcome of an embezzlement enquiry—meant that Heinrich had to leave the gymnasium after only a few months and go to the less expensive *Realschule,* which did not prepare its pupils for higher education. At the age of fourteen he left school and was apprenticed to a grocer. After five-and-a-half years of drudgery even this lowly way of life was denied him: at nineteen Schliemann tore a blood vessel while moving a heavy cask and was dismissed.

Perhaps it was these early experiences—the death of his mother, his ostracism from the village community, the scandals that dogged his father, and his demotion to a cheaper school and humble profession—that accounted for the lonely ferocity of Schliemann's later ambition. Whatever it was that drove him, driven he undoubtedly was, and his dismissal from the grocer's shop was the turning point. His mother had left him a small bequest in her will, and he used it to train as a bookkeeper, learning the Schwanbeck method in only a few months, demonstrating for the first time the prodigious capacity for intellectual effort that would propel him through the rest of his remarkable career. Seeking his fortune first in Hamburg and then in Amsterdam, he realized the enormous commercial advantages of learning foreign languages and set himself the task of mastering English and French, spending hours every day writing, speaking aloud, and memorizing long passages. Having thus strengthened his memory, Dutch, Spanish, Italian, and Portuguese easily followed. In 1844 he applied for a position at one of the leading trading houses of the day and began working as a correspondent and bookkeeper. He secured his first promotion by learning Russian, whereupon he was sent as the firm's representative to St. Petersburg. Within a few months he had set up his own operation, although he continued to act as the company's agent. Dealing in indigo, wine, sugar, saltpeter, tea, and coffee, he began to accrue his enormous fortune.

Schliemann went from modest wealth to stupendous riches by exploiting the vagaries of history: he set up a bank in Sacramento during the gold rush, leaving California under suspicion of short-weighing gold dust; he traded in saltpeter, brimstone, and lead during the Crimean War, breaking the British blockade on Russian ports. In 1852, he made his unsuccessful first marriage to a Russian girl of good family, who refused to join him in his compulsive traveling. She had three children

by him; they quarreled incessantly about money; by 1864 he was thoroughly disenchanted with family life and left on a world tour, depositing a will with his lawyer before departing. In just under two years, propelled by an all-consuming curiosity, he visited Tunisia, Egypt, Italy, France, India, China, Japan, California, Mexico, and Cuba, writing diaries in English, Italian, German and Hindi, and producing his first book, a travelogue of the Far East, composed in French and published in Paris. Paris was where he decided to settle, and he began to invest in property.

As he tried to educate himself in the manner befitting a man of fortune, Schliemann began to evince an interest in archaeology. An 1868 trip back to St. Petersburg from Paris took him through Rome, where he observed the excavations on the Palatine Hill, and thence to Naples, where he spent three days at Pompeii. After a brief stop in Sicily, he sailed to Corfu. From that point on, his itinerary provided him with the narrative of his second book, *Ithaque, le Péloponnèse et Troie*. This work was greatly indebted to John Murray's 1854 *Handbook for Travellers in Greece*, which alerted Schliemann to the parts of this beautiful rugged landscape of rocky islands and turquoise sea that had been identified with different episodes in the Homeric sagas. The section on the island of Ithaca in the *Handbook*, for example, comprised a detailed discussion of the most likely locations of various sites associated with the homecoming of Odysseus. When Schliemann arrived on the island he tracked down each of these places. At the spot listed in the handbook as the possible site of Odysseus's palace, he actually took a spade to the ground and dug out twenty vases filled with ashes, which he identified as probably containing "the bodies of Ulysses and Penelope or their offspring."[2] The heroic archaeologist of Homer's heroic age was beginning to emerge.

From Ithaca, Schliemann caught a boat to Athens, where he had a fateful meeting with a German architect called Ernst Ziller. A few years earlier Ziller had participated in the first attempt to locate the site of Troy using the methods of archaeology, assisting at some preliminary excavations at a site in western Turkey generally believed to be the most likely location of the legendary city. Although the 1864 dig had found no positive evidence, Ziller remained convinced that Troy was just waiting to be found and seems to have communicated his enthusiasm to Schliemann, who promptly changed his travel plans, intending to continue his Homeric adventures with a visit to Troy.

There were, in fact, two principle contenders for the site of Troy: Ziller's mound about three kilometers southeast of a village called Bunarbashi, and some other ruins under a mound called Hisarlik. Hisarlik was the location of the Hellenistic town of Novum Ilium or New Troy, and had been claimed as the site of the Troy of legend since antiquity. But there was one ancient dissenter, the geographer Strabo, and in the late eighteenth century a new contender, Bunarbashi, claimed many adherents. By the time of Schliemann's first visit to the Trojan plain in 1868, scholarly opinion was more or less divided between those who believed Troy was nothing but poetic moonshine and those who believed it would be found at Bunarbashi, with a small minority still championing Hisarlik.

In the account that he published in *Ithaque, le Péloponnèse et Troie,* Schliemann presented his journey to the Troad as a mission to adjudicate between the competing claims of the two possible sites. From the evidence of his diaries, however, it seems to be the case that he had no idea about any site other than Bunarbashi before arriving in Turkey. Hisarlik was first brought to his attention by a resident of the area, a man called Frank Calvert, a member of a British family who owned a farm in the Troad. Calvert, who knew the Trojan Plain intimately, had made some preliminary investigations at Hisarlik and, based on the promising results, had even purchased a part of the site. He had tried to interest the British Museum in funding further excavations but without success. When he met Schliemann Calvert quickly realized that this enthusiastic novice might just possess the money and energy to continue what he had started, and shared with him all his finds and conclusions. As a result of this conversation, Schliemann resolved to invest some of his enormous fortune in the excavations. He returned to Paris and wrote up his trip in a matter of a few months, again displaying the tireless energy that he brought to all his endeavors.[3]

From Paris Schliemann bombarded the endlessly patient Calvert with questions about the logistics of excavating but then postponed his first expedition to Hisarlik because he was engaged in divorcing his recalcitrant Russian wife. No sooner had he secured the divorce than he was writing to a friend in Greece asking him to find him a biddable Greek girl to marry. From the photographs that he was sent, he selected the sultrily beautiful Sophia Engastromenos, a schoolgirl thirty years his junior, and in September 1869 he married her in Athens. It would turn out to be a successful partnership. Although initially cemented by

Schliemann's loneliness and his in-laws' social and financial aspirations, it was later held together by Sophia's undoubted strength of character. By her intelligent participation in Schliemann's archaeological exploits and her particular combination of stubbornness and pliancy, Sophia made herself indispensable to her willful, impatient husband.

By the beginning of 1870 Schliemann had lost patience with the Turkish government's delays and vacillation over the matter of his permit to excavate, and on April 9 he began to dig at Hisarlik without the permission of either the authorities or the landowners. He had hoped that the top of the mound would contain the remains of the principal buildings of Troy: either the palace of King Priam or the Trojan temple of Athena, described by Homer in the sixth book of the *Iliad*. But when he excavated an oblong area at the highest point of the mound's ridge, he found nothing of interest and "lost all hope of finding the cyclopean walls of the temples and palaces that Homer sings about in the Iliad."[4] He struck out further west and dug two long narrow trenches that intersected to form a right angle. Here the results were more promising. One of the trenches was full of pottery sherds, coins, bones, and terracotta statuettes. The other revealed for the first time the potential complexity of the site: the trench was crossed by five walls with another running down its eastern edge, and walls superimposed upon one another provided clear evidence of different occupation levels.

When the owners of the western half of the mound (the eastern half belonged to Calvert) turned up to protest at Schliemann's high-handed behavior, he "crushed them with insults"[5] and later attempted to buy them off. Shortly afterward the Turkish government requisitioned the land and, to Schliemann's disgust, made him apply for a permit in the usual way. He mobilized his contacts in Turkey and promised the government half of all the artifacts he uncovered. In October 1871 he was finally ready to begin excavating legally.

The beginning of the second season was even more disappointing than the first. Right underneath the Hellenistic city, a stratum four meters down from the summit of the mound was characterized by stone tools, hundreds of terracotta spindle whorls, one piece of wire, and some copper nails—nothing, in other words, remotely like the bronze and iron weapons of the Homeric sagas. At the end of three weeks Schliemann was forced to conclude that his contribution to Homeric scholarship might amount to nothing more than settling the question of the existence of Troy negatively. After this low point, however,

his fortunes improved. As he dug deeper he began to uncover a large number of bronze and copper artifacts—brooches, knives, spearheads, and nails alongside a number of terracotta pitchers filled with human bones. By the end of the season of 1871, the question had become not whether the mound of Hisarlik hid the remains of Troy, but which of the occupation levels of the site corresponded with the Homeric city.

The following year Schliemann employed over a hundred workers to dig a vast trench, 79 meters wide, right across the north-south axis of the mound. Even by the terms of his own obsessions, let alone the standards of archaeology today, Schliemann had committed a grave error. In his zeal to dig down to the lowest stratum, which he believed to be the level of Homer's Troy, he destroyed much valuable evidence, including, ironically, much of the level of the city now considered to correspond with the date of the legendary Trojan War. In June he stopped the excavations on the south side of the mound and began digging Frank Calvert's land. Here he came across the find of the season, an exquisite Hellenistic marble relief of Apollo or Helios driving four horses across the sky with a sunburst behind the god's head. Exposing his ruthless business instincts, Schliemann bought out Calvert's half-share of the sculpture for the equivalent of £40 and then promptly tried to sell it on for £2,000.

Later in 1873 Schliemann dug up the loot that would make him a household name. As recounted in the book he later published, on the morning of May 31 Schliemann thought he spied the glint of gold behind a large copper artifact which was lying under a layer of "red and calcined ruins . . . as hard as stone."[6] He promptly sent his workmen off for an early breakfast and jumped down into the trench with his knife. There, while the men were eating and resting, he cut out from the deposit a shield, cauldron, and vase of copper; an electrum cup; five silver vases with lids; dozens of copper weapons; and a bottle, cup, and sauceboat-shaped vessel, plus two diadems, a headband, sixty earrings, and nearly 9,000 small ornaments, all of gold.

The interpretation of these artifacts that eventually found its way into print was a florid piece of Homeric archaeological fantasy. Schliemann reconstructed a scene in which a member of King Priam's family was rushing out of the citadel to escape the Greek army, when "the hand of an enemy or the fire overtook him, and he was obliged to abandon the chest."[7] On August 5 the discovery of "Priam's treasure"

appeared in the *Augsburger Allgemeine Zeitung* and caused an immediate
sensation. Abbreviated versions of the report were published in news-
papers all over the world. Although many archaeologists thought his
attribution of the treasure to King Priam was absurd, Schliemann had
seized the public imagination, and he shot to fame. In 1874 he pub-
lished the results of the first three seasons at Hisarlik in French, Ger-
man, and English.

As soon as he had published the first reports from Troy, Schliemann
turned his attention to "golden Mycenae," capital city of Homer's bad-
tempered protagonist King Agamemnon. Unlike Troy, there was no
question as to Mycenae's whereabouts, its massive citadel walls and fa-
mous Lion Gate having survived the millennia since the Heroic age. Be-
fore the Greek War of Independence various travelers and explorers had
visited the ruins, carting off bits and pieces from the beehive tomb out-
side the citadel known as the Treasury of Atreus. In 1841, in a symbolic
celebration of the heritage of their newly independent nation, the Lion
Gate had been cleared down to the threshold by the Greeks. Despite
its fame and visibility, however, Schliemann carried out an unauthor-
ized excavation at Mycenae in 1874, employing from three to twenty-six
workmen for five days until he was stopped by the authorities.

As usual, Schliemann's wealth cushioned him from the consequences
of his recklessness. In 1876 the permit to excavate Mycenae was awarded
to the Greek Archaeological Society. The society was perennially short
of funds, and so it engaged Schliemann—one of its most generous bene-
factors—to carry out the excavations at his own expense on its behalf.
The dig began in August 1876. The society also engaged a young Greek
archaeologist, Panagiotis Stamatakis, to supervise the work, whose
thankless task it was to try and restrain Schliemann from destroying ev-
erything that did not appear to be related to the Homeric epics.

There were three main areas of excavation: the Lion Gate itself, now
buried under a pile of debris washed down from the top of the acropolis
by winter rains; a spot inside the citadel just to the right of the gate; and
one of the beehive tombs outside the walls. In late August, a series of
erect stone slabs appeared at the place where Schliemann's workmen
were digging inside the citadel. They seemed to form a large double
circle. Inside the circle the workmen uncovered a number of larger in-
dividual slabs, some carved with crude figures and patterns in low relief.
Schliemann knew that his greatest publicity coup would be to locate

the tombs of Agamemnon and his companions, who were murdered, according to legend, when they returned from the Trojan War. These tombstones seemed to be the perfect candidates for the legendary burials. At the end of November, when the digging had revealed that there were indeed deep rock-cut tombs under the slabs, some filled with gold funereal goods, he sent a telegram to King George of Greece declaring that he had discovered "the graves of Agamemnon, Cassandra, Eurydemon and their companions, all slain at a banquet by Clytemnestra and her lover Aegisthos."[8]

On November 30, in one of the tombs, he discovered three large corpses, two of which were wearing gold death masks. Upon removing one of the masks, the skull beneath it crumbled, but when he turned to the other, he found that "the round face with all its flesh had been wonderfully preserved under its ponderous golden mask."[9] Thrilled by this glimpse of actual Homeric flesh, Schliemann promptly fired off a telegram to the Greek press that boasted, "This corpse very much resembles the image which my imagination formed long ago of wide ruling Agamemnon" (later rewritten as the apocryphal "I have gazed upon the face of Agamemnon").[10] A local pharmacist was commissioned to preserve the body, and gum arabic was poured over the remains before the whole thing was cut out of the soil and transported to Athens.

By announcing to the world that he had dug up the treasure of the Trojan King Priam and touched the very flesh of the Homeric warlord Agamemnon, Schliemann gave the most famous myths of the Western canon a basis in material reality. His excavation of the great sites of pagan legend elevated the Homeric epics to the status of a non-Christian origin for Western civilization, a pagan prehistory for a secular modernity. Boasting about his superhuman exploits in the service of resurrecting the heroes of legend, Schliemann's self-mythologizing resonated with a whole series of cultural anxieties about the struggle for existence. As early as 1865 Rudolf Virchow, the famous cell biologist, anthropologist, and soon-to-be fellow excavator of Troy, ringingly declared that human remains in archaeological excavations tell us "where the road of our present development" might be "leading us and our descendants."[11] More pithily, Virginia Woolf wrote in her diary of her overwhelming impression of Mycenae after Schliemann's excavations: "There never was a sight I think less manageable . . . it . . . forecasts a remote future; retells a remote past."[12]

In 1880, after a further season at Troy, Schliemann further added to the prophetic aura of his archaeological career by insisting, against the advice of his publisher and his colleagues, upon prefacing his *Ilios* with an autobiographical parable. The story went that for the Christmas of his seventh year, little Heinrich had been given the copy of a book with an engraving depicting King Priam escaping from the burning city. "Father," he cried, "if such walls once existed, they cannot possibly have been completely destroyed: vast ruins of them must still remain, but they are hidden away under the dust of ages." His father demurred, but eventually "agreed that I should one day excavate Troy."[13] The rest of his life, Schliemann declared, had led him inexorably toward this final goal. In the inclusion of this fable, the archaeologist displayed the sound commercial sense that enabled him to amass his vast fortune: the book became a best seller on the strength of its introduction, which was then published as a separate pamphlet and became required inspirational reading for German schoolboys.

There seems to be no reason to give any credence to the childhood story. Schliemann's first book of Homeric topography, *Ithaque, le Péloponnèse et Troie,* was prefaced with an autobiographical essay making no mention of the conversation with his father. In this earlier version, he dates his love of Homer back to his teenage years as a grocer's assistant, inspired by a drunken miller who had come into the shop and recited some passages from the *Iliad.* It appears that he confected the earlier scene for his *Ilios* in order to win a priority dispute with Frank Calvert.

After Schliemann's first couple of seasons, Calvert was worried that the artifacts from the first and second strata at Hisarlik were far too early to have anything to do with the Trojan War. Invoking parallels from Ur, he suggested that Schliemann's Troy was in fact a prehistoric settlement dating back several centuries before the Homeric city. Calvert published these doubts in his summary of the excavations in the *Levant Herald* in 1873, asserting (correctly) that Schliemann's search for the Troy of Priam was bedeviled by a lacuna of more than a thousand years. Schliemann, always wounded by criticism and especially stung by what he knew were valid objections, hit back with everything he could. In *Troy and Its Remains* he represented Calvert as an adversary of his excavations and an opponent—rather than, as was actually the case, the *source*—of the theory that Hisarlik was the site of Troy. When Calvert challenged this ridiculous piece of chicanery, Schliemann asserted in an article that "Homeric topography has, of course, always been of

paramount interest to me," a boast that he expanded later that same year into the story about being shown a picture of Troy by his father as a child. By presenting Homeric topography as the motivating force of his whole life, Schliemann hoped to make nonsense of Calvert's version of events.[14]

Before Schliemann, the very prestige of the historical sciences—geology, paleontology, archaeology, philology—was intimately bound up with the rationalism of the enterprise of retrospective prophecy—"back-telling," in the formulation of Thomas Henry Huxley. The past was in principle knowable; the future was not. The enormous impact of Schliemann's childhood scene with his father introduced a new *prospective* twist to the business of retrospective prophecy, a quasi-occult self-fashioning in which special individuals gained oracular insight into the puzzles of antiquity.

Schliemann launched his preface with a pious sentiment: "If I begin this book with my autobiography, it is not from any feeling of vanity, but from a desire to show how the work of my later life has been the natural consequence of the impressions I received in my earliest childhood."[15] By focusing on his early life, Schliemann tapped into a powerful vein of fantasy and desire in his readers. The idea of childhood already featured in the archaeology of the Greek Bronze Age: the pre-Hellenic Mycenaean age was considered, under the terms set by Victorian anthropology, to be the childhood of Western civilization. As the fame of Schliemann's autobiography spread, the world of childhood took on yet another role in the already thrilling drama of Mycenaean archaeology, becoming the crucible in which the ambitions and insights of the future archaeologist were formed. Schliemann's bildungsroman brought to archaeology's myth about itself a potent mixture of magic, adventure, and buried treasure. He was the boy who grew up to realize his childhood dream in a series of magnificent adventures in exotic settings. As a child he had predicted that one day he would prove the truth of the magical stories of Homer, and as an adult he had fulfilled his glorious destiny.

A Prophecy of Tragedy

At the same time as Schliemann was rousing the Homeric heroes from their centuries-long slumber, his much younger compatriot Friedrich Nietzsche was also shaking awake the early Greeks and setting them

to work in his forging of a post-Christian future. A classics professor by trade, Nietzsche invented a new diction, writing in the voice of a neo-Greek prophet of modernity. He attracted countless followers and imitators, disciples of his oracular method who looked to the deep past for clues about the near future. Without exception, all the classicists, revolutionaries, artists, writers, poets, and psychoanalysts who were inspired by Cretan archaeology labored under Nietzsche's towering influence.[16]

Schliemann's confected childhood scene is a perfect example of a pseudo-prophecy, an oracular utterance retrospectively insinuated into a narrative of origins in order to legitimate a claim, glamorize a reputation, or appropriate a discursive field. (There will be many others in the following pages.) Nietzsche's prophetic practice is of a quite different order. His utterances were both accurately predictive and powerfully performative. He foresaw the consequences of a post-Christian crisis of values, and he stirred his readers to enact his solutions, a combination of prophetic gifts that makes his work uncannily prescient as we read it in the light of the events of the twentieth century. Nowhere were his rhetorical gifts more apparent than in his posthumous shaping of the archaeology of pre-classical Greece.

From his reading of Greek literature Nietzsche managed to discern two pre-classical shadows moving behind the bright clarity of classical art. One of these dark shapes—an ecstatic cult of music and intoxication imported to Greece in the sixth century B.C.—would lend its name to his protomodernist aesthetics. The other—the aristocratic code of the warlike Nordic tribe who conquered Greece a few centuries before the time of Homer—would provide the substance of his nihilistic moral credo. These analyses seemed to be confirmed by archaeology, and the excavation and reconstruction of the Aegean Bronze Age became one of the means by which Nietzsche's prophecies were fulfilled. As his historical scheme was reified and literalized through archaeology, the emergence of apparently solid evidence for the correctness of his categories helped to persuade a whole generation of poets, politicians, scholars, and scientists to adopt various deformed versions of his cure for the cultural ills of the modern world. By the sheer force of his prose and the dark brilliance of his interpretation of Homer, Nietzsche turned the Bronze Age into the prehistory of modernity.

Juxtaposing Nietzsche and Schliemann as the two great prophets of the concrete labyrinth reveals some striking symmetries. The tragic

philosopher and the charlatan archaeologist were both neopagan sons of Lutheran ministers in rural Germany; both were linguists and root-less cosmopolitans; both were dedicated to an awe-inspiringly relent-less practice of "self-overcoming" (*Selbstüberwindung*—the word is Nietzsche's); both were posthumously recast as Nazi heroes in defiance of their mutual ambivalence about Germany and their shared inability to sustain any sort of racist or anti-Semitic thinking; and the prose of each is characterized by Wagnerian grandiosity. They were also men of completely opposite temperaments. Under a rather crude reading of his philosophy of self-becoming, Nietzsche could never hope to be as Nietzschean as his relentlessly successful compatriot. With a will to power forged in the white heat of childhood poverty and disgrace, Schliemann was a natural amoralist, a consummate survivor, and an in-stinctive pagan.[17] The philosopher, by contrast, was a scholar of such delicate scruples and such precarious health that his vision of Homeric amorality was as physically and psychically unrealizable by him as it was intellectually compelling.

The differences in temperament between Nietzsche and Schlie-mann also appear in the contrasting characters of their respective fa-thers. While Ernst Schliemann was a blustering hypocrite, Karl Ludwig Nietzsche was to all accounts a man of integrity: musical, erudite, and unfortunately, doomed. He died of "softening of the brain" at the age of thirty-six when Nietzsche was only four. After his father's death Nietzsche's family moved around until finally settling in Naumberg, installing itself in the very house to which he would to return at the age of forty-four, incurably insane, to be cared for by his mother until his death.

When he was fourteen Nietzsche was sent to the famous Pforta School where he received that superbly rigorous education in the clas-sics only available in the German-speaking lands. During this period his main extracurricular activity was the founding of a small literary and musical society consisting of him and two friends from home who would meet during the holidays to share their own musical and liter-ary compositions. Although he was confirmed in 1861, his days of piety were numbered: already he was bringing the same historical skills that his teachers lavished on the texts of ancient Greece and Rome to bear on his reading of the Scriptures. Many of Nietzsche's insights into his own times and the future were based on this inversion of the usual ap-proach to the founding texts of Western civilization: he read the works

of pagan antiquity with the emotional passion usually reserved for the Christian Bible, and read the Bible with the historical skepticism and moral repugnance usually directed at the pagan classics. The results would prove to be explosive.

In 1864 Nietzsche registered at the University of Bonn and tried, without success, to be a normal young man: he joined a student society and endeavored to enjoy drinking beer; he availed himself of the mandatory dueling scar—a scratch across his nose—in a fencing match lasting all of three minutes; he visited a brothel where he may or may not have partaken of the services. At Bonn he also abandoned the study of theology and began his lifelong quest to explore the farthest reaches of atheism. In 1865 he transferred to Leipzig, following his professor of philology, Friedrich Ritschl. There Nietzsche became Ritschl's protégé: the older man's enthusiasm for Nietzsche's work was what persuaded him to become a philologist. After a short spell in the military, Nietzsche was discharged, and he returned to Leipzig. Plans to go to Paris with a friend to sample the delights of absinthe and the cancan were cut short by the news that Ritschl had proposed him as a candidate for the professorship of classical philology at Basel University. He was appointed to this prestigious position—despite the fact that his doctorate was incomplete—at the age of twenty-four.

Nietzsche's intellectual self-confidence and his capacity for complete emotional immersion in the philosophical and spiritual questions of antiquity served him well as a teacher. Recollecting his pedagogical style, his former pupils were "united in the impression they had sat at the feet not so much of a pedagogue as of a living ephor from antique Greece, who had leapt across time to come among them . . . As if he spoke from his own knowledge of things quite self-evident and still completely valid."[18] But Nietzsche was too young, too creative, and too headstrong for the academic yoke, and the publication of his first book, *The Birth of Tragedy*, would destroy his reputation as a classicist. Far more important to him than any professorial appointment was his cultural apprenticeship to Richard Wagner. The year before he took up his post at Basel he had ingratiated himself with the composer and been absorbed into the thrilling goings-on at Wagner's satin-swagged, cupid-bedecked home at Tribschen in Switzerland. Adoration of Wagner's music had inspired in Nietzsche a vision of German cultural renewal in which the operatic art of his idol signaled a return to the exalted spirit of the ancient world. Accordingly, his first book was framed

as an extended appreciation of the composer, and opened with a parable on the origin of Greek tragedy.

Nietzsche claimed that the tragic art of the ancient Hellenes arose from a reconciliation between the warring creative impulses represented by two Greek deities: Apollo, sponsor of the serene arts of sculpture and epic poetry, and Dionysus, god of wine, song, sex, and frenzy. According to Nietzsche's historical scheme, the lucent serenity of Homer's Apollonian gods represented an Iron Age defense against the barbarous Dionysian temptations that pressed in on Greece from the south and the east. In the sixth century B.C., however, the Apollonian equanimity of Greece was shattered when the Dionysian impulse "began to break forth from the deep substratum of Hellenism itself."[19] The Greek Dionysus manifested in a new kind of religious music, the Dionysian dithyramb, in which the chorus clamored "to sink back into the original oneness of nature."[20] Apollo was compelled to join forces with the reckless, self-dissolving magic of this new god, and their union begat the tragic art of Aeschylus and Sophocles. The great tragic age was in turn brought to a premature close by the advent of Socrates and his spirit of rationalist enquiry, a symptom—in Nietzsche's provocative reversal of received wisdom—of cultural degeneration, the lamentable excesses of which were still everywhere visible in nineteenth-century scholarship.

Nietzsche's analysis of the deep past paved the way for a prophecy of the near future. Characterizing "German music, in its mighty course from Bach to Beethoven, and from Beethoven to Wagner"[21] as a Dionysian force, he asserted that late nineteenth-century Germans were "living through the great phases of Hellenism in reverse order and seem at this very moment to be moving backwards from the Alexandrian age into an age of tragedy."[22] The confidence of his diagnosis was bolstered by what he perceived as a reversal of the Socratic victory over the forces of unreason. After centuries of "theoretical optimism"—the faith in the power of rational thought personified by Socrates—science was irresistibly approaching "those outer limits where the optimism implicit in logic must collapse."[23] Kant and Schopenhauer's use of "the arsenal of science to demonstrate the limitations of science"[24] was as symptomatic of the emergence of a modern tragic age as were the ecstasies of German music.

Along with tragedy and Dionysian music, Socratic rationalism also destroyed mythological consciousness, thus sapping Greek culture of

the nourishment necessary for full creativity. It followed that the music and philosophy of the modern tragic age must spawn a new mythology, the exact psychological purpose of which could be experienced by any sensitive spectator at a performance of Wagner's *Tristan and Isolde*. Mythology was an Apollonian buffer that protected the listener from the shattering effects of Dionysian music. Without the interposition of the narrative events enacted on stage, Wagner's music would bring the audience to the brink of complete psychic dissolution. In the same way, the plots of the great tragedies of ancient Greece shielded the audience from the devastating impact of the music of the Dionysian chorus. (These ancient sounds were lost and could only be imagined: in Nietzsche's scheme their power and beauty might be extrapolated from the text of the tragedies by analogy with the relationship between the libretti and the scores of the Wagnerian corpus.)

Presenting as a "contradiction" the fact that Wagner's listener is not driven crazy by the impact of the music is an argument only narrowly saved from absurdity by Nietzsche's raising the philosophical stakes. In *The Birth of Tragedy* he hitched his passionate aestheticism to a critique of morality, declaring that "only as an aesthetic product can the world be justified to all eternity."[25] The animal forces represented by Apollo and Dionysus—the dreams and intoxications that flowed directly from nature through human creativity to realize themselves as art and ritual—were merely part of the "extravagant fecundity of the world will"[26] and justified themselves on aesthetic criteria alone.

After the publication of this adoring tract, however, the tension between Nietzsche's own incendiary brand of free thought and Wagner's Teutonic mysticism began to trouble the young acolyte. His hopeless infatuation with Wagner's wife Cosima, the beautiful and talented daughter of Franz Liszt, may also have accelerated his disenchantment with his idol. By 1874 he was consciously ambivalent about the Wagnerian aesthetic and devoting more time to the publication of works— the second and third of his *Untimely Meditations*—remote from the composer's concerns. When, in 1878, Wagner sent Nietzsche a copy of the text of *Parsifal*, his Christian allegory, and received from the philosopher a copy of *Human, All Too Human,* a ruthless psychological dissection of idealism, it became obvious that the two men were traveling quickly in opposite directions, and the friendship came to an end.

The second of Nietzsche's *Untimely Meditations,* a polemic in praise of the invigorating effects of cultural amnesia entitled *On the Advan-*

tage and Disadvantage of History for Life made explicit the prophetic relationship between antiquity, modernity, and the future implied in *The Birth of Tragedy*:

> only so far as I am the nursling of more ancient times, especially the Greek, could I come to have such untimely experiences about myself as a child of the present age. That much I must be allowed to grant myself on the grounds of my profession as a classical philologist. For I do not know what meaning classical philology would have for our age if not to have an untimely effect within it, that is, to act against the age and so have an effect on the age to the advantage, it is to be hoped, of a coming age.[27]

This manifesto of Nietzsche's method located his ability to know the future in his power to shape it. And it was, indeed, the extraordinary force of his prose—its capacity to persuade people not only to believe in, but also to enact, his prophecies—that lends his works their uncanny divinatory aspect. His announcement in *The Birth of Tragedy* that modernity was moving backward from the Alexandrian age to an age of tragedy was as much exhortation as it was prediction. This was the method of the neo-Greek prophet: from the perspective of a passionate engagement with antiquity, he levels a critique of modernity so powerful and oracular that it shapes the future.

In 1879 Nietzsche was forced to resign from the University of Basel due to a complete breakdown in his health. He was pensioned off, and spent the rest of his life as a solitary wanderer without fixed abode. Despite his mental and physical anguish, he continued to write with a ferocious pace and intensity. In 1880, volume 2 of *Human, All Too Human* appeared; the following year he published *Daybreak: Thoughts on the Prejudices of Morality*. *The Gay Science* was published in 1882, containing the utterance for which Nietzsche is most famous: "The greatest recent event—that 'God is dead'; that the belief in the Christian God has become unbelievable—is already starting to throw its first shadow over Europe."[28] Despite their unprecedented stylistic brilliance and rhetorical power, both *Daybreak* and *The Gay Science* were received with almost complete indifference, confirming Nietzsche in his loneliness and the "untimeliness" of his utterances.

In spring 1882, however, Nietzsche did make one last effort to overcome the solitariness that had so far characterized his existence. He

had traveled to Rome at the end of April and found out that his great friend Paul Rée was there in the company of a young lady. The woman in question was one Louise Salomé, the daughter of a Russian general who had been studying at the University of Zurich when she had fallen ill and gone to Rome to recover. There Rée had met her at the house of a mutual friend and been immediately smitten. His proposal of marriage was turned down, but Salomé counter-proposed that they set up house together with a third person and live and study together as brother and sister. Rée assented to the plan and suggested Nietzsche as the third party. Nietzsche arrived, met Salomé, and also fell violently in love. Two marriage proposals, one misguidedly issued through Rée, his competitor for her affections, were turned down, after which Rée whisked Salomé away from under Nietzsche's nose, leaving him humiliated, furious, and lonelier than ever.

This sense of aloneness thenceforth became a central tenet of Nietzsche's self-fashioning, finding its most exalted expression in the persona of Zarathustra, the Persian prophet who in about the seventh century B.C. founded the ancient Persian religion Zoroastrianism and who became the philosopher's second alter ego (after Dionysus). *Thus Spoke Zarathustra,* the bizarre, exuberant Bible of moral nihilism that Nietzsche wrote between 1883 and 1885, has been rightly called "a hymn to solitude, and its hero the loneliest man in literature."[29]

The Persian prophet Zarathustra was, in Nietzsche's estimation, the first moral realist, the first person to see morality "as force, cause, end in itself." Nietzsche took his name on the grounds that the creator of "this most fateful of errors . . . must also be the first to *recognize* it."[30] *Thus Spoke Zarathustra* is a very odd book, whose combination of shrill misanthropy and blissful self-love reflects the poignant contrast that had by now opened up between the rapture of the Dionysian prophet and the sufferings of the man who had created him. Nearly blind, hopelessly insomniac, plagued by constant vomiting and terrifying headaches, the physical circumstances of Nietzsche's life seem as incompatible with Dionysian ecstasy as it is possible for a life to be. Photophobic, he fled from city to city in search of the right dim light to soothe the pain in his eyes; he had to be fanatically careful and circumscribed in his habits, dining alone off a mild diet, eschewing all but the smallest amount of alcohol; he was often too poor to heat his rooms in the winter and wrote many of his works with hands that were blue with the cold.[31]

In 1886 Nietzsche's former publisher bought the copyright of all of Nietzsche's works with a view to reissuing them under his own imprint. The new preface for *The Birth of Tragedy,* entitled "An Essay in Self-Criticism," summarized its arguments, attempting to extract a few nuggets of profundity from the dross of adolescent enthusiasm. Shorn of its Wagnerite excesses, Nietzsche judged his investigation into pagan creativity as posing one question of pressing importance to a post-Christian world: "What meaning does morality have, seen through the lens of Life?"[32]

Nietzsche attempted to answer that question in his two following books, *Beyond Good and Evil* and *On the Genealogy of Morality.* The latter is the only one of his books other than *The Birth of Tragedy* to mount a sustained argument about the relevance of the example of the early Greeks for modernity. Nietzsche's history of moral concepts chronicled a dialectical confrontation between the aristocratic "master" ethic of the Homeric world and the egalitarian "slave" morality of the Christian faith, to the great advantage of the former. Against the aristocratic ethic of a pagan nobility happy in their effortless superiority, he contrasted the vengeful weakness of "the Jewish slave revolt in morality" that culminated in the Christian doctrine of forgiveness for the enemy. According to Nietzsche, the Homeric heroes took out their healthy rage on their enemies in this world, whereas the Jewish slaves turned the other cheek here on earth in order to protect their weakness but vented their ire by devising a horrible fate for their pagan enemies in hell.

Nietzsche's portrait of Greek "master morality" takes for granted the historical reality of the Homeric heroes, demonstrating the extent to which the once-radical conclusions of Schliemann's archaeology had become part of the background assumptions of any speculation about Greek prehistory. The philosopher's portrait of the splendid bestiality of the early Greeks is constantly run together with reflections on German ancestry, a set of connections that culminate in Nietzsche's inclusion of "Homeric Heroes" in his list of terrifying "blond Germanic beasts":

> At the centre of all these noble races we cannot fail to see the blond beast of prey, the magnificent *blond beast* avidly prowling round for spoil and victory; this hidden centre needs release from time to time, the beast must out again, must return to the wild:—Roman, Arabian,

Germanic, Japanese nobility, Homeric heroes, Scandinavian Vi-
kings—in this requirement they are all alike. . . . The deep and icy
mistrust which the German arouses as soon as he comes to power,
which we see again even today—is still the aftermath of that inextin-
guishable horror with which Europe viewed the raging of the blond
Germanic beast for centuries.[33]

Nietzsche's nihilistic anthropology of Greek morality was already con-
ceived before Schliemann became a household name—his two early
essays "The Greek State" and "Homer on Competition" contain the
seeds of much that bloomed in *The Genealogy of Morality*—but the
archaeologist's Homeric literalism grounded Nietzsche's speculations
ever more firmly in the soil of science. By turning Agamemnon into
flesh and blood, Schliemann had made the heroes available for Nietz-
sche's proto-sociobiological project of viewing ethics "through the lens
of life."[34]

Nietzsche was by now reaching the end of his productive life. His
bizarre, prophetic autobiography, *Ecce Homo,* composed during the
prolific final year of his sanity, 1888, contains a series of chapters named
for the titles of his books. He contemplates the appearance of *The
Birth of Tragedy* in the 1870s wonderingly, amazed at its untimeliness:
"One would rather believe the book to be fifty years older."[35] It would,
in fact, be about thirty years *after* its composition that his theory of
Greek tragedy would be hailed as a prophetic insight into the religion
of the "pre-Hellenic" peoples, confirmed by the discoveries of Cretan
archaeology. Those novel insights were, according to Nietzsche:

> [F]irstly the understanding of the *dionysian* phenomenon in the case
> of the Greeks—[the book] offers the first psychology of this phe-
> nomenon, it sees in it the sole root of the whole of Hellenic art—.
> The other novelty is the understanding of Socratism: Socrates for the
> first time recognized as an agent of Hellenic disintegration.[36]

Detecting the Dionysian strain running through all of Greek art and re-
ligion would become a minor academic industry in the early twentieth
century. Classicists who had fallen particularly heavily under the spell
of *The Birth of Tragedy* would also search for "agents of Hellenic disin-
tegration" in just those aspects of ancient Greek culture that had en-

joyed the greatest prestige in the nineteenth century, before Nietzsche
had burst on the scene with his anarchic reversals of the received wis-
dom about Greek serenity. Under Nietzsche's influence, preclassical
Greece became one site for the modernist rebellion against the ratio-
nalist, bourgeois nineteenth century.

The final chapter of *Ecce Homo* is entitled "Why I Am a Destiny."
It is both hopelessly overblown and tragically prophetic. "I know my
fate," he declares:

> One day there will be associated with my name the recollection of
> something frightful—of a crisis like no other before on earth, of the
> profoundest collision of conscience, of a decision evoked *against* ev-
> erything that until then had been believed in, demanded, sanctified.
> I am not a man, I am dynamite. . . . there will be wars such as there
> have never been on earth.[37]

Taken on its own, this reads simply as one of those passages in *Ecce
Homo* where the pressures of Nietzsche's incipient madness have exag-
gerated his already extreme grandiosity into caricature. From a postwar
perspective it stands as a terrifyingly accurate prophecy of the most
prominent aspect of his posthumous reputation.

Shortly after penning this passage, Nietzsche descended into mad-
ness. On January 3, 1889, his landlord in Turin was walking along one
of the main streets of the city when he saw a crowd of people gath-
ered around two municipal guards, one of whom had Nietzsche in a
firm grip. He enquired what had happened, and the guards reported
that they had found the professor outside the university gates, cling-
ing tightly to the neck of a horse and refusing to let go.[38] His landlord
took Nietzsche back to his rooms, where the philosopher thumped
the piano and sang and shouted, only calming down when threatened
with the police. Then he sat down and tore off a series of letters to his
friends and to the courts of Europe announcing his final manifestation
as Dionysus and "the Crucified." He was taken to a sanatorium in Ba-
sel and then transferred to an asylum in Jena, to be, at her insistence,
nearer his mother. The diagnosis was "general paralysis of the insane"
as a result of a syphilitic infection.[39] By the spring of 1890 it had be-
come clear that he was not going to recover, but equally that he posed
no physical threat to those around him, and he was released into his

mother's care. She looked after him devotedly until her death in 1897, after which her maid, Alwine, took over the burden of his care, nursing him until he died in 1900.

Fascism's Greek Prehistory

The story of how Nietzsche's name came to be associated, despite his profound misgivings about Germany, with the excesses of National Socialism, is a familiar one. His sister, Elizabeth, had married Bernard Förster, an extremely unpleasant German anti-Semite who committed suicide in 1889, the same year as Nietzsche's final breakdown. The Försters had been involved in a disastrous colonial experiment in Paraguay, "New Germania," and by 1893 the colonists had had enough of Elizabeth and threw her out. She returned to Germany, reinvented herself as Elizabeth Förster-Nietzsche, and set herself up as the self-appointed priestess of a cult of her brother. She founded the "Nietzsche archive" at the family home, knocking the two top-floor rooms into one, and filling them with memorials to his life and work (he was still alive at this point, kept carefully sequestered out of the sight of tourists). Soon the archive was overflowing the space and it was moved to a larger house in Naumberg. Elizabeth then talked her mother into signing over the ownership of all his works and moved the archive to the Mecca of German culture, Weimar.

Nietzsche himself was moved to the house in Weimar after his mother's death, where the family maid Alwine took care of him invisibly in one of the upper rooms while Elizabeth presided over an increasingly mystical cult of his memory. Occasionally he was exhibited to visitors, clad in white robes, to exploit the voyeuristic thrills to be had by contemplation of his abrupt and complete breakdown. Elizabeth also gathered up all the retrievable fragments of paper that he had left behind in his peripatetic career and published a book of aphorisms entitled *The Will to Power*, consisting almost entirely of material that Nietzsche himself had discarded. Elizabeth stood for everything that her brother despised—Christian piety, German nationalism, and anti-Semitism—but it was she who defined his immediate legacy. Partly as a result of her efforts, Nietzsche—a prophet of the post-Christian crisis of values out of which Nazism emerged—came to be promoted as the first Nazi philosopher, a reputation that he still has not entirely shaken off.

Less familiar than this sorry tale is the story of how various versions of Nietzsche's mythological speculations were reified and transformed into scientific truth through the medium of Bronze Age archaeology. In particular, Heinrich Schliemann's excavations were assimilated into a series of sub-Nietzschean solutions to the political insecurities and imperial ambitions of the new Germany. Archaeology gave Nietzsche's nihilistic interpretation of the Homeric corpus material form and thereby facilitated its assimilation into the human sciences.

Schliemann was almost as reluctant a patriot as Nietzsche. During the Franco-Prussian War his loyalties lay with France, his adopted country. After the 1874 publication of *Troy and Its Remains,* his first excavation report, German scholars, famously the most rigorous and critical in Europe, refused to join in the chorus of acclaim, and he was widely ridiculed, with cartoons appearing in the papers mocking his Homeric pretensions. A few years later he explained in a letter that he had written his book on the excavations at Mycenae and Tiryns in English because in England he was "loved and respected."[40] But contrary to his pessimistic expectations the book was well received in his native land. He wrote to a friend that "I am happy to say that *all* the German critics speak very favorably of my book and highly appreciate it. I thought that I should not live to see myself appreciated in Germany because for years I have been ill-treated there."[41]

In January 1879 Schliemann received a letter from one of the giants of German science, the pathologist, anthropologist, and pioneering cell biologist Rudolf Virchow, whom he had met briefly and who had always been one of his supporters. Virchow, an experienced excavator, wanted to join Schliemann at Hisarlik for the season beginning in March that year. This overture began one of the most important friendships of the archaeologist's life.[42] By early September, Schliemann's attitude towards Germany had undergone a complete reversal, a change of heart that he attributed to his friendship with Virchow. Intoxicated with a new patriotism, he decided to bequeath to the German nation his entire collection. When the Trojan treasures were received in Berlin in January of 1880, Schliemann was hailed for his "warm devotion to the fatherland" and given honorary citizenship of Berlin.

The bequest of the treasures of Troy marked the beginning of the real German infatuation with Schliemann and his discoveries. Aspects of Schliemann's interpretations appealed directly to the identity crisis faced by the newly minted nation. Most of the forty-one million

people living within the borders of the new Germany would describe themselves not as Germans but would claim instead their regional identity as Bavarians, Prussians, Badeners, Saxons, among others. (Virchow and Schliemann themselves, having in common underprivileged backgrounds in northern Germany, would sometimes converse in *Plattdeutsch,* a dialect incomprehensible to southerners.) Into this cultural void swept a grand narrative of racial origins, the story of the diffusion of a peculiarly energetic northern people from their homelands in the Caucasus Mountains whose purest modern descendants were to be found in Germany.

Aryan theory had its roots in linguistics. Following the discovery that Sanskrit was related to Persian, Greek, Latin, and other European languages, the Sanskritist Max Müller suggested that the "Aryas" of the Hindu epic *Rigveda* were a northern people, speaking a proto–Indo-European tongue, who had invaded India from their base in the mountains of north-central Asia and then fanned out westward into Persia and then Europe. The story was taken up by race theorists who transformed the speakers of the language into the bearers of various genetic characteristics, often extolling the ancient Greeks as the most perfect examples of the Aryan type.

Schliemann, having fallen under the baleful influence of the anti-Semitic director of the French archaeological institute in Athens, Émile Burnouf, quickly leapt onto the Aryan bandwagon.[43] Scenting an intellectual fashion, he absorbed the whole of the literature on Aryan diffusion in one great gulp and proceeded to contribute his own particular insight to the Aryanist project, recognizing as an "exceedingly significant religious symbol of our remote ancestors" the "suastika" scratched on some pots that had been unearthed in Germany.[44] Through this act of recognition, the swastikas of Troy were linked to the swastikas of Königswalde, thus relating modern Germans to the heroes of Homer. The *Iliad* could now join the *Rigveda* as the historical record of the military prowess of a racially pure people, who left a trail of swastikas in the wake of their irresistible westward advance and whose true heirs were the Prussian army.

In 1881 Schliemann published his *Ilios,* the least Aryanist of all his excavation reports. His devotion to Émile Burnouf had by this time waned, and he persuaded Max Müller himself to contribute a short essay on the swastika. Müller (desperately trying to stuff the genie of

race back into the bottle of linguistics) attempted to deflate Burnouf's proposal to link the symbol exclusively to Aryan diffusion: "Identity of form does as little to prove identity of origin in archaeology as identity of sound proves identity of origin in etymology."[45] Unfortunately, Müller's efforts were to no avail. Only three years later came Schliemann's final statement on Troy, his *Troja* of 1884, with a preface by the professor of Assyriology at Oxford, A. H. Sayce, who trumpeted that "we, as well as the Greeks of the age of Agamemnon, can hail the subjects of Priam as brethren in blood and speech."[46] *Troja* was also adorned with an appendix by the Anglo-German journalist Karl Blind asserting the "Teutonic Kinship of Trojans and Thrakians," whose first sentence announced: "I believe it to be a thesis admitting of the clearest proof, that the Trojans, or Teukrians, were of Thrakian race; that the Thrakians were of the Getic, Gothic of Germanic stock; hence, that the Trojans were originally a Teutonic tribe."[47]

It still required a certain amount of fancy footwork before the swastikas of Troy could be appropriated as symbols of Nordic racial supremacy. First, physical anthropology had to be grafted onto the delicate business of philology. In 1886 the anthropologist Karl Penka published his highly influential *Origin of the Aryans*, in which he argued that tall, fair-skinned, blue-eyed Germans were the only possessors of true Aryan blood and that cold climates were required for the preservation of Aryan racial purity.[48] Three years later a Polish librarian named Michael Zmigrodski hosted a display at the Paris Exposition that brought together drawings of over three hundred objects with swastikas on them, celebrating the symbol as "the heraldic device of the Aryo-Germanic family." Zmigrodski was an anti-Semite whose aim was to prove that "in a very ancient epoch, our Indo-European ancestors professed social and religious ideas more noble and elevated than those of other races."[49]

The final move in the construction of a Greek prehistory for German fascism was to move the Aryan homeland westward. In 1921 the German prehistorian Otto Grabowski published his *Secret of the Swastika and the Cradle of the Indo-Germans*, in which he chastised Schliemann for suggesting that the Aryan homeland was in Asia rather than northern Europe.[50] A few years later the Nazi archaeologist Gustaf Kossinna brought out a two-volume work, *Origin and Diffusion of the Germans in Pre- and Early History*, which argued that the occupants of Schliemann's

Mycenaean shaft graves were representatives of a conquering Nordic race (*nordischen Herrenschicht*) and that these Teutonic warriors were the "first Achaeans."[51]

In 1933, in celebration of von Hindenburg's decree of March 12 ordering that the swastika flag was to be hoisted as the symbol of the German Reich, one of the party faithful, Wilhelm Scheuermann, brought out a book *Where Does the Swastika Come From?* that synthesized all this work into a concise little prehistory for National Socialism. His first chapter galloped through a history of swastika scholarship, detailing how the symbol was finally recognized as a "the ancient Aryan tribal coat of arms," reserving a special mention for Schliemann's "lucky discovery of the treasures concealed beneath the soil of Troy and Mycenae."[52]

Scheuermann's slim volume was adorned with a few carefully chosen illustrations, including an engraving of one of the most revered of Trojan artifacts, a lead figurine of a female holding her breasts with her vulva marked by a triangle surrounded with dots. In his drawing the figurine has a swastika in the middle of her pubic triangle, and Scheuermann's caption announces that "here the swastika served as a fertility symbol."[53] This figurine was pivotal to the Aryan argument. Because the swastika was mostly found scratched into the clay of Trojan loomweights, it ran the risk of demotion by association with this humble and ubiquitous object. Its appearance on the pubic triangle of a "goddess" gave it inarguable religious significance.

But the swastika is one of Schliemann's fakes—a 1902 catalog of his Trojan collection by a museum curator contains a minutely detailed description of the object that concludes with the aside that the figurine was "falsely" shown in figure 226 of *Ilios* with a swastika in the pubic triangle.[54] In his caption to the illustration in *Woher kommt das Hakenkreuz?* Scheuermann solemnly explains that the swastika was "corrupted" when the figurine was cleaned.[55]

The inclusion of Schliemann's be-swastika'd lead figurine in *Woher kommt das Hakenkreuz?* perfectly exemplifies one aspect of the modernist appropriation of archaeology. The game was the "invention of tradition," the legitimization of new political movements by means of false ancient pedigrees. The method was a dramatically vertical archaeology in which the symbols of a mute prehistory were interpreted according to modern preoccupations and then held to have retained their significance for thousands of years. Racial science was the overarching frame-

FIGURE 3. The illustration from Heinrich Schliemann's *Ilios* depicting a goddess figurine made out of lead, falsely shown with a swastika on her vulva. Heinrich Schliemann, *Ilios*, fig. 226.

work within which these objects were understood and fakes of one sort or another were always on hand to plug any inconvenient gaps in the hermeneutic circle. In the case of Scheuermann's little book, the hoisting of the Nazi flag was celebrated—with the help of Schliemann's sleight of hand—as nothing less than the *continuation* of a prehistoric practice in which the swastika served as a means of "mutual recognition" for the ancient Aryans.[56]

This incorporation of Schliemann's work into the glorious Aryan tradition required just one last element to make it complete. In 1933, the first authorized biography of Schliemann, Emil Ludwig's *Schliemann of Troy: The Story of a Gold Seeker,* was burned in Berlin on the grounds that it had been written by a Jew and did not show the archaeologist in a sufficiently heroic light.[57] A teacher at one of Schliemann's old schools, Ernst Meyer, was quickly engaged to write a more flattering account of his life and work and to edit the archaeologist's letters.[58] In a breathtaking bit of anti-Semitic quasi-phrenology, Meyer wrote of Ludwig that "he lacks the organ to recognize the German in Schliemann, especially his romantic idealism."[59] The Nazi appropriation of both the archaeologist and the symbol thus completed each other, bound together into a mutually reinforcing logic of Aryan self-recognition.

What Ariadne Is

Hailing Schliemann and Agamemnon as Nazi *Übermenschen* is but one Nietzschean response to the archaeology of the Bronze Age Aegean. A hundred miles south of Mycenae, a little mound on the island of Crete became the site for a very different unfurling of Nietzsche's classically inflected prophecies. As soon as Schliemann defined the enterprise of Homeric archaeology, the mound had been recognized as the probable site of the legendary Palace of Knossos. In April 1879 a Cretan antiquarian named, appropriately enough, Minos Kalokairinos, went to Knossos with twenty workmen and dug the site for three weeks until he was stopped by order of the Cretan assembly, afraid that any unearthed antiquities would be whisked off to Istanbul to adorn the palaces and museums of Crete's Ottoman overlords. Before his excavations were aborted, Kalokairinos found the traces of a large rectangular building and a storeroom filled with huge terracotta jars, five feet tall. In a collection of notes written many years later he identified the

building as "le Palais royale de Roi Minos" and speculated that a large underground stone quarry to the south was the Labyrinth to which the Athenian prisoners were marched by Minos's soldiers.[60]

After Minos Kalokairinos's excavations, many other people had a go at digging the mound of Knossos. In 1880 a scholar with the French School of Classical Studies at Athens wrote up Kalokairinos's finds and proposed that the French carry on the work. The Muslim authorities did nothing with the proposal. In 1881 an American diplomat who had been stationed in Crete returned to the island under the authority of the Archaeological Institute of America to appraise Kalokairinos's discoveries. He applied to Istanbul for a *firman* or decree to dig and started to excavate, only to be stopped when the authorities turned down his petition. In 1885 an Italian archaeologist excavated a Roman villa at a spot just north of the Knossos mound and proposed that the Italians acquire the site. Nothing came of this proposal, either.

Heinrich Schliemann himself also regarded Knossos as the next site to conquer. Various reports on the "Daedalian Labyrinth" had excited his interest and in 1886 he went to Crete to look for himself. He confirmed that the remains at Knossos seemed contemporary with the Mycenaean sites of the mainland and he started to haggle with the Turkish owners of the mound. But his business instincts trumped his scholarly curiosity, and he could never bring himself to pay what they demanded, on the grounds that (among other outrages) they had lied about the number of olive trees on the land. He died in 1890, still trying to wangle Knossos out from under them. Before Schliemann was cold in his grave, the French School had another try, and secured permission from one of the owners to excavate for two years. Political instability made this impossible.

In the spring of 1894 the mound of Knossos finally met its destiny in the shape of the British petitioner for its favors, Arthur Evans. Believing, correctly, that ancient Crete would turn out to be the place of origin for a pre-Phoenician European system of writing, he had arrived at Knossos hot on the trail of the tiny, intricately carved Mycenaean sealstones that he had started collecting in 1888. As soon as he laid eyes on the mound he began to scheme, managing, in a few short days, to elbow out all other claimants to the excavation rights and begin negotiations with one of the four proprietors of the site. He quickly bought a quarter share of the land and then bided his time. In 1900, the political

situation on Crete had stabilized, and Evans was able to purchase the rest of the site, securing his complete domination over the greatest archaeological prize of the age. His next forty years would be devoted to the excavation and reconstruction of the temple palace.

When the archaeology of Greek myth moved from Troy and Mycenae to the island of Crete, the synthesis of Nietzschean philosophy with Bronze Age archaeology took a new turn. Because, in the legends about Knossos, it was Dionysus who stepped in at the end of the story to marry the Cretan princess Ariadne, Cretan religion provided an origin point for the Nietzschean story about the cult of the drunken god. As they contemplated the seal-stones depicting scenes of religious ecstasy, theorists of Minoan religion saw an early incarnation of the Nietzschean Dionysus. For them the swastika was not a heraldic device of Teutonic Aryan militarism but instead a symbol of Dionysian ecstasy.

In his 1914 book about Zeus, the classicist Arthur Cook declared that "both Attic and Cretan art presuppose the swastika as the earliest ascertainable form of the Labyrinth."[61] Following Evans, he argued that the Labyrinth represented a Dionysian ritual to promote the fertility of the crops, its twists and turns denoting the pattern made by the feet of flower-wreathed Cretan youths dancing in one of the great courtyards of Knossos. At the same time as the Homeric archaeology of Troy and Mycenae rehearsed the nihilism of the *Genealogy of Morality*, the Labyrinth of Knossos harkened back to early Nietzsche, to the subjectivism and passionate aestheticism of *The Birth of Tragedy*.

In the course of its journey to Crete, however, Nietzsche's story underwent one crucial deformation. As the Bronze Age archaeology of the eastern Mediterranean moved backward from the Homeric warrior society of Troy and Mycenae, it discovered a "feminine" stratum lying beneath the heroic age, an ancient matriarchy with its cultural and political center on the island of Crete. Nietzsche had characterized the original Dionysian impulse as an Oriental brew of lust and cruelty in sore need of Apollonian sublimation. According to Minoan archaeology, however, the Dionysian cult that swept across Greece in the sixth century B.C. was none other than the return of the ecstatic worship of "Aphrodite-Ariadne," a Cretan form of the Great Mother Goddess.

In *Ecce Homo*, Nietzsche lamented his exalted loneliness: "[S]o does a god suffer, a Dionysus. The answer to such a dithyramb of a sun's solitude in light would be *Ariadne* . . . Who knows except me what *Ariadne* is?"[62] For all his claim to exclusive insight into "what" Ariadne was,

however, every invocation of her name in his work is riddling to the point of emptiness. An 1887 notebook contained this cryptic fragment: "Oh Ariadne, you are yourself the labyrinth, from which one does not emerge again." A late poem, "Klage der Ariadne" (Ariadne's Lament), ended with this speech from Dionysus:

> Be wise, Ariadne! . . .
> You have little ears, you have ears like mine:
> let some wisdom into them! —
> Must one not first hate oneself if one is to love oneself? . . .
> *I am your labyrinth.*[63]

Another reference to Ariadne's small ears appeared in *Twilight of the Idols,* in which Dionysus says, "I find a kind of humor in your ears, Ariadne, why are they not longer?" The clue to all these fragments seems to be a letter Nietzsche wrote in January 1889 from the Jena asylum to Richard Wagner's wife Cosima containing only this one naked sentence: "*Ariadne, ich liebe dich! Dionysos.*"[64] Nietzsche's Ariadne was Cosima Wagner (proud possessor, like Nietzsche, of unusually small ears), wife of his friend and mentor, for whom he had harbored feelings that could only find expression when madness had ripped away his inhibitions. Ariadne was the one great conundrum that Nietzsche could never solve — the enigma of woman and the riddle of love.

Arthur Evans turned out to be perfectly poised to assume his position as archaeologist-theologian for Nietzsche's new tragic age. The eldest son of an antiquarian who inducted him in the methods of retrospective prophecy from his childhood, Evans was raised amid the rubble of the Biblical narrative. As an adult, he exported his father's industrial stratigraphy to a mythical landscape on the borders of Europe, turning disenchantment into reenchantment and retrospective prophecy into archaeological wonder working. From the beginning of the excavation of Knossos he was looking for traces of Ariadne, and he gave her name successively to the queen of Knossos, the Great Cretan Goddess, and the Minoan butterfly deity. He reconstructed and reenacted Ariadne's ritual dance and identified the historical moment that her mysteries passed into the hands of her son and consort Dionysus.

Although Evans himself never gave any indication that he was aware of the infamous classics professor who died the year the excavation of Knossos began, the Nietzschean import of the Minoans did not

escape his audience. One after another, the more creative of his devo-
tees turned Evans's archaeology into a passage point through which
Nietzsche's prophecies were transmitted. And because it was Ariadne,
rather than her legendary consort Dionysus, who led the way through
the concrete labyrinth, the story of Knossos reveals the contradictory,
often faintly ridiculous ways in which Nietzschean neopaganism and
biological essentialism were hitched to that great twentieth-century
slave revolution in morality, the liberation of woman.

The excavation of Knossos began at the same time as the ardent
Nietzschean Otto Weininger began composing his *Sex and Character,*
an immensely influential text, published in 1903, in which the "absolute
female" was characterized as a creature without morals, logic, judgment,
memory, or dignity; a being without a subjective center that could en-
ter into relation with an idea; a hollowness at once utterly shameless
and totally vain.[65] At Knossos, the vacuum described by Weininger
was filled. The reconstructed cult of the Great Cretan Mother rein-
stated the female principle—*das Weib*—as eternally and archetypally
different from the male, and yet it redeemed that difference along the
axis of pure opposition to the atrocities of war. Accepting the essen-
tialist thesis in all its interpretative certainty, female procreativity was
reinvented as the *source* rather than the negation of morality.

{ II }

STAND-UP TRAGEDY,
1851–1899

Schliemann was a colossus of the new world order that came into being with the birth of Germany; his early Greeks were eventually drafted into that nation's extreme experiment in militarism. Arthur Evans, British to the core, belongs to another age—somewhere between the endless childhood of J. M. Barrie's *Peter Pan*, and the swashbuckling imperial adventures of Rider Haggard's *King Solomon's Mines*. He was an Edwardian perpetual boy-man, whose frivolous, androgynous, goddess-worshipping Minoans seem more at home in the decadent cabaret of Weimar Berlin than at any Nuremberg rally.

Evans brought formidable powers of observation and intellectual synthesis to his archaeological work but, like Schliemann, he placed his brilliance at the service of a rampant interpretative overconfidence that stemmed from his ability single-handedly to finance the excavation. The result was an idiosyncratic and subjective vision, a Minoan world that not only answered to the political and cultural imperatives of the twentieth century but also one that was also shaped by more intimate desires—by psychological needs and spiritual hungers formed

FIGURE 4. Arthur Evans at Knossos. Arthur Evans, The *Palace of Minos*, vol. 4,
p. vi. By permission of the Ashmolean Museum, Oxford.

in the archaeologist's privileged childhood. Indeed, this scholarly
Peter Pan saddled the "childhood of Europe" with such a rich reper-
toire of Freudian neuroses, that Freud himself would eventually iden-
tify Bronze Age Crete as the pre-Oedipal phase of the whole white
race.[1]

The Dry Smell of Time

Some of the modernist themes that would animate Evans's archaeo-
logical paganism may already be detected in the circumstances of his
mid-Victorian childhood. He was raised in a household where the Bib-

lical narrative was tested against the findings of the historical sciences and found wanting. He was only seven years old at the time, and much of the emotional substance of his solution to the problem of God's demise seems to have dated from the same early period of his life. The lyrical intensity of his search for the Great Cretan Mother was surely driven by his unresolved grief at the death of his own mother, while the fairy-tale aura of the Minoan world was partly a generational reaction against the rational, industrial archaeology of his toweringly successful father.

Arthur's father, John Evans, was one of those nineteenth-century patriarchs of apparently inexhaustible vigor who managed to combine the joys and sorrows of three wives and six children with the astute management of a paper mill and the pursuit of a distinguished scientific career. He began his working life early. At the age of sixteen he was apprenticed to his uncle, owner of the aforesaid paper mill. The loneliness was intense. Despite proving his usefulness and diligence, he was kept well away from the sophisticated social life that his uncle's children enjoyed as the offspring of a wealthy man. He kept up his spirits by pursuing an interest in coins and fossils, giving his first paper to an archaeological society at the age of twenty-three. He also began to acquire an expertise in the stratigraphy of the local chalklands after being drafted by his uncle to help fight a canal company whose wells were leaching away the mill's water supply. By the time he was in his mid-twenties he was well versed in a whole range of historical sciences—geology, archaeology, paleontology, and numismatics.

In 1848, seemingly out of nowhere, John Evans and his uncle's younger daughter, Harriet Ann Dickinson, a lively, intelligent young woman of exactly his age, decided that they were in love. In the teeth of fierce opposition from her bad-tempered father, Harriet stuck with her humble suitor and in September 1850 they were married. Grudgingly, John Dickinson made his nephew into a junior partner in the firm and built the young couple a cramped and ugly house in the local village. Ten months after the wedding, on July 8, 1851, their first child was born, named Arthur John after his two grandfathers. Harriet, perhaps taken aback by the relentlessness of a newborn's needs, judged her first son to have inherited a little of her father's "Volcanic Nature" but consoled herself with his "very finely formed head and marked intelligent features."[2]

Arthur's parents were a hardworking couple. Besides geological work connected with the still-unresolved legal wrangle with the canal

company, John was busy excavating a nearby Roman villa, and in 1852 he was elected to the Society of Antiquaries. He experimented with various innovatory techniques of papermaking at the mill and introduced the manufacture of envelopes. John Dickinson, now in his seventies, began more and more to hand over the running of the business to his industrious nephew and son-in-law. Harriet, for her part, started a library for the workers at the Mill and established a school for the village girls in an abandoned chapel. The births of two more children took their toll on her health, but the family prospered, finally moving in 1856 to the elegant eighteenth-century house in which she had grown up. There she gave birth to her first daughter, Alice.

In March of that year, John Evans took over the mill. They were suddenly much better off, and Alice, a delicate child, seemed to be growing stronger. Harriet passed a happy summer and autumn, pregnant with her fifth child, sewing and reading in the garden of Nash Mills House, watching her children playing among the flowerbeds, wondering if Arthur "was as impervious to learning as he seemed."[3]

On December 19, 1857 Harriet gave birth to a baby girl. The nurse who attended the birth had come from an infected case, and soon Harriet was critically ill. Arthur was sent away to his grandfather's house. His mother lingered for ten days, but on New Year's night she died. Years later Arthur Evans's half-sister Joan wrote about the effect of his mother's death upon him:

> On Arthur the blow fell at an evil time. He was still in virtue of his childhood dependent on his mother; she was the active centre of his world. With her loss the world fell to pieces, and no one, least of all his father, realized the depth of his bewilderment and grief as he stood among its ruins. When the children came home from Abbot's Hill, John wrote in his wife's diary that they did not seem to feel her loss; more than seventy years later Arthur Evans was to write an indignant *NO* in the margin. Arthur was only six, and could find no escape in action; no thought or deed of his could set the world going anew. He had learned too young what bitter grief love could bring; and thereafter the innermost recesses of his heart were guarded by fear.[4]

John Evans was left with the paper mill to run and five children from a six-year-old to a newborn baby to look after. He started to court a

cousin of his, Fanny Phelps, who had been a bridesmaid at their wedding and had been devoted to Harriet, looking after her when she was ill. By the time Fanny left for Madeira in November 1858 to spend the winter with her parents they had agreed that they would eventually marry to provide the five young children with a mother. John Evans wrote to her regularly: "I cannot help thinking that there was something quite Providential in your being here to take dear Harriet's place + be a mother to her children—I could never have borne to put a stranger over them."[5]

John Evans's letters to Fanny are studded with fond observations of his oldest son, who "takes his own part in the nursery against arbitrary power by the force of reason." A certain independence of mind on Arthur's part is well illustrated by an anecdote about a birthday party held for Lewis, the next oldest, in which he can be seen trying to make sense of the class hierarchy in the household. Because the servants were asked to this celebration, John Evans did not attend. Lewis, to account for this absence said to his governess that "it would be like mixing the good and bad seed." Arthur rebutted with "No, Loo, servants are not *all* bad seed, it would be like mixing garden flowers and wildflowers."[6] In his report of this exchange to Fanny, John Evans seemed quite proud of his oldest son's independence of mind, if not his nascent liberalism.

One of John Evans's closest friends was a man named Joseph Prestwich, the employee of a firm of London wine merchants, who indulged his passion for geology on his many business trips by studying the strata revealed by railway cuttings. After Harriet's death the two men began to research the question of the antiquity of the gravel drifts exposed by the industrial building projects of the mid-nineteenth century. It was a most exciting time for practitioners of the historical sciences. As the earth's crust was exposed during the construction of railways, canals, and the foundations of vast factory buildings, the resulting cross-sections provided vivid evidence for the flora and fauna of earlier ages. In 1858, Evans and Prestwich went to Bedford to inspect the fossil bones of a herd of elephants that had been found in the gravel stratum of a railway cutting.

The following year Evans and Prestwich were called upon to lend their expertise to one of the thorniest questions that arose from the industrial exposure of the earth's crust. Until the late 1850s, speculation about the age of the earth had been safely kept separate from questions about Biblical authority. A compromise had been reached, which

acknowledged that the earth was far older than the human race, but broke up the history of the world into distinct periods. Only the last of these epochs was the human world whose chronology had to fit with the book of Genesis. In the early nineteenth century, British geologists and archaeologists were agreed that the first appearance of humans was a major event in the history of the earth, dividing the "modern" world of the Christian Bible from a series of former worlds populated by now-extinct animals.[7]

But in the late 1830s, a French customs officer in Abbeville in the Somme Valley named Jacques Boucher de Perthes began to collect flint tools (revealed during the construction of the town's fortifications) that he claimed had appeared alongside the bones of extinct mammals.[8] The Frenchman's draughtsmanship was not good enough to imperil the delicate Anglican truce between Scripture and science, and Boucher de Perthes was dismissed as a crank in geological and archaeological circles in England. Then, in 1858, a cave in Devon yielded seven flint tools along with the bones of long-extinct rhinoceroses, cave bears and hyenas. It was time to reconsider the compromise and revisit the claims of de Perthes.

Joseph Prestwich was asked to travel to the Somme to judge the validity of the custom officer's conclusions. He recruited John Evans, and on May 1, 1859, the two men arrived in Abbeville to find the eccentric and amiable old antiquarian living in a "complete Museum from top to bottom, full of old paintings, old carvings, pottery etc. and with a wonderful collection of flint axes and implements found among the beds of gravel and evidently deposited at the same time."[9] It was not, of course, the collection alone that could convince the two British geologists, but the location of the tools at the time of finding. After lunch they set off for Amiens to view a flint axe in its original position: "sure enough the edge of an axe was visible in an entirely undisturbed bed of gravel and eleven feet from the surface. We had a photographer with us to take a view of it so as to corroborate our testimony."[10]

Back in London, Evans immediately set about mastering the art of flint knapping, and both men went to work writing papers to deliver to their respective societies. Evans's presentation to the Archaeological Society and Prestwich's to the Royal Society were both triumphs, and their conclusions met with little resistance, despite the implied blow to Scriptural chronology. Months before the publication of Charles

Darwin's deicidal text *On the Origin of Species*, Arthur Evans's father took aim at Biblical literalism with an arrowhead made of flint.

John Evans's reputation was securely established by the solidity of this achievement, and his distinguished career as a successful scientist and capitalist was crowned by a knighthood. The extent to which his historical preoccupations suffused the whole texture of his and his children's life is captured in an olfactory portrait of the house in which Arthur grew up, penned by Arthur's half-sister Joan:

> The house in those days had even a scent that was all its own: a scent compounded of the spiciness of leather bindings, the sour smell of flints, the slight acridness of rusted bronze, the faint aromatic incense of carpets and hangings from the East; with newer and more transitory whiffs of drying glue and burnt sealing-wax. The perfume of jasmine might blow in at the window, and rose petals might drift through the open door: but the essential scent was the dry smell of Time itself. In such an antiquary's house the present always retained its true proportions: an infinitesimal, a non-existent moment between an infinite past and a hurrying future.[11]

In Nietzsche's 1882 parable about the demise of Christian faith, a madman cries out, "Do we still hear nothing of the noise of the grave-diggers who are burying God? Do we still smell nothing of the divine decomposition?"[12] The same year as *The Gay Science* was published, John Evans's daughter Alice—a dutiful participant in her father's archaeological activities—cut her wedding cake with a knife made out of flint.[13] The "dry smell of Time itself," produced by the Victorians charged with the task of rewriting the Bible, was the odor given off by a decomposing God.

Growing up with the "sulphurous smell of newly broken flint"[14] in his nostrils, Arthur Evans would eventually contribute a significant chapter to the secular narrative of human cultural origins. But how different was the romantic archaeology of his *Palace of Minos* from his father's methodical disenchantment of the Christian cosmos. As Ronald Burrows put it in his populist *Discoveries in Crete*: "The Minotaur! The Labyrinth!—such words do not suggest the solemnities of antiquarian research. . . . Knossos . . . moves along the broad ways, and carries us back, behind our learning and education, to the glamour and romance of our first fairy stories."[15]

John Evans sought from the traces of early human occupation an
origin story for industrial man. For this self-made Victorian factory
owner and his contemporaries, early man was an engineer, and the story
of humanity was a history of technical innovation. Although it seemed
that Arthur would later follow in his father's footsteps, practicing the
science that he had been exposed to since his infancy, their approaches
were in fact diametrically opposed. By relocating the analysis of stratig-
raphy to a nonindustrial location chosen for its mythical associations,
Arthur Evans transformed industrial archaeology into a vector for Dio-
nysian reenchantment. The Victorian engineer spawned an Edwardian
mystic; the father's history of technique and construction yielded to
the son's excavation of essences and archetypes; the heir of the retro-
spective prophet grew up to be an archaeological visionary.

Eastern Questions

The Oedipal dialectic between the father's archaeology and the son's
may be unique in the annals of the discipline, but it was the outgrowth
of generational differences typical of the time. John Tosh, in his 1999
book *A Man's Place: Masculinity and the Middle-Class Home in Victorian
England,* has traced a series of changes in the nineteenth-century mas-
culine ideal to which the differences between the lives of John and
Arthur Evans exactly conform. Evans senior was the product of a world
in which many middle-class boys ended their formal education in their
midteens and immediately began to spend long hours at work sur-
rounded by people much older than themselves. In this world "there
was little concept of adolescence in the modern sense of an extended
transition between childhood and adulthood."[16] By the end of the cen-
tury, the length of childhood in middle-class families was increasing,
extended in some cases by prolongation into adulthood of material de-
pendence on the parents.[17]

Our hero was a particularly extreme example of this shift. A stu-
dent until he was in his midtwenties, Arthur refused to go into the
family business but accepted a generous, lifelong allowance from his
father. Entering by right a world of learning and wealth, he always
prized danger and adventure over security and stability. In 1871, dur-
ing an Oxford vacation, he traveled with his brother Lewis to France,
still at war with Prussia, wearing a scarlet-lined cloak, but was told by

a customs inspector that he looked like a spy and would be "shot like a dog" if he insisted on wearing it.[18] Later that year he set off on a tour of then still remote reaches of Eastern Europe, falling irrevocably in love with the bright costumes and wild landscapes of the Ottoman territories. There he met Turks for the first time, and was immediately fascinated, investing in a set of Turkish clothes, complete with fez. After an 1873 trip to northern Sweden and Finland he returned home wearing a reindeerskin coat, the smell of which prompted his stepmother to expostulate, "I can't think how he could bear himself."[19] In his peripatetic lifestyle and romantic self-image Evans resembled the protagonists of a "heroic, exotic and bracingly masculine"[20] genre of best-selling adventure fiction that first began to appear in the 1880s.

In his final exams at Oxford University, Evans refused to answer the required number of questions, expatiating instead on a single topic. He still managed to get a first class degree, and emerged into adulthood an ardent liberal and "a fantastically conceited young man,"[21] possessed of an unquenchable lust for adventure. After he graduated in 1875, he spent a few uninspiring months at Göttingen University before setting off once again with his brother Lewis for the Ottoman territories. Finding himself in Bosnia in time for an insurrection against the sultan's rule, Evans threw himself into the cause of Slavic nationalism. When he returned to England he published (at his father's expense) an account of the trip, sympathetic to the Bosnian insurgents. The book caused a stir in liberal circles; Gladstone quoted from it in Parliament when he came out of retirement to become the "scourge of Turkey" and Evans was made Balkan correspondent to the *Manchester Guardian*.

This trip defined Evans's political commitments for the rest of his life. It was, above all, the geopolitical fault line where the decaying Ottoman Empire confronted the nascent nationalisms of revolutionary Europe that shaped and directed the prophetic activism of Evans's archaeology. In 1875 the most violent activity along that fault line was in Bosnia and Herzegovina. By the time of the excavation of Knossos, the political aftershocks had moved southward to Crete. As the twentieth century wore on, the accelerating dissolution of the Ottoman Empire opened up an abyss of violence that drew the whole world into war. Evans's antiquarian speculations created a series of defiantly

optimistic prehistories for these upheavals and catastrophes, "foretell-ing the past" in the image of his liberal ideals of peace, freedom, and prosperity.

In 1875, when Arthur and Lewis Evans set off on their journey to Herzegovina, the "Near East" or "Turkey-in-Europe" was poised to de-scend into its most volatile phase. From the fourteenth to the sixteenth century, the Imperial armies of the Ottoman Empire had swept across three continents, absorbing along the way most of southeastern Europe including all of modern Greece and the Balkans. By the late eighteenth century, the imperial machinery was toppling under the weight of its own territory—top-heavy and bloated, it was woefully ill equipped to deal with new political and economic realities. The mercantile suc-cesses of Spain, Britain, Holland, and France had destabilized the once protected, now backward economies of the Ottoman regions, and the sultan began to lose control over his peripheral territories.[22]

Between 1804 and 1817, a series of uprisings by Serbian farmers in-spired by the French Revolution broke out on the western edge of the empire. These were suppressed through a combination of atrocities and concessions, but the beginning of the end of Ottoman domina-tion had been signaled. No sooner had the Sublime Porte (the Imperial palace in Istanbul whose name became synonymous with the Otto-man government) wrested back a degree of control over the *pashalik* of Belgrade, than the sultan found himself facing a rebellion among the Greeks of Thessaly and the Peloponnese.

Greek independence (of which more later) came in 1830. Serbia fi-nally expelled the Ottomans in 1867. In Bosnia and Herzegovina, bitter resentment against the Ottoman tax collectors was exacerbated by the failure of the harvest in 1874. In June 1875 a band of Serbian rebels in eastern Herzegovina fired against a caravan of Muslim traders, and the uprising was launched.

Judging from Evans's later appetite for revolutionary upheaval, news of the insurrection may have served as an extra spur for him and Lewis to press ahead with their planned trip to the troubled region. Armed with "an autograph letter from the *Vali Pashà* or Governor-General of Bosnia," and equipped with knapsacks, sleeping gear, and a revolver apiece, the brothers embarked on a two-month odyssey. They took the train from Vienna to Zagreb and made their way down the River Sava (the border between the Austrian and the Ottoman Empires). At Brod,

they were briefly detained by the Austrian police as Russian spies. Then they crossed the river into Turkish Bosnia—which had just been put under martial law—and continued on foot down to Sarajevo and thence to the Dalmatian coast, sleeping rough, drinking from streams and puddles, and throwing themselves on the sometimes less-than-tender mercies of the local people. In the introduction to his account of the trip Evans boasted that they were "able to surmount mountains and penetrate into districts which . . . have never been described, and it is possible never visited, by an 'European' before."[23]

The book contains many of the themes and motifs that would animate all of Evans's subsequent work. His early training in antiquarian and natural historical observation is everywhere evident in his effortless identification of flora and fauna, his meticulous descriptions of the native costumes, his comparisons between a piece of peasant jewelry and its prehistoric counterpart or a Croat jug and its Roman predecessor. But the solid Victorian erudition that Evans absorbed at his father's knee is spiked with his own more oracular ingredients—a bright streak of diehard romanticism harnessed to a revolutionary zeal for a better future.

In one rhapsodic passage he describes a glade in the primeval forest, full of butterflies: "a Purple Emperor, Dukes of Burgundy, majestic Swallow-tails, a cream-spotted Tiger-moth—beauties of Camberwell—not to speak of blues and lesser stars—mash fritillaries and delicate wood-whites." At the end of this list he sees "a black and mysterious butterfly, which I am content to leave within the limits of the unknown. It is not for me to enquire into the transformations of such sooty insects . . . for we are now treading enchanted ground." The description of the glade becomes more and more extravagant. By the end he has bequeathed to the spot its Bosnian woodsman's name of "Vila Gora—the fairy mountain," and he concludes by invoking the good spirits of the dell in the name of the struggle for freedom:

> They are singing the fates of men; they are weaving destinies; they are watching with motherly tenderness over the slumbers of the heroes of the race, who, lapped in their bosoms, are dreaming on of better days in many a mountain cave, till the guardian nymph shall rouse each warrior from his sleep, to sunder for ever the chains of the oppressors. Methinks they are waking even now![24]

As for the actual flesh-and-blood "heroes of the race," Evans's descriptions of the local people are riven with a tension (shared by many romantic revolutionaries of the nineteenth century) between his belief in the perfectibility of man and his impatience with the manifestly imperfect specimens of humanity with whom he was often confronted. His accounts of the people he encountered met were generally essentialist—each individual standing as a type specimen of his or her race—but they were rarely crude. Physiognomic signifiers of cruelty, boorishness, or ignorance would be minutely described and then hastily explained away by the history of oppression suffered by these unfortunate souls, born to bear the burden of their past on their faces.

This tendency reaches its apogee in a passage toward the end of the book about the lamentable manners of a boy—a "good specimen of the untutored savage as he exists in Bosnia at the present day"—who brings the two Englishmen their dinner one evening. "Nature's gentlemen the Bosniacs certainly are not!" Evans expostulates after describing the boy fingering their bread, staring at them while they ate, drinking from their water jug, and spitting on the floor. "Among the Mahometan burghers," he admits "there is certainly a very considerable amount of politeness and a natural dignity, due to the grand Oriental traditions with which their conversion to Islam has imbued them, to which I willingly pay homage. But among the Christians," he goes on, "even of the highest social strata, the want of politeness and that ungenerous vice of mean spirits—ingratitude—are simply astounding."[25]

He then beats a hasty retreat from this sentiment by attributing the "too obtrusive familiarity of the people" to an unpleasant phase of a national virtue—the "democratic habit of mind common to the whole Serbian and indeed the whole South-Sclavonic race." This is followed by a passage that has of late brought Evans some unhappy notoriety:

> In the Illyrian lands I have been addressed as "*brat*" or brother, and the Bosniac are known to call the stranger "*shij*," neighbour. I, who write this, happen not to appreciate the "*egalitaire*" spirit. I don't choose to be told by every barbarian that I meet that he is a man and a brother. I believe in the existence of inferior races, and would like to see them exterminated.[26]

These sentiments generally seal the case against Evans as a unrecon-
structed Conradian villain—a "racist who regarded minorities (whether
modern or ancient) with contempt"[27]—but the sentence that follows is
actually much more representative of his political commitments and
his untiring work in the cause of Slavic liberation:

> But these are personal mislikings, and it is easy to see how valuable
> such a spirit of democracy may be among a people whose self-respect
> has been degraded by centuries of oppression, and who in many
> respects are only too prone to cower beneath the despot's rod: for
> one need not be enamoured of liberty coupled with equality and
> fraternity not to perceive that, when the choice lies between it and
> tyranny, freedom, even in such companionship is to be infinitely
> preferred; and a man must be either blind or a diplomatist not to per-
> ceive that in the Sclavonic provinces of Turkey the choice ultimately
> lies between despotism and a democracy almost socialistic.[28]

Even at this early stage in Evans's career, archaeology and politics
are inextricably intertwined. In one section he describes some long-
abandoned mines that they came across in a desolate region, evidence
of the industry and prosperity that once distinguished this now mori-
bund economy. These archaeological traces also provide Evans with a
mental picture of the future. "Would, as the world grew older," he de-
mands, "something of the tremendous energy of our Midlands burst
forth upon this stagnant valley—blasting, boring, blackening, meta-
morphosing its every feature?"[29] This (somewhat ambivalent) rhetori-
cal question is followed by a denunciation of the obstructiveness of the
Ottoman authorities faced with the petition of a German mining com-
pany: "Nothing can be obtained at that sink of all human corruption
without copious bribery."[30]

This optimistic vision of Bosnia's prosperous, law-abiding future
was, however, to be indefinitely deferred. After the brothers' return from
their trip, the anti-Ottoman insurrection spread to Bulgaria. Attracted
by the heady fragrance of imperial decay, the Great Powers—Russia,
France, Britain, newly unified Germany, Austria-Hungary—began to
circle above Turkey-in-Europe ever more tightly. In July 1876, backed
by a powerful faction in Russia, Serbian forces crossed into Ottoman
territory. When the Ottomans crushed the Serbs, the Russians declared

war, and in early 1877, the sultan was forced to capitulate to the tsar. Peace was concluded at San Stefano, where the Turks signed a treaty giving Russia strategic control over the Balkans.

In 1877, after the Treaty of San Stefano, Evans went back to Bosnia in his capacity as the Balkans correspondent to the *Manchester Guardian*, his political ire at this juncture principally reserved for the new Russian overlords.[31] He made his base in Ragusa (now Dubrovnik), a city with which he had fallen passionately in love. During one relief mission in Montenegro he learned that the historian Edward Freeman, a great admirer of his anti-Ottoman activism, was in Ragusa with his two daughters. Evans traveled overnight to join them, and after a few days of intense enjoyment at the company of his compatriots he and the elder daughter, Margaret, embarked on an epistolary courtship. They were reunited in England later that year, and formalized their engagement, celebrating with a trip to London to view the Trojan treasure excavated by Schliemann. To Margaret's dismay, Evans returned to Ragusa after only six weeks at her side, and embarked on an open-ended mission combining antiquarian activism, relief work, journalism, and political agitation.

Meanwhile, the nations of Western Europe, unhappy with the settlement that gave Russia control of the Balkans, convened an 1878 peace conference in Berlin chaired by Bismarck. The deadly Great Power rivalries that would result from the carving up of the Ottoman territories had begun to intensify, and the indigenous demands of the Balkan states were subordinated to three expanding spheres of interest: Austro-Hungarian, Russian, and British. The result was political dynamite—an unstable mosaic of impecunious elites, local folk traditions, nationalist ideologies, and religious sectarianism, exploited by cynical diplomats on behalf of the most powerful nations on earth. The Slavic insurgency into which Evans had thrown himself so passionately resulted not in self-determination for the people of Bosnia-Herzegovina but in the annexation of their lands by the Austrian Empire.[32]

In September 1878, Evans returned to England to marry Margaret. He swept his bride off to Ragusa and then disappeared on a relief mission for refugees in the mountains where he stayed the whole winter. When he returned to Ragusa, he took in an Hezegovinian orphan and paid his school fees, while a blind woman who lived at the gate was given dinner every night. Unfortunately, his care for the downtrodden did

not extend to his wife. Margaret's health was precarious, and in March 1880 she returned to England without her husband, who remained in the Balkans for another six months.

After he and Margaret returned to Ragusa in 1881, Evans came to loathe the bureaucratic brutality of the Austrian administration as deeply as he had condemned the arbitrary despotism of Ottoman rule: "The people are treated not as a liberated but as a conquered and inferior race; their sense of Right—which they do possess in a remarkable degree—is simply trodden underfoot. It is military law plus bureaucratic vexation."[33] Constitutionally unable to conceal his feelings, he wrote a series of letters in support of an insurrection in Crivoscia, and in 1882 he was arrested and spent an uneasy seven weeks in a jail in Ragusa. He was finally released, but his beloved adopted city was barred to him and he and his wife had to return to England. In a rueful acknowledgement of the inextricability of Evans's archaeology and his politics, Joan Evans recalled that a "heartfelt prayer went up from Nash Mills that Arthur would not take to Celtic archaeology and try to right the wrongs of Ireland."[34]

The Road to the Labyrinth

After a rootless couple of years chafing against the dullness of life in England, Evans was appointed to the keepership of the Ashmolean Museum. He presided over the building of splendid new quarters (for which he rather unexpectedly acquiesced to a neoclassical style), appointed the aesthete Charles Bell to look after the fine art side of things, and filled the other half of the museum with a splendid array of new acquisitions, including his father's archaeological collections, a share of anthropologist Flinders Petrie's Egyptian finds, and the vast collection of ancient pottery and bronzes, majolica and Renaissance sculpture accumulated by Charles Drury Fortnum of specialty goods store Fortnum & Mason fame.

In search of good air for his ailing wife, Evans bought a sixty-acre estate in Boar's Hill near Oxford and set about designing a vast folly of a house. In 1893, however, Margaret succumbed to tuberculosis, and she died that summer in Italy. They did not have any children, and Evans never remarried. After her death, he directed his emotional energies, again in conformity with the stereotypes discussed by John Tosh, into

the Boy Scout movement, and into the adoption of two "lost boys"—
Lancelot Freeman, the delicate son of Margaret's brother, and James
Candy, the waiflike child of tenant farmers on his Boar's Hill estate.

By 1894, Evans felt that he could safely leave the running of the
Ashmolean to an assistant, and he set off again on his travels. A few
years before, he had acquired for the museum a collection of so-called
"Phoenician" seals, gathered by a local cleric in the bazaars of Greece
and the Middle East: tiny translucent objects made of semiprecious
stone, engraved with symbols and scenes of astonishing complexity and
aesthetic perfection. Evans, with his childhood training in numismat-
ics, noticed that some of these seals featured characters that suggested
an unknown script. In Arthur Milchhöfer's 1883 *The Beginnings of Art*,
he read that the source of these intriguing objects was to be found on
the island of Crete, then still under Ottoman rule.

In 1893 he bought his first seal-stone at a flea market in Athens, and
by November he was ready to announce, to the Hellenic Society in
London, that he had deduced from these exquisite artifacts the exis-
tence of a Mycenaean script. The following year Evans went to Crete
for the first time, determined to follow the trail of these clues to their
source. Arriving at Candia (later renamed Iraklion), he immediately
felt at home in the mixture of Venetian and Turkish architecture that
reminded him of Ragusa. He bought twenty-two seal-stones in the ba-
zaar for the equivalent of five shillings, and the Russian vice-consul to
Crete sold him a further twenty-one seals, plus a gold signet ring, said
to have been found near the mound of Knossos.

On March 19, Evans paid his first visit to Knossos. At the time, the
mound had at least three different names. The Greco-Turkish name
was the *kephala,* a word describing the mound itself meaning "head" or
"big head," a particularly appropriate name for a hillock such as this
one, composed of the debris of successive occupation levels, contain-
ing, so to speak, the "memories" of many generations of human life.
The full name, *tou tselebey hey kephala,* acknowledged the proprietorship
of the *kephala* by the local bey or chieftain. The name of a legendary
palace—*Knosos*—had also clung to this little hill, and it was common
to find ancient Roman coins in the nearby fields and olive groves with
the word "Knosion" or the abbreviation "Knos" on one side and a lab-
yrinth symbol or an image of a minotaur on the other. After Minos
Kalokairinos's 1878 excavations, the location had acquired a third title,
becoming known as *ta pitharia* after the huge jars or *pithoi* that he had

discovered buried there. In his diary Evans observed that the mound was "brilliant with purple white and pinkish anemones and blue iris."[35]

To Evans's intense excitement, the marks engraved on the stones exposed by Kalokairinos looked just like the indecipherable symbols on the tiny semiprecious seal-stones that had led him to the site in the first place. He poked around the local village for antiquities and was sold a fragment of a Mycenaean vase and some seal-stones, one depicting a butterfly. Fired with enthusiasm—and with pockets as deep as his determination—he promptly began negotiations with the Cretan authorities about the possibility of securing the site for excavation. Taking advantage of the fact that the French agreement with the Turkish owners of the *kephala* was "somewhat obscurely worded," he summoned up out of the ether a nonexistent "Cretan Exploration Fund" that would pay for the excavation, and began to press his suit.[36]

By 1895, when he returned again to Crete, he was the proud owner of a quarter share of the site. Lunching with a friend in a field overlooking the mound, he announced, "This is where I shall live when I come to dig Knossos," and this spot would indeed be the location of his future Cretan residence, the Villa Ariadne.[37] As a coproprietor of the *kephala*, he was in a position to compel the sale of the whole site, and on May 16 he gave instructions to his representatives in the administration in Candia to push through his compulsory purchase order.

This 1895 visit also involved some further exploration of the island. He and his friend John Myres explored the Lasithi Plain, a large agricultural area ringed by mountains. At the southeast corner, they climbed a zigzag track, a path that Evans was convinced belonged to "Mycenaean times" (the term "Minoan" had not yet been coined). Following the track across another plain and descending into the town of Kritsa, they ran across a series of ancient structures, which they interpreted as forts. Upon their return to London, they wrote up an account of their explorations, which began to delineate a network of Bronze Age fortifications strung across eastern Crete.[38]

The article narrates the progress of the two men's journey along the ancient route, detailing the abundant evidence that "in the great days of Kretan history—namely, the early Mycenaean times—these remote uplands harbored more than one walled city."[39] These walled cities vividly evoke a warlike society. One is described as "an early akropolis."[40] Another, which "must once have been a stupendous work," comprised "the remains of a vast primeval fortification intended to protect the

defile against an enemy coming from below."[41] Below this, "the road was commanded by another 'Cyclopean' work, this time more in the nature of a castle rising on a rocky knoll between the road and the ravine."[42] All along the route, ancient walls connected an extended network of "forts," "bastions," "breastworks," and "watchtowers."[43]

No archaeological report from Evans would be complete without his oracular linking of past and present, and "A Mycenaean Military Road" provides him with the opportunity for some rueful reflections on the continuity of human violence:

> [I]t is interesting to remark that already at this remote period Krete presented a phenomenon only too familiar to us at the present day: the combination, namely, of lines of intercourse engineered at great expenditure of skill and labour, with huge defensive works proclaiming that the neighbour of to-day was likely as not to become tomorrow a hostile invader. We might be on the Vosges instead of the Kretan mountains.[44]

In his allusion to the Vosges, a mountainous area of France that had been annexed by Germany after the Franco-Prussian War, Evans was contrasting the present-day turbulence of northern Europe with the peaceful remoteness of modern Crete. Even as he wrote those words, however, political tensions were building on the island. In January 1895 the Ottoman massacre of the Armenians of Anatolia had shocked the west. As part of their attempt to clean up their image, the Turks replaced the Muslim governor-general of Crete with a Christian. A Turkish group opposed to the appointment embarked on a terror campaign with a view to destabilizing the administration, and in June—a few short weeks after Evans had arrived back in London—the Cretan Assembly was dissolved. A patriotic Christian "brotherhood" formed itself and began to organize an insurrection. A Turkish garrison was besieged. Violent reprisals followed. The Powers intervened to impose some conditions on the Ottomans. By August 1896 the situation seemed to have recovered, and another Christian governor-general was appointed.

Evans returned to Crete in the midst of the 1896 conflict to continue his archaeological research, commenting in his report: "In spite of the insurrectionary movement in Crete, the tranquility then pre-

vailing in the eastern provinces enabled me to devote this spring to a more thorough investigation of their early remains."[45] This trip consolidated many of his theories about ancient Crete's succession of scripts, her cultural borrowings from Egypt, and the nature of her religion. His impression of the warlike character of ancient Crete was also affirmed when he discovered the remains of a "town of castles": "A group of 'Cyclopean' strongholds, all within hail of one another, each of which . . . might be described as an acropolis in miniature."[46] To this belligerent offshoot of the heroic civilization revealed by Schliemann and his successors, Evans gave a name: "The great days of Crete were those of which we still find a reflection in the Homeric poems—the period of Mycenaean culture, to which here at least we would fain attach the name *Minoan*."[47]

The "tranquility prevailing in the eastern provinces" of Crete would be short-lived. The new regime fell apart in a maelstrom of violence, and in the spring of 1897 the Cretan struggle erupted into war. Perhaps because he had learned caution from his imprisonment fifteen years before in Ragusa, Evans stayed away. When he returned in 1898 in his capacity as correspondent to the *Manchester Guardian,* the eastern parts of the island that he knew so well had been devastated by a series of Christian-Muslim massacres.

Describing the horrible aftermath of these, Evans lost his appetite for reconstructing ancient military installations. He would never return to the string of forts and guardhouses that he and Myres had come across in 1895, or the "town of castles" he had observed in 1896. Instead he selectively focused on the traces of the ancient Cretan past that were compatible with a more pacific interpretation of the Minoan world. In 1901 he asserted, in an article for the popular *Monthly Review,* that Knossos betrayed "no sign of an elaborate system of fortification such as at Tiryns and Mycenae."[48] Again and again in the years that followed, he would interpret the evidence as bearing out the more benign aspects of Cretan mythology. His King Minos was a famous lawgiver rather than an infamous tyrant; his labyrinth was a dancing floor rather than a monster's prison. So successful was he, that Mycenae and Knossos eventually came to be seen as opposite extremes, one militaristic and patriarchal, the other peaceful and feminine. Out of the violent hell of the struggle for Cretan independence was born the pacifist paradise of Minoan Crete.

Greek Defeat

The 1897 war that won Crete its independence was a small-scale, now long-forgotten conflict, but at the time it aroused much passion and regret.[49] The Greek army was routed by the Turks; the conflict dashed Greek territorial ambitions on her northern frontier, and the defeat was deemed a ghastly humiliation. After the war, it was only the intervention of the Great Powers that resulted in Crete achieving any political gains. Cretan autonomy was clearly inevitable, given the ever-increasing feebleness of the Ottoman Empire; the 1897 war bought it early at far too great a price.[50]

The struggle for Cretan independence was a long one. Back in 1814 a group of Greek merchants had organized themselves into a secret society, the *Philiki Etairia* (Society of Friends), with the objective of "the liberation of the Motherland."[51] The question was, where was this motherland to be? Greek speakers were spread across the Ottoman Empire from Syria to Moldavia (the *Philiki Etairia* itself was based, nowhere near modern Greece, in the Russian Black Sea port of Odessa); they identified themselves principally in relation to the Greek Orthodox Church, and any anti-Ottoman sentiment was likely to draw its historical inspiration from the Byzantine Empire, making Constantinople the Greek capital. In order, however, to stake a claim to a nation in the French Revolutionary mode, the Greeks had to figure out who they were as a *people,* rather than just as bearers of a faith.

Attracting sympathy and support from all corners of the classically educated world, the Greek-speaking populations of the Ottoman Empire began to look once more to their ancient pagan past to define the contours of their future state. By the turn of the nineteenth century, they had added a new term to the various names by which they were known. No longer just Christians (*Kristianoi*), Romans (*Romoi*), or Greeks (*Graecoi*, the Roman name for them) they could now choose to anoint themselves Hellenes (*Ellenedes*), the ancient Greek name for the ancient Greeks.

One of the ironies of Greek nationalism was that the Greek identity that was available for the revolutionaries of the *Philiki Etairia* was mediated by traditions of northern European classical scholarship almost completely dislocated from the Greek present. The "Hellenic ideal" that had emerged in northern Europe in the course of the eighteenth and nineteenth centuries was a complex creation, at once racist and

revolutionary, susceptible to both Christian and secular appropria-
tion, oscillating uneasily between universalism and particularism.

Every nation had its own version of Hellenism. In the German-
speaking lands, for example, the eighteenth-century art historian
Johann Joachim Wincklemann had trained classicists to admire the
"noble simplicity" and "serene grandeur" of Greek art, in contrast to
the artificiality of the Latin nations. At one stroke, Protestantism, Ger-
manic tribal history, and Gothic architecture could all be reclaimed as
"Greek." (Nietzsche's Hellenism was in this respect the rebel offspring
of Wincklemann's.) In France, as the government ricocheted between
republics, restorations, and empires following the 1789 Revolution, the
debate between authoritarian and liberal solutions to the problem of
political order was often couched in terms of the authoritarianism of
Sparta versus the democracy of Athens. In Victorian Britain, Athens
was reinvented as an imperial democracy in the British mould whose
aesthetic principles of harmony and order supported the bourgeois vir-
tues of propriety and stability. (Evans's Knossian Empire would par-
take of much of this spirit.)

Despite the great cultural prestige of their shared classical heritage,
however, the governments of the European Great Powers shunned the
Greek rebels when the War of Independence first broke out in 1821.
The allies who had defeated Napoleon had no desire to see the deli-
cate balance of power, so carefully hammered out in Vienna in 1815,
imperiled by the disgruntled Christians who shouldered the Ottoman
yoke. Huge pressure was put on this position by the hundreds of phil-
hellenes from all over Europe who flocked to Greece to fight on behalf
of a classical ideal often rather imperfectly embodied in the goat herd-
ers and bandits they generally encountered once they arrived at a rebel
stronghold.

In 1827, the high cultural status of Hellenism finally translated into
significant military victory. On the November 20, egged on by the phil-
hellene British consul in Istanbul, Admiral Edward Codrington turned
his guns on the sultan's army at the Battle of Navarino, and Ottoman
naval power was brought to an abrupt end. The war was effectively
won, and by 1830 it was over. Profiting from the stature of their pagan
heritage, the Christian Greeks had clawed back some of the lands lost
to Islam centuries before.

The power vacuum left by the defeat of the Ottoman army led
quickly to civil war, cynically exploited by the Great Powers vying for

political influence in the new protectorate. The bloodshed finally ended when Russian, Britain, and France agreed to impose on the Greeks the young Bavarian Prince Otto (1832–1862), son of King Ludwig of Bavaria, an eccentric philhellene monarch who had rebuilt Munich in his image of ancient Athens. The political settlement granted the Greek mainland and the Peloponnese their independence, but Crete, Epirus, and Macedonia were left outside the borders of the newly established Greek state, to remain under Ottoman rule. This solution was imposed by the British, who, having helped themselves to Cyprus and Corfu in 1815, were firmly opposed to anyone else getting too much control over the islands. Many Cretan Christians had died in the war, and the survivors felt betrayed. A series of fruitless Cretan uprisings against the Turks in the decades that followed achieved nothing for the Christians of the island.

In 1897, a secret society plotting to free Macedonia from Turkish rule took up the cause of Crete and started to smuggle arms to the island. It seemed like an opportune moment. The most recent Cretan uprising had occurred the summer before and the memory of its violent suppression was still raw. King George (Otto's successor, a Dane with a Russian wife) seized the opportunity to prove himself a good patriot and sent an expeditionary force to the island. Turkey promptly appealed to the Great Powers, who set up a "neutral zone" around the capital, warning the Greeks not to attack. But the Greek commander replied that he was under orders to take possession of the island, and continued to organize Cretan rebels. The Great Powers charged that his troops had trespassed into the neutral zone and opened fire.

Hundreds of Greeks from all parts of the Ottoman Empire poured into Athens to wait for ships to take them to join the fighting. There was widespread outrage in Europe with articles and demonstrations in favor of the Cretan rebels. Volunteers from England, Denmark, France, Italy, Russia, and Sweden joined the Philhellenic Legion. On March 2, 1897, the Great Powers agreed that Crete could have a limited autonomy with its own local government but still nominally under Turkish rule. Union with Greece was still out of the question. The sultan accepted the autonomy of Crete, but the Greeks prevaricated. The conflict escalated. The Greeks and the Ottomans, both conscious of the fact that Macedonia and Epirus would be the real strategic prizes in any war, began to mass troops all along the northern border of independent Greece. On April 17, war was declared.

Outnumbered and outmaneuvered, the Greeks were soon forced to retreat. Within days, exhausted, panic-stricken soldiers filled Volos, the capital of Thessaly, waiting for the transport ships to take them back to Athens. By mid-May, the war had been lost, and the Greek troops were recalled from Crete. Under the terms of the peace treaty, arranged by the European powers, Turkey obtained a large indemnity and a rectification of the Thessalian frontier, carrying for them some new strategic advantages. Athens was made to hand over control of its budget to a Great Power commission. Crete was forced to accept the solution of partial self-rule nominally under the sultan, but in practice under the four protecting powers: England, France, Italy, and Russia.

The island was divided into four regions: the Italians took Chania; the British undertook to oversee the capital Candia (later Iraklion), the French went into Lasithi and the Russians into Rethymnon. Prince George, second son of King George of the Greeks, was named as high commissioner. Despite this partial solution to the Cretan rebels' grievances, the settlement was a considered a bitter, pointless end to an ill-judged campaign.

Reconstructing the Nation

At the end of March 1898 Evans returned to Crete, taking up once again the mantle of correspondent to the *Manchester Guardian*. His first report, filed at the beginning of May, began with a furious tirade against what he came to call "the Turco-British regime in Candia": "where British diplomacy continues to 'hob-nob' with Turkish official-dom."[52] Despite his fury at the British cooperation with the Ottomans, Evans was most alive to the horrors of the massacres perpetrated by Christian Cretans against the Muslims of eastern Crete, and the report ends with a long account of these atrocities.

Reluctant to let the Christian Cretans bear ultimate moral responsibility, Evans blamed the genesis of the massacres on "a swarthy half-breed . . . a member of the Sultan's negro guard, who had distinguished himself in the Armenian massacres at Constantinople . . . and went from village to village stirring up the faithful to do the same by the Cretan Christians."[53] Under this provocation, Evans argued, "the population of eastern Crete—usually so peaceful and docile—was stirred to deeds of mad ferocity."[54] His genuine horror at these deeds is unmistakable, however:

But the most deliberate act of extermination was that perpetrated at Eteà. In this small village, too, the Moslem inhabitants, including the women and children, had taken refuge in the mosque, which the men defended for a while. The building itself is a solid structure, but the door of the small walled enclosure . . . was finally blown in, and the defenders laid down their arms, understanding, it would appear, that their lives were to be spared. Men, women and children, they were all led forth to the church of St. Sophia, which lies on a hill about half an hour above the village, and then and there dispatched—the men cut to pieces, the women and children shot. A young girl who had fainted, and was left for dead, alone lived to tell the tale.[55]

Although Evans marveled at the "complete return of peace and orderliness among these Eastern Cretans," the landscape of Muslim Crete was deeply scarred. The Messara Plain, once the site of fifty Muslim villages, was now completely deserted, the blackened walls of burnt dwellings all that remained as witness to the destruction:

The roofs have been torn away for firewood and the rubble walls battered in; the mosques have been blown to pieces; the olives and vines have been cut; the whole countryside where Mahometan villagers once lived is a scene of desolation; the paths are almost impassable on account of the scattered debris of ruined walls and the torn limbs of fruit-bearing trees; dead animals have been thrown into the cisterns; the minarets in some cases have afforded crematories for the dead.[56]

Upon this scorched earth a nation had to be built. British diplomatic accommodation of the remnants of the Ottoman administration was finally brought to an abrupt end by a riot in Candia in September 1898 in which dozens of Christian Cretans, seventeen British soldiers and the British Consul on the island perished. The British promptly hanged seventeen Turkish "ringleaders" and ordered the Ottoman forces to leave the island. On December 21, 1898, Prince George of Greece, bearing the title of high commissioner of the Great Powers, was given a rapturous welcome as he disembarked to undertake control of the island. He gave a speech exhorting the citizens of the newly liberated island to "forget your old differences and, regardless of race or religion . . . live in harmony together, under a common and benign state."[57] A sixteen-member committee was charged with drawing up a

constitution for Crete and in January 1899 elections took place, with 138 Christians and fifty Muslims taking their places on the Cretan Assembly.

Great challenges clearly faced the architects of the new order. The economy of Crete, precarious at the best of times, was now in tatters. The vast majority of Christian Cretans were agricultural laborers, farmers, and herdsmen; the departure of many of the Ottoman elite and extremely high illiteracy rates among the Christian population made the prospects for economic regeneration seem bleak. A series of disastrous harvests exacerbated the problem. The project of reconstruction was undertaken energetically, however, with the first government of the autonomous Cretan state losing no time in passing laws and acts, issuing a Cretan currency, taking public health measures to halt the spread of leprosy and organizing a police force with Italian officers.

For archaeologists, autonomous Crete represented a land of opportunity.[58] The political imperatives of Cretan nationalism—to move towards union with Greece—were in perfect harmony with the archaeological goal of finding in prehistoric Crete the origins of ancient Greek culture. Academic prestige thus went hand in hand with political aspirations. Moreover, the economic plight of ordinary Cretans ensured that a willing workforce would be available to do the digging, sifting, and cleaning of artifacts. For the new government, archaeology was at once a sure sign that liberation and stability had been achieved, a promise that the deep past would underwrite the political goals of the immediate future, and a potentially significant contribution to an ailing economy.

Accordingly, among the first laws passed by the assembly were a series of regulations governing the excavation and disposal of Cretan antiquities. These were highly favorable to interested explorers from the protecting powers, and the archaeological sites were divided up among French, Italian, and British excavators, roughly in accordance with the areas that these nations were overseeing in an administrative capacity. The Cretan government undertook to requisition the land from its proprietors on behalf of the archaeologists, with the excavators only required to compensate the owners for any damage incurred. Antiquities were to be the property of the Cretan nation, but duplicates and other unwanted items could be exported. Britain, in the person of Arthur Evans, secured the site of Knossos, fortuitously located within the British protectorate of Candia.

{ III }

ARIADNE'S LAMENT,
1900–1913

In excavating the Labyrinth of Knossos, Evans could choose from among a rich array of famous mythological figures to endow his dig with glamour and mystery. Knossos, after all, was where Theseus fought the Minotaur, where King Minos lay with his faithless wife Pasiphae, where the princess Ariadne danced the labyrinth dance, and where the architect Daedalus constructed the wings for his doomed son Icarus. Eventually the archaeologist would settle on the lawgiver King Minos as his symbol of a peaceful, prosperous island nation, but at the beginning of the excavation it was Minos's daughter, the princess Ariadne, whom he sought and found in the fragments of the past.

Evans's Ariadne bore the burden of many of his most cherished themes. His first gesture was to place her on the throne of the palace, suggesting that Crete had been one of the last outposts of a once-universal matriarchal stage of human cultural evolution. She didn't last too long as the ruler of Knossos, but Evans compensated for her loss of temporal power by anointing her the queen of the Minoan heaven, the Great Mother Goddess of an ecstatic nature religion practiced on the

mountaintops and in the sacred groves of the island. Above all, it was Ariadne's legendary "dancing floor" that he would return to again and again as a symbolic location that united the deep past with his fondest hopes for the present and the future of Crete.

Ariadne's Throne

At the beginning of 1900 Evans tooled up for his first season at Knossos, placing an order with the Junior Navy stores in London for plum puddings, ox tongues, Eno's Fruit Salts, quinine pills, and all the other means by which the wealthy British explorer transported the comforts of the haute-bourgeois nursery to hotter climes. In March he arrived in Crete, paid the Turkish proprietors for the rest of the site of Knossos and had the house on the site disinfected. He also secured some less malarial lodgings in Candia, for which he hired a housekeeper, a butler, and a small swarm of other servants.

On Friday, March 23, Evans rode out on a donkey from Candia to the *kephala*. A crowd of Muslims and Christians of all ages and both sexes had gathered at the nearest taverna, hoping to be selected to work on the dig. From the assembled crowd, Evans's Cretan foreman chose thirty-two diggers, shovelers, barrowmen, waterboys, and washerwomen (to clean the finds), told them that the workday ran from sunrise to sunset, and led them out to the mound.

Evans—who celebrated his proprietorship of the site by translating its Greek name into the quintessentially English-sounding "The Squire's Knoll"[1]—pitched a military tent in the shade and ran the Union Jack up a short flagpole. At about eleven that morning, the first shovelful of earth was thrown off the mound. In the afternoon, the excavation was joined by the Scottish archaeologist Duncan Mackenzie who would end up supervising the dig for the next thirty years, keeping the records of the excavation and contributing his pioneering understanding of the logic of stratigraphy.[2]

The first few days were spent digging test pits and nothing of much note came to light. At the end of the first week Evans moved the operation to the top of the mound, right into the ancient structure that Minos Kalokairinos had begun to clear in 1878. Immediately, finds began to pile up, including, to Evans's joy, a clay tablet "with a script on it and what appear to be numerals."[3] He had come to Crete in search of an indigenous European system of writing and here it was. By April 1,

the number of workers digging the mound had risen from 32 to 100; ten days later there were 140 people at work, stripping away the mound of Knossos layer by layer.

On April 13, 1900, Evans's workmen excavated a room containing a large square alabaster basin, with steps descending into it. Opposite the stairs, a small but elaborate alabaster chair came to light, with its carved back plastered into the wall. Watching with a small crowd of visitors as this regal-looking bit of furniture emerged from the soil, Evans ringingly announced to the assembled company that they were looking at "the Throne of Ariadne."[4] In his excavation diary for that day he referred to the alabaster basin as "the Queen Ariadne's bath."[5]

In 1876 Schliemann had exhumed a Bronze Age burial site and told the world that he had found the mortal remains of King Agamemnon. Now Evans seemed to be playing the same game. Like Mycenae, Knossos was a site that had never lost its legendary associations, and Evans must have been well aware that the best way to grab some headlines was to announce that he had dug up the actual setting for the famous stories of King Minos, Queen Pasiphae, Princess Ariadne, and the monstrous Minotaur. But the very fact that he immediately crowned "Queen Ariadne" the sovereign of Knossos, rather than her father King Minos, shows how far he was from Schliemann's Homeric literalism. By putting a legendary female on the throne, Evans was trying to reconcile the ancient myths of Knossos with a rather more modern set of stories.

In the 1860s, as Darwinism and the burgeoning feminist movement conspired to undermine the assumption that the patriarchal family was either God-given or natural, the idea arose of a universal matriarchal stage of cultural evolution. From the beginning, the island of Crete occupied a privileged place in these speculations. The first text to explore these ideas—Swiss legal scholar Johann Jakob Bachofen's 1861 *Mother Right*—devoted a whole chapter to the island. Crete's importance was due to its reputation as the place of origin of the Lycians who, according to Herodotus, took their names from their mothers. Bachofen characterized it as a place where traces of the matriarchal system—such as the custom of referring to Crete as the "motherland" rather than the "fatherland"—were still visible in classical times.[6] The founding text of American anthropology, Lewis Henry Morgan's *Ancient Society* (1877), followed suit, speculating that "the insulation of [the Lycians] upon the island of Crete . . . may afford an explanation of their retention of descent in the female line."[7]

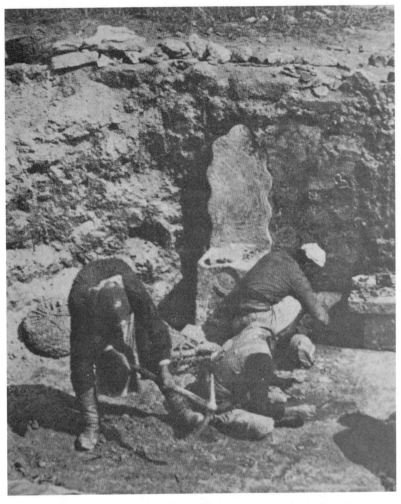

FIGURE 5. "Ariadne's Throne" at the time of excavation. Arthur Evans,
The Palace of Minos, vol. 4, fig. 881. By permission of the
Ashmolean Museum, Oxford.

This theory about ancient Crete seemed to be vindicated in 1884
when an Italian archaeologist, Frederico Halbherr, literally stumbled
over a piece of inscribed marble sticking up out of a path near the
Cretan town of Gortyn. A local peasant told him that more inscribed
stones were to be found in the water course of a local mill. When the
inscription was pieced together it turned out to be a legal code, carved

into a huge semicircular wall, thirty meters long, written in a Doric dialect in a style known as *boustrophedon* ("ox-ploughed"), the lines reading alternately in different directions.

The Law Code of Gortyn—dated to the fifth century B.C.—reveals a strictly hierarchical society: five witnesses were needed to convict a free man of a crime, only one to convict a slave; raping a free man or woman incurred a fine of five hundred staters, raping a slave only five. But the laws also include a provision that women were entitled to retain all their prenuptial property in the event of a divorce (a right that had only been bestowed in England two years before Halbherr's discovery, with the passing of the Married Women's Property Act of 1882). The legal status of women in Crete in the fifth century (although far from equal to that of men), was higher than in contemporary Athens, and the code was accordingly interpreted as confirming the long survival of traces of the island's prehistoric matriarchy. Evans's Queen Ariadne signaled his acceptance of the notion that Crete retained at least some vestiges of the matriarchal system into the Late Bronze Age, thousands of years after it had been supplanted elsewhere.

The Great Cretan Mother

By the time Evans got around to filing his first excavation report with the British School at Athens, "Queen Ariadne" had been deposed by her father, King Minos. After describing the gypsum throne with its seat "hollowed out to suit the form of the human body," he remarked that another seat—this one more crudely carved and made of wood— had been found in an adjoining room "in which the hollowed space was larger." "It seems probable that this was intended for a woman," he asserted, "while the seat of the throne seems better adapted for a man."[8] It is not exactly self-evident that the larger seat would have better suited a woman, but a footnote clarified Evans's position:

> The prominence of the female sex in the Mycenaean period—as illustrated by the cult-scenes on the signet rings—might itself favour the view that a queen had occupied the throne here . . . But it must not be forgotten that the masks on the royal tombs of Mycenae were of the male sex. The leading part played by Goddesses and female votaries in the cult-scenes may have been due to the long survival in the domain of religion of ideas attaching to the matriarchal system.[9]

This compromise—in which "the matriarchal system" receded into earlier prehistory, leaving temporal power in male hands and spiritual authority in the hands of women—gave Evans the widest possible license in interpreting images of Minoan femininity.

As he attempted to reconstruct the sexual politics of his ancient society, the coordinates that Evans used to define Minoan womanhood consisted of a gloriously heterogeneous index of fin-de-siècle assumptions about femininity, in which Victorian stereotypes of the spiritualized angel in the house jostled uneasily with Orientalist visions of the harem, and smoking-room quips about the eternal frivolity of womankind confronted the New Woman's androgyny. When it came to the immortal realm, however, Evans managed to construct a thoroughly modernist female archetype, the Cretan Great Mother: primitive and yet complex, nurturing, powerful, and fecund.

In one wall painting Evans saw coquettish beauties straight off a Toulouse-Lautrec poster, "fresh from the coiffeur's hands with hair *frisé* and curled about the head and shoulders."[10] In another fresco he saw muscular, transvestite girls joining in the impossibly dangerous sport of "bull-leaping": "female *taureadors* . . . attired in precisely the same way as the 'cow-boys.'"[11] In 1902 he divided the palace itself into male and female areas, with the latter marked as such by the "strict system of guardianship and surveillance"[12] surrounding it. Having thus identified the "Domestic Quarter" he interpreted one of the pictographic signs carved into its columns as a distaff—a "sign of 'the spindle side' and a distinguishing mark of the chambers somewhat specially set apart for women."[13] Despite this delightfully literal interpretation of the distaff side of Knossos, a keynote in many of his interpretations was androgyny, with Minoan men emerging as distinctly feminine creatures, unbearded and slim-waisted, with hair streaming down beneath their shoulders "while above it curled, often into a double crest."[14]

The archaeologist's most elegiac prose was always reserved for visions of the Great Goddess. For Evans she was, above all, a "Goddess of Maternity" belonging to "the very ancient class of Virgin Mothers":

> She presides over births and fosters the young both of land and sea. Like Artemis, she combines the attributes of nurture and of the chase . . . [She] seems to be essentially the same as she who is elsewhere shown . . . standing on her sacred peak with her pillar temple behind her. Sometimes we see a similar figure bearing a double-axe,

sometimes it is held aloft by her votaries, and on the great signet of Mycenae the same Mother Goddess is shown seated beneath her sacred fruit tree, while the *labrys* emblem appears in the sky above. . . . It would even appear that the lion-guarded Goddess is essentially the same as she whose emblem is the dove.[15]

Evans always insisted that all representations of the great goddess depicted a single figure appearing under different aspects. His Great Mother was an archetype of divine femininity distilled from many different images, like one of the "composite photographs" so beloved of fin de siècle criminologists, in which the imposition of dozens of different faces one on top of another was supposed to yield the typical features of a murderer or a hysteric.

Ariadne's Dancing Floor

Ariadne may have given up her throne by the end of the first season's digging, but in Evans's excavation report for that year she reemerged, appearing in the guise of some lines from the *Iliad*. The lines occur in Homer's description of Achilles' shield, upon which appear a series of magical scenes—images of wedding parties, ploughed fields, vineyards, town elders adjudicating between grievances, a harvest banquet, cowherds followed by their dogs, and wide pastures dotted with sheep. Right at the end of the list of Arcadian vignettes comes the most exquisite: "a dancing floor like the one Daedalus made at Knossos for Ariadne," where beautiful young men and girls are circling, touching each other's hands, the girls in garlands of flowers and soft linens, the men sporting gold-hilted daggers.

The scenes on Achilles' shield provide almost the only break in the *Iliad*'s bleak landscape of military wrath and Olympian capriciousness. The tragic contrast between the events unfolding on the battlefields of Troy and the idyllic miniature universe depicted on the shield was a perfect fit with Evans's agenda for Knossos. Ariadne's dancing floor positioned ancient Crete exactly where he wanted it to be: as a dream of peace and a magical domain, already legendary by the time of the Trojan War. Evans would return again and again to this scene, locating the original dancing floor at various different sites in and around the palace, reading it into dozens of different artifacts, and developing an ever more elaborate reconstruction of the dance itself.

Evans's first reference to the dancing floor was explicitly politi-
cal. Referring to the deadly religious strife that marked contempo-
rary Crete's assumption of political independence, he remarked that
"[i]t had been my practice from the beginning to employ both Maho-
metan and Christian workmen, so that the work at Knossos might be
an earnest of the future cooperation of the two creeds under the new
régime in the island." As evidence of how well his policy was working
he described a holiday celebration that he had organized. "On a com-
mon feast day they even danced together the Cretan 'Choros' in the
Western Court of the Palace," he exulted, and then finished his sen-
tence with two lines from Homer describing Ariadne's dancing floor
at Knossos.[16]

"Choros" is a word with a multiplicity of meanings. It can refer to the
chorus of a Greek play—either to the actors themselves or the words
or music that they perform—and it can also mean "winding dance" or
"dancing place." Evans used it here first to refer to the sinuous, traditional
line dancing of the Cretan peasants, and then switched the meaning to
Ariadne's dancing floor. With this shift in the meaning of the word, he
brought together Cretan myth and peasant custom under the sign of the
labyrinth dance. To him, the political significance of this reenactment
resided in the fact that his Muslim and Christian workers were able to
transcend their recent conflict by reclaiming their pagan past.

In April 1903, Evans decided that he had actually discovered the
dancing floor's original location. That year he hired another one hun-
dred and fifty men to break new ground northwest of the palace. Broad
steps appeared, descending to a paved area that he concluded was some
kind of theater. "What performances," he asked in that year's exca-
vation report, "are likely to have been given in the paved area?"[17] He
quickly concluded that "this first of theatres, the Stepped Area with its
dancing ground, supplies a material foundation for the Homeric tradi-
tion of the famous 'choros.'"[18]

Having established to his satisfaction that this theatral area was
none other than the original Daedalian dancing floor, Evans then made
two very characteristic leaps across time. The first leap connected
Minoan Ariadne to the Greek Dionysus. Referring to the "Great Dio-
nysia" of Athens, the annual festival at which the tragedies of Aeschy-
lus, Sophocles, and Euripides were performed, he asserted that "[i]t is
symptomatic of the increased importance attached to male divinities
in the later religion of Greece that 'choros' and theatre should pass

FIGURE 6. Cretan workmen at Knossos dancing the traditional line dance that Evans likened to the Labyrinth dance. Evans Archive. By permission of the Ashmolean Museum, Oxford.

from the Goddess [i.e., Ariadne] to the God [i.e., Dionysus]." Again, the multiplicity of the word is what stitches together the grand sweeps of time covered by Evans's narrative. Ariadne's "Choros"—that is, her dancing floor—becomes the ancestor of the chorus of the plays staged in fifth-century B.C. Athens: "In the more recent cult the 'choros' of Ariadne is superseded by that of her consort Dionysos."[19]

Evans then brought the story up to date, describing that year's reenactment by his "Cretan workmen and their womenfolk" of the Knossian scene on Achilles' shield:

> The sinuous, meandering course of the dancers, as they were led hand in hand by the chief performers in each set, was curiously appropriate to the ancient traditions of the spot. Of such a kind, we are told, was the *geranos* dance, mimicking the mazy turns of the Labyrinth, by Theseus instituted at Delos before the image of Aphrodite, that he

had received from Ariadne, and which was in fact Ariadne herself in her cult aspect.[20]

By suggesting that Cretan folk dancing was "curiously appropriate to the ancient traditions of the spot," Evans was hinting that the Minoan labyrinth dance had somehow survived the centuries, ready to be awakened to its true significance by the agency of archaeology. The idea that peasant customs represented the survival of ancient religious rituals was a recurring motif of anthropology, most famously deployed by J. G. Frazer in the opening scene of *The Golden Bough,* in which a strange Roman tradition is described as the remnant of a more barbarous age, like a "primeval rock rising from a smooth-shaven lawn."[21] As usual, however, Evans's deployment of the doctrine of "survivals" represented an inversion of Frazer's Victorian disdain. The effect of his annual reenactment of the labyrinth dance was to cast pagan ritual as a healing force for a peaceful future rather than a barbaric remnant of a violent past.

In 1909 Evans found a gold signet ring with a ritual scene engraved on its bezel that supplied another detail in his reconstruction of the labyrinth dance. The scene shows four women in Minoan dress in a field of lilies. The central figure has her head bowed with her right hand raised and left hand down. Struck by the similarity between this gesture and the characteristic posture of the "whirling dervishes," Evans interpreted this scene as a dance of ecstatic possession to invoke the goddess. In an address later that same year to the Royal Institute of British Architects, Evans showed a slide of the ring and reconstructed for his audience the "orgiastic dance"—whirling, labyrinthine, Dionysian—held in honor of the Minoan mother goddess in the "Dancing-place of Ariadne."[22]

By the time he published the third volume of the *Palace of Minos,* Evans had spotted Ariadne's dancing floor in dozens of different artifacts. Based on a fresco showing a large audience watching a dance performance in a grove of olive trees, he had decided that the dancing floor actually lay outside the palace, and he included a photograph of a spot of level ground just east of Knossos that he thought resembled the painted scene. In the same chapter he asserted that a "very fair idea of the original 'mazy' dance may be obtained from the dances still performed in the neighborhood of Knossos and elsewhere by the Cretan

peasants." There follows a long description of various versions of the traditional Cretan dance, each one corresponding in some detail with a feature of Evans's reconstruction. Because he believed that the original labyrinth dance had been an all-female affair, of especial interest were the women-only dances from one particular Cretan village, where the "opening dance at weddings is performed by girls alone, the bride leading." At the same location, the girls and women of the village also enacted a *mystikos choros* or "secret dance," accompanied by a woman on a violin, from which men were rigorously excluded.[23]

"Who but I knows what Ariadne is?" Nietzsche had asked in 1888. Now Evans had the answer. 'Ariadne" meant "most holy" in the Cretan dialect of Greek. The Cretan princess of myth was thus none other than the Great Cretan Mother. The legendary Labyrinth represented the distant memory of a ritual at which she was honored by her female devotees in an orgiastic, whirling, winding dance. During the centuries-long transition from matriarchy to patriarchy different aspects of Ariadne's cult passed to her legendary consort Dionysus. At some point in the post-Minoan period, young men started to participate in the labyrinth dance. This mixed version of the ritual survived in legend as the labyrinthine Crane Dance with which Theseus celebrated his victory over the Minotaur on the island of Delos. The women-only version had been passed down through the generations in Crete's remote villages to survive into the twentieth century as the all-female *mystikos choros*. "It would seem," Evans nervously remarked of these ceremonies, "that a male intruder might share the fate experienced by Pentheus at the hands of Agavê, when he broke in on the secluded orgies of the Theban women amidst the wilds of Kithaeron."[24]

For Nietzsche's devotees, the great significance of Evans's reconstruction of the labyrinth dance was how it extended and altered the narrative of *The Birth of Tragedy*. Dionysus, it turned out, was not a barbaric import from the Orient but a home-grown Greek. He was the son and consort of Ariadne, "the most holy," the Great Cretan Mother, and it was in his name that the sacred forms of the feminine Minoan cult were appropriated by a male-dominated pantheon. In the sixth century B.C., when the Dionysian frenzy swept across Greece, the rituals contained much of the matriarchal content of ancient Cretan religion. Nietzsche's "Dionysian dithyrambs"—the dissonant, ego-rending music of the Greek chorus that readied Athens for the age of tragedy—

were the old songs of Crete. The theater at which Sophocles and Aes-
chylus staged their plays was a direct descendant of Ariadne's dancing
floor. Tragedy, it seemed, was born from a mother as well as a father.

The Making of a Goddess

All that remained was for someone to make explicit the Dionysian nar-
rative buried in Evans's dense and elliptical prose. Sure enough, almost
as soon as the excavations started, Jane Ellen Harrison, a famous clas-
sicist, began to broadcast a devoutly Nietzschean invocation of the
Great Cretan Mother. Harrison's fashionable synthesis of archaeol-
ogy with the latest theoretical developments in the social sciences was
highly influential among artists and writers, alerting the new tragedi-
ans as to the Dionysian significance of Knossos. Her passionately par-
tisan interpretation of Cretan artifacts introduced the Minoans into
modernism, making the paradigmatic European primitives available
for appropriation and identification by poets and artists.

From a feminist perspective, whatever great historical trauma brought
Harrison's avant-garde Minoans were not only Nietzschean, they
were also militantly feminist. In 1877 the debate about primitive matri-
archy had taken on an overtly political character with the publication
of Friedrich Engels's *Origin of the Family, Private Property and the State.*
The text was full of memorable phrases: "The overthrow of mother
right was the *world historical defeat of the female sex.* The man took com-
mand in the home also; the woman was degraded and reduced into ser-
vitude; she became the slave of his lust and a mere instrument for the
production of children."[25] Harrison's narration of the gradual demo-
tion of the Great Cretan Goddess from all-powerful creator to "slave
and plaything" is full of the same anger.

From a feminist perspective, whatever great historical trauma brought
Minoan civilization to an abrupt end—perhaps a huge earthquake or
an invasion from the mainland—the burning of the last palace of Knos-
sos looked like the very moment that Engels's world historical defeat
of the female sex was achieved. But, as Harrison's own career attested,
the excavation of Knossos began just as the first women were breaking
into the professions of archaeology and classics. It followed that what-
ever power was lost to the women of antiquity when Minoan Crete
came to an end would be gained by the new woman of the twentieth
century when her campaign for professional, sexual, creative, and po-

litical equality was won. The beginning of patriarchy, in other words, seemed to be dug out of the Cretan soil just at the moment that the first hazy outlines of its decline were coming into view.

Harrison was Evans's almost exact contemporary, born in 1850 in Yorkshire.[26] After her birth her mother developed puerperal fever and died, leaving Jane with a legacy of guilt at having caused her demise. In 1855, her father married the children's governess, who turned out to be a highly unsympathetic character, insisting on strict religious observances from her charges, isolating them from friends and family alike, and eventually producing nine children of her own. While her stepbrothers were sent to the famous Harrow School, Jane was confined to learning the womanly arts of needlework, Bible studies, and deportment from a series of governesses. Even a pedagogical regime as dispiriting as this one was transformed by her hungry mind, and she learned, almost completely unaided, to read and write German and to read a little Latin and Greek. Finally, a flirtation with a curate (who had aroused her interest by referring to a mistranslation of a passage in the Bible) resulted in her being sent to school, and in her seventeenth year Jane went to Cheltenham Ladies' College.

Tentatively, experimentally, a few academic examinations had been opened up to women. The London matriculation examination had been opened to women in 1869; that year eight women took it with only two passing. In 1870, Jane Harrison was one of the three Cheltenham Ladies' students to pass it. With this triumph she did what was expected of her, and returned home to take up the post of governess to her nine step-siblings. But when she came of age in 1871 and inherited an annuity from her mother, Jane rebelled and left for Europe.

On her return she won a scholarship to Newnham College, Cambridge. To everyone's surprise, her father did not stand in her way, and in 1874 she found herself among the small group of women who lurked at the margins of university life. Their privileges were few. They had no access to libraries or laboratories, could only attend a few specially prescribed lectures, were barred from the social life of the university and had no right to read for a degree. But the year after she arrived the students were able to move into Newnham Hall, a haven of light, airy rooms and peaceful gardens.

Harrison's college years were marked by the effortlessness with which she dominated the social and intellectual life of Newnham, so

it was an intense disappointment to her when the results of the final examinations in classics were announced and she found herself placed in the second class (not thereby earning herself a degree, since it would not be until 1948 that Cambridge extended that right to women). She had expected to stay at Newham as their first Classics tutor, but no offer of employment was forthcoming. She worked for one term at Oxford High School for Girls and then moved to London where she supplemented the annuity from her mother with lecturing at museums and schools. Over the course of the next two decades she studied and traveled, visiting archaeological sites in Greece and museums all over Europe; she published many articles and several books, was awarded honorary degrees from the universities of Aberdeen and Durham, and participated in a social circle that included the poet Robert Browning, the novelist Henry James, and the critic Walter Pater.

Despite her achievements, professional advancement remained elusive. She applied for two posts at London University and was passed over in favor of male colleagues whose training in the ancient languages was more firmly grounded than hers. Finally, at the age of forty-eight, just as her prospects were looking their most bleak, she was invited back to Newnham College as a research fellow. She would remain there for the next twenty-four years. It was within the confines of Cambridge college life that Harrison did the work for which she is remembered, becoming one of a group of classicists who would make the ancient world urgently relevant to artistic and literary modernism.

One of the founding gestures in the formation of the "Cambridge Ritualists" (a moniker only later applied to this group) was a fan letter that Harrison wrote to her colleague Gilbert Murray, inspired by this passage in one of his books:

> Reason is great but it is not everything. There are in the world things not of reason but both above and below it; causes of emotion which we cannot express, which we tend to worship; which we feel, perhaps, to be the precious elements in life. These things are Gods or forms of God: not fabulous, immortal men, but "Things which Are," things utterly non-human and non-moral, which bring a man to bliss or tear his life to shreds without a break in their own serenity.[27]

With this extraordinary invocation of irrationalism, Murray proved himself to be a fellow traveler in the post-Nietzschean landscape of

modernist academia. It was their shared commitment to the exploration of things "utterly non-human and non-moral, which bring a man to bliss or tear his life to shreds without a break in their own serenity" that linked the work of the Cambridge Ritualists to the experimental, mythologically inflected literature of the new tragic age.[28]

Harrison's terms of employment—freed from undergraduate teaching, having only to give one lecture a week, and often given time off from even this light load for travel and writing—must have been the envy of all her peers. In February 1901 she took advantage of this generous dispensation to go on an extended tour of Italy and Greece, during which she visited Crete twice, the first time spending three days at Knossos in the company of Arthur Evans. Returning to England in a ferment of inspiration, she wrote up a series of lectures that would eventually become the material of her most famous book, *Prolegomena to a Study of Greek Religion.*

According to Harrison, in a much-quoted chapter called "The Making of a Goddess," hundreds of coded references to the traumatic transition from matriarchy to patriarchy could be detected in legend, ritual, relief, and vase painting. The story was a bitter one: "Woman who was the inspirer, becomes the temptress; she who made all things, gods and mortals alike, is become their plaything, their slave, dowered only with physical beauty, and with a slave's tricks and blandishments."[29]

It was the excavations at Knossos that supplied for Harrison the perfect image of the original matriarchal divinity. This had been found stamped onto a series of broken clay fragments, all bearing the impression of a single seal. Evans had his resident artist make a sketch of the complete image, enlarged three times, which he published in the *Annual of the British School at Athens.* Harrison remarked that when she first saw the drawing she was inclined to think that it was "too good to be true" but then was allowed, on her visit to Crete, to examine the original fragments and was satisfied that the restoration was correct. These fragments of clay became for Harrison "a veritable little manual of primitive Cretan faith and ritual," depicting "the Mountain Mother," guarded by lions, standing "with her sceptre or lance extended, imperious, dominant."[30] This celebration of the cult of the Cretan mother goddess first appeared in 1903, only two years after the Cretan excavations had begun. Her narrative of the primordial oneness of the original Great Goddess breaking down into the squabbling divinities of the Olympian pantheon was highly influential, reaching

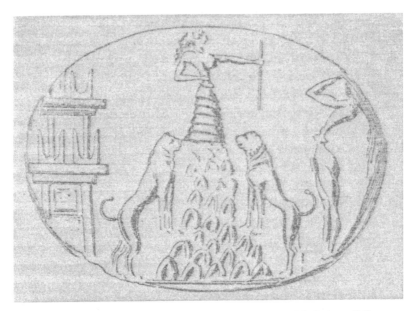

FIGURE 7. The great mountain mother. Arthur Evans, *The Palace of Minos*,
vol. 2, fig. 92. By permission of the Ashmolean Museum, Oxford.

the same audience as was susceptible to J. G. Frazer's formulation of
the universal archetype of the dying god.

After the publication of the *Prolegomena*, Harrison embarked on the
devoutly Nietzschean task of recreating the Minoan origins of the cult
of Dionysus. So preoccupied was she with puzzling out the exact phys-
ical details of proto-Bacchic ritual that Gilbert Murray wrote to Ber-
trand Russell in mock despair, "I wish you could persuade her that she
cannot—no, nor all Newnham together—tear a live bull to pieces with
her bare hands . . . she believes that some Cretan women actually did it."
Russell duly took up the challenge. "That absurd B. R. came in the other
day," Harrison protested to Murray, "with his eyes shining & sporting
an offer to "stand" a Wild Bull if I wld rend it from limb to limb."[31]

The fruits of these speculations found their way into Harrison's
1912 book *Themis*. One chapter is devoted to reading the Cretan origins
of Dionysian ritual from the paintings on the sides of a Minoan sarco-
phagus. As usual, Harrison's description of the painting throbs with
sound, life, and movement: "In the centre we have the sacrifice of a
bull . . . He is dying, not dead; his tail is still alive and his pathetic eyes

wide open, but the flute player is playing and the blood flows from the bull's neck."[32] Harrison links this scene with the later cult of Dionysus, and at the end of the chapter she summarizes her conclusions: "It was this religion of the Mother and the holy Bull-Child and the spring," she rhapsodizes, "that came down afresh . . . to enthral civilised, Olympia-nized, patriarchalized, intellectualized Athens"[33]

In the preface to a later edition of *Themis*, Harrison was moved to apologize for the partisan tone of her work. "My critics have blamed me, and justly, for my intemperate antipathy to the Olympians," she confessed. "Disciple as I am in this matter of Nietzsche, I ought never to have forgotten that humanity needs not only the intoxication of Di-onysos the daimon . . . but also, and perhaps even more, that 'appease-ment in form' which is Apollo the Olympian."[34] What Harrison did not acknowledge was the compelling transformation that Dionysus had undergone at the hands of Cretan archaeology. Between Nietzsche's *Birth of Tragedy* and Harrison's *Themis,* the excavation of Knossos had turned the drunken god into the offspring of the Great Goddess of an-cient Crete and the Olympians into patriarchal usurpers. Dionysus was no longer the savage temptation that needed Apollonian Hellenism to tame it into the shape of great art. Now he stood as the descendant of a female principle that required not taming or sublimation but rather *reinstatement* in all its original Cretan glory: "The mythology of Zeus, patriarchal as it is through and through, lays no stress on motherhood," Harrison sniffed, before reassuring her readers that "in Crete, most happily, the ancient figure of the mother has returned after long burial to the upper air."[35]

The Villa Ariadne

Meanwhile, at the actual site of Knossos, the concrete reconstructions had begun. They were the fruit of a difficult season. In the summer of 1905 the simmering political resentment on the island boiled over once again into violence. Dissatisfied with the rule of the Great Powers, the Christian Cretans who wanted union with Greece had continued to organize. Their leader was the lawyer-turned-politician Eleftherios Venizelos, who had resigned from the first Cretan administration in 1901 in disgust at the political compromises made by the fledgling na-tion. By 1905 Venizelos had assembled enough of a power base to form an opposition government, and by mid-March the island was once

again embroiled in an uprising. The rebellion lasted until November, when the Great Powers appointed a commission to resolve the dispute, which recommended the removal of foreign troops and the creation of a Cretan militia.

Although the Knossos excavation itself was unaffected by the uprising, the architect whom Evans had engaged to supervise the reconstruction work fled Crete in the face of the threat of violence. Severe winter rains then left the fragile ruins in a parlous state. Especially precarious was the "grand staircase," a structure in the palace's residential quarter whose first two flights had been uncovered in 1901. It was already one of the most delicate areas of the excavation. The upper flight of stairs, complete with its stepped balustrade, had been found practically in position, resting on a mass of hardened debris. To keep the upper stairs in place while excavating the lower flights necessitated the construction of a tunnel supported with a succession of wooden arches. Luckily two of the Cretan workmen had worked in the ancient silver mines at Laurion near Athens and were able to oversee the tunneling operation.[36] In 1902, one of the walls started to give way and had to be hoisted back into a perpendicular position. The storms of 1905 once again threatened the whole structure with collapse. Faced with the imminent disintegration of the grand staircase, and no architect, Evans quickly engaged the services of the Cambridge-educated Christian Doll. As well as supervising the reconstructions, Evans commissioned him to build a house near Knossos—the Villa Ariadne.

For the Villa Ariadne, Doll introduced to Crete a new building material—reinforced concrete. As soon as Evans saw the shell of his house going up, he realized that his architect had also presented him with a solution to the problem of shoring up the remains of the ancient buildings. Reinforced concrete was a relatively new building material. Although the method had been patented in the 1860s, it was not until examples of its virtuosity were displayed at the Paris Exhibition of 1900 that it began to be widely used. As usual in architectural history, the new material was first adapted to existing building types, but soon its combination of plasticity and strength was inspiring a florescence of innovative styles, along with a new commitment to unadorned architectural "honesty." At the site of Knossos, the Villa Ariadne, which was faced in limestone, represents a conservative use of the new material, while the reconstructed palace proudly displays the naked surfaces of modernist concrete construction.

Doll's diaries for 1906–1907 are a litany of complaint and frustration, detailing his struggles with the workmen, the climate, and his own ill health. Work on the Villa Ariadne and on the palace of Knossos runs together, all part of the same profoundly irritating texture of life on the island. In the following entry the first set of stairs belong to the modern villa; the second to the ancient palace:

> Got out to Knossos and had a great row with the men about not working out of doors. Their only plea was the cold. Considerable trouble. Getting on with the stairs. Cutting balusters etc. . . . in the evening I went on with notes for Knossos. . . . Took off dimensions on Grand Staircase and could not agree with Mr. Fyfe's [the previous architect's] plan.[37]

Eventually Doll managed to measure the stairs to his satisfaction and the reconstructions could go forward. The steps and balustrades of the upper floor were removed piece by piece and the debris that had underlain them was cleared away. Iron girders masked with cement replaced the wooden scaffolding, and new columns were fitted into the circular depressions cut in the balustrade. In 1910 some gypsum slabs that had been set aside as being of no significance were found to fit into marks in the wall that showed where a fourth flight had ascended. The pieces were hoisted up into position and held in place with reinforced concrete beams and slabs. On one side an elaborate construction of concrete columns and lateral supports was erected just to hold a single massive block of ancient gypsum.

Taking the longer view, the Villa Ariadne and Evans's concrete reconstructions are just the latest in a succession of buildings stretching back nearly ten thousand years, when the first settlers of the island built a mud brick village on the same low hill upon which the palace stands. The best exposition of the longer view, however—the 1976 *Aerial Atlas of Ancient Crete*—lists the Villa Ariadne in its painstaking catalog of every building that has ever left a trace on the site but makes no mention of Evans's reconstructions. The *Atlas* also includes a number of photographs of Knossos taken from the ground that artfully manage to avoid featuring a single squat red column.[38] There are good reasons for this omission. The restored palace defies straightforward architectural analysis, and it must have seemed expedient to ignore Evans's legacy. For the purposes of the present work, however, the whole complex

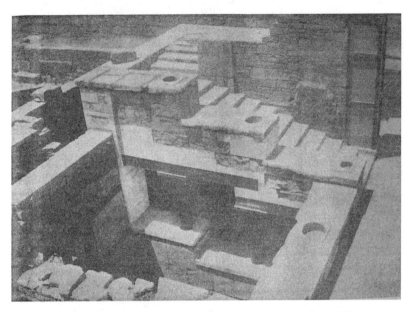

FIGURE 8. The "grand staircase" at Knossos, 1905–1910. Arthur Evans,
The Palace of Minos, vol. 1, fig. 245. By permission of the
Ashmolean Museum, Oxford.

of early twentieth-century buildings on the site may be understood
together.

At the end of the 1910 season, the American dancer Isadora Duncan
visited Knossos. Duncan—who described herself as "a battlefield where
Apollo, Dionysos, Christ, Nietzsche and Richard Wagner disputed
the ground"[39]—had recently embarked on an abortive attempt to re-
vive Greek paganism by building a temple near Athens based on "Aga-
memnon's Palace" (presumably referring to the buildings uncovered in
the 1890s on the top of the acropolis of Mycenae). Unfortunately, her
plans were foiled by the complete absence of water on or near the site
that she had chosen. The resurrection of the palace of Knossos must
have seemed like the fulfillment of her dream. Upon sighting the four
completed flights of the grand staircase, she "could not contain herself
and threw herself into one of her impromptu dances for which she was
so well known. Up and down the steps she danced, her dress flowing
around her."[40]

It is recorded that Duncan Mackenzie, Evan's site supervisor, was shocked at this display, "and told Sir Arthur that he did not approve as it was quite out of keeping with her surroundings."[41] What the notoriously woman-shy Mackenzie failed to appreciate was how fashionably appropriate Duncan's anachronisms were. As she whirled up and down the grand staircase with her bare toes and her wispy garb—her dancing amply supported by the strength of ferro-concrete—she perfectly embodied the Dionysian significance of the reconstructions. Here was a place where the most outlandish expressions of post-Nietzschean enthusiasm for the modernity of the Greek spirit could find expression, and where liberated femininity (clad in the unrestricting folds and pleats of Duncan's completely un-Minoan "Greek" costume) could insinuate itself into the new tragic age.

Cretan Victory

Crete's 1898 partition into administrative and military districts under the jurisdiction of the four protecting powers (three of the districts complete with their own national team of archaeologists) was a microcosm of the political division of the old Ottoman territories. The 1905 Cretan uprising that gave the island its own militia was a relatively slight tremor in the political fault line that divided Europe, but the pressure was building. In 1908 a group of westernized Turkish military officers—the "Young Turks"—led a rebellion against the sultan in Macedonia. The speed with which the Sublime Porte crumbled took everyone by surprise, and the resulting power struggles in Ottoman territories precipitated a series of crises of increasing ferocity. Exploiting the political chaos, the Balkans exploded into a frenzy of nationalism. Bulgaria declared itself independent; Austria-Hungary annexed Bosnia and Herzegovina, and Greece declared union with Crete. Modernist Knossos was not only a temple to the Great Mother of all the pagan gods, it was also Evans's monument to a pacifism that became increasingly urgent and forlorn as the world around it tilted inexorably toward total war.

In August 1912 an alliance of Balkan states, including Greece under the leadership of the Cretan politician Venizelos, declared war on Turkey. In less than six weeks, the Turks were routed. At the Treaty of London of May 1913, Crete finally won union with Greece. Evans,

entertaining the delegates to the conference at his mansion outside Oxford, marveled at the fact that all the rivalries and animosities of centuries seemed to have been set aside. His incredulity seemed amply justified when, the following July, Greece and Serbia rounded on their former ally Bulgaria, keen to grab a larger share of the spoils. The second Balkan War lasted only a month, and under the terms of the Treaty of Bucharest the Bulgarians were forced to give up almost everything they had gained in their battles with the Turks.

For Greece the Balkan Wars were a triumph: they had suffered the fewest casualties and made the greatest gains, including the longed-for union with Crete. If those two brief conflicts had been the end rather than just the beginning of the post-Ottoman turmoil in twentieth-century Europe, the Minoans might have been allowed to retire early from their labors as the exemplary pacifists of the ancient world. But the Balkan Wars were quickly revealed to be merely the latest in a series of shocks and aftershocks. As the Young Turks presided over the shrinking of the Ottoman Empire to the boundaries of the modern Turkish state, competition among the Great Powers to grab a share of the spoils exploded into the First World War.

In June 1914 the apocalypse commenced. The Austro-Hungarian government sent the heir to the Hapsburg throne, Archduke Franz Ferdinand, to Sarajevo on a state visit, where he was assassinated by a Serbian nationalist. The authorities in Vienna declared war against Serbia, and the Austro-Hungarian armies began their bombardment of Belgrade. The "Third Balkan War" rapidly escalated.[42] In response to the declaration of war, Russia—which sided with the Serbs as a means of leverage in the old Ottoman territories—ordered a general mobilization. Germany used this as an excuse to declare war on Russia and on her ally, France. Germany's decision to invade France via Belgium precipitated Britain's entry into the war.

In 1915, an eastern front opened on the Gallipoli Peninsula, right across the Dardanelles from Hisarlik, the site of Schliemann's Troy. As the disastrous campaign unfolded, one writer after another, from the poet Rupert Brooke to Schliemann's biographer Emil Ludwig, recalled the Greek siege of Priam's city: "Stand in the trench Achilles, / Flame-capped, and shout for me."[43] As the Third Balkan War metastasized into the Thirty Years' War of 1914 to 1945, Evans's ancient utopia would haunt and rebuke war-scarred modernity like the vision of Ari-

adne's dancing floor on the shield that Achilles wore on the battlefields of Troy.

Evans himself engaged in a series of archaeo-political interventions during and after the First World War as the Austro-Hungarian Empire lost its grip on the Balkans just as the Ottoman Empire did before it. A memorandum that Evans sent to the British government in 1916 on the national union of the South (or Jugo) Slavs was composed of a characteristic mixture of archaeology, anthropology, and politics, linking the Roman organization of the district and the ethnography of the Adriatic peoples to a plea for the recognition of the South Slavs as a national entity.[44]

In a 1916 address to the British Association for the Advancement of Science, Evans laid out for the audience the political significance of archaeology, a manifesto of his prophetic method. He began by acknowledging that his audience might find archaeology a rather abstruse topic in the face of the overwhelming calamity of the Great War: "But archaeology—the research of ancient civilizations—when the very foundations of our own are threatened by the new barbarism!" He went on to suggest, however, that there was urgent contemporary relevance to antiquarian research:

> [T]he past is often seen to hold a mirror to the future—correcting wrong impressions—the result of some temporary revolution in the whirligig of time—by the more permanent standard of abiding conditions, and affording in the solid evidence of past well-being the "substance of things hoped for." Nowhere, indeed, has this been more in evidence that in that vexed region between the Danube and the Adriatic, to-day the home of the Serbian race, to the antiquarian exploration of which many of the earlier years of my own life were devoted.[45]

In the summer of 1917, the Serbians, Croats, and Slovenes made a formal declaration of their national unity at a meeting in Corfu, and in the negotiations with Italy and the Armistice powers that followed Evans was recognized as an unofficial Slav delegate. The sudden collapse of the Hapsburg Empire in October 1918 opened the way for Serbian ambitions and on December 1, Prince Alexander of Serbia proclaimed the kingdom of Serbs, Croats, and Slovenes. The entity that would become Yugoslavia (South Slavia) had begun to emerge.

After the war, at the 1919 peace conference in Paris, Evans gained the ear of Arthur Balfour, foreign secretary to Prime Minister David Lloyd George. Impressed by the depths of his knowledge of the region, Balfour listened to Evans's arguments and abandoned his support for the Italian claim to the Dalmatian coast in favor of the Slavic cause. Britain forced Italy to withdraw her troops, and by the end of 1920 the borders of the new state of Yugoslavia were finally determined: "The frontiers might not be those he had dreamed of, but Evans lived to see the country of his adoption a free sovereign state. By his researches into her past, his activities for her present and his faith in her future, he had repaid his debt to the romantic beauty of Illyria."[46]

Ariadne in Chirico City

Exactly coinciding with the period of the Balkan Wars, the Nietzschean artist Giorgio de Chirico produced a series of paintings of Ariadne, depicting the Cretan princess as a solitary statue, lying despairing and paralyzed in the middle of a strange, semiurban landscape. De Chirico's antiwar explorations of Cretan myth, fertilized by Nietzsche's prophetic method, were wrought out of the same set of political, spiritual, and architectural impulses as modernist Knossos. The urban square in the middle of nowhere in which de Chirico's Ariadne sits, baking in the glare of the afternoon sun, anticipates by some fifteen years the concrete reconstruction of the west court of Knossos and elevates and distils the same set of architectural influences into another futuristic vision of the classical world.

It might be said that the building of modernist Knossos transformed a wild part of Crete into a central piazza of "Chirico City," that "instantly recognizable world of statues, trains, clocks and smokestacks, all situated within a deeply shadowed and eerily silent urban square."[47] In their pessimism and somberness, however, the Ariadne paintings were a more accurately prophetic commentary on the future betokened by the Balkan Wars than Evans's seemingly irrepressible faith in the triumph of peace and democracy.

Georgio de Chirico was born in 1888 in Volos, the capital of Thessaly. His father was a prominent Italian engineer then working on the Thessalian railway lines, an important resource for the maneuvering of the Greek troops. In his memoirs, de Chirico recalled the Greco-

Turkish War of 1897, which he witnessed as a ten-year-old, character-
izing this small-scale, nineteenth-century war as a microcosmic antici-
pation of the horrifying industrial-scale wars of the century to come.
Volos was then close to the border with Turkish-ruled Macedonia, and
during the 1897 war the Turks occupied the town as they advanced into
Thessaly:

> During our stay at Volos in 1897 war broke out between the Greeks
> and the Turks. I witnessed many sights full of fear, anguish, pity and
> suffering, sometimes they were even revolting, and, multiplied by a
> hundred or a thousand, I saw them again during the First World War
> and later still during the Second. When the Graeco-Turkish War
> was declared there were, as at the beginning of all wars, moments of
> enthusiasm. Soldiers who had been called up passed by singing. . . .
> The first bad news came. The Turks advanced into Thessaly and the
> army of the Crown Prince Constantine was beaten. Panic broke out
> at Volos. Many people fled. Small steamers and also sailing ships,
> overloaded with refugees, moved heavily out of the gulf directly
> towards Attica.[48]

When his family moved to Athens in 1899, Giorgio took drawing les-
sons from Émile Gilliéron, the artist who would later be responsible
for the reconstruction of the wall paintings of Knossos: "a tall robust
man with a thick white beard trimmed to a point."[49] After his father's
death in 1905 the family moved to Munich, and there de Chirico en-
rolled in the Academy of Fine Arts, the same school where Gilliéron
had received his artistic training.

In 1909 the family settled in Milan, where de Chirico discovered the
writings of Nietzsche.[50] During the next couple of years he moved to
Florence and then, fleeing Italian military conscription, to Paris. The
Florentine military tribunal caught up with him in 1912 and ordered
him to report for duty in Turin. De Chirico was in military service in
Turin for less than a week, quickly escaping back to Paris, where he was
welcomed into the exiled Greek community in the city. This milieu,
consisting of artists, writers, diplomats, and aristocrats, came together
under the shared cause of the ongoing struggle for Greek independence.
In October the Balkan League declared war on Turkey, and the first Bal-
kan War commenced. At around the same time, de Chirico embarked

on the first of his paintings exploring the theme of the abandoned Ariadne, the whole series haunted by the ominous failures of the 1897 war that he had witnessed as a child and informed by what he called his "Nietzschean method."[51]

In the first of the Ariadne paintings, his *Melanconia* of 1912, the Cretan princess is shown abandoned, sorrowing, and passive, "reduced to a state of depressed inactivity, a paralysis that resonates with the viewer's own feelings of uneasiness and disquiet when faced with this work and others from the series."[52] Two tiny figures with long shadows stand in the middle distance. Another figure to the left of the Ariadne statue is implied by its shadow but remains hidden behind one of the pillars of an arcade. After *Melanconia* came de Chirico's *The Melancholy of a Beautiful Day*. Here the statue of Ariadne faces a forbiddingly plain arcade under a row of shuttered windows, which rears up in an arid landscape defined by a huddle of little houses on a distant hill. This architectural incongruity evokes the way in which the abandoned cities of antiquity stand amid the inhabited villages of the present. In *The Lassitude of the Infinite*, a speeding train makes its first appearance in the background, standing in for the ship that bore Theseus away from Naxos, and perhaps also the trains built by the artist's father that carried the Greek troops away from Volos.

The next two paintings in the series reflect a growing confidence after de Chirico's critical success at the Salon d'Automne of 1912, being among the largest paintings he made during his time in Paris. In *Ariadne,* the recumbent statue is in the foreground, the distorted perspective of her plinth giving the vertiginous impression of a steep slope to the sandy ground. The ubiquitous arcade has an exaggerated vanishing point and a monumental shadow that only just falls short of shrouding Ariadne in darkness. A strange, mausoleum-like building dominates the background, to the left of which a train approaches, while a ship in full sail is visible to the right. In *The Soothsayer's Recompense,* the statue lies right on the front edge of its plinth, while a clock appears on the pediment of the arcade, apparently stopped at ten to two, but featuring only eleven numbers on its face.

De Chirico's cavalier treatment of time and space—his topographically irrational and yet visually convincing cityscape—was explicitly inspired by his reading of Nietzsche: "After having read the works of Friedrich Nietzsche," he wrote, "I became aware that there is a host of strange, unknown, and solitary things which can be translated into

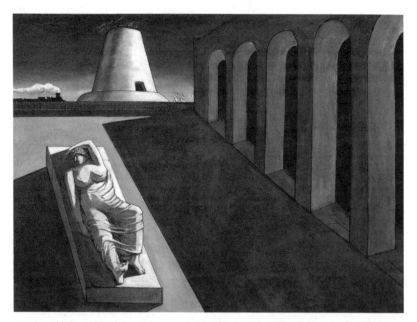

FIGURE 9. Giorgio de Chirico, *Ariadne*, 1913. Metropolitan Museum of Art, New York. By permission of the Artists' Rights Society.

painting."[53] In 1911 he painted a self-portrait that replicated the pose seen in a famous photograph of the philosopher, but with the eyes painted blank, suggesting the interior vision of the sightless prophet. He was at first feverishly absorbed in *The Birth of Tragedy*, but then became interested in the late Nietzsche, and developed an obsession with the atmosphere of Turin, the place where the philosopher threw his arms around the neck of a horse and collapsed into unconsciousness. The artist's own stay in Turin for military service was extremely brief, but it filled him with wonder at the city's long shadows and lonely perspectives, an atmosphere of claustrophobic emptiness he tried to evoke in the Ariadne series.

De Chirico's Nietzsche is the Nietzsche of the devotees of Knossos—not the philosopher of war or the inventor of the *Übermensch*, but the tormented prophet of modernism whose nihilism was the antidote to an exquisitely painful moral sensitivity. Nietzsche may have despised Euripides for his "degenerate" pacifism, but de Chirico's Ariadne series passes a comment on the futility of war that is pure *Trojan*

FIGURE 10. **Giorgio** de Chirico, *Silent Statue*, 1913. Kunstsammlung
Nordhein-Westfalen, Dusseldorf, Germany. By permission
of the Artists' Rights Society.

Women. The conflict in the Balkans ended in September 1913, coincid-
ing with de Chirico's painting of the *Silent Statue.* A close-up of the Ari-
adne statue's face and torso dominate the foreground of the picture,
but she is caught in late afternoon shadow, rendered in a funereal pal-
ette of blacks and browns. Behind her an arcade and a red tower catch
the last of the light. Greece might have been celebrating its political
and military triumph, but de Chirico's final statement on the Balkan
wars is ominous and prophetic, as though the shadow of the war to
come has already fallen over the Cretan festivities.

 The war was not long in coming, and when Italy joined on the side
of the Allies in 1915, de Chirico finally enrolled in the military. Still
hopelessly unsuited to army life, de Chirico promptly succumbed to
a series of nervous disorders for which he was sent to a military hospi-
tal. The artist's last, glancing reference to Ariadne was to include a few
folds of her tunic in one corner of the painting-within-a-painting in his

The Double Dream of Spring, the 1915 summation of his Paris work created just before he joined up.

In between the wars—while the reconstruction of Knossos unfolded according to the Nietzschean dream logic of de Chirico's prewar paintings—the artist himself neglected Ariadne. The one exception was a series of designs for the backdrop of a ballet based on the myth, *Baccus et Ariane,* performed at the Paris Opera in 1931, which have a light-hearted exuberance very different from the paintings of his earlier period. During the Second World War, de Chirico, now in his fifties, lived in Italy, and in 1945 he published a violently antimodernist, philo-Semitic memoir.

After the war, however, de Chirico returned again and again to the figure of the recumbent Ariadne in an arcaded piazza, producing literally hundreds of pastiches of his original series. These self-quotations, lacking the brooding charisma of the earlier paintings, again locate the artist's work within the same currents of cultural history as the concrete labyrinth—kitsch, repetitious, and garish, they echo the serried ranks of Minoan souvenirs in the tourist shops of postwar Knossos. Andy Warhol recognized in de Chirico's later work a prefiguration of his own technique of serial repetition, and in 1982 he produced *Italian Square with Ariadne (after de Chirico),* a silkscreen with four brightly colored repeats of one of the later Ariadne paintings. .

De Chirico was also caught up in a series of art world scandals in the postwar period that ran parallel to the attempts by Cretan archaeologists to purge their own discipline of replicas, reconstructions, and fakes. In July 1946 he declared that a whole series of canvases attributed to him that were on display in Paris were forgeries. His attempt to have the paintings sequestered by the police failed, and the exhibition went ahead much to his disgust. In 1948 he denounced the Venice Biennale for showing a forged de Chirico. His credibility, however, was not enhanced by his practice of sometimes antedating his own work, such as the 1970 Ariadne painting, *Piazza d'Italia with Statue,* to which he appended his signature and the date of 1937.

De Chirico's postwar oeuvre has been described by one critic as "proto-postmodern": "With their emphasis on repetitive imagery over uniqueness, the lack of fixed authorial identity, and an insistence on the synchronicity of all periods, not just of his own work but of the entire history of Western art, de Chirico's late works can be understood . . . as a radical critique of time."[54] Considered in relation to

Cretan archaeology, what is interesting about the late Ariadne paint-
ings is the contrast between their evasive, ironic, and superficially
optimistic "critique of time" with the ominous, profound, and tragic
Nietzschean irrationalism of the earlier series. The tourist destina-
tion that is present-day Knossos, with its restored reconstructions, its
cheerful souvenir shops and its shabby suburban air, similarly overlays
its own prewar history. Chapter 4 will chronicle that period, during
which the concrete labyrinth fulfilled de Chirico's original prophetic
vision, becoming a site where Cretan mythology and industrial moder-
nity united into a Dionysian vision of the future.

{ IV }

THE CONCRETE LABYRINTH, 1914–1935

When excavations at Knossos ceased abruptly with the declaration of war, Evans used the time to work on the first volume of *The Palace of Minos*. Stubbornly adhering to the use of a goose-quill pen, he laid out each new section of manuscript on yet another trestle table in the library of his outsized Boar's Hill mansion. The four-volume, seven-tome excavation report that resulted from his labors—bound in dark blue with gold double-axes on the spines—was in many ways a truer monument to his vision than the concrete reconstruction of the palace itself. Lavishly illustrated and lyrically written, Evans's paper reconstruction of Minoan civilization became the principal means by which his oracular archaeology was disseminated into modernist culture.

The beginning of the First World War also heralded the emergence of a brisk and fantastically profitable trade in fake Minoan antiquities. A select few of these artifacts Evans himself fell for, either purchasing them for his own collection or sanctioning their acquisition by museums outside Crete. Several were given pride of place in the pages of *The Palace of Minos*. One series particularly cherished by Evans, crafted in

ivory and gold, represents a parade of contemporary fashions, from the stiff Edwardian lady of the first of these figurines to appear on the black market in 1914, to the last of the series, an outrageous lesbian cabaret goddess who made her debut in 1930.

After the Great War, work on the physical reconstruction of the palace continued at full throttle. Much of the restoration of the 1920s was undertaken without significant warrant from the existing remains, turning Knossos into the complex of concrete ruins that stand there today. At the same time, reconstructions of the wall paintings were replicated in bright colors and hung in concrete frames all over the new walls, destroying whatever aesthetic unity even the modernist buildings might enjoy. The resulting mixture of flimsy Mediterranean modernism, moulded "broken" columns, and Technicolor art nouveau wall paintings is almost postmodern in its aesthetic whimsicality and eclecticism.

The Throne Room Complex

Evans made use of an elaborate vocabulary to describe his reconstructive activities. For the rebuilding of the palace, his preferred term was "reconstitution." "Resurgence" and "resurrection" were also keywords. His fascination with Minoan symbols of resurgence like butterflies and chrysalises carried over to his own self-image as the agent of the resurrection of the ancient Cretans. He also deployed the language of "resurgence," "epiphany," and "re-emergence" to gloss over the doubtful provenance of some of his most cherished artifacts, which he describes as appearing almost as if by magic in the hands of private dealers outside Crete.[1]

In December 1926, Evans read a paper to the Society of Antiquaries entitled "The Work of Reconstitution in the Palace of Knossos," which began with a disarming admission: "To the casual visitor who first approaches the site . . . the attempt may well at times seem overbold, and the lover of picturesque ruins may receive a shock."[2] He immediately went on to explain to his distinguished audience that "the supreme effort to preserve the record of the upper floors revealed by the process of excavation was from the first actually imposed on myself and my colleagues by the unique character of the remains."[3] Owing to a "miraculous" accident of preservation, the wooden frame of the building had burnt or decayed without necessarily causing the collapse of

the upper stories. This had necessitated the insertion of supports and the construction of some kind of frame so that the excavated structure might remain in place where it was found or where it was conjectured to have stood.

The props that shored up the walls as they were being excavated were then replaced by wooden columns covered with plaster, "coloured to reproduce the effect of the original Minoan columns as shown on the wall paintings."[4] When these proved inadequate to Crete's climate, the wooden columns were replaced with prohibitively expensive stone cores with a covering of painted plaster. Finally Evans "decided to have recourse to the experience at that time gained by our Cretan masons in the use of ferro-concrete."[5]

In his presentation to the Society of Antiquaries, Evans went into considerable detail about the rebuilding of the "grand staircase," the five-level structure whose restoration was justified on exactly the grounds that he laid out. Structural elements made of stone were found in position surrounded by burned and rotten timbers, and the reinforced concrete was put in place in order to support them once the debris had been cleared away. He was much less forthcoming about the so-called "throne room complex," a part of the site that was undergoing extensive "reconstitution" without any of the same justification from the existing remains.

The gypsum throne with its back plastered into the wall behind was one of the most important finds of the first season at Knossos and Evans had immediately to face the problems of conservation posed by a delicate artifact that was fixed in position in the site and could not therefore be whisked away to a museum. In 1901 he had the throne room roofed over; over the years this protective structure became increasingly elaborate; by 1930 the throne room complex had sprouted an additional two stories.

The roofing over the throne room was the first place where the effect of Evans's wealth made itself felt. Rather than erecting a bit of scaffolding and slapping a corrugated tin roof on top—the standard operating procedure—Evans had the luxury of fastidiousness about the appearance of the structure: "[T]he desire to avoid the introduction of any incongruous elements amid such surroundings determined me to reproduce the forms of the original Mycenaean columns."[6] The design of the columns could not be ascertained from the charred remains of the originals that had emerged along with the throne but were based

instead upon a fresco fragment depicting what appeared to be the exterior of the palace. They were constructed out of wood, covered with plaster, and painted, while a series of square brick pillars were added to support the outer edges of the flat wooden roof. In 1904 the flat roof was replaced by a more permanent, tiled, pitched roof using iron girders for support. "The loft and covered galleries thus provided have now been fitted up with wooden shelves for the baskets of minor fragments of pottery," Evans announced. "In this way," he declared, "it has been possible to organize on the spot a kind of reference museum for the whole excavation."[7]

After the First World War, the work of reconstitution accelerated, transforming the throne room complex and other parts of the building into an unmistakably twentieth-century building. Modernist Knossos was the work of the architect Piet de Jong, whose engineer father emigrated from Holland to Yorkshire in the 1880s, married an English widow, and raised a family in Leeds. De Jong was born in 1887 and trained as an architect at the Leeds School of Art. In 1913 he was taken on as a junior member of a Leeds firm of architects where he produced designs for his most significant work outside Crete, the First Church of Christ Scientist in Headingly Lane. (Construction of the church was delayed, but it was eventually built in the 1920s, at the same time as the reconstruction of Knossos, featuring some of the same stylistic characteristics as the throne room complex—stripped-down classicism allied to a certain flat-fronted monumentalism.[8])

After the First World War, de Jong was released from military service and immediately drafted into a "Reconstruction Service" charged with the rebuilding of Greece and the Balkans. He worked for two years on an ambitious reconstruction program for Macedonia, but a change of administration in Greece in 1920 saw the plans shelved. The architects and engineers in the service drifted into other employment, and de Jong found himself in Mycenae making drawings for the archaeologist Alan Wace. The archaeological network hummed with the news of his competence and collegiality, and in 1922 he set off for Crete. For the rest of the decade Evans was his main employer, and not a year went by without de Jong supervising a major restoration project at Knossos.

In 1923 de Jong supervised reconstruction of the "Stepped Portico" next to the throne room, making the pitched roof that had been built over the gypsum throne look even more incongruous. This incongru-

ity was ameliorated by a frenzy of building activity during the season of 1930, including the reconstitution of the whole throne room complex in ferro-concrete, the addition of new frescos on either side of the throne itself, and the construction of two completely conjectural upper levels. Evans had justified the addition of higher floors in other parts of the palace on the grounds that elements of the upper stories had been held in position by all the debris even though the supporting wooden structure had rotted away. In the case of the two levels above the throne room there was no such justification—the throne itself had been discovered only inches below the surface of the mound.

The contrast between the throne room area at the time of its excavation in 1900 and the final restored complex of rooms as they stood in 1930 can be seen in photographs in the Evans archive at the Ashmolean. In the first photograph the throne is exposed to the elements amid the rubble and confusion of the excavation. To the left of the room a series of large blocks could be interpreted as the remains of a flight of steps. A cluster of modern buildings is visible in the background. In the second image no less than three floors of the reconstituted throne complex rear up in the foreground, blocking out the view. The steps are crisply restored and have grown in number from five to twelve (with a further flight beyond not visible in the photograph). The lines of the reconstructed buildings are functionalist, the lack of detail conspiring with the material of which they are made to endow the whole structure with a distinctly modernist appearance. Ironically, the throne room complex looks more modernist than Piet de Jong's only modern building to be realized, the First Church of Christ Scientist in Leeds.

The relationship between modern movement architecture and Mediterranean archaeology has been analyzed by the professor of Italian literature Jeffrey Schnapp in an article about the fascist reconstruction of the city of Pavia. Schnapp outlines how a group of modern movement architects sought to transform Pavia into a model city "[t]hrough an ambitious program of demolition and new construction . . . rigorously laid out according to the criteria of rationalism and functionalism, as recently articulated by the likes of Le Corbusier."[9] At the heart of this radical break with the past, however, was a paradoxical engagement with classicism and tradition:

> [R]ationalism and functionalism may be the foundation stones of
> a new international style, but . . . they are, nonetheless, profound

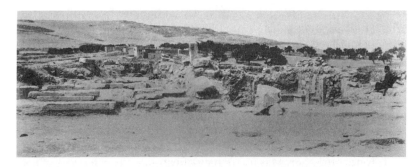

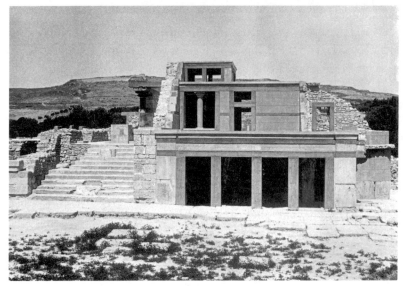

FIGURE II. *Above*, the throne room in 1900. *Below*, the throne room in 1930.
Evans Archive. By permission of the Ashmolean Museum, Oxford.

expressions of an originary moment within Mediterranean culture.
Whether that moment in question is Roman, Etruscan or Minoan . . .
matters less than the conviction that the city of the future coincides
with the city of a prelapsarian remote past. The avant-garde's degree
zero of representation and construction, its revolt against merely or-
namental forms of historicism, its blank slates and utopic grids, close
the door on antiquity, only to reopen it once again in the mode of an
archaeology of archaic structures.[10]

Knossos was doubly implicated in this paradoxical modern engagement with tradition. Not only did the Minoan past provide inspiration to the modern movement,[11] it was itself a modernist structure, enfolding past and present into a closed loop of aesthetic self-referentiality.

Captain of the Blacks

In the last volume of his *Palace of Minos,* Evans explained why the walls of the palace were hung with bright paintings: "[I]t seemed the duty of the excavator to preserve, wherever practicable, the history of the building by replacing *in situ*—even when it entailed some reconstitution of the walls—replicas of the fresco designs as completed from the existing fragments."[12] Evans employed a father-and-son team, both named Émile Gilliéron, to "complete" the frescoes. Some of the most popular images of Minoan life, such as the "Ladies in Blue" fresco are almost complete inventions of these twentieth-century artists.

Émile Gilliéron *père* was a Swiss French artist, born in 1851, who studied drawing at the Gewerbe Schule in Basle and then at the Académie des Beaux Arts in Munich. The Académie was the place where the group of German artists known as the Nazarenes had invented a method of fresco painting using wax, suitable for cold northern climates, which was used to recreate nineteenth-century Germany and England in the image of ancient Greece and Rome.[13] Gilliéron's subsequent career was bound up in the inverse task: the reconstruction of newly independent Greece in the image of neoclassical northern Europe. He worked as drawing teacher to the Greek royal family, designed the commemorative stamps for the first modern Olympic Games in Athens in 1896, and devised a technique for making metal copies of ancient bronze, silver, and gold objects from moulds, which were produced in Germany and sold by mail order.[14]

Gilliéron *fils* was born in 1885 and after training in Paris was appointed artist of all the museums in Greece. Both father and son worked for Evans, producing copies and restorations of the Knossos wall paintings, sometimes extrapolating large and complex scenes from tiny fragments. They are also remembered in at least one anecdotal account as the masterminds behind the forging operation that produced dozens of Minoan fakes in the twenties and thirties.[15] Taken as a whole, their work was always crossing and recrossing the

blurry boundary between restorations, reconstructions, replicas, and fakes.

In one example of an extravagant reconstruction, a mosaic of fragments depicting a red-skinned figure with a couple of patches of black paint behind him was restored by Gilliéron *fils* into a painting representing "a Minoan Captain . . . leading the first of a negro troop at a run."[16] The so-called "Captain of the Blacks" fresco licensed three pages of speculation in *The Palace of Minos* about '[t]he employment of negro auxiliaries by Minoan commanders." Evans argued that the Minoans must have employed "black regiments for their final conquest of a large part of the Peloponnese and Mainland Greece." Parallels are drawn from such diverse sources as "the part played by . . . Senegalese troops" in the Great War and the deployment of "Nubian mercenaries" by the Egyptian pharaohs. The section concludes with the sentiment that "[t]here is no reason to suppose that negro mercenaries drilled by Minoan officers, like the troops before us, were otherwise than well-disciplined."[17]

The "troops before us," though, are based on nothing but a couple of fragments of black paint. From these, Evans and the Gilliérons have extrapolated a narrative of such longue durèe that the subservience of Senegalese soldiers to their British officers in the First World War is made to look like the outcome of facts of nature rather than a product of the changing tides of history and politics. The stability of the categories assumed by fin-de-siècle racial science forms a telling contrast with the profound geopolitical upheavals of the time. Invented traditions such as Evans's "negro auxiliaries" or Schliemann's Aryan genealogy for the swastika symbol served to naturalize relationships of power at a moment when nothing could be taken for granted.

There is no denying Evans's racism. Images that seemed to depict Africans would sometimes draw from him adjectives like "repugnant" and "grotesque."[18] He concludes one such discussion with the thought that "[i]t is possible, however, that we have here to do with members of some African race under negroid influence rather than with actual niggers."[19] This casual contempt is unquestionably the real heart of darkness in Evans's work, but even this most virulent of prejudices was seamed with contradiction. He had no truck with Aryan theory and insisted that all that was civilized about the Minoan society originated in the advanced cultures to the south and the east of Europe. His "black regiments" deployed by the Minoans for their final conquest of main-

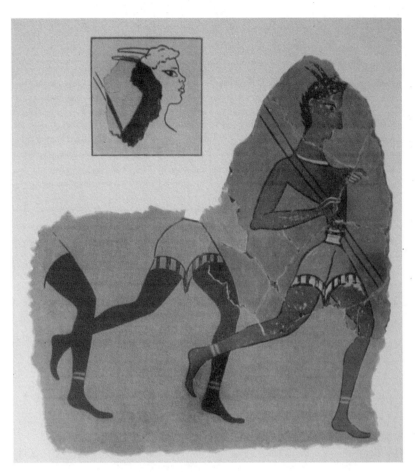

FIGURE 12. The "Captain of the Blacks" fresco. Arthur Evans, *The Palace of Minos*, vol. 2, plate 13). By permission of the Ashmolean Museum, Oxford.

land Greece represented his conviction that this cultured southern people had easily vanquished their barbaric northern neighbors. Above all, his talk of "niggers" is at odds with his larger overview of Minoan relations with sub-Saharan Africa, an inconsistency almost as striking as his rant against "inferior races" in his otherwise sympathetic account of the 1875 Bosnian uprising against the Ottomans. In both cases, his personal reactions are characterized by a degree of arrogance and elitism typical of a man of his class and time, while his broader analysis had political implications that were atypical in their extreme liberalism.

In the preface to volume 2 of *The Palace of Minos,* Evans had asserted that the "first formative influence . . . that enabled Cretan civilization gradually to detach itself from an inert Aegean mass" hailed from Egypt and Libya.[20] According to this scheme, Crete rose above the inertia of her northern neighbors as a result of successive waves of immigration from the south, including that of "negroized elements" hailing from Libya and the Nile Valley.[21] Cretan relations with sub-Saharan Africa were then elaborated in his discussion of the "Captain of the Blacks" fresco:

> The early intercourse between Crete and the lands beyond the
> Libyan Sea had brought the islanders primarily into connexion with
> an ethnic stock of more or less kindred Mediterranean type, akin to
> the modern Berber, but it must never be left out of account that the
> caravan routes leading from the African interior to the coast opposite
> Crete are many of them of immemorial antiquity. The routes from
> Tunisia to Niger are marked by a series of Neolithic settlements,
> and it is probable that those within nearer access to Crete, such as
> those from Tripoli to lake Chad, and also to the Niger, or those from
> Benghazi to the Western Soudan and Darfur, were of equally ancient
> date. We may well believe, indeed, that it was by these routes, at least
> as much through the Nile Valley, that such exotic products as ivory,
> ostrich eggs, gold dust and some, perhaps, of the long-tailed Soudan
> monkeys reached the Southern havens of Crete.[22]

Here Evans undercuts the logic that would confine Minoan racial origins to various "Mediterranean types," with a disquisition on the ancient trade routes leading from the African interior to the Libyan Sea.

Minoan relations with Africa were also vividly evoked through Evans's reconstruction of a Bronze Age road running on a north-south axis through Crete, linking Knossos with harbors on the south coast. He retraced this trade route to Africa in several epic journeys along the north-south axis of the island in 1923, traveling with his usual aristocratic entourage of servants.[23] His description of the north-south road and its functions forms a striking contrast with his 1895 article "A Mycenaean Military Road." Using exactly the same evidence—an immemorial mule track with traces of ancient walls strung along it—he reconstructed a very different vision of the Cretan Bronze Age. In 1895 the emphasis was on the militaristic aspect of the "vast primeval forti-

fications."[24] In 1925, by contrast, he warns the reader "not to lay undue
stress on the military side of such arrangements." Instead he interprets
the route as evidence for peaceful commerce, and summons up a vi-
sion of a prosperous and flourishing protocapitalist bureaucracy, with a
road network facilitating "official postal communications."[25]

His optimistic reconstruction of ancient Cretan relations with her
neighbors may have been partly prompted by the political situation that
was then unfolding. As part of the land grab that ensued in the wake of
the Great War, the Greek premier Eleftherios Venizelos (of Cretan
fame) was encouraged by the British to invade the last rump of the Ot-
toman lands with a view to occupying Anatolia. Deserted by Britain,
the Greek army was routed by the Turks. The peace settlement, nego-
tiated in 1922 in Lausanne, determined that some 1.3 million Greek Or-
thodox Christians should leave Turkey, while 800,000 Muslims would
travel the other way. Evans fought to keep his Muslim foreman, but
the victory was partial: Ali Aga was permitted to remain, but his lands
were confiscated.[26] The ideal of religious unity that Evans had pro-
moted with the annual reenactment of the labyrinth dance at Knossos
had given way to a horrible convulsion of Great Power bungling, forced
partition, and ethnic cleansing.

In the introduction to volume 2, Evans asserted that the cultural
roots of Minoan Crete had a "fundamental bearing on the origins of
European civilization."[27] This conviction had already been anticipated
in 1917 by an article "The African Origin of Grecian Civilisation" in the
Journal of Negro History. The piece has no author's name attached to it,
but declares itself to be the text of a paper read to the Omaha Philo-
sophical Society in April 1917. According to the historian Ivan van
Sertima, the speaker was one George Wells Parker, cofounder of the
Hamitic League of the World and a supporter of black activist and pub-
lisher Marcus Garvey.[28] Arguing—horribly prematurely, as it turned
out—that Aryan theory was already completely moribund, Parker de-
mands, "What, then, are some of those discoveries which have so com-
pletely destroyed the ethnic fetish of the Caucasian race?" Immediately
he answers: "The greatest and most conclusive of them all was the dis-
covery of the palace of Minos by Sir Arthur Evans."[29]

Parker's interpretation of the ancient Cretans depicted in the fres-
coes asserts the complete racial identification of Africa with classical
Greece:

The tint of the flesh is of a deep reddish brown and the limbs finely
moulded. The profile of the face is pure and almost classically Greek.
The hair is black and curling and the lips somewhat full, giving the
entire physiognomy a distinct African cast. In the women's quarters
the frescoes show them to be much fairer, the difference in complex-
ion being due, probably, to the seclusion of harem life. But in their
countenances, too, remain those distinguishable features which link
with the African race.[30]

Describing the ancient Aryans as "savages from Neolithic Europe"[31]
and Helen of Troy as "a beautiful brown skin girl,"[32] Parker's archaeo-
logical sermon turns into an oracular denunciation of prejudice in the
name of a better future. After a passage on various racist mistransla-
tions of Homer, Parker declaims that he dreams "of a magical time
when the sun and moon will be larger than now and the sky more blue
and nearer to the world." In Biblical cadences, he evokes this future
state as being one in which "the translators who shall again bring into
life the dead tongues will not let prejudice cloud their brains or truth
make bitter their tongues." Then, the "heroes of Homer shall . . . wear
the livery of the burnished sun and be knit by binding ties to the blood
of Africa's clime from whence civilisation took its primal rise."[33]
 The piece ends with another glimpse of the promised land:

I close with the hope of a time when earthly values will be measured
with a justice now deemed divine. It is then that Africa and her sun-
browned children will be saluted. In that day men will gladly listen
with open minds when she tells how in the deep and dark prehistoric
night she made a stairway of the stars so that she might climb and
light her torch from the altar fires of heaven, and how she has held
its blaze aloft in the hall of ages to brighten the wavering footsteps of
earthly nations.[34]

Parker's hopes may not have been realized in their entirety, but the
cadences of his speech echo loud and clear in the voice of the Reverend
Martin Luther King Jr. half a century later. Some of the specificities
of his aspirations have also been fulfilled in the piecemeal scholarly ac-
ceptance since the 1970s of the Afrocentric narratives of the Senega-
lese historian Cheikh Anta Diop and his followers. As overreaching as
any Teutonic appropriation of the Mycenaeans from the same period,

Parker's deployment of Minoan archaeology in the name of a people's liberation turned out to be truly prophetic.

Court Ladies

Although Evans was somewhat ahead of his time in his attitude toward his female colleagues,[35] contradictory impulses were nevertheless at work in his reconstruction of women in the Knossos frescoes. One of the "miniature frescos" dug up in a small chamber to the northwest of the central court, for example, depicts a great crowd of men and women overlooking some type of activity. The men are depicted in a kind of pictorial shorthand—rows of heads sketched in over a red wash; the women, by contrast, are represented individually, and are larger, more prominent, and more detailed. Evans had the Gilliérons restore the frescos and published them with a commentary betraying his usual interpretative confidence.

"One of the seated figures" he announces, "is seen fingering a necklace, a sign that their conversation—as is said to be commonly the case with harem ladies at the present day—may, even under the freer conditions of Minoan women's life, have concerned itself with jewellery and fashions."[36] Another tiny clue—that one of the figures has her "pendent breasts" outlined, rather than just two dots indicating her nipples—is interpreted as "a mother giving social advice to a debutante daughter."[37] "The conversation," Evans asserted, was "broken up into pairs, very much as an English dinner party."[38] In some cases actual words are put into the mouths of the "Court Ladies": "'You don't say so!'—the sense of the words can be supplied, though we may never decipher the language."[39] Another of the figures is described as "apparently sharp-tongued."[40]

The whole court ladies scene is summed up in a long passage inspired by Charles Bell, the keeper of the fine art department at the Ashmolean, who had suggested a number of parallels for the fresco: "These scenes of feminine confidences, of tittle-tattle and society scandals, take us far away from the productions of Classical Art in any Age. Such lively *genre* and the *rococo* atmosphere bring us nearer indeed to quite modern times." The court ladies reminded Bell of the figures in an eighteenth-century Giovanni Tiepolo fresco "absorbed in their own social interests, gossiping and flirting under cover of fans" or "seem to reincarnate themselves in Guardi's modish figures, with high perukes—

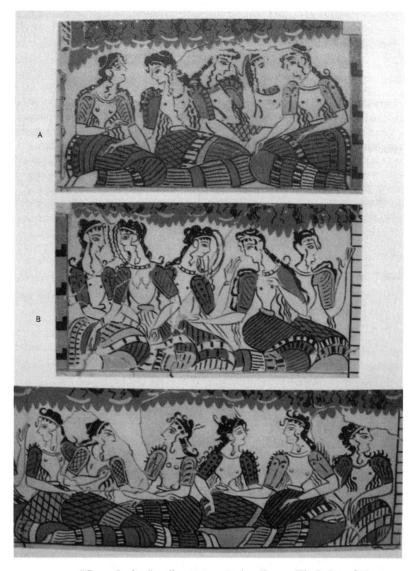

FIGURE 13. "Court Ladies" wall painting. Arthur Evans, *The Palace of Minos*,
vol. 3, plate 17. By permission of the Ashmolean Museum, Oxford.

feathered, bejewelled, smirking and ogling their beaux."[41] Here Evans
attributes to the "gay Minoan ladies" all the attributes of decadence.
By portraying them as the last flowering of a degenerate aristocracy, he
brought the Minoan world in line with modernity while diffusing the
political implications of the women's apparent high status.

The decadence of the Minoan court was a serious theoretical commitment for Evans. In the introduction to the first volume of *The Palace of Minos* he had justified his chronological scheme—a tripartite division into Early, Middle and Late Minoan, each in turn subdivided into its own three phases—as "in its very essence logical and scientific. In every characteristic phase of culture we note in fact the period of rise, maturity and decay."[42] The theory of decline endorsed in this claim was typical of a pessimistic fin-de-siècle extension of Darwinism to embrace a hypothetical late, degenerate stage of the evolutionary process. As we will see below, in the 1920s it became a badge of sophistication to understand Cretan society as already decadent some fourteen centuries before the birth of Christ. If the whole of Minoan society was as effeminate as fin-de-siècle Europe, these tightly corseted, bare-breasted "court ladies" were no more than a symptom of the inevitable biological processes of "rise, maturity and decay." "Feathered, bejewelled, smirking and ogling their beaux," they appeared more like the prostitutes immortalized by Degas and Toulouse-Lautrec than the ruling matriarchs of a suffragette utopia.

Priest King and Cowgirls

Further evidence of Minoan decadence seemed to be supplied by the only "royal portrait" that Evans published. As restored, the "Priest King Fresco" presents the very image of a Wildean aesthete. Modeled life-size in low relief, an androgynous young man, naked except for a belt and loincloth, strolls through a garden of flowers. A butterfly dances behind him. A crown of lilies and peacock feathers sits atop his long dark hair. The introduction to the first volume of *The Palace of Minos* gives the reader instructions as to how to interpret this vision: "a Minoan Priest-King may have sat upon the throne at Knossos, the adopted Son on earth of the great mother of its island mysteries. Such a personage, indeed, we may actually recognize in the Palace relief of a figure wearing a plumed lily crown."[43] By this time the priest-king had assumed great importance in Evans's reconstruction of Knossos. He was the ruler of the great Minoan empire, the bearer of the dynastic title of Minos and the divine son of the Great Cretan Mother Goddess. The plumed lily crown that he wears in the restored fresco became the emblem of the whole project, gilded onto the cover of each successive tome of *The Palace of Minos*.

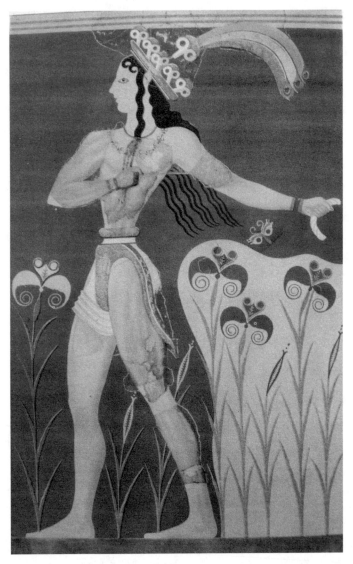

FIGURE 14. The "Priest King" relief, Knossos. Arthur Evans, *The Palace of Minos*,
vol. 2, plate 14. By permission of the Ashmolean Museum, Oxford.

The plaster fragments from which the priest-king was assembled
were discovered during the season of 1901, scattered through a base-
ment deposit in the southern wing of the palace. Evans greeted the
discovery without much excitement—he made no note of the find at
the time—and published the fragments in the excavation report from

the season as belonging to three different figures—"the back and ear of a male head wearing a crown," "a male torso found near the relief of the crown," and "the thigh and the greater part of the leg of another figure."[44] After a discussion of various parallels with Mycenaean grave goods and Egyptian wall paintings he declared that "[t]hese analogies afford a real presumption that in this crowned head we see before us a Mycenaean King."[45]

In 1905 Gilliéron *père* made the first attempt to bring the pieces together as a single figure, and the basic stance of the lily prince as determined at this point survived into all the later versions. Some finessing was necessary in the later plaster reproductions in order to make the torso more credible as part of the same figure as the crown. An ear attached to the crown was the only part of the face to survive, and the figure of which this was a part faces to the left of the viewer. The torso, however, seemed to face the other way with the right shoulder in the foreground. The modeling of the armpit in the replicas was subtly altered in order to elide this difficulty. In the later replicas, some strands of hair were also added to the torso fragment.[46]

Apart from this manipulation of the pieces, another problem with the interpretation of the figure arose from the color of the skin. In his interpretations of Minoan paintings Evans applied with complete consistency a convention (shared by ancient Egyptian and Anatolian art) according to which male figures were always shown with dark-red skin and females with white skin. The priest-king is white-skinned. Evans overcame this difficulty by claiming that the skin was originally colored reddish-brown and had faded. The plausibility of this argument was undermined by the fact that the relief was modeled against a flat red background, unfaded and presumably chosen for contrast. (The equivalent life-sized figure of the "Cup-Bearer" has red skin against a white background.) A further difficulty was presented by the lily necklace and bracelet on the torso, which are both picked out in red paint. Here Evans's argumentative resources began to show some strain:

> [T]he lilies of the collar seem to have been attached in separate
> pieces coloured to represent metal work. This applied decoration
> has, however, become detached leaving the surface below printed, as
> it were, in its original ruddy hue against the faded surface of the rest
> of the torso.[47]

There is, however, no precedent for "detachable" jewelry on the frescos and the lily collar gives no impression of having been "as it were" printed, but seems to have been painted on in the usual way. The jewelry is also picked out in blue, a detail that fails to fit in with Evans's argument. Neither of the Gilliérons was ever able to follow Evans's reasoning in this regard, and all their restorations of the priest-king fresco depict the figure with very pale skin, as the logic of the fragments demand.

Elsewhere, Evans's reliance on skin color code had produced a veritable Dionysian throng of androgynous characters. The libation bearers on a famous Minoan sarcophagus, with their feminine dress and their dark red skin, were interpreted as transvestite priests. The loinclothed figures in the bull-leaping frescoes with their white skin, on the other hand, were female "cow-boys" who had undergone "sexual transformation":

> As participants in the feats of the *taurokathapsia* these trained girl athletes—who may be thought to represent the presiding Goddess in a superior degree—had first to undergo a kind of sexual transformation, by divesting themselves of all articles of feminine dress except their head-gear and necklace, and by adopting the sporting costume of the male performers, including the universal exterior sign of the masculine sex, the Minoan version of the "Libyan sheaf."[48]

Evans was very attached to his Minoan girl-athletes. Near the bull relief that adorned the north portico, he had found a plaster fragment of a pale, life-size lower leg very similar to the legs of the priest-king that he interpreted as "the legs of a woman of the 'Cow Girl' class."[49]

The white-skinned cowgirls were, however, rather anatomically problematic, having completely flat chests:

> These performers—whether they display their acrobatic skill in the Palace Circus or in the open field—are consistently depicted with very slight pectoral development, so much so that in the wall paintings, were it not for the convention of the white skin colouring, it might be difficult to distinguish them from the youthful male taureadors who take part in the same scenes.[50]

Given that he had already indulged in this bit of interpretative license with the bull-leaping frescoes, the pale skin of the priest-king presented

Evans with two choices. He could have pressed ahead and interpreted the figure as a female bull-leaper, but such a masculine-looking torso, while just about credible on a fresco fragment, was clearly too much to assimilate on a life-sized relief. Alternatively, he could have abandoned the convention of skin color, in which case he would have had to sacrifice the titillating spectacle of young girls engaging in the bull-leaping sports. But by insisting—in defiance of the evidence—that the priest-king had originally had red skin, Evans was able to retain his carnival of Minoan sexual inverts while reserving the crown of Minos for his favorite character—the divine son of the Great Cretan Mother.[51]

Lost Boys

The Cretan divine son was perhaps Evans's most characteristic and, indeed, symptomatic creation. In his reconstruction of Minoan womanhood the note most frequently sounded was ambivalence, as he mixed Victorian stereotypes of spiritualized maternity with modernist images of androgynous athleticism. The divine son is a more coherently Edwardian figure, a sacrificial pagan king laced with wistful overtones straight out of *Peter Pan*. One reason for his relative coherence is that there was so little evidence for the divine son's existence: Evans had to create him almost ex nihilo, weaving a web of mutually reinforcing correspondences between a number of different artifacts, the most important of which were fakes. Various historians of the late nineteenth and early twentieth centuries have commented on the emergence in about 1880 of boyhood as a locus of hope, fantasy, and anxiety. "The Victorians," writes one author, "liked little girls. The Edwardians worshipped little boys."[52] If the Cretan boy-god had not existed, it would have been necessary to invent him, and invent him Evans did.

Above all, the Cretan divine son bears the imprint of James Frazer, the greatest of all armchair anthropologists, who was Evans's almost exact contemporary (1854–1941). Frazer had stumbled into anthropology from classics, and a secure berth as a lifetime fellow of Trinity College, Cambridge, allowed him to spend up to fourteen hours a day adding to his ever-growing catalog of ancient and primitive religious conceptions, *The Golden Bough*. The first edition appeared 1890; by 1915 it had swollen to twelve volumes. (The 1922 abridgement is the form in which it is most widely known.) In it Frazer argued that the

figure of an agricultural year-god—a deity incarnated in an unfortunate priest-king who reigns only for one year before being slain by his equally unfortunate successor—underlies most primeval religious conceptions, including the Christian sacrament of the Eucharist. Sticking faithfully to this hugely influential template, Arthur Evans wrote of the Cretan god: "That his death and return to life were of annual celebration in relation to the seasonal re-birth of Nature is an almost irresistible conclusion."[53]

In the Frazerian scheme, the male god is both son and consort to the great goddess, but Evans made sure to distance the Cretan pantheon from any suggestion of incest. In a section entitled "Evidence of a Simpler Relationship of Child to Mother," he asserts that the "sustained purity of all Minoan artistic representations" makes it difficult to believe in the "more degrading episodes." In Evans's scheme, Cretan religion does not look backward or sideways to the sexually incontinent deities of the Orient but forward to the purity of the relationship between Christ and His Virgin Mother. Elaborating on this theme, he points out that the cave sanctuary of the Cretan "mortal Zeus" on Mount Juktas had been supplanted a bit further along the ridge by a "little pilgrim church of 'Christ the Lord.'"[54]

By far the most striking objects to serve this story comprise a divine family of gold and ivory forgeries that Evans published as authentic pieces in the 1930s. The "Boston Goddess" is a small ivory figure, about 12 centimeters in height, with gold serpents made of two flat ribbons of metal spiraling up her excessively long arms. She has the usual Minoan bare breasts with one gold nipple sticking out. With her sharp little nose, haughty expression, and pointed crown, she slightly resembles John Tenniel's Red Queen from *Alice through the Looking Glass*. The flounces of her skirt are also picked out in gold. She occupies a proud position in her own case in the middle of a gallery in the Museum of Fine Arts, Boston.[55]

Made of the same materials and similar in style are two ivory "boy-God" figurines. One is short with shoulder-length tresses, a tiny waist, and a tall tiara; the other is larger and older looking with a little gold loincloth. Both were bought by Evans from the same dealer in Paris, one ending up in the Seattle Art Museum, and the other at the Ashmolean. Both have since been removed from display as fakes. These three figurines only made it to Boston, Oxford, and Seattle because no

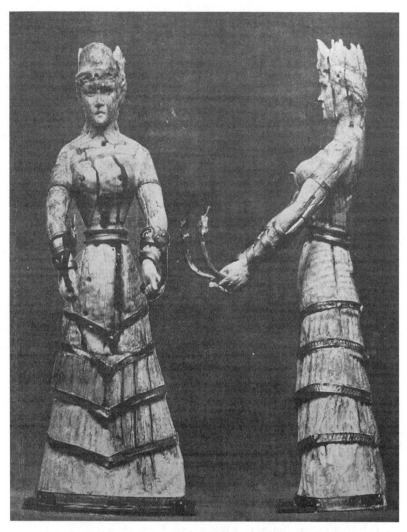

FIGURE 15. The "Boston Goddess." Arthur Evans, *The Palace of Minos*, vol. 3, fig. 305. By permission of the Ashmolean Museum, Oxford.

one had seen them come out of the soil of Crete. Had their provenance been respectable, the Cretan government would never have let such important and unique pieces leave the island.[56]

In a collection of anecdotes published in 1962, the archaeologist Leonard Woolley recounts going with Evans and Duncan Mackenzie to the deathbed of one of the Knossos restorers, who confessed that he

and another member of the restoration team had for years been forging
Minoan antiquities. The two archaeologists went to the forgers' work-
shop, where they found

> things in every stage of manufacture. For instance, people had
> been recently astounded at getting what they call chryselephantine
> statuettes of ivory decked out with gold—there is one in the Boston
> Museum and one at Cambridge, and one in the Cretan Museum at
> Candia. These men were determined to do that sort of thing, and
> they had got there everything, from the plain ivory tusk and then the
> figure rudely carved out, then beautifully finished, then picked out
> with gold. And the whole thing was put into acid, which ate away the
> soft parts of the ivory giving it the effect of having been buried for
> centuries.[57]

It seems that Evans may have actually visited the forgers' workshop but
still went ahead and published as authentic a series of figurines made of
the very material that the fakers were using.[58]

In his description of the pieces, moreover, Evans's doubts seem very
close to the surface: on more than one occasion he praises the "moder-
nity" of their features and their similarity with each other, suggesting
that they must have come from the same workshop: "the most remark-
able characteristic of the chryselephantine statuette is the physiognomy
itself. It is a curiously modern type. The eyes are sunk to their natural
depth below the brow, a method of treatment practically unknown to
ancient Art of any kind before the Fourth Century B.C."[59] Even put-
ting aside the discovery of the forgers' workshop, the "modern" look
of their faces and their murky provenance should have alerted Evans to
the fact that the figures of this series were likely forgeries.

Evans began his argument as to their authenticity by reporting the
discovery of some ivory fragments in a burnt wooden container in the
"Temple Treasury." Arguing that the "richness of the remains" implied
that they were from the treasury of a shrine, he posited the existence of
"some other carbonized chest" that had been plundered at some point
in the past.[60] Having conjured up this ghostly container he proceeded
to fill it with the fake gold and ivory figurines, his embarrassment at
the cumulative implausibility of the argument betrayed by a certain
hesitancy in the language: "it is not too much to say that, owing to a re-

markable chain of circumstances, there seems to be a high probability that, as regards its most essential features, the lacuna in our evidence has since been supplied."[61]

The ivory boy-god initially appears in *The Palace of Minos* as "a remarkable resurgence from the soil of Crete" that had

> migrated to Paris a few years after the War where it made its appearance amongst a series of objects said to have been discovered by a Cretan Miller. But the boy was in bad company. Of the numerous associated objects—all said to be Minoan and to have been found at the same spot—it was hard to recognise any genuine relic beyond one or two fragments.[62]

Why did Evans single out this figure from among all the fakes "said to have been discovered by a Cretan Miller"? Some of the complex identifications that may have been provoked by the first sight of the ivory boy are indicated by the language with which Evans describes its discovery—"the boy was in bad company." In the years since his wife's death, Evans had been collecting some lost boys of his own: children whose parents were unable to look after them. First he adopted his wife's nephew and later the son of one of his tenant farmers. The second of his adopted sons, James Candy, had been spotted by Evans when the local Boy Scout troop was using the grounds of his mansion outside Oxford for its drills. "It seems" writes Candy, "that Sir Arthur had noticed that I was very pale."[63] Evans's immediate desire for the boy-god when he saw it among the other fragments found by the aforementioned "Cretan Miller" betrays the same tenderness for boyish vulnerability as his adoption of the sickly Boy Scout. The ivory boy remained his favorite piece; he kept it in his own collection until his death, and can be seen holding it in a 1935 portrait.

Evans's narrative of the ivory boy's discovery then takes an even more poignant turn, the story of a male child being reunited with his mother, the Boston Goddess. Here the dubious provenance of the two pieces is precisely the hook upon which the story hangs, allowing Evans himself to be the agent of their reunion: "[H]aving been successful in rescuing [the boy-god] from the midst of doubtful elements in a Parisian dealer's hands, it has been possible to ascertain [that] . . . the two figures in fact form a single group of the divine Child God saluting

the Mother Goddess."[64] The connection between the two pieces, moreover, is indicated by the modernity of their style: "It is impossible," Evans declares, "not to be struck by a great similarity of style. The modernness of treatment is shared by both . . . can it be doubted that both works are by the same artist?"[65]

The apotheosis of the reunion between mother and son comes as Evans commissions his resident artist (Gilliéron *père,* almost certainly an important link in the chain between the forgers and the museums and dealers of Europe and America[66]) to draw a portrait of them facing each other as part of a single tableau:

> What, indeed, can be more beautiful and more natural than the relationship which the attitude of the boy-God itself suggests? Standing on tiptoe with his face slightly upturned he has the appearance of actually gazing at the slightly higher figure . . . It is the Divine Child adoring the Mother Goddess.[67]

Celebrating the figurine as "perhaps the most living embodiment of young boyhood to be found in the whole range of Ancient Art," Evans concludes the section with his usual insistence on the purity of the relationship between mother and son: "It suggests nothing of the more sensuous association . . . Rather, the image speaks clearly of the simple and natural relationship of the divine Child to his Mother."[68] Evans's emotional treatment of the figurine betrays a complex series of identifications: he is at once the foster father of the ivory boy, the benign archaeological wizard who reunites orphan and parent and, of course, the boy himself, adoring the image of his long-dead mother.

As art historian Kenneth Lapatin has pointed out, Evans not only misidentified the boy-god as a genuine Minoan piece, he also seems to have mistaken the forgers' intentions. The "boy" has distinctly feminine outlines, and Lapatin argues that he was originally meant to be one of the putatively female, white-skinned bull-leapers made so famous by the "Taureador Fresco." But no sooner had Evans's interpreted the figurine as a boy-god, than the forgers obliged with an unambiguously masculine version, this one complete with male genitalia (coyly hidden under a gold loincloth), which Evans also fell for and purchased. A section of volume 4 of the *Palace of Minos* was devoted to the new figure, using it to reinforce his interpretation of the Boston Goddess and the other boy-god.

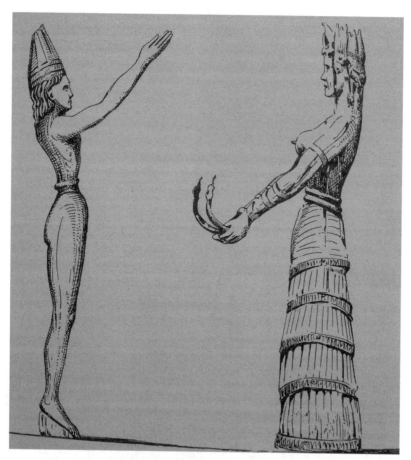

FIGURE 16. The boy-god reunited with his mother goddess. Arthur Evans,
The Palace of Minos, vol. 3, fig. 318. By permission of the
Ashmolean Museum, Oxford.

The Lady of Sports

The second boy-god was accompanied by another figurine, also seem-
ingly produced in response to Evans's failure to recognize a female
bull-leaper in the first ivory statuette. The so-called "Toronto Lady of
Sports"—on display in the Royal Ontario Museum until 2005—is the
most absurd figurine of the whole group. Looking like a magnificently
perverse bit of 1930s pornography, she is as unambiguously female as
her fellow statuette is male, having large breasts with little gold nails

for nipples. Under her impressive bare bosom she wears a tight gold
corset. In a clear nod to Evans's fondness for the "sexual transforma-
tion" undergone by the girls in the bullring, she also wears an outsize
codpiece.

In volume 4 of the *Palace of Minos* she appears in a starring role as
a full-color frontispiece, picked out in metallic gold ink. Again, the
passage describing her discovery deploys the language of "release" and
"epiphany" to gloss over the uncertainty of her origin:

> A remarkable chryselephantine image that has now seen the light . . .
> may be regarded as representing the third Epiphany of members of
> a divine group . . . The "Boston Goddess" in her original fragmentary
> state was actually seen at Candia some twelve years after the discov-
> ery [of the genuine ivory figurines excavated at Knossos]. The ivory
> boy-God . . . was "released" at Paris after about an equal interval of
> time. The third figure has made its appearance only quite recently in
> a still more distant trans-Atlantic site. . . . This, though still not the
> last of these emergent forms, is certainly the most surprising.[69]

It is the phrase "emergent forms" that shelters the hopeless provenance
of the chryselephantine figurines and betrays Evans's indifference as to
their source.

Evans's most recent biographer, J. A. MacGillivray, has speculated
that the inclusion of "obviously modern pieces" in the third and fourth
volumes of *The Palace of Minos* was "part of a larger picture of Evans
slowly losing touch with his critical faculties, becoming less able to
distinguish fact from fiction."[70] Evans turned eighty the year that vol-
ume 3 was published and so might be excused his failures of judgment
on the grounds of age. It seems, however, not so much of a lapse of
his customary rigor as an intensification of his life-long confidence in
his own subjectivity. From the first days of the excavation, when every
fresco fragment depicting a human form was an "Ariadne," to the ring-
ing tones with which he laid out his reconstruction of Minoan theol-
ogy, to the enthusiasm with which he embraced the "Lady of Sports,"
he always knew what he was looking for—and he made sure that he
found it.

The "emergence" of a series of figurines that perfectly illustrated
his Minoan theology represented not the failure of Evans's archaeol-
ogy but rather its final achievement. His use of theological vocabulary

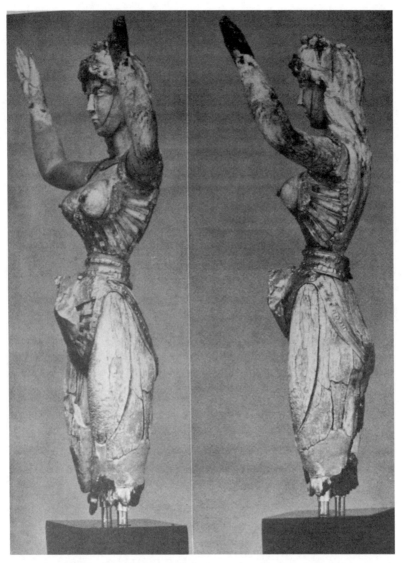

FIGURE 17. The "Lady of Sports." Arthur Evans, *The Palace of Minos*, vol. 4, fig. 14. By permission of the Ashmolean Museum, Oxford.

to describe the appearance of these objects constitutes more than just a smokescreen for their dubious authenticity; it goes right to the heart of how Evans regarded his archaeological vocation. Incurably romantic and unquenchably visionary, he was the archaeologist that "went native," reconstructing the Minoan world through his intensely

subjective identification with the spirit of Minoan art, architecture, and religion. Evans senior had applied Huxley's method of Zadig in all its exquisite caution, building his case for the antiquity of man step by step, constructing an argument as solid as any piece of Victorian engineering. Evans junior followed his trail of clues to Crete in the manner of a magical quest, and then fitted the pieces together into a series of glittering visions of a vanished world.

One of Evans's favorite stories told how he had ordered a well to be dug to provide water in the vicinity of Knossos. His Cretan workmen had insisted that the location was dry, but Evans, with a gesture of priestly authority, had struck a spot on the hillside with his beloved walking stick and ordered them to dig. A couple of feet below the surface were the remains of a Bronze Age well. Within minutes it had filled with fresh water.[71] Evans experienced his archaeological destiny as liberally peppered with minor miracles of this kind, and so perhaps it came as no surprise to him when, in the last decades of his life, he found that he had projected a religious vision so powerful that votive objects had appeared out of nowhere to furnish the museums of Canada and America. After a passage delicately alluding to the poor provenance of the Boston Goddess, Evans remarks that "[m]ore cannot be said; but none need regret that the Knossian Goddess—so admirably reconstituted—should have found such a worthy resting place and that she stands today as a Minoan 'Ambassadress' to the New World."[72]

The Magic Ring

In 1925, Evans found himself able to provide his readers with a glimpse "of the Minoan Underworld." The previous spring he had bought a heavy gold ring, which he recounted to a cousin as an act of fairytale heroism: "I went on a journey into the Morea in quest of a magic ring: which I ran to earth. Quite a wonderful relic, with a handy map of the Elysian regions of my old people."[73]

According to Evans's account, the ring turned up in 1907 when a party of German archaeologists interrupted a group of Greek peasants dismantling three Mycenaean beehive tombs in an olive grove near "sandy Pylos," a spot that Homer had hinted was the burial site of one of his protagonists. The archaeologists shooed away the peasants, dubbed the site the "Tomb of Nestor," and extracted whatever

had survived the plunder, managing to assemble from hundreds of pottery shards a series of amphorae in a typically Minoan style.[74] But the peasants had got away with the real prize: a solid gold signet ring with a scene engraved on its surface crowded with about twenty animal and human figures. Evans described how the ring passed from father to son and thence to the owner of a neighboring vineyard, doing his best to lend a gloss of respectability to this rather shady provenance: "On information reaching me of its existence from a trustworthy source, I made a special journey into that somewhat inaccessible part of Greece and was finally able to secure it."[75]

The Ring of Nestor may be yet another forgery. Not only does it employ stylistic conventions found nowhere else in Minoan art, but in the 1930s Emile Gilliéron *fils* reputedly confessed to having made it.[76] (The "Thisbe Treasure" discussed in the same article, a magnificent hoard of gold artifacts, one of which depicts a supposed Bronze Age version of the story of Oedipus and the Sphinx, is now known to be fake.)

If Nestor's ring was indeed made by the younger Gilliéron, one wonders if he was delighted or disconcerted when Evans asked him, in his capacity as the resident artist at Knossos, to represent his own handiwork in a number of different ways, beginning with a photo enlargement, moving to a drawing of the figures enlarged twenty times, and finally transforming the scene into a full-color fresco, in which all the little scratches and blobs in the original engraving were turned into faithful depictions of Evans's interpretations.

Through this series of metamorphoses, a couple of tiny squiggles that appear in the top left corner of the ring's oval face are transformed into the centerpiece of Evans's reading of the whole scene: "Fluttering near and almost settling on [her head] are two butterflies, and above these in turn two other objects."[77] Aided by an "eminent entomological authority," Evans asserts that this pair of fat commas "may be unhesitatingly accepted" as two chrysalises of the Common White butterfly. He follows with a twelve-page discussion of the role of butterflies as "symbols of the life beyond" in Minoan religion. Sprinkled among his descriptions of Mycenaean and Minoan artifacts featuring butterflies are abundant examples from etymology, myth, and folklore:

> In certain districts of Wales and Western Scotland, indeed, White
> butterflies, as being the souls of the dead, are fed on sugar and water,
> while as part of the same custom, coloured ones are killed. It is

FIGURE 18. The scene on the intaglio of the "Ring of Nestor." Arthur Evans,
The Palace of Minos, vol. 3, fig. 104. By permission of the
Ashmolean Museum, Oxford.

noteworthy that the Greek word Ψυχη [Psyche], a spirit, as trans-
ferred to a butterfly, is illustrated by Aristotle, who in this connexion
first described the genesis of the perfect insect from a caterpillar and
a chrysalis, by the life cycle of a White butterfly.[78]

He goes on to document the connection between white butterflies and
the souls of the dead in locations as diverse as ancient Egypt, Burma,
and Northumberland.

In the course of a trawl through thousands of years of art and lit-
erature in search of scenes resembling those on his magic ring, Evans
suggests that the enduring popularity of the tale of Eros and Psyche—
the Greek folk tale in which a beautiful mortal girl's transformation
into a goddess is symbolized by butterfly wings—could be explained
by the Psyche symbol being "so deeply rooted in an older stratum of
the population." In offering an origin story for the perennially popular
tale of Cupid and Psyche, Evans was riding high on a wave of intellec-
tual and artistic fashion. At the time of the publication of his Ring of

Nestor pamphlet, a new translation of the myth, a fresh crop of verses based on it, or another book of essays on a theme inspired by it were appearing every few months. Between the start of the excavations at Knossos in 1900 and the appearance of Evans's article in 1925, dozens of translations and reprints of the version of the tale from Apuleius's first-century Latin novel appeared, alongside no fewer than sixty-four plays, poems, sculptures, ballets, paintings, novels, or operas inspired by it.[79] Evans's Minoan Psyche provided an origin point for the wildly popular tale: archaeological excavation had made visible in the silly heroine of Apuleius's bawdy fable, traces of a religious conception of immemorial antiquity: the butterfly and chrysalis as a symbol for the soul's transformations.

The Psyche Element

Evans's acceptance of the ivory and gold figurines presents itself as a symptom to be explained, and the wistfulness with which he wrote about reuniting the ivory boy with his mother provides a convenient diagnosis. In his neurotic susceptibility to the forgers' art, Evans betrayed that the Cretan Great Goddess was the product not only of Victorian maternal ideology and nineteenth-century matriarchal theory, but also of the unresolved emotions of an archaeologist who had been deprived of his own mother at an early age. By virtue of an additional piece of evidence as to Evans's behavior in the aftermath of his childhood loss, it seems that his acceptance and interpretation of the Ring of Nestor also falls prey to the same psychoanalytic pathos.

In March 1859, a year and three months after Harriet's death, John Evans wrote to his soon-to-be fiancée that he had observed seven-year-old Arthur enacting a strange ritual out in the garden:

> He is a very odd child and though I am an Evans myself to a great extent, I cannot quite understand him. Think of his burying a china doll (with its legs broken) with a butterfly and some other things in the garden, and placing this inscription over them "KING EDWARD SIXTH and the butterfly and there cloths and things." Whether he had some notion about the resurrection or not I cannot say, but the Psyche element is very singular and the placing of the clothes in readiness for his re-existence looks like forethought.[80]

John Evans's reading of his son's burial ritual is a gloriously pre-psychoanalytic mixture of ancestor theory, Christian doctrine, and pagan symbolism. He hints that Arthur's "oddity" may be a family trait— "though I am an Evans myself to a great extent, I cannot quite understand him"—perhaps alluding to a strain of Celtic mysticism inherited from his Welsh ancestors. He recognizes the butterfly as a symbol of "the resurrection"—the definite article locating the concept in Christian belief—but gives it the pagan name "Psyche."

In the 1850s, Psyche stood for a widely diffused symbolic association between butterflies and the soul's immortality, popularized through children's books, in which fashionable lepidoptery was given an improving Christian twist. Perhaps Arthur had been exposed to the Religious Tract Society's 1839 *History of Insects,* a children's book that ended with an extended comparison between the metamorphosis of a butterfly and the miracle of the resurrection. Or maybe his governess, Miss Stewart, had read him the verses of the anonymous "Dreamer in the Woods" whose lavishly illustrated *Butterflies in Their Floral Homes with Butterfly Fables* (1855) ended with the sentiment that a "creeping creature" that only "seemed to die" before bursting forth as a "glittering butterfly" was an appropriate symbol for a dying man's hope of attaining immortality.

Arthur's half-sister judged that "no thought or deed of his could set the world going anew" when his mother died, but clearly the hothouse schoolroom at Nash Mills gave the little boy some intellectual resources for dealing with his bereavement. By the time Arthur was out in the garden burying the butterfly, John Evans was able to report in his letters that the little boy had "distinguished himself of late by mathematical and historical acquirements."[81] What was it about the doomed king Edward VI—ten years old when he ascended the throne, already an accomplished scholar, amateur astronomer, and lute player, who died at the age of sixteen of consumption—that prompted Arthur to memorialize the young king's passing? And did the dying boy-god—that pagan Christ so beloved of late Victorian anthropology—continue to carry the burden of his emotional freight into adulthood and old age?

Arthur's early years were both sheltered and shadowed. His mother died but he remained surrounded by kindness and swaddled by wealth, a beneficiary of the romantic cult of the child that had been picking up steam since the middle of the eighteenth century. This combination of loss and privilege came together with the rigors of the Nash

Mills schoolroom to dilate his imagination and intelligence, but also, it seems, to prevent him ever fully outgrowing the sensibility of that precocious child. In his enthusiastic interpretation of some of the most dubious Minoan artifacts, Evans reproduced all the symbolic content of his childhood ritual—the ivory figure of a boy-god who dies and is resurrected every year ("a china doll with its legs broken" representing the doomed young king Edward VI), the Boston Goddess (the mother with whom he longed to be reunited), and the Ring of Nestor ("the Psyche element"). To render literal a psychoanalytic metaphor, it seems that the man dug up what the child had buried.

Little Souls

Important though it is to note that Evans was neurotically invested in his Minoans (with the divine son an especially narcissistic creation), his emotional susceptibility is only one corner of a larger picture. Just as Evans's personal stake in resurrecting the Minoan mother does not necessarily negate the fact that the Bronze Age Cretans did worship a goddess,[82] so the relationship between Evans's buried butterfly and the butterfly symbolism of the Ring of Nestor cannot necessarily be dismissed as merely an old man's expression of unresolved childhood grief. The discovery of an unquestionably genuine Minoan ring that reproduces all the same symbolic elements allows for a rather more generous, complex, and rehabilitative reading of Evans's Psyche, one that comes much closer to the spirit of mythical modernism itself.

In the 1990s a gold signet ring was unearthed at a Cretan site called Archanes with a scene engraved on its face that fits very well with Evans's interpretation of the Ring of Nestor:

> In the centre of the scene is the Minoan goddess . . . to the right a man shown in violent movement, either grasping or uprooting the sacred tree from a tripartite sanctuary, and on the left another figure who has fallen upon a pithos-like object in an attitude of lament. Shown on the ground once again is the eye of the all-seeing goddess, two butterflies, a chrysalis and a kind of stand.[83]

To explain the iconographic similarities between the Ring of Nestor and their ring, the excavators of Archanes supply a simple answer. They propose that the presence of butterflies and a chrysalis on the face of

their ring proves that "the so-called Ring of Nestor, is authentic, and not the fake that it was generally believed to be."[84]

Whether or not the Ring of Nestor is genuine, the iconography of the Archanes ring—butterflies, chrysalises, the goddess, and two mourning youths—is an even better fit with the materials that Evans buried in the garden when he was seven years old. How to explain the uncanny resemblance between a Bronze Age mourning ring and a mid-Victorian primal scene? Perhaps it is only Evans's own great catalog of butterfly iconography drawn from scattered locations and times that is capacious enough to accommodate the two. The coincidence in symbolic content can be explained by the fact that Psyche—the metamorphosis of caterpillar, chrysalis, and butterfly as a symbol of the soul's transformations—is grounded in something stable in the relationship between the natural and the human worlds, something delicate and yet enduring that has arisen independently in different places and times. The symbol replicates itself without the necessity for direct transmission because the association between butterflies and mourning can arise anywhere loved ones die, caterpillars metamorphose, and people look to nature for a symbolic embodiment of their spiritual hopes.

The "Psyche element" in Evans's work belongs to a distinctively modernist literary genre, a type of neo-Romantic poetics fashioned from the sober cloth of the Victorian historical sciences. The chapter of *The Palace of Minos* about Ariadne's dancing ground ends on this Keatsian note:

> Over the lower slope, where the remains of the Palace walls still stand . . . the evening shades creep early. Often enough, indeed, they tempt some little shepherd, homeward bound with his goats from the neighbouring hamlet, to seek a short refuge here from the outer glare while he plays a strain of old-world music on his native pipe. Those eerie notes can hardly fail to wake more distant echoes in the listeners' ears and the magic of the spot calls up visions of the festal scenes once enacted on the level flat below—shut in, beyond, by the murmuring stream—where the immemorial olive trees still spread their boughs. Fitfully, in the early summer, there float and poise in the sunny spaces between the trees swallow-tail butterflies, saffron, fringed with blue, like the robes of the dancers on the fresco, as if they were in truth the "little souls" of those gay ladies.[85]

As in Keats' "Ode to Psyche," Evans rhapsodizes about the old pagan gods, inspired by his sighting of butterflies in an Arcadian scene complete with the eerie notes of the shepherd's pipe. This updated romanticism, with its quest for the universal, original or archetypal core in the pagan stories, was the place where archaeology and modernism converged.

By rebuilding the Palace of Minos in modern materials, reconstructing the wall-paintings in a modern style, and authenticating absurd forgeries such as the Lady of Sports, Arthur Evans contributed much to a pervasive sense that the pre-Christian and the post-Christian worlds had much in common. But it was where the intense subjectivity of his interpretative technique flowered into a visionary neopaganism that Evans's work came closest to modernist literature. It was this aspect of his archaeological method—the combination of magic, mythology and science, the distillation of sexual essences and symbolic archetypes, the central obsession with the figure of woman—that left its mark on the Dionysian art of the twenties and thirties.

❦ V ❧

PSYCHE'S LABYRINTH,
1919–1941

In *The Birth of Tragedy,* Nietzsche suggested that modernity was antiquity moving backward. According to his scheme, the age of rationalism was inaugurated in the fifth century B.C. by Socrates. By the nineteenth century A.D., this desiccated analytical mode had created a cultural desert in the midst of which German music (Richard Wagner) and German philosophy (Schopenhauer and Kant) had miraculously begun to pour forth their antirationalist, Dionysian wisdom. Now, exhorted Nietzsche in 1872, "we are living through the great phases of Hellenism in reverse order and seem at this very moment to be moving backwards from the Alexandrian Age into an age of tragedy."[1]

In the chronological paradoxes and inversions of modernist artists' engagement with the ancient Cretan world, the stunning force of Nietzsche's exhortations can be clearly seen. According to his scheme, Knossos was the most modern of ancient sites, and his followers lost no time in fulfilling the implications of this prophecy. This was, of course, Nietzschean world making with a very un-Nietzschean twist. In the wake of one terrifying war and in the shadow of another, many of

these artists and thinkers deployed the Minoans as a means to under-
stand the catastrophe that was engulfing their world. In the immediate
aftermath of the Great War, ancient Crete was recreated in the image
of a decadent civilization devoured by its own weakness. As the Sec-
ond World War loomed ever nearer, the Minoans assumed the shape
of a ghostly ancient idyll, the very image of Ariadne's dancing floor on
Achilles' shield. By the time the bombs were raining down on London,
Crete had become the archetype of a lost pacifist paradise.

Mythical Method

In *The Pound Era,* his famous mimetic tribute to the modernist canon,
the critic Hugh Kenner argues that Schliemann's excavations were re-
sponsible for the rebirth of mythological consciousness at the begin-
ning of the twentieth century. Attempting to convey the impact of
Homeric archaeology on modernism, Kenner coins the term "second
Renaissance." This second rebirth of modernity through antiquity was
inspired by the humble domestic details of the heroic age: the cook-
ing vessels, safety pins, and window latches of Bronze Age Greece.
According to Kenner, it was Schliemann's revelation of the mundane
materiality of Homer's world of heroes that made it possible for an art-
ist like James Joyce to render heroic the prosaic details of modernity:
"Schliemann had been to Troy and a cosmos had altered."[2]

Of course, if Schliemann is allowed to have ushered in a renaissance,
then there must have been more than two. Rather than dividing the
long and ever changing history of the modern European engagement
with antiquity into two discrete periods—an implausible proposi-
tion—what Kenner's analysis more usefully does is to underscore both
the intensity and the distinctiveness of modernist classicism: its some-
what ambivalent fealty to the natural sciences, its neopagan slant, its
primitivism.

In the mid-nineteenth century, Arthur's father John Evans and his
fellow flint-knappers argued for a continuity between natural and cul-
tural history with their excavations of the earliest human tool users.
Over the course of the next couple of decades, this continuity was de-
cisively consolidated under the rubric of social and cultural evolution.
In the 1870s, Schliemann's excavations of Troy and Mycenae added a
twist to the narrative, bringing Greek myth into the scientific fold. As
Bronze Age archaeology matured, the materials of the classical curricu-

lum were welded onto the end of the long narrative of human prehistory and, by extension, of natural history. The classics had become a source for the human sciences. By the turn of the twentieth century, anthropology, psychology, racial science, the history of religions, philology, paleontology, geology, and archaeology were all loosely grouped as stratigraphical disciplines, resulting in a florescence of new information about the ancient world and a proliferation of new methods of interpreting it. In 1920, T. S. Eliot poked gentle fun at the "curious Freudian-social-mystical-rationalistic-higher-critical interpretation of the Classics and what used to be called the Scriptures," wondered at the "tropical exuberance" of the new sciences that kept springing up, and commented wryly that "the garden, not unnaturally, has come to resemble a jungle."[3]

The king of the jungle of modernist classicism, especially for artists and writers, was, of course, Friedrich Nietzsche. In 1910, Thomas Mann attempted to sum up the effect of Nietzsche's life and work on the generation born in the years around 1885:

> We who were born around 1870 are too close to Nietzsche, we participate too directly in his tragedy, his personal fate (perhaps the most terrible, most awe-inspiring fate in intellectual history). Our Nietzsche is Nietzsche militant. Nietzsche triumphant belongs to those born fifteen years after us. . . . the twenty-year olds have from him what will remain in the future, his purified after-effect. For them he is a prophet one doesn't know very exactly, whom one hardly needs to have read, yet whose purified results one has instinctively in one. They have from him the affirmation of the earth, the affirmation of the body, the anti-Christian and anti-intellectual conception of nobility, which comprises health and serenity and beauty.[4]

The artists and writers who interpreted the excavations at Knossos between the wars belong squarely in the younger generation characterized by Mann. Theirs was a "Nietzsche triumphant": atheistic or polytheistic without his crushing burden of guilt, knowing what to do with the sexual liberation promised by his paganism, and confident—often over-confident—in their understanding of womankind.[5]

Kenner's argument that Joyce labored in a Schliemannesque cosmos holds best for the main body of *Ulysses,* the odyssey of heroic antihero Leopold Bloom through a single Dublin day. But in the first section of

the book, the so-called "Telemachia," the flavor is more Minoan than Mycenaean. Joyce's alter ego Stephen Dedalus is a self-conscious inhabitant of Nietzsche's new tragic age, but like Evans's Daedalus—the architect of a goddess's dancing floor rather than a monster's prison— his is a pacified and feminized cult of Dionysus. In Joyce's world, as in Evans's, the place of the recently deceased Christian God is taken by the specter of a dead mother, and the maternal archetype is summoned into being by the sorrow-dilated imagination of a grieving son.

As a continuation of his autobiographical novels *Stephen Hero* and *Portrait of the Artist as a Young Man,* the first section of *Ulysses* is very closely based on Joyce's own experience. In 1904 the twenty-two-year-old genius-in-training, finding himself temporarily homeless, moved in with a new friend, the prosperous, blasphemous, witty, philhellene medical student Oliver Gogarty. The house was the strangest residence Joyce was ever to inhabit, a tower with eight-foot-thick walls built a hundred years earlier to defend Dublin's coast against Napoleonic invasion. Gogarty liked to call the tower the "Omphalos" after the navel stone at Delphi and regarded their chaotic household as a temple of neopaganism inspired by Nietzsche.

The opening chapters of *Ulysses* provide a glimpse—hallucinatory in its vividness—of what it was like to live in the grip of archaeologically and anthropologically inflected neopagan modernity. It is the astonishing achievement of Joyce's prose—his ear for the exact cadence of people's speech, his memory for the precise texture of everyday life, and his powers of description—that it can carry the reader back one hundred years to experience the labyrinth of modernism in its living, breathing actuality.

The book opens with the character based on Gogarty—"Stately, plump Buck Mulligan"—wielding a razor as he transforms his morning shave into a parody of the Catholic Mass: "For this, O dearly beloved, is the genuine Christine: body and soul and blood and ouns. Slow music, please, shut your eyes, gents. One moment. A little trouble about those white corpuscles." The melancholy Stephen Dedalus, "displeased and sleepy," resists Mulligan's flirtatious mockery, regarding his antics with a jaundiced eye.[6] "What have you against me now?" Mulligan demands. Dedalus, still in mourning for his mother a year after her funeral, admits that soon after her death he had overheard Mulligan describe him as *"only Dedalus whose mother is beastly dead."* To this accusation Mulligan responds: "And what is death . . . your mother's or yours or my

own? You saw only your mother die. I see them pop off every day in the Mater and Richmond and cut up into tripes in the dissecting room. It's a beastly thing and nothing else. It simply doesn't matter."[7]

Mulligan is the true heir to Nietzsche, the dangerously charming medical student whose dissecting room experiences are all too compatible with moral nihilism. Poised to dive into the bay, he cries out "I am the *Übermensch*."[8] And like Nietzsche, he recognizes in the pagan polytheism of his beloved Greeks a religion compatible with his radical atheism: "God, Kinch, [Gogarty's real nickname for Joyce, the sound of a knife-blade cutting] if you and I could only work together we might do something for the island. Hellenise it."[9]

In counterpoint to Mulligan's amoral cheerfulness, the whole opening scene is rendered through the veil of Dedalus's obsessive relationship with his mother's memory. Even the view of the bay from the tower—"a grey, sweet mother," in Mulligan's Swinburnian formulation—evokes the horror of her last days: "The ring of bay and skyline held a dull green mass of liquid. A bowl of white china had stood beside her deathbed holding the green sluggish bile which she had torn up from her rotting liver."[10] Dedalus catalogs the objects that she left behind: "Her secrets: old feather fans, tasselled dancecards, powdered with musk, a gaud of amber beads in her locked drawer."[11] She appears to him in a nightmare whose olfactory vividness continues to disturb his waking hours: "In a dream, silently, she had come to him, her wasted body within its loose graveclothes giving off an odour of wax and rosewood, her breath bent over him with mute secret words, a faint odour of wetted ashes."[12]

An English anthropologist is staying with Mulligan and Dedalus in the Martello tower, and over breakfast the two men mock his earnest search for Gaelic authenticity, presenting the old woman who brings the milk as a figure from the annals of Irish mythology. But despite their banter, Stephen's thoughts drift as he contemplates the old woman pouring the milk into their jug, fashioning her as an ancient archetype: "Old and secret she had entered from a morning world, maybe a messenger. She praised the goodness of the milk, pouring it out. Crouching by a patient cow at daybreak in the lush field, a witch on her toadstool, her wrinkled fingers quick at the squirting dugs."[13]

Everywhere, the figure of the mother haunts Dedalus. The second chapter takes place in the school where he teaches classics to a class of inky schoolboys. One pupil approaches him afterwards for help with

his mathematics homework, and Dedalus surveys him with a combination of disdain and reluctant kindness: "His tangled hair and scraggy neck gave witness of unreadiness and through his misty glasses weak eyes looked up pleading." After helping him with his sums he considers the boy again:

> Ugly and futile: lean neck and tangled hair and a stain of ink, a snail's bed. Yet someone had loved him, borne him in her arms and in her heart. But for her the race of the world would have trampled him underfoot, a squashed boneless snail. She had loved his weak watery blood drained from her own. Was that then real? The only true thing in life?[14]

In Mulligan's Omphalos, Nietzsche's new tragic age has arrived, and now Dublin can take on the mythic dimension of the old epics. As T. S. Eliot famously put it:

> In using the myth, in manipulating a continuous parallel between contemporaneity and antiquity, Mr. Joyce is pursuing a method which others must pursue after him. . . . It is simply a way of controlling, of ordering, of giving a shape and a significance to the immense panorama of futility and anarchy that is contemporary history. . . . It is a method for which the horoscope is auspicious. Psychology (such as it is, and whether our reaction to it be comic or serious), ethnology, and the *Golden Bough* have concurred to make possible what was impossible even a few years ago. Instead of the narrative method, we may now use the mythical method.[15]

But what Eliot did not acknowledge was that the archaeology of Bronze Age Greece had already been avidly pursuing the mythical method as a way of controlling, ordering, and giving shape to prehistoric remains. Under the pervasive influence of "ethnology and the *Golden Bough*," Evans had arrived at the same idiom as Joyce, and filled the vacuum left by the death of god with the same maternal archetype.[16] Joyce was to Evans what Nietzsche was to Schliemann: the much younger compatriot whose unprecedented gift for the music of language wrought from the same materials an oracular art of the highest order, one that defined a new relationship between past, present, and future.

The Decline of Crete

The same year as *Ulysses* was making its first tortuous foray out into the world, the world historian Oswald Spengler published his magnum opus, *The Decline of the West*. Spengler is one of those writers whose fame during their lifetime is equaled by their posthumous obscurity. A classicist by training, and an ardent Nietzschean by inclination, he worked as a schoolteacher for a few years, before his mother's death in 1911 enabled him to give up his profession and stake his small legacy on the pursuit of a literary career. His first attempts at fiction comprise a series of unfinished fragments, all sounding variations on a single theme: the impossibility of an artist fulfilling his creative potential in a decaying culture. Perhaps it was to further affirm this conviction of his own thwarted artistic genius that Spengler began to develop the theme of cultural decline into a massive historical work.

During years of self-enforced isolation, Spengler devoured hundreds of books in art, literature, history, science, philosophy, and archaeology. Hoping to shed light on what he saw as the lamentable degeneration of his own times, he asked himself if there were patterns in cultural decay whose recognition would facilitate diagnosis, prognosis, and even possibly cure of the cultural ills of the twentieth century. The framework within which he investigated the degeneration of the culture was the one Evans had used to organize the chronology of *The Palace of Minos*: the division of human history into the biological phases of birth, growth, maturity, and decay. Like Joyce, Spengler was using the mythical method to give "shape and significance to the immense panorama of futility and anarchy which is contemporary history." The result was a strange fusion of optimism and pessimism: he subscribed to the cult of strife that animated many of his contemporaries, agreeing that war was a force for national renewal and pacifism a disease, but as early as 1911 he predicted that Europe was plunging headlong into a conflagration that would amount to cultural suicide for all the nations concerned.[17]

When the First World War did finally break out Spengler attempted more than once to sign up for active duty, but his migraines and weak lungs barred him from enlisting, and he spent the years of the war working on his book, the first volume of which appeared in 1918. In the end, Germany's defeat created the ideal climate for the reception of Spengler's epic and in 1919—dubbed by some historians the "Spengler

Year"—he found himself with an unlikely best seller on his hands. By
1926 his dense, gloomily metaphysical world history had been trans-
lated into every major European language and over a hundred thousand
copies had been sold to a public eager to contemplate the imminent
downfall of Western civilization.

Spengler maintained that cultures not only follow something akin to
the biological life span of organisms, but that they each possess a dis-
tinctive character akin to a soul. In a chapter entitled "The Soul of the
City," he contrasted the respective characters of Knossos and Mycenae
in terms that would become hugely influential. Knossos was decadent,
old, feminine, elegant, and smug, while Mycenae was young, thrusting,
crude, and barbarous. The Mycenaeans were humbled by the etiolated
civility of their southern neighbors while hoarding the secret knowl-
edge that the future was theirs:

> About the middle of the second millennium before Christ, two
> worlds lay over against one another on the Aegean Sea. The one,
> darkly groping, big with hopes, drowsy with the intoxication of deeds
> and sufferings, ripening quietly towards its future was the Myce-
> naean. The other, gay and satisfied, snugly ensconced in the treasures
> of an ancient Culture, elegant, light, with all its great problems far
> behind it, was the Minoan of Crete. . . . I see it before me: the humil-
> ity of the inhabitants of Tiryns and Mycenae before the unattainable
> *esprit* of life in Cnossus, the contempt of the well-bred of Cnossus
> for the petty chiefs and their followers, and withal a secret feeling of
> superiority in the healthy barbarians, like that of the German soldier
> in the presence of the elderly Roman dignitary.[18]

Under the terms of this dichotomy, Mycenae always played the part
of Germany with Minoan Crete occupying the role of a decadent Med-
iterranean culture: "As it was . . . between Cnossus and Mycenae, so it
was between the Byzantine court and the German chieftains."[19] And
again: "That which stands on the hills of Tiryns and Mycenae is *Pfalz* and
Burg of root-Germanic type. The palaces of Crete—which are not kings'
castles, but huge cult buildings for a crowd of priests and priestesses—
are equipped with megalopolitan—nay, Late Roman—luxury."[20] Myce-
nae is by implication Teutonic, Protestant, spiritual, forward-looking,
masculine, and vigorous, while Crete is Latin, Catholic, feminine, ex-
hausted, backward-looking, materialistic, and decadent.

Spengler's set of culture soul correspondences exposes the current of rather sinister optimism that tended to flow under the superficial despondency of degeneration theory. If only the fatherland could recover a little of its god-given natural vigor, he hinted, victory was assured. Accordingly, any German, Englishman, or American humbled by the rich cultural heritage of Italy, Greece, or France could take comfort in the inevitable turning of the tables against the tired old south in favor of the vigorous north. Characterizing Cretan architecture as "accustomed to catering for the most pampered taste in furniture and wall decoration, and familiar with lighting, water circulation, staircases and other suchlike problems" Spengler compares the Minoan aesthetic unfavorably with the Mycenaean:

> In the one, the plan of the house is a strict life symbol; in the other, the expression of a refined utilitarianism. Compare the Kamares vases and the frescoes of smooth stucco with everything that is genuinely Mycenaean—they are through and through the products of an industrial art, clever and empty, and not of any grand and deep art of heavy, clumsy, but forceful symbolism like that which in Mycenae was ripening towards the geometric style. It is, in a word, not a style but a taste. . . . A Mycenaean palace is a promise, a Minoan something that is ending.[21]

Spengler's view of Minoan Crete as Latin and decadent resonated perfectly with the nihilistic temper of the interwar years. In the spring of 1929, when Evans's reconstructions of the palace were entering their final and most extravagant phase, Evelyn Waugh read *Decline of the West* on a Mediterranean cruise and arrived at Knossos primed by Spengler to file a darkly hilarious view of the Minoans: "I think that if our English Lord Evans ever finishes even a part of his vast undertaking, it will be a place of oppressive wickedness," he announced, satirizing the Cretan tendency to elevate Evans from "Sir" to "Lord." "This squat little throne . . ." he went on, "is not the seat of a lawgiver nor a divan for the recreation of a soldier; here an ageing despot might crouch and have borne to him, along the walls of a whispering gallery, barely audible intimations of his own murder." Waugh also had the aesthetic acumen to remark that the Gilliérons had "tempered their zeal for accurate reconstruction with a somewhat inappropriate predilection for covers of *Vogue*."[22]

Another rendering of decadent Knossos took the form of a novel by the Russian writer Dmitri Sergeevich Merezhkovsky (1865–1941) entitled *The Birth of the Gods*. Merezhkovsky had read *The Birth of Tragedy* at a susceptible age and became a popularizer of Nietzsche in Russia, later devoting his energies to an attempted reconciliation between the extreme individualism of Nietzschean paganism and the moral code of Christianity. Crete, with its tradition of the mortal god, became a focus for this enterprise: "The peoples are many," Merezhkovsky intones in the introduction to the English edition of *The Birth of the Gods,* "but the mystery is one—the mystery of God who dies and rises again from the dead." The book is a fictional rendering of Minoan Crete featuring vegetarian priestesses of the great goddess, lesbian bull-leapers, a lily crown with peacock feathers, and a wealth of other archaeological details derived from Evans's reconstructions. The plot concerns one of the priestesses, who rebels against the human sacrifice demanded by the mother goddess at the bull sports. The final sentence sees her pondering the reason for the sacrifices that she has witnessed: "Now she knew what it was for: that He might come. Mother Earth, in the agony of childbirth—the agony of human souls—was giving birth to God."[23]

Perhaps the most debauched and dystopian of Minoan fictions came from the pen of Nikolas Kazantzakis, the Greek writer who later achieved worldwide fame for *Zorba the Greek*. Based on an "apocalyptic conflation of ideas from Schopenhauer, Nietzsche, Spengler, and Marx,"[24] Kazantzakis saw in the fiery end of decadent Minoan Crete a horrible enactment of all his fears for modernity. His *The Odyssey: A Modern Sequel*, is based on the premise that domestic bliss on Ithaca quickly bored Odysseus, who set off again on his wanderings, this time not intending to return. The hero goes through Sparta, picks up Helen, and takes her off to Crete. Here they witness a bull-leaping ritual in the Theatral Area with an obscene denouement far from anything dreamt up by Evans. The king orders his own daughter to face the bull alone—a certain death sentence—and she ends up impaled on a huge bronze double axe. The masses are then excluded from the palace precincts and a nightlong orgy of sex, bestiality, and the consumption of raw flesh ensues, at the end of which a slave revolution, led by another of the king's daughters, brings the palace civilization to a violent end.

Achilles' Shield

If 1920s Knossos was characterized by its decadence, the 1930s saw
the emphasis shift decisively to the pacifism of Minoan civilization. In
the middle of the decade, in a clear nod to the discoveries of Cretan
archaeology, Pablo Picasso produced a series of etchings and gouaches
that brought the Minotaur into the bullring. Picasso's fascination with
the bullring was lifelong, and his earliest extant drawing, made when he
was ten years old, is of a bullfight. The myth of the Minotaur was of ur-
gent interest to the surrealists, and it was André Masson who suggested
"Minotaure" as the title of a new art review, which ran from 1933 to 1939,
with Picasso contributing a collage of the Minotaur as the first cover.
When it turned out that the two themes were united in the famous
bull-leaping frescoes from Knossos, Picasso responded with a series
of depictions of the Minotaur clearly indebted to Evans's excavations.

In his book on Picasso's famous *Guernica* mural, the art historian
Anthony Blunt comments that the artist's depictions of bull-fighting
scenes underwent a metamorphosis in 1934, when the male "matador is
replaced by a woman" and the Minotaur begins to "play an important
part in Picasso's mythology."[25] Blunt does not connect these changes to
the material from Knossos, but the presence of female bull-leapers in
conjunction with Cretan mythology suggests that Minoan art was the
source. In a 1934 etching, a bare-breasted woman is seen tumbling acro-
batically over the back of a bull, whip in hand, an eroticized version of
the famous cowgirl frescos. Unlike her boyish, athletic Knossian coun-
terparts, the bull-leaper in this rendering is full breasted and ripe for
ravishment, carried by the bull toward her erotic destiny rather than
outwitting it in a virtuosic display of skill and courage. This image was
followed by a series of etchings of blind Minotaurs, led along by flower-
bedecked Ariadnes, including an enchanting one in which a blossom-
wreathed girl watches the monster sleep behind a diaphanous curtain.

A number of gouaches painted in 1936 all featured a Minotaur with
a human face. In the one closest to Evans's Minoan Crete, the mata-
dor is a slim, bare-breasted girl on horseback who wheels round the dy-
ing Minotaur in triumph, brandishing a spear. On the left of the field,
Ariadne, in her wreath of flowers, gazes at the scene from behind the
dark transparent sail of the boat that will carry her away from Crete.
She raises her hands in a gesture of benediction as the Minotaur stares

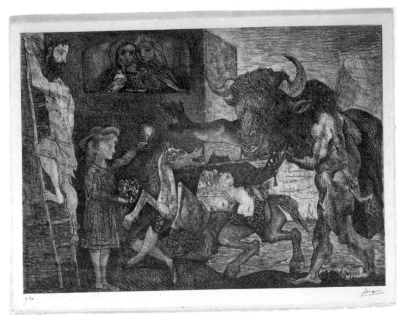

FIGURE 19. Pablo Picasso, *Minotauromachia*, 1935. By permission of the
Artists' Rights Society.

at her in his death agony. Theseus, meanwhile, quietly gathers in a net
of fish, his role as conqueror of the beast usurped by the Knossian cow-
girl on her horse.

The great *Minotauromachy* etching of 1935, a dense field of cross-
hatched figures, makes more explicit the themes and symbols of the
Minotaur series. Here the beast advances from the right brandishing a
sword. On the left, a young girl, a version of the Ariadne figure, holds up
a taper from whose light the monster shields his face with a huge paw.
In the middle, the bare-breasted female toreador lies on the back of a
galloping horse. Above the girl with the candle, two women and two
doves are framed by a window, while on the extreme left a bearded man
escapes the scene by climbing a ladder. In the background a tiny boat
with a single sail can be seen against the horizon. As Anthony Blunt says
of this image: "The exact meaning of every symbol may not be clear, but
Picasso has rarely given such forceful expression to the general theme
of the checking of evil and violence by truth and innocence."[26]

The various elements of the *Minotauromachy* etching would soon
metamorphose into Picasso's most famous work: his response to the

German annihilation of the Basque town of Guernica.[27] The imploring woman in the center of the mural who holds out a candle is the descendant of the Ariadnes of the earlier images—the feminine principle who might momentarily tame the Minotaur of human violence, but who can now do nothing but helplessly beseech the unstoppable forces hurtling the world toward war.

The most nakedly pacifist response to Knossos was penned by Henry Miller, whose *Colossus of Maroussi* chronicles a trip to Greece undertaken during the summer of 1939, when the mythical land was made all the more luminous by the shadow of impending war. Miller was an admirer of Spengler, and at Knossos he distilled the Spenglerian view of the contrast between the Minoans and the Mycenaeans into a sermon on pacifism and civilization. In marked contrast to Waugh's mischievous characterization of the palace as a place of "oppressive wickedness," Miller displays a touching fidelity to Evans's political agenda. Shrugging off the controversy about the restorations—"However Knossus may have looked in the past, however it may look in the future, this one which Evans has created is the only one I shall ever know. I am grateful to him for what he did."—he documents the lessons of the site:

> Knossus in all its manifestations suggests the splendour and sanity and opulence of a powerful and peaceful people. It is gay—gay, healthful, sanitary, salubrious . . . far closer in spirit to modern times . . . than other later epochs of the Hellenic world. . . . I felt, as I have seldom felt before the ruins of the past, that here throughout the long centuries there reigned an era of peace. . . . The religious note seems to be graciously diminished; women played an important, equal role in the affairs of this people; a spirit of play is markedly noticeable. In short, the prevailing note is one of joy.[28]

With the Second World War already looming, pacifist Knossos lost its whiff of nihilistic decadence and began to look like an unambiguous paradise.

Freudian Archaeology

Perhaps the most complex appropriation of Minoan Crete on the eve of the Second World War was its integration in the historical scheme of *Moses and Monotheism*, Sigmund Freud's prophetic 1939 meditation on

the roots of anti-Semitism. In the Freud Museum in Hampstead, the dark blue spines of *The Palace of Minos* can still be seen on the shelves of the famous consulting room, surrounded by the rest of Freud's extensive archaeological library and his lovingly amassed collection of antiquities. For the founder of psychoanalysis, the excavation of Knossos held a very peculiar significance. He averred that Minoan Crete was not only an early stage in the development of European culture, but also that it corresponded to a childhood stratum in the European psyche. According to Freud, the ancient Cretans lived through and also somehow "laid down" the pre-Oedipal stage of the whole European race.[29]

Freud's commitment to recapitulative theories of psychic development has long been a source of embarrassment to his admirers. Minoan Crete in its turn was something of an embarrassment to Freud, who could never quite figure out how to hammer the great mother into his overwhelmingly patriarchal historical scheme. This double difficulty lends a certain riddling sketchiness to Freud's comments on Evans's excavations, but, thin though they are, they repay amplification. His thoughts on Crete not only represent one of the more eccentric and symptomatic modernist responses to the reconstruction of the Minoan world, they also potentially render more comprehensible an aspect of Freud's thought that has baffled many commentators.

When Freud first heard news of the identification of Knossos he wrote excitedly to his friend Wilhelm Fliess: "Have you read that the English excavated an old palace in Crete, which they declare to be the real labyrinth of Minos? . . . This is cause for all sorts of thoughts too premature to write down."[30] It took over thirty years for Freud's thoughts on Knossos to mature. In 1931, inspired by the fact that Minoan religion seemed to center upon the worship of a mother goddess, he linked ancient Crete with the period in a girl's life when her primary attachment is to her female parent, commenting that his discovery of the feminine pre-Oedipal stage had "come as a surprise, like the discovery of the Minoan-Mycenaean civilisation behind the civilisation of Greece."[31]

This simile was but one example of a long-standing motif in his writings in which the relationship between archaeology and psychoanalysis was an analogical one. In the case history that Freud characterized as his "first full-length analysis of a hysteria," he compared his procedure "of clearing away the pathogenic psychical material layer by layer," to "the technique of excavating a buried city."[32] Of all the analogies that

he and his coauthor Josef Breuer deployed to explain their "talking cure," this seemed the most appropriate. Psychoanalysis and archaeology shared the same backward chronology. A neurosis or a hysterical symptom was like an archaeological tell—a mound of memories that had to be peeled away, layer by layer, starting from the present and working back to the past, in search of a primal scene.

Freud returned to the archaeological analogy again and again in his writings, deploying it to a range of ends. He likened the psychoanalyst to an explorer who excavates some remote ruins (the unconscious) and makes the "stones speak."[33] Hysterical symptoms were likened to the characters of a pictographic script, with psychoanalysis functioning as an excavated bilingual inscription that unlocked their meaning.[34] When a patient's primal scene had to be reconstructed from fragments of memories, Freud compared this with archaeologists' piecing together of vases or frescoes.[35] He amassed a large collection of antiquities, which he kept in his consulting room, and would sometimes point to an artifact during a session in order to clarify for the patient his theory of the burial of painful or obscene memories.[36] His most extended use of the analogy between the psychoanalyst's reconstructive methods and that of the archaeologist appears in his 1937 essay "Constructions in Analysis" and seems to be based on Evans's rebuilding of Knossos, completed six years before:

> [J]ust as the archaeologist builds up the walls of the building from
> the foundations that have remained standing, determines the number
> and position of the columns from depressions in the floor and recon-
> structs the mural decorations and paintings from the remains found
> in the débris, so does the analyst proceed.[37]

Surely no archaeologist other than the famously extravagant Evans was actually building up the walls of his site "from the foundations that remained standing"?

Although the relationship between the two disciplines was usually elaborated in Freud's writings through the workings of metaphors and similes, archaeology was in truth far more than just a convenient analogy for psychoanalysis. The archaeological excavation functioned as a model for the psychoanalytic investigation precisely because Freud's model for the workings of memory was actually stratigraphical. In an 1896 letter to Fliess, Freud wrote, "As you know, I am working on the

assumption that our psychic mechanism has come into being by a process of stratification." He goes on to explain that each memory is laid down not just once but many times, "subjected from time to time to a *rearrangement* in accordance with fresh circumstances." Neurosis arises, under the terms of this model, when the rearrangement of a memory fails to take place. Then the patient deals with the repressed material "in accordance with the psychological laws in force in the earlier psychic period, and along the paths open at that time." "Thus," he concludes, "an anachronism persists . . . we are in the presence of 'survivals.'"[38]

This passage proposes a dynamic model of the stratigraphical psyche in which memory is always subject to revision. Freud also subscribed to a more ponderous and contentious version of psychic stratigraphy—the concept of inherited memory. This theory postulated that momentous events in human history laid down inheritable physical traces that accumulated through the generations. Apart from anything else, this concept had the effect of making the layers of the individual psyche even more like the successive deposits in an archaeological tell.[39] Freud's first major excursion into anthropology, his 1913 *Totem and Taboo,* claimed that the putative resemblance between savage religion, neurotic obsession, and childhood fantasy could be laid at the feet of inherited memory. In a passage added in 1919 to his *Interpretation of Dreams,* he demonstrated how close was the analogy between archaeology and psychoanalysis under the terms of the inherited memory concept:

> Dreams and neuroses seem to have preserved more mental antiquities than we could have imagined possible; so that psychoanalysis may claim a high place among the sciences which are concerned with the reconstruction of the earliest and most obscure periods of the beginnings of the human race.[40]

These ideas surfaced again in his final book, *Moses and Monotheism.* After sketching the history of the Jewish people using the psychoanalytic vocabulary of "latency" and "repression," Freud claimed that the outlines of this history resembled the development of an individual neurosis. From pointing out this resemblance it was but a short step to conclude that: "Early trauma—defence—latency—outbreak of neurotic illness—the partial return of the repressed. . . . The reader is now invited to take the step of supposing that something occurred in the

life of the human species similar to what occurs in the life of individu-
als."[41] In Freud's scheme, the family of races that made up the European
world could be psychoanalyzed like any ordinarily neurotic family. Anti-
Semitism had its roots in the sibling envy felt by the Nordic races
toward the favored son: "jealousy of the people which declared itself
the first-born, favourite child of God the Father, has not yet been sur-
mounted among other peoples even today."[42] It is an oddly literal ren-
dering of Spengler's central thesis—that nations, peoples, and cities
experienced lifecycles analogous to those of individual organisms. And,
like Spengler, Freud put this concept to prophetic use. If the latency
period in individuals and in races had exactly the same structure, it fol-
lowed that the tools of psychoanalysis could be used to *predict* the out-
come of archaeological excavation:

> With our present psychological insight we could, long before
> Schliemann and Evans, have raised the question of where it was that
> the Greeks obtained all the legendary material which was worked
> over by Homer and the great Attic dramatists in their masterpieces.
> The answer would have had to be that this people had probably expe-
> rienced in their prehistory a period of external brilliance and cultural
> efflorescence which had perished in a historical catastrophe and of
> which an obscure tradition survived in these legends. The archaeolog-
> ical researches of our days have now confirmed this suspicion, which
> in the past would certainly have been pronounced too daring. These
> researches have uncovered the evidences of the impressive Minoan-
> Mycenaean civilisation, which had probably already come to an end
> on the mainland of Greece before 1250 B.C. There is scarcely a hint at
> it to be found in the Greek historians of a later age: at most a remark
> that there was a time when the Cretans exercised a command of the
> sea, and the name of King Minos and his palace, the Labyrinth. That
> is all, and beyond nothing has remained but the traditions which were
> seized on by the poets.[43]

It is a slippery argument. Freud asserts that he *could* have predicted
the archaeological discoveries of Schliemann and Evans if only he had
been in possession of "our present psychological insight" before they
started to dig, and then hints that the archaeological confirmation *did*
in fact come after the psychoanalytic prediction: "The archaeological
researches of these days have now confirmed our suspicion."

Freud had been working on his inherited memory theory for many years, but in *Moses and Monotheism* he made a significant addition to his recapitulative racial history. In an attempt to grapple with the implications of Evans's excavations, matriarchy and mother goddesses made a belated and rather half-hearted appearance in his historical scheme, sandwiched awkwardly between two periods of absolute male domination: "A fair amount of the absolute power liberated by the removal of the father passed over to the women; there came a period of *matriarchy*."[44] And again: "At a point in this evolution which is not easily determined great mother goddesses appeared, probably even before the male gods, and afterwards persisted for a long time beside them."[45] The brevity of his treatment of the matriarchal stage seems to betray a certain difficulty with the concept, and Freud's only sustained consideration of Minoan religion was consigned to a lengthy footnote:

> It seems that, in those obscure centuries which are scarcely accessible to historical research, the countries around the eastern basin of the Mediterranean were the scene of frequent and violent volcanic eruptions, which must have made the strongest impression on their inhabitants. Evans assumes that the final destruction of the palace of Minos at Knossos too was the consequence of an earthquake. In Crete at that period (as probably in the Aegean world in general) the great mother-goddess was worshipped. The realization that she was not able to protect her house against the assaults of a stronger power may have contributed to her having to give place to a male deity, and, if so, the volcano god had the first claim to take her place.[46]

Under the terms of the inherited memory concept, the traumatic realization that the Great Mother Goddess could not protect Minoan Crete from destruction, and the consequent transfer of allegiance to the volcano god, would—through some Lamarckian process—have left traces in the brains of modern individuals. The psychic phases to which these events correspond are clearly the ones described in Freud's essay "Female Sexuality." Here he described "two facts which have struck me as new: first, that the great dependence on the father in women merely takes over the heritage of an equally great attachment to the mother and, secondly, that this earlier phase lasts longer than we should have anticipated."[47] In the earlier essay the psychological discoveries are merely *likened* to the "discovery of the Minoan-Mycenaean civiliza-

tion"; by the time of the writing of *Moses and Monotheism* Freud has strengthened the link to a direct causal one with predictive powers: Minoan civilization, and the trauma that brought it to an end, actually *laid down* the psychic strata of the pre-Oedipal stage and its termination.

Freud's inheritable memory concept has caused much consternation. The historian Yosef Yerushalmi deplores the theory as absurd and characterizes the assumptions underlying *Moses and Monotheism* as "structures of thought and modes of discourse as alien as those encountered by an anthropologist studying the Bororo or Nambikwara tribes in the Brazilian unknown."[48] Peter Gay, author of *Freud: A Life for Our Time,* calls it "one of Freud's most eccentric and least defensible intellectual commitments."[49] Freud's friend, colleague, and hagiographer, Ernest Jones, records a talk in which he "begged" the master to purge *Moses and Monotheism* of the passages concerning inherited memory "since no responsible biologist regarded it as any longer tenable."[50] And, perhaps jolted by Jones's vehemence, Freud himself confessed that he was quite aware that the theory had fallen from grace, but admitted that he needed this unfashionable doctrine for his historical scheme to work:

> My position, no doubt, is made more difficult by the present attitude of biological science, which refuses to hear of the inheritance of acquired characteristics by succeeding generations. I must, however, in all modesty confess that nevertheless I cannot do without this factor in biological evolution.[51]

The indispensability of the inherited memory concept for Freud becomes a lot less puzzling when viewed in relation to his archaeological obsessions. In the case of Evans's excavations, a record exists of an analytical encounter in which Minoan Crete played a pivotal role. In Freud's 1933 analysis of the writer Hilda Doolittle, his diagnosis linked her obsession with Greek islands to her mother fixation, suggesting that her symptoms arose from a pathological regression to the Minoan/pre-Oedipal stage of the racial psyche. Their interaction, mediated by a shared enthusiasm for Evans's work, demonstrates how an analysand who shared his archaeological interests could provide what appeared to be *clinical evidence* for the inherited memory concept.

It is important to note that neither H.D. nor Freud ever made it to Crete, although the poet did get close to the island during a cruise she

took in the spring of 1932, prevented only by inclement weather from
going ashore. For Freud, Greece had always been an infinitely desir-
able destination, but he recorded that when he finally made it to the
Athenian Acropolis in 1904 he fell prey to a welter of uncomfortable
emotions. The psychoanalytic relationship with to Minoan archaeol-
ogy was mediated entirely by the paper labyrinth of Evans's lavishly il-
lustrated writings.

Psyche's Muse

Freud's partner in his archaeological *folie à deux* might stand as the type
specimen of the "Nietzsche triumphant" generation. Hilda Doolittle,
aka H.D., was caught up in the heady atmosphere of Dionysian mod-
ernism when she was only in her teens. Cast by some of the famous
writers of her time as a living reincarnation of the spirit of preclassical
Greece, H.D. was the muse who spoke, a typewriting oracle of post-
Nietzschean paganism, who enacted her neoprimitivism with none
of the sense of irony or slightly queasy ambivalence so common in her
peers and forerunners. It is exactly this lack of distance that makes
H.D.'s quarter-century journey through the concrete labyrinth so ex-
ceptionally revealing of the thwarted aspirations and tragicomic con-
tradictions of Minoan modernism.[52]

Born in 1886 in Bethlehem, Pennsylvania, Hilda Doolittle spent her
adolescence in the company of an ardent band of fellow travelers who
were to become some of the most important poets of their generation.
When she was fifteen she met Ezra Pound at a Halloween party—"One
would dance with him for what he might say"[53]—and a few years later,
when she was at Bryn Mawr, their friendship turned to romance. In
1907 Pound presented H.D. with a book of poems, the first literary
celebration of her physical charisma. Couched in the language of the
troubadours, he used pagan symbolism to describe her, in accord with
his nickname for her, "Dryad": "child of the grass," she "swayeth as a
poplar tree," with "some tree-born spirit of the wood about her."[54] At
Bryn Mawr, H.D. met Marianne Moore, who later recalled seeing her
for the first time on campus: "I remember her eyes which glittered and
gave me an impression of great acuteness . . . I remember her leaning
forward as if resisting a high wind . . . I thought of her as an athlete."[55]
H.D.'s height—she was five foot eleven—and those glittering eyes also
attracted the attention of Ezra Pound's fellow student at the University

of Pennsylvania, William Carlos Williams, who recalled her with mixed affection and exasperation in his autobiography, remembering her "almost silly unwillingness to come to the point" and her "young girl's giggle and shrug which somehow in one so tall and angular seemed a little absurd."[56]

In 1911, after breaking off their engagement, first Pound and then H.D. went to England. The following year, acting as the London scout for *Poetry* magazine, Pound made the famous founding gesture that brought into being the Imagist movement. Seizing a sheaf of Doolittle's early poems, he made a few revisions, penned at the bottom of one of them "H.D.—Imagiste," and sent them off to Chicago for publication. The first poem she had given Pound to read was "Hermes of the Ways," a spare lyric inspired by an invocation to Hermes that had been included in a *Greek Anthology* he had given her: "Wind rushes / over the dunes / and the coarse, salt crusted grass / answers."[57] H.D. looked the part with her height and grey eyes, and her austere verse fed a new appetite for an ancient Greece shorn of nineteenth-century floweriness. Even the most satirical accounts of her self-presentation in this period read as grudging tributes:

> Her pose was perfect. What could be more fascinating than that studied artlessness . . . Her features were Greek, they suggested a hamadryad . . . Her whim to be the first to speak was always respected. The result was an effective hush into which her rich, low, beautifully modulated voice might break like a note from an organ.[58]

In 1913 she married fellow writer Richard Aldington, but the union quickly turned into one of the period's many disastrous experiments in free love. A premature labor brought on by the news of the sinking of the *Lusitania* in 1915 resulted in the stillbirth of her first child. Soon afterward Aldington took a mistress, encouraged in this by H.D., who wanted to be free to pursue her passion for D. H. Lawrence. Then, in 1916, when Aldington went to war in France, H.D. went to Cornwall to stay with critic and composer Cecil Gray, and in 1918 became pregnant for the second time. Toward the end of the pregnancy, against the background of her divorce, she heard the news of her brother's death in France and her father's death from shock. D. H. Lawrence, who had been furious when H.D. actually followed his prescriptions for sexual freedom by becoming Gray's lover, broke off all communication with

her upon learning of her pregnancy. In 1919, H.D. succumbed to the influenza epidemic and nearly died.

It was a woman friend, the writer Bryher (shipping heiress Winifred Ellerman) who found H.D. in 1919, in a room in Ealing, alone, heavily pregnant and in an advanced state of double pneumonia. "If I could walk to Delphi," H.D. told her, "I would be healed."[59] The baby was born, a daughter whom H.D. named Perdita. Mother and child both survived, but after the birth H.D. suffered a nervous breakdown and Bryher swept her off to Greece on one of her father's ships, leaving the baby behind. H.D. was to be cushioned by the other woman's enormous wealth for the rest of her life, but the relationship was a profoundly ambivalent one. Accepting the support of someone whose passion she did not reciprocate, she became, to all intents and purposes, a closet heterosexual.

One of the people whom H.D. turned to in the period between her first pregnancy and her second was the sexologist Havelock Ellis. Ellis's descriptions of H.D. in his autobiography—she is masked under the moniker Person—are some of the most extreme of all the over-wrought responses to her physical allure: "Even as in her form the virginal and the maternal were marvelously united into a harmony of adolescent youth, so it was in her spirit."[60] In keeping with the turn-of-the-century practice of invoking ancient Greece in order to license unorthodox sexual practices, Ellis reserved his most rapturous descrip-tion for that ecstatic moment when H.D. complied with his request that she urinate on him:

> [T]he form before me seemed to become some adorable Olympian
> vase, and a large stream gushed afar in the glistering liquid arch,
> endlessly, it seemed to my wondering eyes, as I contemplated with
> enthralled gaze this prototypal statue of the Fountain of Life, carved
> by the hands of some daring divine architect.[61]

Perhaps because her role as a muse imposed a certain totalizing dis-cipline on her experience of the new tragic age, H.D. resolved the con-tradictions of Dionysian modernism entirely from within her mystical worldview. From the outside, the posture could sometimes look rather unimpressive, as for example under D. H. Lawrence's jaundiced but nevertheless proprietorial gaze:

... my "women," Esther Andrews, Hilda Aldington [H.D.] etc., represent, in an impure, and unproud, subservient, cringing bad fashion, I admit—but represent none the less the threshold of a new world, or underworld, of knowledge and being. . . . my "women" want an ecstatic subtly-intellectual underworld like the Greeks.[62]

The lived experience of pagan antiquity informed the scheme of H.D.'s first published novel, the 1926 *Palimpsest,* which consists of three interlocking stories, linking the deep past with the modernist present. The first is set in war-torn ancient Rome, the second fragment takes place in First World War London, and the final story unfolds in the 1920s during the excavation of an Egyptian tomb. Here the epic conflicts of ancient Greece, Rome, and Egypt bleed through to the twentieth century, like the traces of imperfectly erased characters on a wax tablet or palimpsest. For H.D., what linked the psychic traumas of the present with the historical traumas of antiquity was not an evolutionary scheme, not progress or degeneration, but repetition.

In 1925, Evans's excavations at Knossos made their first mark on H.D.'s work. Upon reading Evans's reconstruction of the Minoan soul symbol in his pamphlet on the Ring of Nestor, she was inspired to one of her most powerfully overwrought acts of poetic self-invention. In the autobiographical novel that she began to write soon after the publication of Evans's article, she narrated the story of a teenage nervous breakdown as a modernist Psyche fable, no longer featuring the silly young girl of mythology but rather the feminine soul, whose descent into the underworld and reemergence into the upper air followed the archetypal metamorphosis of the caterpillar, chrysalis, and butterfly:

> A white butterfly that hesitates a moment finds frost to break the wavering tenuous antennae. I put, so to speak, antennae out too early. I felt letting Her so delicately protrude prenatal antennae from the husk of the thing called Her, frost nip the delicate fibre of the star-fish edges of the thing I clung to.[63]

In the 1930s, at Bryher's urging, H.D. undertook to address the root causes of her psychic fragility, and went into analysis, first with Mary Chadwick in London and then briefly with Hanns Sachs in Berlin. Sachs then recommended that she go directly to the founding

father of psychoanalysis, and wrote her a letter of introduction to Freud. In February 1933, at the age of forty-seven, H.D. traveled to Vienna and booked herself into the Hotel Regina in preparation for the encounter with the master. Our knowledge of H.D.'s analysis is one-sided: we have many different accounts from her pen, but he left no record of their encounter. Bryher was paying for the sessions, and H.D. wrote to her at least once and sometimes two or three times a day.

Crete on the Couch

On March 1, 1933, H.D. went to meet Freud for the first time. In her letter to Bryher she describes arriving at the broad steps of his apartment building with "time to powder," except that "a gent with an attaché case emerged and looked at me knowingly and I thought 'ah—the Professor's last.'" The door was left open and H.D. walked in to be "moaned over by a tiny stage maid," who attempted unsuccessfully to divest H.D. of her coat. Freud—"a little white ghost"—then appeared at her elbow, and "said, 'Enter, fair Madame,' and I did and a small but furry chow got up in the other room, and came and stood at my feet." H.D. was overwhelmed to be in the presence of the great man, but the dog standing at her feet reassured her:

> God. I think if the chow hadn't liked me I would have left, I was so scared by Oedipus. I shook all over, he said I must take off my coat, I said I was cold, he led me around the room and I admired bits of Pompeii in red, a bit of Egyptian cloth and some authentic coffin paintings. A spynx faces the bed. I did not want to go to bed, the white "napkin for the head" was the only professional touch, there were dim lights, like an opium dive. . . . He said he would prefer me to recline . . . then remarked, "I see you are going to be very difficult. Now although it is against the rules, I will tell you something: YOU *WERE* DISAPPOINTED, AND YOU *ARE* DISAPPOINTED IN ME." I then let out a howl, and screamed, "but do you not realise you are everything, you are priest, you are magician." He said, "no. It is you who are poet and magician." I then cried so I could hardly utter and he said that I had looked at the pictures, preferring the mere dead shreds of antiquity to his living presence. . . . I then howled

FIGURE 20. Some of the archaeological collection in Sigmund Freud's
consulting room in Vienna. Getty Images.

some more and said that he was not a person but a voice, and that in
looking at antiquity, I was looking at him.[64]

Freud's chagrin that his latest client had preferred the "mere dead
shreds of antiquity to his living presence" anticipated the unique char-
acter of this psychoanalytic encounter. Alone of all his patients H.D.
had a relationship with archaeology that paralleled and equaled his. He
had been given a copy of her novel *Palimpsest* before their first meet-
ing, and so he was aware that she too had discovered the same set of
correspondences between past and present that he had unearthed. As
H.D. recorded in that same letter: "He said I had got to the same place
as he, we met, he in the childhood of humanity—antiquity—I in my
own childhood."

In this first letter we see H.D. and Freud energetically colluding with each other's self-mythologizing. H.D. confesses that she was "so scared by Oedipus," identifying Freud not as the discoverer of the Oedipus complex, but as the tragic hero himself.[65] Then, in response to H.D.'s declaration that he was a priest and a magician he responded that it was she who was "poet and magician," a remark that seems to have undone her completely—"I then cried so I could hardly utter" (March 1). In the context of a conversation about "race and the war" Freud then went on to give the archaeological metaphor a unique twist, in which he figured himself not as an archaeologist but as an archaeological artifact:

> We talked of race and the war, he said I was English from America and that was not difficult, "what am I?" I said, "well, a Jew—" he seemed to want me to make the statement. I then went on to say that that too was a religious bond as the Jew was the only member of antiquity that still lived in the world. He said, "in fragments." (March 1)

In his analysis of H.D., Freud's archaeological collection played a more central although less didactic role than for his other patients. During the second session he took her into the study that lay beyond the double doors, and showed her the figures which were arranged in a semicircle on his desk, his audience of deities with whom he communed while working: "He got, off his desk, an ivory Vishnu that the Calcutta psychs sent him, and dug out a Pallas, about six inches high that he said was his favourite. O lovely, lovely little old papa. I am so calm, so peaceful" (March 2). Just as his collection of antiquities moved her to tenderness, so her stories of her travels to archaeological sites, undertaken with the eye for detail of a poet and novelist, moved him: "Freud has not been to Egypt, as you know, and wept when I told him of the live scarabs in the yellow sand" (March 3). This letter was written on the evening after the third session and H.D. wrote to Bryher again the following morning, describing the convergence of her mystical vision with Freud's archaeological analysis: "It's all very uncanny, much more 'magic' than I had anticipated, a collection of green and blue antique Greek and Crete-like glass jars in another case, there is so much I can't take it all in."[66]

By March 6 Freud was claiming to have worked out an explanatory scheme to account for the mythical dimensions of her life story:

I am . . . living very cerebristically, having clicked like mad with papa, since embarking on the Scilly Isles and the Fish Notes. He looks a very wise owl and shrugs with his left shoulder–wing and says, "Ach, later, I will explain all that—it is very simple." However, I must say he is an exquisite old fish-papa and seems most excited over the life-in-myth that I seem to have had "pockets" of, what with . . . all the Greek cult and the fish experiences. (June 3)

H.D.'s "Fish Notes" and "fish experiences" referred to a cluster of events that would become the basis of Freud's diagnosis. In 1920 Bryher had taken H.D. on a Greek cruise to recover after her illness and the birth of her daughter. On the boat she met a man whom she subsequently referred to by many different names—Peter Rodeck, Pieter Van Eck, and Mr. Welbeck. She recorded that they had had a flirtation and that Rodeck (his real name) had wanted her to accompany him to Egypt or take him along to Athens. One evening she had shared a supremely peaceful moment with him on the deck of the ship during which they had seen dolphins jumping and swimming alongside. On going back down below deck she had found Bryher in an inexplicably bad mood, having been unable to find H.D. anywhere. It was also later than she had expected—the violet light and calm sea had disappeared and the porthole showed nothing but a circle of darkness. They were late for dinner and dressed in a hurry.

At dinner she referred to the dolphins and turned to Rodeck for confirmation. He seemed baffled, and gently sidestepped her question. Only later did she realize that she had imagined or hallucinated the whole incident, remaining completely unaware of her actual surroundings. H.D. would puzzle over this event for the rest of her life—maintaining, in the face of Freud's opposition, that it was not just a neurotic symptom but rather an "event out of time," a message from a transcendent realm that she would eventually associate with Minoan Crete.

On March 12 Freud announced that he had cracked the code: "Papa says he has now the outline of the "history" and the fun will begin with the Greek Cruise 1920" (March 12). Freud's diagnostic revelation, however, was interrupted by the political crisis in Vienna. Hitler's accession to the chancellorship in Germany in January 1933 had emboldened the Austrian Nazis, who began to receive supplies from across the border. Nervous at the prospect of massive Nazi victories at the elections, Austria's Chancellor Dollfuss seized the opportunity created by

a chaotic session of the national government on March 4 to suspend parliamentary activities (eight days before Hitler followed suit in Germany). The crisis came to a head on March 15 when the police occupied the parliament building while a large rally of right-wing paramilitaries assembled in the square outside.

H.D. made it to her psychoanalytic session that day and reported the next day to Bryher that "Papa talked to me yesterday about the politic situation, said they expected a "wave of it from Germany," but, as he explained, the "Austrians are really very kind people, so we do not actually expect any real danger." In an effort to reassure Bryher, who had been following the situation in the newspapers, she promised to "try to get over to Cooks as they are very, very nice and decent there, and told me they anticipated no trouble whatever, that the press abroad was making the most of any little Austrian fracas, but they themselves were absolutely calm and secure" (March 16).

After this date, H.D.'s accounts of her analysis are interspersed with reports about the worsening political situation, a surreal contrast emerging between the intricacies of psychic archaeology and the brutal contemporary realities playing themselves out on the streets of Vienna. Her report of March 19 opens with the fatalistic sentiment that "I am thinking of you constantly and worried about the 'situation,' but what can one do?" and moves on to describe how Freud "took me into the inner sanctum yesterday to show me some more of the Egyptian images . . . We had about half the hour sitting and talking over the Egyptian, I suppose this is part of the "treatment," anyhow, it is most thrilling and unexpected and links the whole thing up with Egypt, Crete, Greece" (March 19).

On March 21 their archaeological rapport seemed to reach its zenith when H.D. told Freud about Arthur Evans's Ring of Nestor pamphlet and his interpretation of the psyche symbol:

> Can you find, dear Fido, that broschure of Sir Arthur Evans, on the last analysis of some coins he found, or a ring, butterfly and chrysalis? Freud had not seen it. Did I leave it in London? If so, could you order me a new one to take to Freud? He was so excited. He has all Evans on his shelf. We got to Crete yesterday. I went off the deep end, and we sobbed together over Greece in general. He hasn't one of the little Crete snake goddess. I said, "I will get you one." He said, "Ah . . . I doubt if even YOU could do that." Now my object in life will be to starve in an attic and get him a little goddess for his collection.

He loves Crete almost more than anything and I had to tell him how we balanced there in rainbows last spring and I felt it was a promise and I would return. We are terribly en rapport and happy together. Do you happen to know how one would go about finding him a goddess? Would there be one in a private collection or are they very, very rare? Please let me know. Would you write Evans for me, he might like to know Freud has all his books, he might help one get one for Freud. (March 21)

H.D.'s claim that she would obtain a serpent goddess for Freud's collection was, as he gently pointed out, grandiose, and it might have irked Bryher to hear that the woman whom she kept in such comfortable style had conceived of the ambition to "starve in an attic." The sense of accord, however, is unmistakable. The affection that Freud felt for H.D. is well attested, and conversations such as these, discussing their shared esoteric understanding of archaeology, cemented their bond.

On March 23, Freud plunged on with his diagnosis:

> F. says I have sketched in, in the large, all the chief points of importance, he thinks, and the fun comes in the details. The "transference" was, of course, the all-important thing. He also cheered me up one day by saying that my special kind of "fixation" was not known till three years ago, so perhaps it is as well, that I was not analysed some ten years back, as I always feel I should be . . . or twenty years back. F. says mine is the absolutely FIRST layer, I got stuck at the earliest pre-OE stage and "back to the womb" seems to be my only solution. Hence islands, sea, Greek primitives and so on. (March 23)

According to this diagnosis, H.D.'s attraction to the symbols and artifacts of goddess-worshipping pre-Hellenic Greece was part of her unresolved mother complex. The fixation that "was not known till three years ago" was the pre-Oedipal stage in girls, the subject of his 1931 paper "Female Sexuality." The main symptom of her arrested development was her obsession with "islands, sea, Greek primitives and so on." In the 1931 paper Freud had likened the excavation of the pre-Oedipal stage to the discovery of "the Minoan-Mycenaean civilisation behind the civilisation of Greece." Here on his couch, however, was living evidence of a far stronger connection between the archaeological and

the psychic strata: this patient embodied the inherited memory theory that was eventually to find its way into *Moses and Monotheism.*

At this point the encounter was perfectly poised to satisfy both parties. While H.D. performed for Freud a regression to the psychic stratum of pre-Hellenic Greece, Freud, for his part, incarnated her all-encompassing mysticism by fulfilling his priestly role of museum curator, temple keeper, and reincarnation of Oedipus. Freud's stubborn adherence to the inherited memory concept was the outcome of the "prehistoric truth" that spoke through the dreams, memories, and experiences of patients like H.D. Her transcendent retranscription story—the inescapable narrative into which her life seemed to cast itself—was only ringingly confirmed by the palimpsest of Freud's consulting room, with its layering of antiquity and modernity.

The mutually self-fulfilling nature of the encounter can best be understood by triangulating the poet and the psychoanalyst with the archaeologist. For H.D., it was Freud's archaeological bent that made the experience of analysis "all séance and fortune-telling bee" (March 27). Evans's poetic, theological style was for her confirmation of the repetitious, cyclical nature of the great human drama. What better verification could she have of her grasp of the spiritual essence of antiquity than Evans's recreation of the cult of the Minoan Psyche? And what greater affirmation of her beliefs could there be than the fact that Freud himself was a keeper of the same archaeological mysteries?

For Freud as well, archaeological excavation and reconstruction was a source of scientific truth, a fixed point around which he had to construct his understanding of the relationship between past and present. His failure to apply the "hermeneutics of suspicion" to archaeological writings—did it never occur to him that it might be the archaeologist who suffered from a mother fixation?—resulted in the formation of psychoanalytic categories cut from the whole cloth of archaeological texts. Blind to the neurotic element in archaeology, he argued for an archaic element in neurosis. Freud began *Moses and Monotheism,* with its stubborn adherence to the inherited memory concept, shortly after H.D. left Vienna. Mother-fixated, goddess-worshiping ancient Crete fits awkwardly into his grand narrative of Oedipal racial neurosis, but its inclusion was necessitated by the clinical evidence for the matriarchal stage provided by his famous literary patient.

Freud's inherited memory scheme transformed Huxley's method of Zadig into a system of correspondences between past, present,

and future. Racial essences were secured in the stuff of neural tissue, ready for reanimation on the psychoanalytic couch and through the unfolding of world-historical events. His latter-day Lamarckism was the warrant for a series of prophetic analogies between individuals and large social and political groupings—the race, the city, the age. The result was an almost mystical totality of signs, a system of correspondences within which any aspect of life was intelligible in relation to a great web of parallels and resemblances, a sign that pointed away from itself in every direction. This compulsive pattern making made stratigraphy into a prophetic activity: an esoteric knowledge of the connections between the mind, the past, and the primitive, revealed a pattern in the unfolding of history that became knowledge of the future.

H.D.'s archaeological literalism invoked an even more esoteric range of archetypes and essences. After the period of perfect accord with Freud, she began to rebel against the psychoanalytic process, studying an astrological text set her by Bryher, working out everybody's horoscope and advancing her own mystical interpretation of her life story, in which she asserted—in mildly anti-Semitic terms—her metaphysical differences with Freud: "These Jews, I think, hold that any dealings with 'lore' and that sort of craft is wrong. I think so too, when it IS WRONG!!! But it isn't always. And I want to write my vol. to prove it" (March 28). As we will see, H.D. did indeed go ahead and write her "vol." It was, in fact, a series of volumes, including two epic poems, two novels, and a memoir of her analysis. In all of these works she mobilized Minoan imagery to define her opposition to Freud's biological materialism, to assert her feminism, and to give poetic form to her vision of a world without war.

The Battle of Crete

Back at the site of Knossos, the old regime was yielding to a new generation. In 1926 Evans had donated the site of Knossos and the Villa Ariadne to the British School in Athens, and appointed his loyal supervisor, Duncan Mackenzie, as the first official curator. Mackenzie's behavior became increasingly erratic, however, and in 1930 Evans reluctantly sacked him and replaced him with the man destined to become one of Crete's bravest war heroes, John Pendlebury. Evans, now nearly eighty years old, was still indefatigable, and the season of 1930

turned out to be a busy one. The reconstruction of the northwest area of the palace was completed, while fresh excavations were undertaken in the theatral area and beyond the west court.

After only five seasons on the job, new rules restricting the extracurricular activities of the curator made it impossible for John Pendlebury to carry on, and in 1935 the position went to the "tall, pacific and unworldly" Cambridge prehistorian R. W. Hutchinson, who installed himself at the Villa Ariadne with his elderly mother.[67] It was the year of Evans's last visit to Crete, which was the occasion for a huge celebration. A bust was unveiled at the entrance to the palace; he was made an honorary citizen of Candia, and, in front of a crowd numbering in the thousands, was crowned with a wreath of laurel leaves. Gesturing to the reconstructions, he addressed the gathered company in Greek:

> We know now that the old traditions were true. We have before our eyes a wondrous spectacle—the resurgence, namely, of a civilisation twice as old as that of Hellas. It is true that on the old Palace site what we see are only the ruins of ruins, but the whole is still inspired with Minos's spirit of order and organization and the free and natural art of the great architect Daedalos. The spectacle, indeed, that we have here before us is assuredly of world-wide significance. Compared with it, how small is any individual contribution! So far, indeed, as the explorer may have attained success, it has been as the humble instrument, inspired and guided by a greater Power.[68]

In this short speech Evans sounded all his favorite themes. By declaring that Knossos showed the truth in myth, he emphasized yet again the fairytale quality of his legacy. By characterizing the architecture as inspired by the spirit of order, organization, freedom, and naturalism, he claimed Crete and its antiquities for democracy and the rule of law against the rigid and despotic spirit of the Oriental tyrant. By gesturing towards the agency of a greater power, he celebrated the supernatural momentum that often seemed to guide the excavation. According to his half-sister, the only creed Evans was ever heard to utter was, "I believe in human happiness," and so we can rest assured that the power to which he alluded was not the Christian god. Perhaps the force that seemed to him to guide the "resurgence" of Knossos was nothing more than the life-worshipping spirit of the Minoans themselves, those

dancing Ariadnes in their swallowtail skirts come to remind a world bent on self-destruction of the pleasures of peace.

The year 1935 also saw the publication of the last volume of *The Palace of Minos*. The concrete labyrinth and its epic excavation report were finally completed, and Evans's work on Crete was done. He remained energetic despite his age, flying to Holland in his eighty-fifth year to gather material for a Boy Scout guide to the Netherlands, and staging an exhibition of Cretan antiquities at Burlington House. In 1938, however, his health finally began to fail. He was operated on, but never fully recovered. News of the war—"the fulfilment of the prophecies he had made and listened to in the years since 1918"—filled him with nothing but pessimism.[69]

When war first broke out, the serene round of life at the Villa Ariadne seemed to continue unchecked. Not wishing to leave the site without supervision, Hutchinson, the curator, stayed in residence with his mother, attending to the day-to-day running of the site while quietly compiling a list of Cretans thought to be loyal to the Allies. Asked what he would have done with his mother—ninety-four years old and a sufferer from rheumatoid arthritis—if the war reached Crete before they could evacuate, Hutchinson airily replied that she would have "gone up to the mountains."[70] In June 1940 they were joined at the Villa Ariadne by John Pendlebury, who had been sent to Crete by the British government to organize guerrillas in the case of an attack.

In October 1940 Mussolini invaded Greece, expecting an easy victory against an impoverished nation of a mere eight million souls, but the Italian air raids failed to break Greek morale and by November the invading army was in full retreat. Taking advantage of the breathing space, a battalion of British troops arrived in Crete to secure the anchorage in Suda Bay on the north coast.

In April 1941, Hitler stepped in where Mussolini had failed, and in a short three weeks the Nazi forces had swept triumphantly through the Balkans. On April 22 the Greek armies in Epirus and Macedonia were forced to surrender to the Germans. The next day, the Greek government announced that it was moving to Crete. Within the week, King George and his retinue arrived at what was still the grandest residence on the island, the Villa Ariadne. Hutchinson showed them around the excavations as if they were just another group of visiting notables and Otto, the royal dachshund, nosed a family of hedgehogs out of the

ruins. The royal family slept in the cool, stone-floored rooms that Evans's architect had situated underground against the heat of the Cretan summers, while the servants found accommodations in the village. On April 30 Hutchinson and his mother finally left the island on a British destroyer.

On May 20, the first airborne invasion in history got underway. "Against the deep blue of the early morning Cretan sky . . . the paratroops looked like little jerking dolls whose billowy frocks of green, yellow, red and white had somehow blown up and become entangled in the wires that controlled them."[71] Within seconds the eerie quiet was shattered by gunfire and bombs. Gliders, swooping silently in the dust clouds between the bombers, landed more German troops. The Germans were expecting to round up soldiers still in their tents, but instead they found themselves under fire from an enemy alerted to the invasion by the code-breakers at Bletchley Park.

The experimental technique of airborne invasion turned out to be a fiasco. The paratroopers were an elite division nurtured in the aftermath of the First World War when Germany was forbidden to have an air force. Denied planes with engines, the sport of gliding became a patriotic symbol of national renewal. After the Nazis came to power, teenage gliding enthusiasts were recruited into the paratroopers, awarded a special badge showing a golden plunging eagle, and encouraged to regard themselves as exceptional soldiers, training for a new and glamorous kind of warfare. Playing on the Nazi cult of youthful self-sacrifice, the parachute song opened with the lines "We are few yet our blood is wild / Dread neither foe nor death."[72] Like so many Icaruses, a high percentage of these idealistic youngsters plunged to their deaths in Crete. Some dropped to the sea and drowned; others were caught in the olive trees or shot as they struggled to free themselves from their parachute harnesses. A few had parachutes that just failed to open. The most grisly fate was reserved for the dozen or so who were impaled on the sharp stems of a stand of bamboo.

Everywhere on the island, the Cretan villagers joined in the fight using whatever weapons they could find. The Germans had never encountered such fierce civilian resistance. In one spot, as the Germans struggled out of the cactus grove where they had landed, they found themselves confronted with a group of men, women, and children armed with scythes and shotguns.[73] Some islanders armed themselves from the paratroopers' weapons containers before the Germans could

get to them, and then waited around the wells until the enemy, maddened by the Cretan heat, became desperate for water, an old trick from the days of fighting the Turks.

At Iraklion, Cretans knifed the paratroopers as they dangled from trees and beat them to death as they struggled to release themselves from the strings of their parachutes. When the German survivors attempted to break into the walled town, they were met by a division of Cretan policemen. The Cretans eventually began to run out of ammunition, and the paratroopers were able to shoot their way into the narrow streets, where the fighting continued through the hours of darkness. John Pendlebury, who had been sent by the British government to organize the Cretans into a fighting force, was in Iraklion and joined in the street battles until dawn. The German commander was forced to fall back to the southern suburbs to regroup.

By the end of the day, it looked like the Allies had the situation under control. German losses were heavy and the second phase of the attack had ended in disarray. But the defense of the island had cost the Allies everything they had, while the Germans still had reserves. Later that night a fatal misjudgment on the part of one of the exhausted Allied commanders, a veteran of the First World War, left the Maleme airfield in German hands. The tide of battle had begun to turn toward the invaders.

On the afternoon of the 21, Pendlebury decided that it was time to go out to meet his guerrilla forces to the west of Iraklion. Seizing a rifle, he made for the old Venetian gate that leads westward out of the city, with a few Cretan followers. At the gate he parted from the Cretans, arranging to meet them later at a guerrilla camp on the slopes of Mount Ida. He went on, alone with his driver. Less than a mile further on he saw a fresh wave of German paratroopers dropping to the ground. He left the car, climbed the hill to the right, and began to fire at them with his revolver. In a hand-to-hand struggle witnessed by a Greek soldier who survived, Pendlebury killed three Germans and then tried to press on westward. Kneeling at the corner of a cottage, firing at the advancing German troops, he was wounded in the right breast. The Germans carried him to a nearby house and left him in the care of two women. At eight in the morning German soldiers broke into the house, brought Pendlebury out, asked him where the English forces were, and when he refused to answer shot him dead. He was buried where he lay by the two woman who had looked after him.

Later, wanting to make sure that the most dangerous man in Crete was really gone, the Germans drove out to the spot with one of Pendlebury's Cretan followers, exhumed the body, removed the glass eye, cut a piece from the collar of his shirt and buried him again. Eventually he was interred in a nearby vineyard, where the Cretans placed fresh flowers on his grave every day. The Germans decided that the site was a source of inspiration for the resistance movement, and the body was moved again. It was only after the war that the body of John Pendlebury finally came to rest in the military cemetery at Canea (present-day Chania).

"Here I am, still alive," Evans is reported to have said, "and that young man with all his promise is gone."[74] He did not, however, outlive Pendlebury by very long. Ten days later, as Crete fell, he became ill and had to be operated on. He never fully recovered. Six months later, on the occasion of his ninetieth birthday, he was able to muster the strength to receive a deputation from the Hellenic Society. They came bearing an inscribed scroll that recalled his extraordinary career, from his early forays into Celtic antiquity, to his keepership of the Ashmolean, culminating in his exploration and interpretation of Minoan civilization. It concluded with a tribute to his "lifelong and strenuous devotion to the cause of freedom in thought and action."[75] Only three days later, he died.

⟨ VI ⟩

THE REBIRTH OF COMEDY,
1942–1949

In the years immediately following his death, Evans's archaeological pacifism took on a life of its own, assuming a burden of political and spiritual significance that would assure its survival into and beyond the Dionysian excesses of the 1960s. Two neopagan poets—H.D. and Robert Graves—were responsible for shepherding the more Dionysian fragments of Evans's Cretan pacifism across the apocalyptic wasteland of the Second World War. They were both members of the generation born in last years of the nineteenth century. Both barely survived the Great War, only to find themselves enduring the rigors of a second conflagration even more far-reaching than the first.

H.D. spent the war years in London, terrified and exhilarated in equal measure by the bombing raid that reduced much of the city to rubble. Graves had to flee his island hideaway during the Spanish Civil War and spent the Second World War in a state of rootless exile. During this time, ancient Crete became for them both a living symbol of pure opposition to the atrocities of modernity, and in the 1940s they both wrote and published major works in which the Minoan world

featured as a prelapsarian past pointing the way to a future utopia. Freed from the last vestiges of rationalism and reassembled with a magnificent poetic disregard for historical accuracy, these late modernist reconstructions of Minoan society represent both a farcical deformation and a poignant distillation of Evans's prophecies of peace.

Psyche Reborn

The story of H.D.'s continuing adventures with the Minoans exemplifies the fate of Dionysian modernism during and immediately after the cataclysm of the Second World War. As the German bombs rained down on London, H.D. and Bryher engaged the services of a Theosophist medium to conduct private séances at their flat. The terrors and privations of the Blitz in combination with the skilled attentions of a professional psychic nurtured the furthest reaches of H.D.'s irrationalism, and during this period she came into her own as a table-tapping, typewriting, neo-Delphic oracle, channeling an eternal feminine howl of protest against war. The Palace of Knossos was one of the pivotal spiritual nodes of her occult narrative, and from her scribbled notes of the séances, she hammered out a complete Minoan theology, linking her own destiny and that of the world to the rise and fall of ancient Crete. In this work her voice was undoubtedly prophetic, although perhaps not in quite the way the poet might have understood her own Pythian vocation. In conceiving of the Minoan world as a site of pure opposition to the atrocities of the Second World War, she confected a neopagan pacifism that anticipated by twenty years the exact temper of the Dionysian counter-culture of the 1960s.

For the duration of the war, H.D. lived with Bryher in a tiny flat in Knightsbridge, dragging old mattresses to the basement to sit out the air raids. It was intensely stressful, and in 1942 H.D. joined the swelling ranks of people seeking comfort and distraction in the spiritualist movement. She put her name down for a few meetings at the Institute for Psychic Investigation, a venerable organization whose headquarters were in Walton Street just around the corner from the flat. At the first meeting she met a young medium called Arthur Bhaduri, the son of an Indian father and English mother. After a few sessions at the Institute, Bryher met with Bhaduri and secured his services for a series of Friday evening séances at home.

H.D. transposed her pencil-scribbled notes of the séances into layer upon layer of text. Between 1942 and 1944 she composed a trilogy of long war poems, published by Oxford University Press as three separate booklets, in which images and insights from the sessions were woven into an archaeologically inflected meditation on war, prophecy, and survival. Beginning in November 1943 she embarked an eighteen-month correspondence with Sir Hugh Dowding, air chief marshal and fighter commander, hero of the Battle of Britain, whose 1943 spiritualist text *Many Mansions* prompted H.D. to contact him with a résumé of her own occult explorations. In 1943–1944, she wrote a spiritualist romance, never published, entitled "The Majic Ring," consisting of carbon copies of the letters to Dowding followed by further description and analysis of the séances addressed to a putative future reader. In 1945 Bryher's literary magazine *Life and Letters Today* began to publish, in serial form, the first version of H.D.'s memoir of her psychoanalysis, in which the content of the séances was subtly deployed as a counterweight to Freud's scientific materialism. After the war she began to compose a thinly fictionalized memoir of the sessions with Bhaduri called "The Sword Went Out to Sea," recently published for the first time.

A Minoan thread runs through all H.D.'s wartime works, but it is the first draft of the "Majic Ring" that makes most explicit the personal dimension of her Cretan theology.[1] It is a curiously naked text, composed in great haste—two hundred pages of typescript written in less than three months—and seems to have been produced under the pressure of a sort of mystical compulsion that did not allow for the fictionalizing typical of H.D.'s prose. The first half of the text consists of five long letters to Sir Hugh Dowding, and mostly relate scenes that H.D. took to be visions of the war hero's past incarnations, engaged in archetypal versions of the great struggle represented by the Battle of Britain. The air marshal himself was gently repressive in his response to these otherworldly communications, and eventually Bhaduri tactfully suggested that H.D. break off the correspondence and continue "the work" on her own. From thenceforth the manuscript turns into a direct report of the séances, clearly intended for publication in some form. Liberated from the preoccupation with Dowding, much of this half of the text concerns H.D's Greek past lives, at which point the narrative leaps into focus. Twenty typewritten pages are devoted to

a description and interpretation of her hallucinations on the Greek cruise of 1920, containing some passages of great immediacy and vividness, ringing with the authenticity of lived experience. Taken as a whole, the Greek theme in the "Majic Ring" constitutes the principal artistic merit of the work.

The sessions seem to have consisted of Bhaduri describing his visions, alternating with laborious spelling out of words tapped out by the spirits on a little three-legged table. Attempting to convey the rhythm of Bhaduri's mediumship, H.D. deploys the image of turning a radio, "wishing to get some idea of the time, or the head-lines of the latest news bulletin" only to get swept up "in a play or an opera or an orchestra in full swing."[2] The metaphor of twiddling the tuning knob on a radio gives a good indication of the eclecticism of Bhaduri's stories. He was assisted in his peregrinations by a Native American "guide" and the scene moves from a Viking ship to an Icelandic cave, from Egypt to Mexico to Tudor England with dizzying rapidity.

A few months into the sessions the spiritual action moves to ancient Greece. As H.D. tells it, by the time Bhaduri breaks off from one of the Viking sequences to announce that he is visualizing a "Doric Temple," even she is weary of all the time trotting, and she leans back in her chair, letting her notebook "go limp" in her lap. "A Doric temple!" she protests. "There is blue sky, a mid-Victorian Greek girl in a chiton and a spray of blossoms. There is a candy-box Greek girl and pretty half-nude Greek boy from an advertisement for soap."[3] Bhaduri, however, manages to snag her attention by announcing, "It is a play enacted in the open air," and then skillfully steers her towards a modernist vision of ancient Greece, worlds away from Victorian soap advertisements and blossom sprays. He describes the players as wearing masks, and characterizes the action of the play as "buffoonery . . . It's comic—it seems to be tragic but its comic. I don't know why it's tragic, because they are dodging about, not dancing, but the whole thing seems to be very full of action." By this time, H.D. is identifying completely with the vision, casting herself as one of the players: "Exactly," she records herself thinking, "we dodged about, we didn't dance, the whole thing was superficially full of action."[4]

Bhaduri goes on to introduce another layer of emotion to the scene: "Why do I get this tragedy? It's beautiful, you know—O—" He breaks off, and H.D. waits for his comment on the Greek vision: "I wait for the word," she says. "The word will come. I do not anticipate the word,

I do not know what the word is, but the word will be final and the word will be spoken." Finally he delivers his verdict: "Poison."[5] H.D. records herself as responding to the word with a grateful rush of recognition, supplying a wealth of emotional content and personal history to fill out this single, cryptic utterance:

> I know it all now, it's all so obvious, there is a group or circle of friends—of friends? ·· It is not a shaft struck in battle, it is some underhanded betrayal. It is comic but tragic. . . . Arthur said "poison" and the blow of the knowledge of poison administered by a friend, in a scene of hallowed beauty struck through me; but with the pain, there was a sort of exultation, "Now I *know*. Now a question has been answered." I didn't say anything, but Arthur felt how the blow reverberated . . . he tried to soften, to qualify it, "But this poison—maybe its something in the play—I mean something to do with the acting and the actors, I mean—" But he knows that I know. He says, "This is you, in Greece." I say, "Yes."[6]

The authenticity of the scene is confirmed by its grotesque elements— the players dodge about, it is "buffoonery," the small personal tragedy evoked by the word "poison" is Prufrockian in its poetic banality. H.D.'s twentieth-century "group or circle of friends—of friends?" comprised a distinguished cast of literary neotragedians—Ezra Pound, William Carlos Williams, Richard Aldington, D. H. Lawrence—each one of whom had administered to her his dose of emotional poison. Bhaduri's vision of their enacting their personal dramas on stage in ancient Greece is a paradigmatic transformation of Nietzschean neotragedy into New Age absurdity—"it seems to be tragic but it's comic."

A few weeks later, Bhaduri conveyed to H.D. that together they were to solve the mystery of the hallucinations H.D. experienced on the Greek trip of 1920. As discussed above, Bryher rescued H.D. in 1919 from her near death in the influenza epidemic, and the following spring whisked the convalescent poet off for a Greek cruise on one of her father's ships. On board, H.D. met a man—variously known in her reminiscences of the episode as Peter van Eck, Peter Rodeck, or Mr. Welbeck[7]—with whom she had a flirtation. She spent one perfect evening with him on deck watching dolphins leap out of a calm sea, but later realized that this episode had not taken place in so-called "clock time." H.D. brought the experience to Freud but he did not diagnose

it to her satisfaction, insisting that it was a dangerous symptom of her mother fixation rather than a genuine mystical experience. The sessions with Bhaduri supply a completely spiritualized interpretation, which licenses H.D. to explore the event in great detail and precision, resulting in some extremely vivid passages.

As reconstructed from the various accounts penned by H.D., it must have been a most uncanny experience. The voyage took place in February 1920 on a ship called the *Borodino*, which had been used as a supply ship during the Great War. H.D. was convalescing from her illness and the birth of her daughter (who did not accompany her on the trip), and was in a fragile state. The man with whom she fell into a shipboard flirtation—"Mr. Welbeck," in this telling—remains a shadowy figure, but in one 1935 letter she describes him in some detail, as "ten years older, an architect, ex-officer, on his way to India," who had "a very dynamic manner" and "became a symbol of everything I had not had, the perfect balance in my life and the support and the father for Perdita."[8] One radiant evening, as the *Borodino* sailed toward the Straits of Gibraltar, she found herself standing next to him at the rail of the ship. Strangely, the deep scar running along his forehead and his thick glasses had both disappeared, revealing him as extremely handsome. Together they watched as silver dolphins began to leap out of the calm water. At one point, H.D. looked up towards the horizon and saw land—a hilly coastline, very distinct, rising from the water. Overcome with the beauty of the scene, she went downstairs to the cabin she was sharing with Bryher, to urge her to come enjoy the light and the sight of land, only to find that it was later than she had thought and they had to hustle off to dinner. At the captain's table, she pressed Mr. Welbeck to tell everyone about the dolphins, but he politely evaded the question. Only very gradually did it become apparent to her that she had actually hallucinated the whole deck-rail scene.

The prominence of the episode in the "Majic Ring" is commensurate with spiritual grandiosity of her interpretation of it. The hallucination, it turns out, is nothing less than a visitation from the gods. The dolphins are the key: "It was the Dolphins who led, tradition had it, the ship of the Cretan priests to the shores of the Gulf of Corinth," she remarks, referring to the famous legend of the founding of the oracle at Delphi. "So this sign was easy enough to read. . . . It was the end of an old dispensation and the beginning of a new. The ancient cult of prehistoric Crete was to be revived in a new setting."[9] Under the terms of

this divinatory reading of the signs, Mr. Welbeck is actually standing in for no lesser personage than Apollo, "Lord of majic and prophesy and music," the god to whose cult the oracle at Delphi was dedicated. "His disguise," H.D. remarks, "was too delicate to be penetrated, though he used the timeworn properties of his ancient drama."[10] Apollo had appropriated the form of Mr. Welbeck (shucking off with suitably divine vanity the scar and glasses) in order to convey an other-dimensional message about the revival of Minoan religion.

There follows a description of the radiant calm of the violet evening and the sight of dolphins jumping in a too-perfect sea shared with a perfected Mr. Welbeck. In this neo-Cretan drama, the clipped dialogue of a 1920s cruise-ship flirtation takes on a burden of prophetic significance in absurdist contrast to its own spareness. At one point, Welbeck holds out his hand, palm downward towards the sea, and one of the dolphins, seemingly drawn up by the magnetic attraction of this gesture, leaps up above the level of the deck, before falling back into the water. "'That one,' said Mr. Welbeck, 'nearly landed.'" H.D. announces that she has been pondering the meaning of this "Delphic utterance" ever since. "In moments of depression and stagnation," she confesses, "I am apt to interpret it as a symbol of failure." If the dolphin had landed, she suggests, Apollo/Welbeck might have made her an instrument of the new dispensation, one of the poets whose task it would be to revive Minoan religion for the new Aquarian age. As it was, the dolphin did not land, and she is consigned to a role on the margins of the great spiritual transformation, granted only a momentary glimpse of "poetry, of myth, of prophesy."[11]

A more cheerful sequence follows, pivoting around Mr. Welbeck's amatory gaze. This modern Apollo may not have chosen her to ride the bridled dolphin to the shadow of Mount Parnassus, but at least he loved her. "Why yes, that was it, he loved me. This was an amazing thing. . . . I felt that Mr. Welbeck had turned, his arm lay along the deck rail, he was looking not so much at me as through me." Unable to meet "the X-ray of his regard," H.D. looks up instead at the horizon and sees land—a vision of the "islands of the blest, the islands of Atlantis or of the Hesperides." Now it is she whose oracular pronouncement comes disguised as small talk: "I said, 'But I didn't know we were so near land.' That is what I said and if his words were oracular, so were mine, for he and the dolphins had blessed me unaware and all at once the burden of mortality—the albatross—fell off into the sea."[12]

Still unable to meet the erotic challenge of Welbeck's stare, H.D. then goes below deck to bring Bryher up to share the radiant evening and the first sight of land. To her surprise it is dark in the cabin, the sea is choppy, Bryher is angry, and they are running late for dinner: "I realized now that it was later than I had imagined, for the port-hole above my upper berth showed only a dark circle were I should have been logically, looking out on a glassed-over but still recognizable series of peaked wavelets on a flat sea."[13] Bryher pulls her watch off her wrist and hands it wordlessly to H.D., who doesn't take it, but starts to fumble around trying to find suitable clothes for dinner. Still not realizing that she has hallucinated the above-deck vision, H.D. then indulges in a detailed fantasy of going down to dinner to be reunited with Mr. Welbeck, who would explain to the disgruntled Bryher about the dolphins.[14]

Mr. Welbeck is indeed at dinner, but "[h]is glasses looked more pebble-thick than ever and the scar was there."[15] Challenged by H.D. to confirm her story of the dolphin sighting—"You remember when we stood by the ship's rail—" Welbeck looks nervously over at Bryher and politely evades the question, merely finishing her sentence: "'Observing nature—' said Mr. Welbeck."[16] H.D. explains that at the time she interpreted his evasiveness as politeness to Bryher, a wish not to contradict the daughter of the owner of the boat. Only later did she realize that the question was neither asked nor answered, at which point the full mystery of the whole incident was borne in on her. It was not the earthly Mr. Welbeck who had stood there beside her on the deck; Bryher had looked all over the boat for her and not been able to find her; and somehow along the way she had lost a couple of hours of ordinary time to a waking dream. Seamlessly, she had stepped into the ordinary realm of "clock time" when she put her foot over the threshold of the stairs going down to the cabins. "Where in other words," she asks, "had 'I' been while 'I' was standing by the deck-rail?"[17]

Given the circumstances of the trip—taken in the aftermath of her desertion by all the men in her life, her near-fatal illness, her rescue by Bryher and the otherwise lonely birth of her daughter—it is hard not to read the episode as a powerful manifestation of wish fulfillment. Recalling that she had been "stricken with loneliness and despair" as the ship had left London, H.D. explains that "[a]n elbow on a deck rail and X-ray eyes that did not look so much at me as through me, had made me realize at last, that I had missed much."[18] A psychoanalytic

reading that resists H.D.'s spiritual interpretation of these events might be left with a compelling portrait of a delusional episode, carrying the burden of the heterosexual desires she repudiated by accepting Bryher's protection. Evans's Minoan theology, however, licensed an interpretation of the hallucination that affirmed her madness as divine and her hallucination as prophetic.[19]

In January 1944, H.D. seemed finally to weary of the séances and the writing. In an attempt to bring the narrative to a close, she put the pages of the manuscript in front of Bhaduri, hoping that he would supply some visions to complete the work. At the meeting on January 20, Bhaduri managed to oblige: "'[H]ere is a picture,' he says, 'There is a lagoon . . . a quiet bay or inlet and there are boats drifting on it. Here is a sort of volcanic mountain and terraces of white houses. . . . It is in the Mediterranean.'"[20] Eventually H.D. interrupts Bhaduri to ask, "Do you think it might be Crete?" and the medium replies "This is a buried or drowned civilisation that is *not known*. Yes, I think it had to do with Crete."[21] After checking with H.D., "Did they bury in jars in Crete?" he goes on to make an archaeological prophecy: "they will find things in Crete that don't seem to link up with anything else. There is a flint knife here — I think a sacrificial altar and they might find another such flint knife and then they would make this link."[22] After a brief detour to South America the session returns to Crete via a "woman with a funny garment with a tight wasp waist," and Bhaduri sums up by assuring H.D. that "this whole department that has to do with this old-old civilisation is wise and safe for you to explore."[23]

The last few pages of the manuscript draw together all the disparate scenes into a grand astrological prophecy, marching through the zodiacal ages, (which proceed in reverse order, a new one every two thousand years), to arrive at the Aquarian age that awaits in the near future. Minoan Crete occupies "the age of the great bull Taurus . . . the great age of the Labyrinth and the great age of the lovely lily-jars and the palace of Gnossos."[24] Later H.D. muses that "the old civilisation that was a related or parallel civilisation of this Minoan Crete, which we know as Troy, was defeated by the later Greek civilisation" and in an apocalyptic vein she asserts that "we are at the turn of another age or aeon. The soul, split like a garden worm, must come together again or the human race is doomed."[25]

The "Majic Ring" manuscript represents a translation of Dionysian modernism into the argot of New Age eclecticism, a transformation

forged in the crucible of war. Evans had painstakingly reconstructed the persistence of archetypal cultural forms—the Psyche symbol, the Labyrinth dance, the Dionysian chorus—providing the poets of a new tragic age with an origin story and a vastly extended sense of tradition. Now the most global war in history was threatening to break that continuity forever. With the bombs raining down on London, and Nazi generals housed in the Villa Ariadne, H.D. and Arthur Bhaduri between them compressed archaeological modernism into a series of visions, at once wispy and grandiose, within which the atrocities of industrial warfare as well as the emotional agony of more personal events could feature as part of the providential unfolding of ancient destinies.

Paradise before Eve

While H.D. was working on the "The Majic Ring," she also composed the epic trilogy of war poems in which the raw material from the séances with Bhaduri was transposed to a subtler key, resulting in work that can stand beside anything in the modernist canon. In the first two poems, the Cretan material from "The Majic Ring" is united with the Psyche symbol that H.D. borrowed from Arthur Evans to create an archetype of female defiance in the face of the insanity of war; in the final poem, the Minoan hallucination on board the *Borodino* provides the material for a dramatic, pivotal scene. In these poems the emotional narcissism of the Greek passages in "The Majic Ring" is sublimated into a higher register, distilling everything affirmative and utopian in Evans's archaeology into a savagely lyrical meditation on pacifism and violence.

The first poem of the trilogy, *The Walls Do Not Fall,* composed sometime in 1942, opens by drawing a parallel between London during the bombing and an Egyptian tomb during its excavation—"there as here, there are no doors."[26] Like an excavation, the Blitz has opened up ancient mysteries for inspection: "trembling at a known street-corner, / we know not nor are known; / the Pythian pronounces—we pass on, / to another cellar, to another sliced wall / where poor utensils show / like rare objects in a museum."[27] The narrator asks why the survivors of the Blitz were spared: "we passed the flame: we wonder / what saved us? what for?"[28] Her answer is that she is one of the "latter-day twice-born"—those who metamorphose like caterpillars—"the carriers, the

spinners / of the rare intangible thread / that binds all humanity / to ancient wisdom / to antiquity."[29] It is the clairvoyant function of the poet that justifies her survival: she who knows "the meaning that words hide / they are anagrams, cryptograms, / little boxes, conditioned / to hatch butterflies . . ."[30]

The title of *Tribute to the Angels,* the second of the series, alludes to the seven angels of the Book of Revelation who wage war in the heavens, pouring out the wrath of God upon the earth. But a pagan figure right out of the pages of "The Majic Ring" interrupts H.D.'s invocation of the Christian angels of the apocalypse: "I had been thinking of Gabriel . . . I had thought / to address him as I had the others . . . how could I imagine / the Lady herself would come instead?" The passages that describe H.D.'s vision of the Lady have a teasing, allusive tone: "We have seen her / the world over, / Our Lady of the Goldfinch, / Our Lady of the Candelabra, / Our Lady of the Pomegranate, / Our Lady of the Chair."[31] The poem describes and then rejects all past depictions of this archetype—"none of these, none of these / suggest her as I saw her"[32]—ending with the confident assertion that: "she is not shut up in a cave / like a Sibyl; she is not / imprisoned in leaden bars / in a coloured window; / she is Psyche, the butterfly, / out of the cocoon."[33] Here, as in the previous poem, Psyche, the Minoan butterfly goddess, is the true and original shape of the poet-prophetess, she who is "the counter-coin-side / of primitive terror; / she is not-fear, she is not-war."[34]

The final poem of the series, *The Flowering of the Rod,* centers on the story of Mary Magdalene's anointing the feet of Christ. In a conversational tone the poet describes a scene in the marketplace with an Arab merchant from whom Mary obtains the ointment. The merchant turns out to be the astrologer and seer Kaspar, one of the trio of wise men who were present at Christ's birth. Contemplating the Magdalene's disordered hair with an uneasy combination of lust and disapproval, Kaspar is suddenly assaulted by a vision, an exquisite elaboration of H.D.'s hallucination on the *Borodino.* Here is the passage from "The Majic Ring" describing her sighting of an otherworldly coastline from the deck rail:

> I was looking at what I supposed was a jagged, broken coast-line,
> because I knew we were nearing land, would sight land, the captain
> had said at lunch time, within 24 hours. It was a bit soon of course, all

the same, we were promised a sight of land and here it was. . . . I for-
got Mr. Welbeck and I did not, after all, turn and meet his eyes, for
his eyes, it seemed now, were my eyes. I was seeing his vision, what he
(though I did not of course realize it) was himself projecting. This was
the promised land, the islands of the blest, the islands of Atlantis or
of the Hesperides. . . . The islands, for islands, I think they must have
been, were not blurred, not cloud-like; they were exact; with their
various indentations and their irregular hilly contours, they lay along
the horizon, not over-symmetrical like the peaked waves, not in exact
temple-frieze formation like the shoal or the school of dolphins.[35]

Compare it with this description of Kaspar's vision:

but before he was lost,
out-of-time completely,
he saw the Islands of the Blest,
he saw the Hesperides,
he saw the circles and circles of islands
about the lost centre-island, Atlantis;
he saw what the sacrosanct legend
said still existed,

.

And he saw it all as if enlarged under a sun-glass;
He saw it all in minute detail,
The cliffs, the wharves, the citadel,
He saw the ships and the sea-roads crossing
and all the rivers and bridges and dwelling-houses
and the terraces and the built-up inner gardens;

. .

and though it was all on a very grand scale,
yet it was small and intimate,
Paradise
before Eve . . .[36]

H.D.'s Minoan hallucination of 1920 is here recast as "Paradise before
Eve," a vision of the islands of the blessed in which female sexuality
goes unpunished. Kaspar, she asserts, understood the message commu-

nicated "through spiral upon spiral of the shell / of memory that yet connects us / with the drowned cities of pre-history; / Kaspar under-stood and his brain translated: / *Lilith born before Eve / and one born before Lilith, / and Eve; we three are forgiven.*"[37]

It is an extraordinary metamorphosis, from the narcissistic grandiosity of the prose to the fierce subtlety of the poetry. Read together, however, the two add up to a more complete theology of Dionysian prophecy than the poems alone. "The Majic Ring" explores of one of the most painful, recurring themes of H.D.'s life. The scene at the captain's table where she insists that Mr. Welbeck explain about the dolphins enacts a shipboard attraction so powerful and unrealistic that it tips over into a delusional episode, another of a series of failures in heterosexual love. But the poet's insistence on integrating the profane and the sacred, the ancient and the modern, the hysterical and the prophetic, into one seamless whole, is the key to the wartime works when they are read together. It is precisely in its marginality, its femininity, and its emotional volatility—its insistence that it is saner to be driven mad by war than not—that her oracular diction reaches back and forward in time. She says, in effect, yes, Mr. Welbeck was an abortive cruise ship crush of mine that tipped over into craziness because I was still reeling from the impact of the First World War, and yes, *this is how the gods appear.*

Psyche Rewritten

In the history of the human sciences, the Second World War represents an epistemic rupture of unprecedented violence, a double holocaust whose nightmarish afterimage is imprinted on the likeness of everything that led up to it. The story of what happened to H.D.'s pacifist vision of Knossos in the immediate aftermath of the war exemplifies in microcosm that traumatic fissure. In February 1946, in the absence of Bhaduri, H.D. tried table tapping on her own. Believing that she was receiving communications from dead pilots about the danger of atomic weapons, she tried to pass on the messages to Lord Dowding over tea at the flat, only to have him emphatically reject the whole business as "frivolous and uninspiring."[38] In the wake of this emotional and spiritual rejection, the creative outpouring facilitated by the séances promptly dried up, and H.D. had a nervous breakdown. She ripped her bookplates out of her books and moved all the furniture in her

apartment out into the hallway. She was unable to recognize any of her friends. Bryher chartered a plane and flew her to a clinic in Zurich.

On September 29, 1946, Bryher wrote to her to explain what had happened: "You want to know . . . why you are at Kusnacht. Last Feb. you were taken very ill and for a time I think you did not know any of us." The letter reassured H.D. that "[t]here are no enemy countries now. And no upheavals," and let her know that "[a]ll your friends have been told that you have meningitis."[39] Shortly after this, it was decided that H.D. was well enough to leave the clinic, and Bryher set her up in a comfortable hotel in Lausanne, a short railway ride distant from the luxurious modernist villa where Bryher lived, on her father's advice, as a tax exile.

In the winter of 1947, H.D. asked for her papers to be sent to her at the hotel, and she started combing through her unpublished texts, re-typing and revising, saving or destroying the traces of her wartime and prewar self. On November 26, 1948, H.D. wrote to her ex-husband, Richard Aldington, about this process of postwar reconstruction:

> I have been going over about 20 old note-books, of slapped-down impressions, Vienna, London, Paris, New York, and combing out all sorry, unpleasant, unhappy references to anybody, more or less. . . . I am only so grateful that the dear Lord spared me, so I can tidy up this mess of papers.[40]

In 1949 H.D. wrote of these notebooks that "once they are in order, I shoot them over to Norman Pearson for his or my 'shelf' at Yale."[41] The 1933 letters in her archive at Yale do indeed show some traces of this revisionist process: certain phrases and names have been carefully excised with a sharp blade. In contrast to these minimal alterations, there was one document from the same period that she completely replaced: the notes she took during the first and most archaeological phase of her analysis with Freud. Instead of "shelving" this notebook at Yale, H.D. destroyed and rewrote it, with a view to publication. In 1974, thirteen years after H.D.'s death, the revised version finally made it into print as an addendum to the third edition of *Tribute to Freud,* appearing under the title "Advent." In a prefatory "Note on the Text" published with this edition, H.D. asserted that "Advent" "was taken direct from the old notebooks of 1933, though it was not assembled until December 1948."[42]

Like most of the fakes, forgeries, false memories, and pseudo-prophecies discussed in this book, this one is not hard to spot. "Advent" purports to document H.D.'s growing awareness of the gravity of the political situation as it unfolded in Vienna and Berlin, but a comparison between the retrospective journal and the letters written at the time exposes the fake. The bulk of the putative journal entries cover the period between March 1 and 25, and H.D.'s letters of 1933 contain plenty of evidence as to her attitude towards political developments during this period. There is no mention of politics in the letters until the crisis of March 15 when rightwing paramilitaries rallied in the square in front of the parliament building: "Fortunate I got here when I did. I had a "hunch" it was now or never. I feel like the nigger in the last part of Gods Angry Man; when told he could clear out, he said, "I stick to de ole' man'" (March 16). Like many of the letters, this one seems designed to reassure Bryher that the crisis was not very grave. H.D. claims for herself a prophetic "hunch" as to the turn of events, while a stage nigger has to carry the burden of her self-congratulation at pressing on with her analysis in the face of rising anti-Semitism.

On March 22 H.D. continued in the same reassuring vein. "Well, I am staggering toward Burg-street," she recounts, writing just before her session with Freud, hastening to reassure Bryher that things are not as bad as they might appear from a distance: "Don't be scared by things you may see in the papers. They did some Macedonian phalanx running formations across the Freiheitsplatz this morning ... I don't know why. I dare say papa will tell me ... but I hate wasting ps-a on politics" (March 22; ellipses in the original). As the level of political disruption increased, however, H.D.'s conversations with Freud about the situation did become more serious, and on March 23 she announced that she has "gone all smug and conservative, for once knowing politically where I stand," adding, "I don't suppose this neat formula would work in London,[43] however ... its something to have a political formula these days if only for five minutes" (March 23). On March 25, she repeats her political formula: "I don't mind a damn who goes and doesn't, to war. All I want is to pick up the pieces, to know how I feel, not to be badgered by conflict. But of course this time one does KNOW the "north" [Nazi Germany] is impossible" (March 25).

By March 25 as a result of her conversations with Freud, H.D. has finally acknowledged the imminent disaster and even chosen her side:

"One does KNOW the 'north' is impossible." In the revised journal, however, the imagery associated with Psyche is deployed to communicate a very different chronology of her changing attitudes towards the political situation. The opening sections of "Advent" are full of butterfly and moth symbols, which she links to her prophetic awareness of the gathering storm. H.D. recalls finding a cocoon in the garden and hatching it in her father's library. She starts out narrating convincing details of the memory: "I broke off the stem and put it with what tobacco-flower leaves were left and placed the cocoon where I felt it would be safest."[44] But, as she tells it, her memory of this incident is far from secure: "I was wrong about the butterfly. I did not break off a heavy cocoon, but I gathered the enormous green caterpillar with the tobacco stalk and placed the stalk and worm in a cardboard box."[45] Then the confusion deepens: "Did I make it all up? Did I dream it? And if I dreamt it, did I dream it forty years ago, or did I dream it last night?"[46]

Later she confesses anxiety about retailing these memories to Freud: "It did not occur to me, until I was back in my bed, that I had omitted to tell the Professor the story of the caterpillar that had so concerned me . . . why did I forget the caterpillar? Why did I remember it?"[47] The answer to these questions comes in a section headed "March 5":

> The story comes back automatically when I switch off the bed lamp.
>
> I do not seem to be able to face the story in the daytime. Yes, it was an abomination. I could see it writhing "It's only a caterpillar." Perhaps I cannot really talk yet. . . . I look down the wide wooden steps. There is the grapevine, as we called it, and leaf shadows. They are crouched under the grape arbor. I can scream. I can cry. It is not a thing that the mind could possibly assimilate. They are putting salt on the caterpillar and it writhes, huge like an object seen under a microscope, or looming up it is a later film-abstraction.
>
> No, how can I talk about the crucified Worm? I have been leafing over the papers in the café, there are fresh atrocity stories. I cannot talk about the thing that actually concerns me, I cannot talk to Sigmund Freud in Vienna, 1933, about Jewish atrocities in Berlin.[48]

In an "entry" dated March 7, a couple of days later, she asks, "How can I tell him [Freud] of my constant pre-vision of disaster? It is better to

have an unsuccessful or 'delayed' analysis than to bring my actual terror of the lurking Nazi menace into the open."[49]

If we accept these passages on their own terms, "the crucified Worm" represents the soul of the prophet writhing with the knowledge of future catastrophe, unable to even articulate to Freud her "constant pre-vision of disaster." But if, as the evidence warrants, we interpret "Advent" as an act of back- rather than fore-telling, Psyche here bears the burden of H.D.'s anxiety at not having felt, or not having faced, or not having expressed, an anguish commensurate with the tragedy that was taking shape in Vienna, 1933, when she was supposed to have written those journal entries. It is the story of her prophetic failure that she is unable to face in the daytime of peace.

In "Advent" H.D. expresses a series of anxieties about the memories that carry the burden of her false prophecy: "I was wrong about the butterfly . . . Did I make it all up? Did I dream it? And if I dreamt it, did I dream it forty years ago, or did I dream it last night? . . . why did I forget the caterpillar? Why did I remember it?" These revisions and reversals may betray her complex feelings of shame, both at her lack of awareness in 1933 and at her strategy for cleaning up the record in 1948. Why did she forget then, and why is she remembering now? Her reply then reads as an answer to her anguished self-interrogation. Maybe something in the original notebooks reminded her that she did "leaf over the papers" in a Viennese café, reading about what was happening in Berlin, and had little reaction beyond a complaint that she hated wasting the psy-a hour on politics. The only way to explain it is to retreat to childhood helplessness: "Yes, it was an abomination. . . . Perhaps I cannot really talk yet. . . . I can scream. I can cry. It is not a thing that the mind could possibly assimilate."

From her seduction by Ezra Pound at the age of fifteen, to her neo-Greek self-fashioning in London, to her Cretan "fortune-telling bee" with Freud, H.D.'s archaeological destiny must have appeared quite seamless. The séances with Arthur Bhaduri were the ultimate affirmation of her mystical worldview, but the revelations of the immediate postwar period exposed the limitations of her supernatural epistemology. She attempted to resolve this by rewriting the notes from the most archaeological phase of her analysis to suggest that she had, in fact, understood the gravity of the political situation and foreseen the disaster that was looming. Completely committed to the prophetic aspects of

her neo-Minoan vocation, she mobilized Evans's Psyche imagery to convey her prevision of the Holocaust.

H.D.'s fugue state in the first months of peace was perhaps necessitated by the very grandeur of the spiritual ambitions that she had cooked up in the pressurized atmosphere of the Blitz. In her antiwar poems of 1942–1944, she asked why the survivors of the bombing were spared: "we passed the flame: we wonder what saved us? what for?" Her answer was prophetic. She is one of the "latter-day twice-born" who are "the carriers, the spinners / of the rare intangible thread / that binds all humanity / to ancient wisdom, / to antiquity."[50] In 1948, recovering from her breakdown, the answer was somewhat less grandiose: "I am only so grateful that the dear Lord spared me, so I can tidy up this mess of papers."[51] The whole episode—with its complicated dance of forgetting, remembering and revising—is emblematic of the rupture dividing the prewar from the postwar world. H.D.'s desire to clean up the record—"tidy up this mess of papers"—represents an attempt to impose continuity and coherence onto something that had been shattered beyond repair.

The Consort

The visionary coherence of Evans's archaeology may have been blasted into fragments by the war, but it turned out that there was much that was salvageable for the new conditions of the postwar world. A popular version of Minoan Crete was easily retooled for the demands of the nuclear age, still offering consolation to despairing pacifists, well suited to the aesthetics of the age of Aquarius, and ready to come into its own as a prehistory for second-wave feminism. It was the poet and novelist Robert Graves who best anticipated all the themes that Knossos would sound during the cold war. His oracular neopaganism was as devoted and as convinced as H.D.'s, but his archaeologically inflected supernaturalism turned out to be a more robust instrument, able to withstand the shock of the peace and to adapt seamlessly to the new political realities of the postwar world. Part of this process of adaptation was his vociferous championing of matriarchal Minoan Crete as the origin of his poetic vocation. By presenting himself as an almost masochistic devotee of the Great White Goddess, he reshaped the sexual politics of Dionysian modernism to fit with the carnivalesque inversions of the 1960s and 1970s, while the dubious racial assump-

tions that occasionally informed his historical scheme were swamped by the sheer eloquence of his celebration of femininity.[52]

As with most of the protagonists in this history of Knossos, it was the twin poles of love and war that defined Graves's relationship with the ancient Cretans. He was born in London in 1895 and grew up in the prosperous suburb of Wimbledon. In 1908, after placing first in the scholarship examination, Robert was sent to Charterhouse, one of those venerable institutions where so many English men of his class first learned the meaning of unhappiness. Particularly horrifying to him was the thick atmosphere of romantic and sexual intrigue between the young boys of girlish appearance who were called "tarts" and the older boys who wooed them.[53] Despite his repugnance at these sexual politics, he eventually found himself infatuated with another boy, one George Harcourt Johnstone, three years younger and a member of the school choir. They began to talk after choir practice and before long Graves was embroiled in the first important romantic relationship of his life, a highly idealized love that he would later describe as "pseudo homosexual" and "chaste and sentimental."[54]

Four days after Graves's nineteenth birthday came the end of his schooldays. He had won an exhibition to read classics at St. John's College Oxford, but less than a week after he left Charterhouse, England declared war on Germany. Earlier, Graves had instinctively aligned himself with the pacifists, arguing in a school debate against the motion that "this House is in favour of compulsory military service."[55] When war broke out, however, exaggerated accounts of German atrocities in Belgium incited his outrage, and he "forgot" his pacifism and decided to enlist.[56] Immediately the family connections swung into action and he found himself invited to take a commission with the Welch Fusiliers.

Despite his pacifism, scruffiness, and latent anarchism, Graves turned out to be a good soldier and was promoted to second lieutenant. In July 1916 he was sent to the Somme to join the Second Battalion of the Welch Fusiliers. A few days into this posting, the Fusiliers were waiting in reserve when the Germans started shelling. Running downhill, Robert heard an explosion and felt as though he had been "punched rather hard between the shoulder blades."[57] A shell had exploded behind him and one piece had gone clean through his breast, emerging two inches above his right nipple. He was put on a stretcher and taken to a dressing station. Late that night a colonel came into the

dressing station and was told that Graves was dying. The usual letter of condolence went out to his parents, and his name appeared on the casualty lists. The next day he was discovered still breathing, and on July 24, 1916—his twenty-first birthday—he came back from the official ranks of the dead.

Recovering his strength in a hospital in Oxford, Robert fell in love with his nurse and thus made the switch in his romantic orientation that would eventually lead him to celebrate ancient Crete as the only society that worshiped women as they deserved. It is tempting to ask what it was that made him into such a zealous devotee of the feminine. His mother's fierce insistence that her children be pure-minded may have been what gave him a lifelong need to spiritualize his own sexual impulses, a force that would sometimes manifest itself in extreme irrationality, but that would also prove to be the very wellspring of his creativity. His first romance, with his school friend George Johnstone, had certainly been highly idealistic. During the Great War, Graves saw the relationship as the antithesis of the profane heterosexuality that pervaded life in the trenches, so it came as an unpleasant shock when he received a letter from a cousin at Charterhouse insinuating that Johnstone was sexually active with men. He persuaded himself that there was nothing to the rumors, but in 1916 he was horrified to receive a newspaper report of Johnstone's arrest for soliciting a Canadian soldier stationed near Charterhouse.[58]

The homosexual panic that swirled around the friendship with Johnstone may have accounted for the evangelical enthusiasm with which Robert belatedly embraced his heterosexuality. His crush on the nurse was scuppered by his shyness, but shortly afterward he went out to a revue with the sister of a friend of his, Nancy Nicholson, a "land girl" from a family of famous artists. They began a correspondence and Graves quickly fell in love. They met again, after which their letters became more intimate. "She warned me that she was a feminist and that I had to be very careful what I said about women."[59] In a very short time they decided to get married. The ceremony took place in January 1918, when she was just eighteen years old and he twenty-two. Nancy had never read the words of the marriage service before the morning of their wedding and was so incensed by their sexism that she nearly did not go through with it. Robert later recalled, "Nancy savagely muttering the responses, myself shouting them out in a parade-ground voice."[60]

They settled in Boar's Hill (near Arthur Evans's estate), and embarked on a married life dominated by Nancy's political outrage on behalf of her sex. Refusing to acknowledge even Robert's war experiences as in any way comparable to the daily sufferings of working-class women, she wouldn't allow newspapers into the house, so afraid was she of coming across something that would offend her feminist sensibilities.[61] Graves obediently joined the newly formed Constructive Birth Control Society and distributed their literature in the village, much to the scandal of his family.

Neither Nancy's political views nor her education in constructive birth control prevented her from executing her plan to have four children in quick succession while still young. By the time she was in her mid-twenties, both she and Graves were worn out with the stresses of a young family and their never-ending money worries. At one point these two fantastically uncommercially minded people had opened a shop (where Graves recalled "selling a packet of Bird's Eye tobacco to the Poet Laureate with one hand and with the other weighing out half a pound of brown sugar for Sir Arthur Evans' gardener's wife"[62]). Deep in debt and with Nancy constantly ill, they sold the shop at a massive loss and moved to another village.

Despite the domestic chaos, Graves managed to be enormously prolific, producing a steady stream of poems, historical novels, and nonfiction works, which met with varying degrees of commercial neglect and critical disregard. In 1924 he published *My Head, My Head*, a Biblical romance in which he laid out for the first time his historical thesis that society had once been matriarchal, and that the beginning of the present misery of the world dated from the time when "the mother lost her rule."[63] Desperate to make money with his pen, he wrote advertising jingles for Huntley and Palmer's biscuits, rhymes for children's annuals, and the libretto for a light opera, but eventually he was driven to find some sort of regular paid employment. Strings were pulled, and he landed the post of professor of English at Cairo University.

In January 1926 Robert, Nancy, and the children left for Egypt. Accompanying them was another addition to the ménage, the American poet Laura Riding, with whom Robert had been corresponding and who had joined them in the euphemistic capacity of "lady secretary." Little did they know that they had invited into their family the woman who would destroy it, becoming in the process Robert's most all-consuming and irrational obsession, the first and most powerful of

a series of poetic muses, and his template for the White Goddess of creation and destruction.

Raised in poverty and instability, Riding was twenty-five years old and on the rebound from a failed marriage. She had already enjoyed some success as a poet and had moved in a number of different literary circles in America, impressing and appalling her fellow writers with her sublime egotism and her single-minded commitment to her art. Disillusioned with the lack of intellectual and spiritual commitment that she perceived all around her, she had leapt at the chance to make a new beginning at the side of a poet of distinction.

Egypt was a disaster. The children were sickly and the job at the university was a joke. Laura quickly made herself indispensable, insinuating herself as a coauthor on a book about modernism that Robert was planning to write. After only six months the ménage returned to England. Back in the domestic chaos of life in their cottage, all three found it hard to do their work. The tense atmosphere was not helped by the fact that the bond between Robert and Laura had thickened to the point that its physical consummation seemed to be only a matter of time. The inevitable split eventually came. Nancy moved away with the children and Robert and Laura set up house in Hammersmith.

Robert's complete abdication to Laura's rule marked the next twelve years. Her behavior, always unconventional and egotistical, became quite unbalanced within the emotional vacuum of his unconditional adoration. She had quickly become sexually bored with a man that she could dominate so effortlessly and in 1929 she summoned from his rural fastness a poet called Geoffrey Phibbs, whom she invited to join the household. Shortly afterward she revealed to Geoffrey what she had already divulged to Robert: that she was more than human, perhaps a goddess, but certainly a figure of destiny, an embodied "Finality." It says much for her extraordinary charisma that Geoffrey was ever taken in by this, jotting down some notes about time and history being either "a projection from Laura" or "necessitated *by* Laura."[64] But he was not so spineless a devotee as Robert, and extricated himself from the poisonous threesome by the ingenious expedient of falling in love with Nancy. Laura responded to his defection by throwing herself out of a fourth-floor window.

Robert prudently ran down one flight of stairs before following Laura out of another window. He emerged shaken and bruised but uninjured. Laura broke four vertebrae, bent her spinal cord and shattered

her pelvis. In the aftermath of this event Nancy and Geoffrey became lovers, and Robert was reinstated as the celibate high priest of the cult of Laura. In accordance with her status as the "Finality," he began to prepare himself to step outside history, and composed a literary farewell to "morals, literature, politics, suffering violent physical experiences, falling in and out of love, making and losing friends, enduring blindly in time."[65] The book, *Goodbye to All That,* an autobiography principally about his experience of the Great War, was published in 1929 to great acclaim and has rarely since been out of print.

When it looked like Laura was in danger of being deported from England on the charge of attempted suicide, Robert began to hatch a scheme to live abroad. In October 1929, after alienating most of their remaining friends and family, he and Laura made their escape, eventually settling in Deyá, a tiny fishing village on the island of Majorca. In 1936, the Spanish Civil War thrust Laura and Robert out of their island paradise and they were forced to wander Europe in a state of exile. During their wanderings, Laura began the machinations that would finally dissolve their partnership. Still on the lookout for a lover, she set her cap at a literary admirer of hers, the critic Schuyler Jackson, who had penned an enthusiastic review of her *Collected Poems.*[66] In the spring of 1939 she and Robert sailed to America to meet with Jackson and his wife, whereupon she succeeded in separating the couple and installing herself as the presiding genius of Jackson's farmhouse.

An inconsolable Robert quickly found consolation in the arms of Beryl Hodge, the wife of an old friend. Robert and Beryl spent the war years in South Devon, where three children were born to them; after the war they returned to Majorca, to the same house from which Laura and he had fled. A series of infatuations with beautiful young women, tolerated by the infinitely understanding Beryl, provided the emotional conflicts that seemed to be necessary for Robert's poetry, and he began to generalize the details of his creative process into a formula for the practice of the poetic vocation. According to this scheme, all true poetry is written under the inspiration of a woman on whom the spirit of the great goddess has temporarily descended—the poet's muse.

In the years during and immediately after the war Graves elaborated his creative dependency on his muses into a full-blown historical narrative linking his poetic vocation directly with ancient Crete.[67] He published two books investigating this Minoan theme. One, *The White Goddess,* became an instant classic, although it is perhaps safe to

say that it is admired more than actually read in its entirety; the other, a futuristic fantasy called *Seven Days in New Crete,* is one of Graves's more obscure works, although a new edition was recently published in America. These books constitute a bridge between the Minoan modernism of the interwar period and the neoprimitive Minoan utopia of the 1960s and 1970s. Graves—with one foot in the rigorous classical curriculum of the English public schools and the other in the untrammeled bohemianism of his island existence—became a translator and interpreter of the classical canon for a new generation unversed in the languages of antiquity.

New Crete

Seven Days in New Crete, published in 1949, is founded upon a premise that Graves had begun to delineate in a 1937 antiwar manifesto: "History proper begins everywhere with the suppression of matriarchal culture by patriarchy, of poetic myth by prosaic records of generation—how this hero begat that hero and he another—with notes of the battles and laws which made each hero famous."[68] In accordance with this theme of the link between war and patriarchy, *New Crete* (published in America under the title *Watch the North Wind Rise*), is set in a future epoch in which the violent breakdown of Christian civilization has necessitated the revival of Minoan religion and culture.

It opens with the narrator coming to consciousness in an alien environment, and then being informed that he has been summoned out of the past by the New Cretan witches in order to answer "a few questions about the Late Christian epoch."[69] He is introduced around, submits to the interrogation of the New Cretan poets, and immediately starts an affair with a gorgeous seventeen-year-old witch called Sapphire. Modeling his behavior on an anthropologist of his acquaintance, he reports back to the reader on the society in which he finds himself.

The population of New Crete, he reports, is "altogether too good-looking," and "almost indecently happy" with faces that are "placid and unlined."[70] Poets are the acknowledged legislators of this ideal world,[71] and women are venerated as the superior sex because they "act directly on behalf of the goddess."[72] It is a pacifist society. "Your chief trouble in the Late Christian epoch," the narrator is told, "is unlimited scientific war which nobody likes but everybody accepts as inevitable; that's a typical by-product of God-worship."[73] Warfare exists in New Crete,

but it turns out to be no more than an elaborate game, played in the spirit of the friendliest rivalry between different villages, and "if anyone were killed we should end it at once."[74]

The narrator enquires of his hosts "by what historical process the New Cretans had arrived at their present pseudoarchaic system of civilisation."[75] In the first phase, he learns, wars of increasing ferocity, culminating in the deployment of a weapon called AIRAR—artificially induced radioactive rain—beggared the societies of the West. This ushered in a "gloomy and antipoetic age"[76] marked by the ascendance of ice-cold logic and the expansion of science. The scientists eventually succumbed to an epidemic of madness, "which sent them dancing like dervishes down the corridors of their all-glass laboratories, foaming at the mouth and tearing in pieces any dog, cat or child that crossed their path." During these Dionysian seizures—farcical reenactments of Nietzsche's denunciations of rationalism in *The Birth of Tragedy*—the scientists "all suffered from the same hallucination: a white-faced, hawk-nosed, golden haired woman who whipped them round and round as though they were tops and urged them to acts of insane violence."[77]

"Logicalism" having thus consumed itself, the responsibility for forming a new ideology was entrusted to an Anthropological Council that decided that without a new religion nothing could be done to alter the habits of humanity. With that in view, enclaves were set aside for the reconstruction "of social and physical conditions as they had existed in prehistoric and early historic times."[78] The Bronze Age enclaves colonized the island of Crete, where they developed "a new religion, closely akin to the pre-Christian religion of Europe and linked with the festivals of their agricultural year," with "the Mother Goddess Mari as the Queen of Heaven." Within a few generations, the New Cretans became "the seed-bed of a Golden Age."[79]

According to a letter that Graves wrote in the middle of the writing of *New Crete*, the twists and turns of the plot seem to have taken their creator somewhat by surprise: "The Utopia . . . is a damned queer affair. I have had only the vaguest idea what was going to happen and left the logic of events to surprise me, chapter by chapter."[80] It turns out that the whole book is actually a fable about the dreariness of a realized golden age: the New Cretans, for all their beauty and contentment, "lacked the quality that we prize as character: the look of indomitability which comes from dire experiences nobly faced and overcome."

Even more serious, the narrator laments that during his tenure in this ideal civilization he "heard no joke that was in the least funny."[81] He seems to have dreamed up his ideal society—an extrapolation of all the utopian and futuristic tendencies in Arthur Evans—only to find himself ambushed by profound ambivalence. It finally emerges that the narrator has been summoned by the goddess herself to sow the seeds of discord among the New Cretans, which he promptly does by exerting a sexual magnetism so powerful that the beautiful witches are prepared to kill for a chance to bed him.

The narrator's anthropology of New Crete culminates in a Frazerian ritual in which the unfortunate male who reigns for one year as a priest king is slain. The narrator is appalled when he learns that it was not a mere mock death as he assumed, but that the witches really did kill the king and, moreover, feasted on their victim's flesh. Reeling from this hideous revelation, he strikes up a conversation with one of the priestesses who participated in the ritual, and she tells him that it is "because of the awful holiness of this sacrifice that New Cretan custom forbids the violent taking of life on any other occasion, even in war." There follows a passage worth quoting in full, as it so perfectly encapsulates why Minoan neoprimitivism managed to get a purchase on the cultural imagination of the interwar years and why it survived the scholarly repudiation of Evans's archaeological reconstructions after the Second World War:

> I thought of the strewn corpses on Monte Cassino, where I had
> been almost the only unwounded survivor of my company; and of
> the flying-bomb raid on London, when I had held a sack open for an
> air-raid warden to shovel the bloody fragments of a child into it; and
> finally of Paschendaele where, in the late summer of 1917, my elder
> brother had been killed in the bloodiest, foulest and most useless
> battle in history—as a boy I had visited his grave soon after that war
> ended, and the terror of the ghastly, waterlogged countryside with its
> enormous overlapping shell craters had haunted me for years. "The
> Goddess knows best," I said to the girl eventually, and she nodded in
> grave assent.[82]

No civilized queasiness about the beastly devices of the heathen, Graves implies, could possibly survive in anyone who had witnessed the monstrous fruits of civilization.

Despite the fact that *Seven Days in New Crete* might have served as both blueprint and warning for the great wave of neoprimitive utopia building that came twenty years afterward, the book barely sold out the first edition. By contrast, Graves's other Minoan-themed volume—published in 1948 right before *New Crete*—has never been out of print. *The White Goddess* is an update of *The Birth of Tragedy,* in which Bronze Age Crete rather than fifth-century B.C. Athens features as the origin point of the true poetic impulse. Dionysian modernism had been shattered by the Second World War, but in *The White Goddess* Graves was able, with the help of the pacifist Minoans, to recrystallize the fragments of Nietzsche's prophecy into a new Dionysian manifesto for a war-weary world.

Nietzsche's book was written in homage to his idol Richard Wagner; Graves's tract is a celebration of his own poetic vocation. As such, his argument must stand or fall on the evidence of the very first page, on which is printed "In Dedication," his hymn of adoration to the White Goddess of the book's title. If the reader finds that it passes Graves's "test of a true poem"—that is, that it affects the reader "with a strange feeling, between delight and horror, of which the purely physical effect is that the hair literally stands on end"[83]—then the arguments of the book about how this effect is achieved are bound to carry more weight. This self-proving thesis places Graves squarely in the oracular tradition initiated by Nietzsche, in which sheer rhetorical power is placed at the service of an argument about the quasi-magical force exerted by art.

In Graves's update, Nietzsche's denunciation of the artistic sterility of the late-nineteenth century is replaced by a lament against the spiritual vacuity of the mid-twentieth:

> "Nowadays" is a civilisation in which the prime emblems of poetry are dishonoured. In which serpent, lion and eagle belong to the circus-tent; ox, salmon, and boar to the cannery; racehorse and greyhound to the betting ring; and the sacred grove to the sawmill. In which the Moon is despised as a burned-out satellite of the Earth and woman reckoned as "auxiliary State personnel." In which money will buy almost anything except truth, and almost anyone but the truth-possessed poet.[84]

Graves's antidote to the atrocities and banality of contemporary life turns out to be reverential male heterosexuality. Nietzsche's old foe

Socrates is the villain of Graves's piece as well, but to the philosopher's many crimes against poetry and magic must be added the offence of homosexuality: "[T]he Arcadian prophetess who magically arrested the plague at Athens reminded [Socrates] once that man's love was properly directed towards women."[85]

All true poetry, according to Graves, concerns a single "Theme": "the antique story . . . of the birth, life, death and resurrection of God of the Waxing Year." J. G. Frazer's dying god was clearly as full of emotional resonance for Graves as it was for Evans. For Evans, however, the god was always a child; for Graves, the central chapters of the Frazerian story "concern the God's losing battle with the God of the Waning Year for love of the capricious and all-powerful threefold goddess, their mother, bride and layer-out."[86] Thus dignified by Frazer, the repetitious love triangles of Graves's romantic entanglements assume mythic proportions.

In arguing that all true poetry is descended from, and reenacts, primitive magic, Graves deploys the recapitulative language that Freud used to make sense of H.D.: "Now it is only by rare accidents of spiritual regression that poets make their lines magically potent in the ancient sense."[87] But like H.D., Graves celebrates this regression as a return to a source of creative and spiritual power—Minoan Crete—rather than just a stunted inability to mature. Poets, in Graves's scheme, are "survivals" in the best sense of the word, a brotherhood of divinely appointed seers, whose spiritual regression keeps alive the worship of the White Goddess.

The bulk of the book is concerned with an elaborate decoding of various riddling passages of Welsh minstrel poetry of the thirteenth century. The density of the presentation has the effect—calculated or not—of crushing the reader's critical faculties under the sheer weight of the author's erudition.[88] Graves's father was a Welsh bard—officially elected as such in the Bangor Eisteddfod of 1902—and Graves's emphasis on the Welsh bardic tradition establishes a genealogy of his poetic inspiration along the male line. As usual, however, we are here concerned with matrilineal descent, the motherland of all true poets being, according to Graves, Minoan Crete. At the beginning of chapter 3, the reader learns that Celtic mythology derived in the first instance from Greece. A dubious reconstruction has Cretan goddess-worshippers colonizing the Peloponnese in about 1750 B.C., who were then driven out of Greece by an invasion from Syria and from there made their way

to Britain.[89] The following chapter summarizes the historical thesis, connecting the Hebrews, the Greeks, and the Celts as students of the Minoans. In a nod to the doctrine of survivals, Graves then claims that the popular appeal of modern Catholicism is because it is based in "the Aegean Mother-and-Son religious tradition, to which it has slowly reverted."[90]

In a chapter entitled "A Visit to Spiral Castle," Graves joins the ranks of those who claim, like Nietzsche, to know "what Ariadne is." "Arianhood," in one of the riddling Welsh poems that he attempts to decode, is the Celtic version of Ariadne.[91] For Nietzsche, it was Cosima Wagner who incarnated Ariadne. In Graves's update, Ariadne assumes the shade of Laura Riding. In a gratuitous aside, Graves distils the emotional masochism of his long celibate obeisance to Riding into a goddess theology, according to which competing with another man for a woman's love is nothing more than a suitable tribute to her divinity.[92] Nine years after Riding left him for Schuyler Jackson, Graves's belief in her holiness still serves as an excuse for her cruelty and capriciousness.[93]

For all her protofeminist sexual dominance over helpless mortal men, Graves's White Goddess still kept one white foot firmly planted in an old-fashioned Aryanist vision of ancient Greece. By a long train of mythic associations and archaeological evidence Graves reaches the conclusion that the Greek alphabet was not invented by the Phoenicians, but by the Minoans. He asserts that a putative alphabet consisting of thirteen, and later fifteen consonants and five vowels, which was sacred to the goddess and ultimately derived from Crete, was current in the Peloponnese before the Trojan War. This alphabet migrated to Egypt and was there adapted to Semitic use by Phoenician traders, who brought it back to Greece some centuries later.[94] In support of this claim he observes that the "Semites, though good business men, were not an inventive people and the unexplained names of the letters are therefore likely to be Greek."[95]

Graves proves himself the equal of Jane Ellen Harrison in righteous indignation when he embarks on his discussion of the transition from matriarchy to patriarchy. It is Harrison's story, with a twist: the great goddess's demotion did not only effect the world-historical defeat of the female sex, it also crushed the spirit of true poetry. The nine muses of Greek tradition were originally one aspect of the great goddess in her poetic or incantatory character. Unfortunately, the goddess allows

the Thunder God to court her and forfeits some of her sovereignty to him. Next she makes the mistake of dividing the power of poetic enchantment between her twins, one male and one female. Then she splits into an insipid troupe of nine little muses, under the tutelage of the former male twin. Finally the male twin, Apollo, proclaims himself the Eternal Sun and the Nine Muses become no more than his ladies-in-waiting. With Apollo's promotion, "poetry becomes academic and decays until the Muse chooses to reassert her power in what are called Romantic Revivals."[96]

As the book draws to a close, Graves turns from the past to the present, striking a rare optimistic note about the coming to Britain of a new Elizabethan Age. (George VI was still on the throne, but his daughter Elizabeth was the heir and would become queen in 1952.) Pleasurable anticipation of the reign of Elizabeth II, he opines, reflects "a stubborn conviction that this is a Mother Country not a Father Land—a peculiarity that the Classical Greeks also noted about Crete."[97] His observations about liberated modern women display a deep ambivalence, however: "[W]oman is not a poet: she is either a Muse or she is nothing," he declares, before backpedalling: "This is not to say that a woman should refrain from writing poems; only, that she should write as a woman, not as if she were an honorary man."[98] For all his obeisance to the White Goddess, Graves's theology would ideally limit women to the role of midwives to male creativity.

From the present, Graves turns to the future, exploring the possibility of a revival of the goddess religion. Here his optimism gives way to pessimism. Even though "the social position of women has improved enormously in the last fifty years," he laments that "the White Goddess in her orgiastic character seems to have no chance of staging a comeback, until women themselves grow weary of decadent patriarchalism, and turn Bassarids again [packs of delirious women given to tearing men to pieces under the influence of ritual intoxicants]."[99] He admits that "[t]his is unlikely as yet, though the archives of morbid pathology are full of Bassarid cases." Just like Freud, Graves implies that the Minoan matriarchal stage persists in the psychic stratigraphy of modern women, ever ready to be exposed in the stress of mental breakdown: "An English or American woman in a nervous breakdown of sexual origin will often instinctively reproduce in faithful and disgusting detail much of the ancient Dionysiac ritual. I have witnessed it myself in helpless terror."[100]

Graves's final chapter, entitled "The Return of the Goddess," rehearses the arguments underlying his *Seven Days in New Crete:* "Only after a period of complete political and religious disorganization can the suppressed desire of the Western races, which is for some practical form of goddess worship . . . find satisfaction at last."[101] Under this scheme, the worship of the White Goddess was, for the time being, confined to true poets. After writing the book, Graves himself certainly remained loyal to its tenets, finding that his poetic inspiration waxed and waned in exact conformity with the degree of emotional excitement provided by a series of muses. The first of these, a beautiful seventeen-year-old American girl, was picked up off a street in Deyá by a friend of Graves and taken to dinner, bemusedly accepted the poems that Graves pressed on her in the following few weeks, only to disappear on her travels with a student of her own age. After her defection, Graves wrote to a friend that "[t]he Goddess has been plaguing me lately, very cruelly, and I have managed to satisfy her by two or three poems written in red arterial blood; she appeared in person in Deyá during the last full moon, swinging a Cretan axe, but is now away again."[102]

In 1916, Robert Graves was left for dead in a dressing station in the Somme. Two years later, in the last stages of pregnancy, H.D. nearly died in the 1918 influenza epidemic. They both survived their brushes with death only to find themselves enduring another global conflagration. Searching in the deep past for some sort of an explanation for the atrocities they had witnessed, they both recreated Minoan Crete as the goddess-worshipping Atlantis that must surely have existed before humans invented war. The works that resulted from their Minoan pacifism are explicitly prophetic and prescriptive in tone, exhorting the reader to learn the great lessons of the twentieth century and to return to the way of Cretan peace. They are also the works of survivors, shot through with a certain irrepressible optimism, a prophetic foreshadowing of some of the absurd contours of the future "Aquarian" age, and the occasional streak of self-satire. As H.D.'s medium said of his vision of the players in ancient Greece, "it seems to be tragic, but it's comic."

THE BIRTH OF FARCE,
1950–2000

During the cold war, the Minoan world assumed many guises, from the spiritually nostalgic to the militantly political. In the 1950s ancient Crete was reinvented as a beatnik Eden of creative spontaneity and existential joy. At the end of the next decade, these neo-Dionysian Minoans were reborn as the exemplary peaceniks of the ancient world, before emerging from their hippie haven to star in an outrageous feminist fable about the matriarchal beginnings of culture. As the cold war arms race escalated, this feminist Eden was retooled for the nuclear age, reenacted by lesbian antinuclear activists as an embattled refuge of Amazonian eco-warriors. At the same time the Afrocentric interpretation of matriarchal, peaceful Minoan Crete was revived to stir up unending controversy in the groves of academe.

In scholarly circles meanwhile, Minoan archaeologists began gradually to dismantle the last vestiges of Evans's pacifism, seizing the headlines at the beginning of the 1980s with a series of finds suggesting that the Minoans practiced human sacrifice and cannibalism. By the end of the millennium, the story of modernist Knossos had come full circle.

After a hundred years of invisibility, the warlike, heroic Minoans of Evans's earliest interpretations were finally ready to make a reappearance, confounding the stark dichotomies of Crete versus the mainland—feminine versus masculine, warlike versus peaceful—that had dominated Bronze Age archaeology since 1898.

Romantic Revivals

In the early 1950s, Henriette Groegenwegen-Frankfort, an archaeologist and art historian of a philosophical bent, described the spirit of ancient Cretan art and religion as one of unalloyed existential joy. The following decade, the Jungian classicist Karl Kerenyi elevated the Minoans into archetypes of Dionysian ecstasy. Like Robert Graves, the authors of these utopian reworkings of Evans were scholars whose intellectual and artistic roots were firmly anchored in the post-Nietzschean bohemia of the 1920s and 1930s, and their ancient Crete reinvented Dionysian modernism for the new political conditions of the postwar world. By the end of the 1960s, this update of Minoan modernism found expression in the image of Knossos confected by the archaeologist Jacquetta Hawkes, a founder member of the Campaign for Nuclear Disarmament.

Henriette Groegenwegen was born in 1896 in the Netherlands and studied Greek and Chinese philosophy at the University of Amsterdam, where she met her husband, Henri Frankfort. The couple spent the 1920s engaged in archaeological work in Greece, Egypt, and Iraq, taking their son with them on the digs as soon as he turned three years old. Their principal residence was in the London borough of Hampstead, where they were absorbed into a circle of avant-garde artists and scholars who avidly followed the latest developments in art, science, psychology, and philosophy. When war broke out, Henri went to America while Henriette stayed behind to join the work of the Red Cross. In 1941, however, she joined her husband in Chicago, where they lived until Henri gratefully accepted the offer of employment at the Warburg Institute and they were able to move back to London.

In 1951, Henriette Groegenwegen-Frankfort, as she was then known, published the monograph for which she is remembered, *Arrest and Movement: An Essay on Space and Time in the Representational Art of the Ancient Near East*. The book is named for a line in the first of T. S. Eliot's "Four Quartets," linking the underlying philosophy of the text

to Eliot's poetic rejection of linear time. In the preface, Frankfort announces that the book "developed out of a desire to account for the eccentricities of spatial rendering in Near Eastern works of art."[1] Dismissing as unsatisfactory the usual explanations, such as the lack of knowledge of perspective, Frankfort claims that the rendering of space in ancient art is susceptible to "interpretation in cultural rather than aesthetic terms."[2] The book amounts to an art-historical diagnosis of the character of a given civilization, somewhat akin to Spengler's analysis of the "soul" of an ancient city.

The text is divided into three sections. The first and longest deals with Egypt, the second with Mesopotamia, and the third with Minoan Crete. The placing of the Cretan section at the end of the book seems to represent a culmination as well as a conclusion, with the Minoan world presented as the positive antithesis of various negative traits of Mesopotamia and Egypt. Above all, where they were concerned with worldly power, Frankfort's Cretan artists were preoccupied with the dynamic cycles of the natural world, never stooping to depict a historical event, military victory, or individual royal personage. What results is one of the most unabashed tributes to the Minoan spirit ever penned, a hymn of praise to its "passionate beauties . . . delicate mysteries . . . its naturalness . . . the beauty of its freedom."[3]

When Frankfort gets down to the business of analyzing how Minoan artists achieved this enchanting effect, she identifies a quality that she calls "absolute motion," a tendency to counterbalance every movement with "a countermovement within the figure, which makes it appear self-centred but never at rest."[4] Absolute motion turns out to be the key to the Minoan cosmos, an aesthetic manifestation of the "Mystic Communion and the Grace of Life"—the title of Frankfort's final chapter—that characterized the florescence of Cretan civilization. The chapter begins with a reinterpretation of all the military subjects in ancient Cretan art, arguing that they depict ritual activity rather than scenes of war. A discussion of the bull-leaping sport and other sacred rituals celebrates Minoan religion as concerned with "the mystic intensification of the experience of life [rather] than the transcendence of death."[5] The book ends with a lyrical summation of the character of Minoan art:

> In Crete artists did not give substance to the world of the dead
> through an abstract of the world of the living, nor did they immortalize

proud deeds or state a humble claim for divine attention in the temples
of the gods. Here and here alone the human bid for timelessness was
disregarded in the most complete acceptance of the grace of life the
world has ever known. For life means movement and the beauty of
movement was woven in the intricate web of living forms which we call
"scenes of nature"; was revealed in human bodies acting their serious
games, inspired by a transcendent presence, acting in freedom and
restraint, unpurposeful as cyclic time itself.[6]

With this passage, Frankfort relaunches the Cretans as antiquity's angel-
headed hipsters, sublimely indifferent to the seductions of worldly pride,
obedient only to the rhythms of nature, and displaying an innate capac-
ity for existential spontaneity.

Frankfort was often quoted in the following decades by fellow en-
thusiasts for the Minoan way of life, including the Jungian classicist
Karl Kerenyi. Kerenyi was born in Romania in 1897, studied classical
philology at the University of Budapest, and was appointed to a variety
of academic positions. Unable to get a job in communist Hungary after
the war, he emigrated to Switzerland, where he became close friends
with Carl Jung. He was immensely prolific, publishing an enormous
corpus of works and devoting his later years to developing a psychologi-
cal view of the Greek gods, analyzing their stories as so many aspects of
the Jungian collective unconscious. Given Evans's insistence on the ar-
chetypal unity of the Great Cretan Mother, the Minoans seemed long
overdue for the full Jungian treatment, and Kerenyi spent the 1960s
working on a manuscript that united the Minoans with Nietzsche and
Jung, and updated the whole package with a hallucinogenic twist.

Kerenyi's *Dionysos: Archetypal Image of Indestructible Life* was not pub-
lished in English until 1976, but the preface, composed after he had fin-
ished writing the Minoan chapters, is dated October 1967. He opens the
book with the argument that radical atheism, especially as embodied in
the person of Friedrich Nietzsche, belongs to the history of European
religion and as such must be of concern to anyone wishing to under-
stand European culture.[7] Since Nietzsche had anointed Dionysus as
the god who was compatible with atheism, an understanding of the Di-
onysian aspects of ancient Greek religion would, according to Kerenyi,
yield an insight into the "human experience" of godlessness. The key to
all of this turns out, of course, to be Minoan Crete: "What Nietzsche
said about the Greeks seems to find its confirmation especially in re-

gard to Minoan culture, which cannot be comprehended unless its Dionysian character is understood."[8]

The first chapter concerns itself with the "spirit" of Minoan art, and Kerenyi assures us of the security of his conclusions by consulting "a modern, objective observer, a woman who studied the art and monuments of Greece and the Near East with like dedication."[9] This objective source is none other than Henriette Groegenwegen-Frankfort, and her passage on the Cretan's "grace of life" is quoted in full. Kerenyi thoroughly endorses Frankfort's beatnik version of the Minoans and rhapsodizes about their "wholly religious situation . . . caught up in an atmosphere of festival as in an enchanted world."[10]

Of all the postwar commentators on ancient Crete, Kerenyi was the one most explicitly faithful to the Nietzschean spirit of Minoan modernism, but his analysis of the Dionysian element also had a Janus face. The preface looked back to Nietzsche, building on work that Kerenyi had been engaged in since the 1930s, while the text itself drank deeply of the intoxicated spirit of the times. Quoting from a 1967 *Bulletin on Narcotics,* Kerenyi asserts that the Minoans were users of opium, as evidenced by a clay figurine of a goddess with a crown made of poppy seed-heads incised with the downward strokes characteristic of opium manufacture. He then appeals to those writings on opium that he deems to be "closest to the spirit of Minoan art," quoting from Thomas de Quincey via Charles Baudelaire: "The ocean with its eternal breathing, on which however a great stillness brooded, symbolized my mind and the mood that governed it . . . a festive peace. Here . . . all unrest gave way to a halcyon serenity."[11] Kerenyi then turns to the Native American peyote cult, asserting that artificial means are only necessary during "decadent phases" of a culture, when the simpler methods of achieving transcendence have stopped working.

At around the same time as Kerenyi was reworking the Nietzschean Minoans as a cross between Romantic opium eaters and Native American visionaries, a new version of ancient Crete appeared that translated the last vestiges of Dionysian modernism into the idiom of the antiwar movement of the 1960s. The author was the popularizing archaeologist and antinuclear activist Jacquetta Hawkes. She was a member of a slightly later generation than Kerenyi and Frankfort, born in Cambridge in 1910, daughter of the Nobel prize-winning biochemist Frederick Hopkins. After studying archaeology and anthropology at Cambridge University, she launched a highly successful career combining politics,

writing, and broadcasting with archaeology. In her early twenties she married a fellow archaeologist, Christopher Hawkes.

During the Second World War, Jacquetta Hawkes worked for the War Cabinet and in the immediate aftermath of the conflict was sent to the inaugural meeting of UNESCO in Mexico City. There she met J. B. Priestly, the famous Jungian playwright, and they embarked on the affair that would break up both their marriages. In 1958, the couple became founding members of the Campaign for Nuclear Disarmament. On January 15, 1962, Hawkes organized a women's rally against nuclear weapons, one of the fruits of which was a pamphlet entitled *Women Ask Why,* consisting of transcripts of the speeches by Iris Murdoch, the scientist Anne McLaren, and Hawkes. Hawkes's contribution laid the most stress on the specifically feminine character of the exercise, arguing that "[m]en have the instinct to fight and to war. We have not."[12]

Hawkes's commitment to this essential difference between the sexes found its way into her book about the roots of Greek civilization, which was published in 1968 under the title *Dawn of the Gods.* In this work she proposed that the culture of classical Greece was the outcome of a union of two cultures, the feminine civilization of Minoan Crete and the masculine society of the Mycenaean mainland. According to her account, Crete was an unambiguous paradise: "The Goddess of fertility and abundance had certainly fulfilled her worshippers' desires," she proclaimed. Part of the paradisial atmosphere was down to their pacifism: "[F]oreign voices and ways were gladly tolerated . . . war was not glorified and peace and sunshine seemed secure."[13] On the basis of the bare breasts on the frescoes, she asserted that the Cretans "reduced and diverted their aggressiveness through a free and well-balanced sexual life."[14] To top off the heady atmosphere of this prehistoric love-in, "It is quite likely, as today, drugs were sometimes taken to encourage a sense of revelation, possession and trance."[15] Like Kerenyi, Hawkes took inspiration from Frankfort's celebration of Minoan art, naming one of her chapters "The Grace of Life" and wondering at how a "minutely accurate art historian" had fallen so hard for the enchantments of ancient Crete.[16]

Hawkes's Jungian interpretation of the sexual essence of Minoan and Mycenaean culture also led her to speculate that "the occupants of Minoan thrones may have been queens"[17] and that "the small, delicately boned Mediterranean race with its relatively slight body and facial hair may have tended also towards a more feminine metabolic balance."[18]

Against this peaceable motherland, Hawkes set the Mycenaean father-
land, characterized by its "aggressive masculinity and ingrained milita-
rism."[19] With this updated characterization of the contrast between
Knossos and Mycenae, Hawkes, one of the founding members of the
modern feminist peace movement, set the precise terms for the rein-
vention of Minoan Crete for the nuclear age.

The White Goddess

Robert Graves may have been convinced that the time was emphati-
cally not ripe for a neo-Minoan religious revival, but it did not, after all,
take either centuries or profound upheavals before he was contacted
in his Majorcan hideaway by the White Goddess's new devotees, for
whom his book had assumed the status of Holy Writ:

> I suppose you know that you are the God of the new Movement here,
> the newest of the new women's movements, and you are the only
> male creature who is admitted to godhead in the movement. Small
> groups from California to New York have formed to defy Christian-
> ity and all organized religion, to worship the female principle, and to
> bring back the Great Goddess.[20]

The writer was Elizabeth Gould Davis, a librarian from California, whose
outraged and outrageous feminist reconstruction of the whole of hu-
man history, *The First Sex*, was a bestseller in the early seventies. For this
"newest of the new women's movements," Minoan Crete represented
the ultimate feminist utopia, the one place where the matriarchy sur-
vived into a technologically and culturally sophisticated age: "The great
universal civilisation of the ancient world reached its apogee in the flow-
ering of Crete in the second and third millennia B.C."[21]

As the 1970s wore on, the story of matriarchal Crete was given further
pacifist elaboration by the Lithuanian archaeologist Marija Gimbutas.
For Gimbutas the ancient idyll of Neolithic Europe—"matrifocal and
probably matrilinear, agricultural and sedentary, egalitarian and peace-
ful"—was shattered by wave after wave of patriarchal Aryans sweeping
down from the Caucasus Mountains, trampling the goddess under the
thundering hooves of their horses.[22] The old ways survived this assault
in a few isolated spots, with Crete holding out for the longest time:
"[O]nly around the Aegean and on the islands did its traditions survive

to the end of the third millennium B.C., and on Crete to the mid-second millennium B.C."[23]

Gimbutas claimed to have deciphered a symbolic system—"the spiritual manifestations of Old Europe"[24]—through the comparative study of artifacts from sites all over a large geographical area extending from the Aegean islands up to Czechoslovakia, southern Poland, and the western Ukraine. Accordingly, her texts tended to be arranged thematically with sections entitled things like "Mistress of Waters: The Bird and Snake Goddess" or "The Great Goddess of Life, Death and Regeneration." What emerged from this thematic organization was nothing less than a comprehensive neopagan theology, perfectly tailored to the concerns of cold war environmentalists and feminists. The archaeologist was compensated for her loss of academic credibility with a profitable spot on the lecture circuit and a shadowy second career as a high priestess of the goddess movement.

Gimbutas attracted a devoted following for whom her work had clear political significance.[25] From the 1976 *When God Was a Woman* by Merlin Stone, to the self-styled "futurist" Riane Eisler's starkly moralistic best seller of 1987, *The Chalice and the Blade*, Crete was extolled as an ancient pacifist paradise. "[T]he differences between the spirit of Crete and that of its neighbours," Eisler lectured, "are of more than academic interest. . . . we find this firm confirmation from our past that our hopes for peaceful human coexistence are not, as we are so often told, 'utopian dreams.'"[26] Just as Evans's reinforced concrete reconstructions survived wars and earthquakes to enjoy their afterlife as a tourist attraction, so his vision of the distaff side of Dionysian modernity persisted in popular culture with its utopian core intact.

Only one chapter of Gimbutas's book *The Goddesses and Gods of Old Europe* deals with a cult of a male deity—the "Year-God," who is, of course, none other than our old friend Dionysus, now traced back through Minoan and Mycenaean religion to the Neolithic. The chapter is full of references to Jane Ellen Harrison's works, and Gimbutas follows her predecessor's interpretation exactly, arguing that the Dionysiac festivals were orgiastic reenactments of the cult of the year god symbolized by a bull.[27] In its cold war reinvention, the tragicomedy of modernist Knossos repeated itself as postmodern farce. The story of valiant little Crete fighting off the Aryan hordes rehearsed the great political traumas of the mid-twentieth century, while the oracular writings of Harrison and Graves were elevated to the status of pri-

mary sources—little fragments of Dionysian modernism, carried ever further away from Nietzsche's original prophecy on the widening ripples of historical time.

Black Athena

Coinciding with the development of the pacifist-feminist Minoan utopia was one of the most infamous interventions in the politics of ancient Crete, a revival of the Afrocentric view of Greek origins first promulgated by George Wells Parker over seventy years earlier. The prime mover behind this postwar iteration of the Black Minoans was the Senegalese polymath Chiekh Anta Diop. Born in 1923, Diop left Senegal in his early twenties and traveled to Paris where he studied physics with Marie Curie's son-in-law. In 1951 he submitted a Ph.D. dissertation to the University of Paris arguing that ancient Egypt was an African civilization and that "the perfect Egyptian is Negritian."[28] The thesis was rejected, and he spent the next nine years adding evidence and refining the argument, during which time a version was published as *Nations négres et culture*. In 1960 the thesis was accepted by the faculty of the university, and Diop finally became a doctor of philosophy. After this long-awaited vindication he went back to Senegal, where the University of Dakar established a radiocarbon laboratory to help him with his research into early African history.

The year 1960 also saw the publication of more sections of Diop's thesis, including *L'unité culturelle de l'Afrique noir* in which he claimed a single matrix for Black African civilization. This monolithic Black culture—which Diop dubbed the "Southern Cradle"—is matriarchal, cosmopolitan, agricultural, optimistic, comedic, and peaceful, in stark contrast to the patriarchal, pastoral, northern, militaristic, pessimistic, tragic, and individualistic "Northern Cradle." This was exactly the same set of oppositions—the same projection of antifascism onto prehistory—that was claimed by feminists for Crete versus Mycenae.

In 1974, *The African Origin of Civilization* became the first of Diop's works to appear in English, and his reputation as the global pioneer of Afrocentricism was sealed. His final work was published in French before his death in 1986, and appeared in English in 1991 under the title *Civilization or Barbarism: An Authentic Anthropology*. The cover of the English edition featured a reproduction of Evans's beloved "Priest King" relief from *The Palace of Minos* (ironically, he is the only image of

Minoan masculinity from Knossos with pale skin). The cover photo, along with some other well-known Gilliéron works, was reproduced inside in a chapter entitled "The Myth of Atlantis Restored," which argued that the legend of the disappearance of the island of Atlantis was a cultural memory of the eruption that blew out the whole middle of the Minoan island of Thera. According to Diop's reconstruction, Thera was an outpost of the Cretan colony of the Egyptian pharaoh Amenophis III, and the volcanic explosion that destroyed the island sent Egypto-Cretan refugees into the Peloponnese to kick-start Greek civilization.

Diop's wide-ranging scientific training—in nuclear physics, chemistry, anthropology, history, and linguistics—as well as his explorations of race as an analytical category, often made him sound rather similar to nineteenth-century Aryan theorists obsessed with the question, who were the Greeks? Like them he combined dazzling erudition with a prophetic commitment to antiquity as a blueprint for the future: "Far from being a reveling in the past, a look toward the Egypt of antiquity is the best way to conceive and build our cultural future. In reconceived and renewed African culture, Egypt will play the same role that Greco-Latin antiquity plays in Western culture."[29] The signal difference, of course, was that for Diop just as much as for the antinuclear feminists, Minoan Crete was the Eden of a slave revolutionary rather than that of a would-be *Übermensch*.

Diop was pretty much kept away from the elite centers of Anglo-American academia, but in 1987 a massively learned version of the African Minoans exploded right in the heart of the Ivy League, bringing Afrocentric scholarship to the attention of a much wider public. The author, Martin Bernal, was a professor of Chinese political history at Cornell University. He was born in London in 1937, son of the famous biochemist and pioneering Marxist historian of science J. D. Bernal. Inheriting both the far-left political leanings and the academic abilities of his father, Bernal was educated at Cambridge University, where he got a Ph.D. in Oriental studies. In the preface to the first volume of the *Black Athena* trilogy, Bernal outlined the trajectory that led him to shift the focus of his studies, including a "midlife crisis" that coincided with the end of the Vietnam War, the awareness that the Maoist era in China was coming to an end, and the accompanying feeling that "the central focus of danger and interest in the world was no longer East Asia but the Eastern Mediterranean."[30]

Bernal certainly turned out to have an appetite for "danger and interest," at least of the academic variety. The first volume of his trilogy, *The Fabrication of Ancient Greece, 1785–1985,* outlined a damning story of extreme institutionalized racism in classical archaeology persisting into the present. He argued that the ancient Greeks themselves were perfectly well aware of their deep cultural indebtedness to Asia and Africa, and that this version of the origins of Western civilization—the "Ancient Model"—was only overturned in the late eighteenth century under the influence of a racial ideology—confected in order to prop up the institution of slavery—that denied the creativity, wisdom, and intelligence of nonwhite people and Jews. Affronted by the very suggestion that Western civilization owed anything to African and Asian people, the disciplines of classics and archaeology substituted the "Ancient Model" with their own "Aryan Model," attributing European superiority to invasions by blond, blue-eyed warriors from the north.

Volume 2 of *Black Athena* opened with the contention that "[t]he place to begin . . . is obviously Crete,"[31] and chapter 4 argued that the great period of the Cretan palaces was the result of a colonization of Crete by Egyptians of the Middle Kingdom. Bernal seemed to relish the political implications of his argument, declaiming in his introduction that *"If I am right . . . it will be necessary not only to rethink the fundamental bases of 'Western Civilization' but also to recognize the penetration of racism and 'continental chauvinism' into all our historiography."*[32] At the end of the introduction he made an endearingly bald statement of intent: "The political purpose of *Black Athena* is, of course, to lessen European cultural arrogance."[33]

Arthur Evans made an appearance in Bernal's story about classical archaeology, but he proved to be a bit of an awkward fit. After all, Evans was working during the height of the Aryan model but had argued from the start that Minoan Crete was profoundly influenced by Egypt and Libya. Bernal got around the difficulty by anointing Evans a member of an "older and more broad-minded generation" while at the same time claiming that "his coining of the name 'Minoan' encouraged people to think of Crete as a unitary culture which was completely detached from the civilizations of the Middle East." Rather than engage with Evans's own work, he quoted a white-supremacist passage from a book by two less well-known British archaeologists, leaving the reader with the impression that Evans's Minoans were part of the Aryan model.[34] The historiographical scheme of *Black Athena* was too rigid to accommodate

the idiosyncrasies of Evans's liberal politics or the sheer plurality of modernist appropriations of the past.

To Bernal's surprise, the first volume of his trilogy was quite enthusiastically received. He was widely reviewed and asked to speak at conferences. The 1989 American Philological Association meeting made the book the topic of its presidential panel, after which he was "flooded with invitations to speak and debate at various universities and colleges around the country."[35] The publication of the second volume in 1991, however, was greeted with a volley of hostile criticism. A volume of rebuttals was published entitled *Black Athena Revisited*.[36] Bernal was moved to respond with his *Black Athena Writes Back*. The dispute between Bernal and his critics became prolonged, personal, and bitter, but there was no denying the impact of the work. As a measure of its importance, at least one whole book was dedicated to examining the cultural politics of the debate itself.[37]

George Wells Parker's argument now goes by the name of the Black Athena thesis, but its essence has remained remarkably consistent: Western civilization originates from ancient Greece; Greek civilization originates from Minoan Crete; Minoan civilization originates from Middle Kingdom Egypt; Middle Kingdom Egypt was ruled by Black pharaohs; and therefore, the origins of Western civilization are Black. I like to think that despite his all-too-manifest racism, Evans's ghost has followed closely the great postcolonial victories of this period and smiles upon these postwar appropriations of his work.

The Road Back to War

Just as the most militantly political deployments of Evans's Minoans were going to press, the academic archaeologists at work in the region were engaged in a wholesale revision of the utopian aspects of his vision. It was a gradual process, but by the end of the 1990s, the pacifist Minoans had been more or less exiled from respectable archaeology. During Evans's lifetime, criticism of his methods and interpretations had been muted, but the challenge that would eventually prove his undoing started rumbling the 1930s, when archaeologists working on the Mycenaean sites in the Peloponnese engaged Evans in a vigorous debate about the direction of cultural influence and political dominance. Did the Minoans really dominate the Mycenaeans, or might it have been the other way around? Evans had always cherished the vision of

Knossian political hegemony over the whole region, while the mainland archaeologists concluded that the Mycenaeans had at some point in their history conquered Crete. It is a testament to Evans's own academic hegemony that he was widely considered, in England at least, to have won the day.

After Evans's death, and in the wake of the Second World War, the way was opened for a more unsparing academic critique of his work. The death of the grand old man of Minoan archaeology liberated a critical impulse that had been kept at bay for forty years, and the visionary coherence of Evans's work quickly turned back into fragments—pottery shards to be analyzed, tablets to be deciphered, frescoes to be reinterpreted, fakes to be denounced. A definitive blow to his version of events came in 1953 with the decipherment of Linear B. When the brilliant amateur linguist Michael Ventris showed that the language of the inscribed tablets found at Knossos was an archaic dialect of Greek, Mycenaean dominance over Crete at the time of the last palace of Knossos became unarguable. Greek is an Indo-European language with northern roots. It seemed that the northern Mycenaeans had conquered Crete, taken over Knossos, and adapted the Cretan script to write their own language.

After the decipherment, questions arose about the dating and findspots of the Linear B tablets at Knossos. Evans had argued that 1400 B.C. marked the destruction of the last palace and the end of Minoan culture. In his interpretation, the two hundred subsequent years saw Knossos occupied by squatters who camped in the ruins and added nothing to the cultural development of the island. This period also happened to coincide with the period of Mycenaean dominance over the rest of the Aegean. In 1960, the philologist Leonard Palmer, wanting to prove that the last palace was coeval with (rather than before) those two centuries of Mycenaean ascendance, began combing through the Evans Archive at the Ashmolean Museum, attempting to reconstruct the tablets' find-spots.[38] He concluded that Evans had systematically falsified the evidence in pursuit of his own interpretations. A protracted and occasionally bitter dispute ensued, one of the fruits of which was the dauntingly technical 1963 volume *On the Knossos Tablets*. In the first half of the book, Palmer marshaled all the evidence for his attack on Evans's credibility, while the second half was given over to the distinguished archaeologist and art historian John Boardman, who attempted to answer Palmer with his own less damning interpretation of the archive.[39]

Palmer's argument was based on a complex series of comparisons. Duncan Mackenzie's daybooks, Evans's Knossos diary, the yearly excavation reports, the pottery shards stored in baskets at the Villa Ariadne, and the *Palace of Minos* were all picked over for inconsistencies and contradictions. Duncan Mackenzie emerged from this as the heroic precursor of the scientific "New Archaeology," while Evans's grand syntheses looked increasingly dubious and sweeping.[40] In 1969 Palmer published *A New Guide to the Palace at Knossos,* which led the reader on a room-by-room tour of uncertain evidence, shaky interpretations, and overcooked reconstructions. His guide to the "Knossos exhibits in the Archaeological Museum," for example, explained that the "Ladies in Blue" fresco was "a spirited composition" by "Evans's Swiss artist M. Gilliéron,"[41] and that the soldiers in the "Captain of the Blacks" fresco were reconstructed from "only the front of a left thigh."[42]

After this assault, the field opened up for deeper revisions of Evans's interpretations. Beginning in 1976, the Greek archaeologist Stylianos Alexiou published a groundbreaking series of articles about ancient fortifications on Crete. In going against the "Myth of Minoan Peace" (as one of his articles was subtitled), Alexiou was bucking a trend that reached far beyond Cretan archaeology.[43] Evans's revulsion at the gruesome aftermath of the Greco-Turkish War of 1897, as well as the subsequent pacifist turn in his interpretations, anticipated a pronounced tendency in the work of war-weary archaeologists after 1945. The study of warfare became increasingly unfashionable and hard to fund.[44] Indeed, the period saw such a definitive turn away from belligerent interpretations of prehistoric evidence that even Mycenae, that archetype of the militaristic walled city, was pacified and democratized by Greek archaeologists as a reaction against the heroic narratives of fascist antiquarians.[45] Alexiou's work on Minoan fortifications nonetheless stimulated a modest research tradition, and others followed in his footsteps.

This academic archaeology flew under the popular radar to a great extent, but at the end of the seventies a melodramatic interpretation of some Minoan finds made the headlines. In 1979 a Middle Minoan temple on the lower slopes of Mount Juktas was excavated under the direction of Yannis and Efi Sakellarakis. Four skeletons were found in the building. Three of these appeared to belong to people who had perished when the building collapsed in an earthquake or in the fire that followed. The position of the fourth skeleton led the excavators to suggest that it belonged to a young man who had been tied up on an

altar like a sacrificial bull and killed by one of the others with a bronze dagger just moments before the earthquake hit. The specter of human sacrifice on Minoan Crete was both shocking and titillating, and the archaeologists found themselves presenting their findings at a packed public debate in Athens in April 1980. In the immediate wake of the Sakellarakis' dig, the news from Minoan Crete only got worse. Later in the same season, the archaeologist Peter Warren excavated a room in the town of Knossos containing a deposit of children's bones covered in knife cuts that suggested that they had been carved up like meat. Were the peace-loving Minoans capable not only of human sacrifice but also of cannibalism?

By 1982, the cracks in Evans's beloved *Pax Minoica* were widening. A symposium convened that year in Stockholm, "Minoan Thalassocracy: Myth and Reality," opening with a paper by the historian Chester G. Starr questioning the evidential basis for the pacifist reconstruction of ancient Crete. Starr argued that it was the naturalism of Minoan art that had led everyone to attribute to them all the virtues of "gentle souls, tending their bulbs and bushes with deep love," but reminded his audience that Heinrich Himmler was a "thoughtful young man who . . . loved birds and flowers."[46] Another paper, subtitled "Military Aspects of Minoan Culture," argued that the ancient Cretans were not only militaristic, but that "the most common and effective Bronze Age weapons were developed first on Crete."[47] A few of the participants acknowledged the long persistence of the image of peace-loving Minoans only to assert its profound implausibility: "We have no reason to suppose that by some quirk of nature or accident of geography the Bronze Age Cretans were any different from other civilised nations of the Near East at the time. Indeed there are hints that they may have been rather more savage."[48]

Two years later, in April 1984, the Greek Ministry of Culture initiated a research agenda dubbed the "Minoan Roads" program, an attempt to explore the network of overland communications in Minoan Crete as a means of understanding the emergence of complex civilization at the time of the first palaces. By 1990 the program had alighted upon an area of particular interest, a triangle of terrain in eastern Crete within the prefecture of Lasithi, which had the "geomorphological and historical prerequisites to form a pilot region for the investigation."[49] This happened to be the same ground that Evans and his friend John Myres had explored in 1895 and described in their article "A Mycenaean Military Road."

Evans never returned to the site of his first Minoan explorations af-
ter the Greco-Turkish War of 1897, quietly dropping the subject of the
guardhouses and fortifications he had identified. The Minoans of his
earliest investigations were a warlike people, and the landscape of east-
ern Crete was densely crosshatched with evidence of man's unquench-
able appetite for violence. Evans did refer to his earlier exploration of
the military road in the second volume of *The Palace of Minos,* but the
whole emphasis of his interpretations shifted. In 1895 the roads and
their attendant structures seemed to him to be clear evidence of inter-
necine strife, each group defending pockets of territory against their
equally belligerent neighbors. By the 1920s, the "guard-stations" of his
earlier interpretations had become "watch-stations" for checking brig-
andage, protecting commerce, and securing postal communications.[50]

Now the "Military Road" that Evans had delineated before the exca-
vation of Knossos was about to become visible once again after nearly
a century of neglect. In 1990, the Ministry of Culture set about in-
tensively investigating and mapping the designated area. Of greatest
archaeological interest were the fortified structures that appeared at
intervals along the ancient roads. These were dubbed "guard stations"
following Evans's interpretation and turned out to be of uniform de-
sign and construction, positioned to allow surveillance of the roads and
built to maximize their defensive character. In 1992, J. A. MacGillivray,
the then-curator of Knossos, described the network of roads and guard-
houses as evidence of an "attempt to impose control or authority where
it may not have been welcomed."[51]

After Evans left Crete in 1895 there was an anti-Ottoman uprising,
but when he returned the following summer, he was happy to report
that the eastern part of the island was mostly unaffected. He continued
to explore the territory and came across a Bronze Age site consisting
of a cluster of fortified buildings, each on its own rock knoll, enclosure,
and fortified ramp. To this vision of extreme aggression and insecurity
he gave the name "A Town of Castles." Again, just as with his military
road, Evans never returned to the site after the 1897 war, preferring
not to complicate his *Pax Minoica* with too much evidence for Minoan
belligerence.

Exactly a century later, in 1996, a research team from the University
of Vienna were given permission to study a site in the far east of Crete
that corresponded with Evans's Town of Castles. Although it was
probably not the same site, it constituted, in the words of the archae-

ologists, an "impressive variant" of the same type of fortified settle-
ment. The team who had excavated it concluded that the Old Palatial
period in Crete was characterized by "small independent communities
at constant war with each other and struggling to defend themselves
against aggressive and more powerful neighbours." According to their
interpretation, the Town of Castles was erected by "freedom-loving
country people" in order to resist the aggressive expansion of Knossian
power over the eastern half of the island.[52]

Other archaeologists concurred. Stella Chryssoulaki of the Minoan
Roads program asserted at a 1998 conference that the "story of the
laying out and constructing of roads was . . . always a military story."[53]
At the same event, the Polish archaeologist Krzysztof Nowicki con-
jured up a dystopian vision of multiple Minoan "zones of conflict" en-
gaging in raids and wars.[54] Alan Peatfield, a classicist with an interest
in martial arts, analyzed the swords and daggers of ancient Crete and
concluded that "weaponry seems to have played a fundamental role in
Minoan society throughout all the phases of its history."[55] Stefan Hiller
analyzed Minoan artistic depictions of warfare and combat.[56] The ef-
fect of all this work was to make the Mycenaeans and the Minoans ap-
pear strikingly similar. The two Bronze Age civilizations that had been
constructed in the early twentieth century as polar opposites—one
masculine and warlike, the other feminine and peaceful—were now be-
ing discussed as cultures that had both experienced periods of violent
internal strife alternating with periods of central control.

Depending on both accidents of preservation and idiosyncrasies of
emphasis and interpretation, it seemed that either civilization could
serve to illustrate the heroic virtues of militarism or the blessings of
peace. In the decades between Schliemann's excavation of the site and
the Second World War, Mycenae became the ultimate Nazi fantasy
of the ancient world, the type specimen of the fascist appropriation
of the ancient Greeks. Through all the same political convulsions and
catastrophes, Knossos served an alternative agenda, as a repository
for that most elusive of human aspirations, the dream of peace. In the
years since 1945, Greek archaeologists reclaimed Mycenae as evidence
for cooperative nation-building and multiculturalism, while their coun-
terparts on Crete began dismantling Evans's utopian legacy. Toward
the end of the cold war, the two reconstructions converged, and the
Minoan doves and Mycenaean hawks of the first half of the twentieth
century began to look like the same species of bird after all.

${ CONCLUSION }$

When I first embarked on this project (more years ago than I care to remember), I thought that the story of modernist Knossos might fit into the study of the cultural politics of memory—a small but then fashionable subfield of cultural history. In keeping with this theme, I was interested in aspects of the subject such as archaeology's entanglement with psychoanalysis, technologies of memory like the archaeological daybook, and the eclectic methods of archaeological reconstruction. It turned out, however, that not all my protagonists shared equally in the memory and forgetting motif, and that something much odder was invariably at stake. The one thing that united all my primary sources was not so much memory as *prophecy*. The archaeology of Greek myth seemed to have created its own neopagan epistemology, a quasi-supernatural way of knowing in which the prehistoric past was not only knowable in advance of the evidence but was also implicated in the unfolding of the present and the future.

Confronted with the extensive catalog of extravagant reconstructions, outright forgeries, invented traditions, and false memories

that litter the record of Greek Bronze Age archaeology, I started out understanding this prophetic mode as necessarily counterfeit. Heinrich Schliemann's prophecies, for example, were as fraudulent as they were influential, a key element in his assiduous self-mythologizing. The confected childhood scene with his father burnished the legend of his extraordinary destiny and established the model life of the archaeologist-prophet. His claim that the mummified corpse in the first shaft grave of Mycenae physically resembled Agamemnon established his kinship with the heroes of antiquity. The act of recognition with which he linked the swastikas on prehistoric German pottery with swastikas from Troy suggested that the kinship might be a racial as well as a spiritual one. At each juncture, he relied on distortions and erasures to endow his work with its oracular substance.

Archaeological prophets after Schliemann continued to avail themselves of dubious materials to construct their systems. Wilhelm Scheuermann's reproduction of the fake swastika on the Trojan figurine exposed the flimsiness of his prophetic prehistory of National Socialism. Evans's delighted reception of the divine family of ivory forgeries revealed the hazards of prophetic overconfidence. Freud's claim that psychoanalysis was in a position to predict the fruits of archaeological excavation was a particularly labyrinthine instance of hollow prophetic rhetoric. H.D.'s faked journal of her analysis with Freud demonstrated the extent to which prophetic self-fashioning underwrote her whole neo-Minoan worldview. In each of these cases, the rules of evidence were sacrificed on the altar of prophetic self-aggrandizement.

As my immersion in the period deepened, however, it became apparent that there were modes of modernist prophecy constructed of more robust materials than this dismal catalog of ersatz antiquities. By virtue of their diagnostic accuracy, rhetorical force, and/or ethical integrity, some of these oracular narratives linking the deep past with the present and future seemed to me to partake of genuine prophetic power. The story of modernist Knossos began then to assume a shape, a sort of call-and-response between an eccentric array of artists, scientists, and assorted visionaries, all trying to make sense of some of the weightiest themes of modernity—the death of God, the woman question, the human appetite for war.

The prologue to this drama was the prophetic manifesto of a young classics professor writing during the Franco-Prussian War. Asserting that Greek religion would answer the crisis of values in a post-Christian

society, Nietzsche declared that Germany was living through the great ages of the Hellenic world in reverse order, and seemed at that moment to be moving backward from the Alexandrian age into an age of tragedy. The reverse chronology of Nietzsche's prophecy was archaeological: as modernity dug ever deeper into its own pagan origins, the excavation moved progressively back in time. This book has tracked the backward movement of Dionysian modernism, through age of tragedy to the Homeric age, and back even further to the peaceful gardens of Minoan Crete. The philosopher himself appears in this story as a latter-day incarnation of Sophocles' blind seer Tiresias, declaiming his untimely oracles to a hostile world: "One day my name will be associated with the memory of something monstrous . . . I am not a man, I am dynamite. . . . There will be wars such as there have never been on earth."

And indeed, as archaeological modernism moved backward from the tragic age to the Homeric age, Nietzsche's interpretations of the warrior creed of the Homeric heroes supplied fascism with its own tailormade prehistory. When an Aryanized *Iliad* replaced the Semitic Old Testament as the founding myth of Western civilization, the corpses from the Mycenaean shaft graves could be reinvented as Teutonic blond beasts and the Trojan swastika appropriated as a badge of racial superiority. Racial science, the aristocratic ethic, and an aggressive commitment to winning the struggle for existence constituted one neopagan way to answer Nietzsche's exhortation to view morality "through the lens of Life."

But there was another way. Faced with the thoroughly inglorious aftermath of the Greco-Turkish War of 1897, Arthur Evans produced a different set of Nietzschean myths for modernity. His palace was a peaceful garden; his heroes were female bullfighters; his gods were Ariadne and Dionysus. The Homeric object that he found (and repeatedly refound) at Knossos was Ariadne's dancing floor, one of the magical, god-wrought scenes on Achilles' shield. Every year Evans's Cretan workers—Muslim and Christian alike—performed the labyrinth dance together in one of the great courtyards of Knossos, linking arms, in the archaeologist's vision, with an unbroken tradition of Cretan dances stretching back to the rituals in honor of the Minoan goddess. As the whole continent of Europe proceeded to crack along the great political fault line that ran through the island of Crete, Evans's yearly reenactment of the labyrinth dance came more and more to resemble the

haunting vision of ancient peace that Achilles carried onto the battle-
fields of Troy.

The artist Giorgio de Chirico was a true disciple of this affirmative,
pacifist version of Nietzsche's prophetic method. He had witnessed as
a child the horrific retreat of the Greek troops during the same 1897
war that shaped Evans's reconstruction of Knossos. His Ariadne series,
painted during the Balkan Wars, represents a potent, if pessimistic,
distillation of the same cultural, political, and spiritual forces that were
converging at the palace of Minos. Paralyzed, somber, and passive, his
abandoned Ariadne awaits the fate of her world among the lengthening
shadows of an empty square.

Others, too, deployed Dionysian archaeology to similarly affirma-
tive ends. Jane Ellen Harrison brought Evans and Nietzsche together
in the service of a feminist prophecy of future liberation. What the
women of antiquity had lost during the traumatic switch to patriarchy,
the women of the future would gain through the triumphant recovery
of their Cretan legacy. George Wells Parker appealed to the African
roots of Minoan civilization to imagine a future free of racial prejudice.
James Joyce defied the loneliness and misanthropy of the Nietzschean
prophet by celebrating the mythic heroism of everyday life in his Dae-
dalian retelling of single Dublin day. Picasso drew on Minoan iconog-
raphy to mount his furious protest against war. Henry Miller saw in
Knossos the joy that awaited if humanity could only solve the riddle of
violence. H.D. hitched her Minoan prophecies to the promise of peace
and the liberation of female sexuality.

Pacifist modernism brought archaeology, psychoanalysis, and exper-
imental literature together in a new magical realist diction. T. S. Eliot,
writing in 1922 about James Joyce's *Ulysses*, proposed that the author
was following the "mythical method" in order to bring aesthetic order
to the modern panorama of chaos and futility. I have argued that Ev-
ans's 1925 reconstruction of the cult of the Minoan butterfly goddess
was another example of this form. It turned out that my attempts to
"unmask" this reconstruction as yet another narcissistic interpretation
of a fake only ended up strengthening its claim to be read on its own
mythic terms. Evans's Minoan Psyche then served as a "tracer object,"
a symbolic cluster that enabled me to track the workings of Dionysian
modernism as they manifested on Freud's famous couch in the person
of that modernist savage H.D.

A whole array of modernist divination techniques were at work in the encounter between poet and psychoanalyst, from Freud's method of Zadig applied to the strata of racial memory, to H.D.'s Dionysian irrationalism lived at an extreme pitch of mystic totality. Freud's inherited memory concept transformed evolutionary theory into an oracular activity—his esoteric knowledge of the connection between the modern neurotic and the primitive mind yielded knowledge of both the deep past and the far-off future. For H.D., the line of transmission between past and present was one in which earthly events were the material expressions of a transcendent narrative of alternately traumatic and redemptive repetition. Minoan archaeology made every aspect of their encounter intelligible in relation to a great web of parallels and resemblances, a neoalchemical "doctrine of signatures" at work in the dreamtime of Dionysian modernism. In H.D.'s willing enactment of the inherited memory concept and Freud's wondering acceptance of her performance, we can see how the human sciences can convince us not just to believe in, but also to enact across our own lives, a prophetic version of our origins.

Part of the pathos of Freud and H.D.'s *folie à deux* derives from its timing. They met in 1933, just as the forces that would smash their fragile archaeological accord were gathering strength. They were reunited in London on the eve of the Second World War, where Freud had moved in his eighty-third year to escape the Nazis. His final work was the monumental *Moses and Monotheism,* a text so steeped in the assumptions of nineteenth-century racial science that it was already obsolete by the time of its writing. He died in his Hampstead home only three weeks after the German invasion of Poland. H.D., for her part, endured the bombing of London by escaping into a parallel occult world, an alternate reality in which Minoan Crete featured as the pacifist Eden from which to mount her poetic protest against war.

H.D.'s rewriting of her 1933 notebooks immediately after the war exemplified in microcosm the traumatic rupture in the human sciences that opened up when the full extent of the Nazi genocide was revealed. After 1945, archaeology embarked on a quiet but pervasive period of reform. The Homeric poems ceased to dominate the interpretation of the Greek Bronze Age. The Aryanized Greeks—the most favored race of all—were quietly turned into speakers of a language and bearers of a culture rather than nature's lucky aristocrats. An archaeology of

everyday life supplanted the focus on the treasure of kings. In harmony with this revisionist zeal, the archive of the Knossos excavations was combed over for inconsistencies and distortions, and Evans was condemned as an autocratic fantasist.

In the introduction I launched the discussion of scientific prophecy with a consideration of Thomas Huxley's 1880 essay "Retrospective Prophecy as a Function of Science." There Huxley lays out a methodology for the proper conduct of the historical sciences, a mode of cause-and-effect reasoning, starting from the visible effect and working backward to the inferred cause. Impressive examples are culled from paleontology, but for the human sciences, he breezily invokes "ordinary human motives" as a basis for historical reconstruction, and asserts his "well-grounded confidence that monuments and works of art and artifice, have never been produced by causes different from those to which they now owe their origin." Since 1945, the search has been on for something to replace Huxley's high Victorian certainty. In postwar anthropology the celebration of the radical otherness of different cultures has tended to undercut any assumption of the immutability of human nature, while the discipline of history has dedicated itself to the recovery of the "incommensurable" worlds of the past. All this has created some difficulties for archaeology, and the discipline has oscillated between extreme scientism and earnest postmodernism in its search for epistemological respectability.

On the fringes of epistemological respectability, however, the more mythic fragments of Evans's oracular vision did reemerge in the postwar world. While the neo-Homeric fantasies of fascist antiquarians were consigned to the dustbin of history, the pacifist, feminist, and Afrocentric Minoans survived the war to enjoy their populist Eighteenth Brumaire in the century's second half. So great was the appetite visions of prehistoric harmony, that even Mycenae, that archetype of the walled city ruled by a warrior king, was reconstructed by Greek archaeologists as a peaceful and essentially benign bureaucracy. In the last decades of the cold war, however, scholars began to reject the pacifist reconstruction of the Minoan world, and by the century's end the archaeology of ancient Crete had returned to the warlike Minoans of Evans's earliest interpretations.

In other ways, too, the human sciences have returned to late nineteenth-century form. In the last couple of decades, the assumption

that human history should be understood as little more than an extension of natural history has come roaring back. Retrospective prophecy has once again entered a grandiloquent phase, opening up great swathes of the human condition to the narratives of historical reconstruction. "Evolutionary pressures on our hunter-gather ancestors" provide the explanatory framework for all aspects of our putatively natural selves. The double helix of DNA is celebrated as a bioarchaeological record of each individual organism's evolution. The search is on for reductive neurological explanations for our complex social behaviors. It seems that the sciences from which Nietzsche derived his dark philosophy have returned with all of the force of the long repressed.

If anything, the ethical paradoxes and problems associated with this natural history of humanity have only deepened. The essentialist synthesis has revived in a postcolonial world, one in which the politics of human identity—"political correctness," if you must—precludes the rigid stratification of the biology of human difference. But as the unstoppable power of these new discourses becomes everyday more apparent, it remains an open question as to whether the science of human difference will transcend or reinforce the politics of human inequality.

The reconstruction of Knossos anticipated some of the political contradictions of our present predicament. Arthur Evans, exposed early in life to the evolutionary sciences, was one of the prophets of essentialism who attempted to align his claims with more robust moral and political imperatives than mere biological nihilism. From the period of his first antiquarian travels during the 1875 Bosnian uprising against Ottoman rule, his archaeology was always put in the service of his political idealism. Caught up in an anti-imperial struggle for self-determination, he sought "solid evidence of past well-being"[1] as a foundation from which to prophesy a prosperous and democratic future for the Slavic lands. On the island of Crete, after the devastation wrought by the Greco-Turkish War, he actually turned his back on the network of fortifications that he had already explored and dedicated his excavation and reconstruction of Knossos to the cause of peace. In 1923, appalled by the forced exchange of Muslim and Christian populations between Turkey and Greece, he embarked on a defiantly optimistic reenactment of Minoan relations with her southern neighbors, reconstructing a trade route linking Knossos to the ancient cultures of sub-Saharan Africa. All this was achieved within the discourse of racial science and within the limitations of his own instinctive racism.

There is no escaping the fact that we read the human past to understand the present, and then interpret it in the light of the future that we fear or desire. Nietzsche was one of the first to exploit the prophetic aspect of our historical reconstructions, and his writings have much to teach us in their tragic awareness of the mythic self-grounding of such work. But it is precisely to the extent that Evans and his fellow travelers embraced what Nietzsche repudiated—their acceptance of the ethical dimension of prophetic narratives—that these lesser oracles may stand as worthy of our consideration. In conclusion, then, perhaps I might be permitted to offer this present work as a prophetic prehistory of its own—my attempt to reconstruct a relatively benign ancestry for the twenty-first-century revival of the essentialist synthesis.

❧ NOTES ☙

INTRODUCTION

1. Arthur Evans, *The Palace of Minos* (London: Macmillan, 1921–1936), vol. 1, p. 1.

2. See, for example, Jan Driessen, *An Early Destruction in the Mycenaean Palace at Knossos* (Leuven: Acta Archaeologica Lovaniensia Monographie, 1990), p. 8: "The lavish use of concrete and cement in the restorations obscures the buildings, thus making a reconstruction of the find-circumstances of the tablets extremely wearisome. Moreover, the final account of the excavations of the building, Evans's gigantic *Palace of Minos,* published more than two decades after the start of the work on the site is, albeit a standard work on Minoan culture, not a reliable source of information on the excavations at Knossos."

3. From Oxford philosopher R. G. Collingwood's unpublished notebooks, quoted in Sinclair Hood, "Collingwood on the Minoan Civilisation of Crete," in *Collingwood Studies,* ed. D. Boucher and B. Haddock (Swansea: R. G. Collingwood Society, 1995), p. 176.

4. See, for example, the introduction to Dorothy Ross, ed., *Modernist Impulses in the Human Sciences, 1870–1930* (Baltimore: Johns Hopkins University Press, 1994). For an excellent discussion of the crisis of rationalism, see David Luft, *Eros and Inwardness in Vienna: Weininger, Musil, Doderer* (Chicago: Chicago University Press, 2003), pp. 13–44.

5. Thomas Henry Huxley, *Collected Essays, Volume Four, Science and Hebrew Tradition* (London: Macmillan, 1898), p. 5.

6. Huxley, *Collected Essays*, p. 6.

7. Huxley, *Collected Essays*, p. 6.

8. Carlo Ginzburg, "Clues: Morelli, Freud, and Sherlock Holmes," in *The Sign of Three: Dupin, Holmes, Pierce,* ed. Umberto Eco and T. A. Sebeok (Bloomington: Indiana University Press, 1983).

9. Gillian Beer, *Arguing with the Past: Essays in Narrative from Woolf to Sidney* (London: Routledge, 1989), p. 16.

10. Huxley, *Collected Essays*, p. 7.

11. Huxley, *Collected Essays*, p. 4.

12. The two modes were certainly compatible, as attested to by the fact that Sherlock Holmes's creator, Arthur Conan Doyle, was an ardent spiritualist.

13. See the chapter "Myth in the Age of the Worldview" in Michael Bell, *Literature, Modernism and Myth* (Cambridge: Cambridge University Press, 1997), pp. 9–40, for a brilliant discussion of the philosophical implications of mythic modernism.

14. Huxley, *Collected Essays*, pp. 9–10.

15. Edward B. Tylor, "The Tasmanians as Representatives of Palaeolithic Man," *Journal of the Anthropological Institute of Great Britain and Ireland* 23 (1894): 152.

16. Bronislaw Malinowski, *A Diary in the Strict Sense of the Term* (New York: Harcourt, Brace & World, 1967), p. 238. For a fuller discussion of archaeological metaphors, see Cathy Gere, "Inscribing Nature: Archaeological Metaphors and the Formation of New Sciences," *Public Archaeology* 2, no. 4 (2002): 195–208.

17. Cathy Gere, *The Tomb of Agamemnon* (Cambridge: Harvard University Press, 2006), pp. 60–145.

18. E. M. Forster, *Maurice* (New York: W. W. Norton, 1971), p. 159.

19. In this aspect, Knossos can be understood as the nonfiction counterpart to the emerging subgenre of feminist science fiction, best exemplified by Charlotte Perkins Gilman's racist, parthenogenetic fantasy *Herland* published in 1915.

20. See, for example, the comment of Joseph Charles Mardrus, famous translator of the *Thousand and One Nights* from Arabic into French. When asked in 1920 whether "savage" art belonged in the Louvre he spluttered "After the six delightful years we've just been through, don't you think Europeans should have the modesty to reserve this word for themselves? But no, they continue to label people with it who have neither the inclination nor the opportunity to reply." Jack Flam and Miriam Deutch, eds., *Primitivism and Twentieth Century Art: A Documentary History* (Berkeley: University of California Press, 2003), p. 152. See also Bronislaw Malinowski's introduction to Jomo Kenyatta, *Facing Mount Kenya: The Tribal Life of the Gikuyu* (London: Secker and Warburg, 1938).

CHAPTER ONE

1. Heinrich Schliemann has legions of biographers, most writing in an unabashedly popular vein, but the scholarly market has recently been cornered by two American classicists intent on busting the heroic Schliemann myth. See William M. Calder III and David A. Traill, eds., *Myth, Scandal and History: The Heinrich Schliemann Controversy and a First Edition of the Mycenaean Diary* (Detroit: Wayne State University Press, 1986); David A. Traill, *Excavating Schliemann* (Atlanta: Scholars Press, 1993); and David A. Traill, *Schliemann of Troy: Treasure and Deceit* (New

York: St. Martin's Press, 1995). A good commentary on this body of antihagiographi-
cal work is Justus Cobet, "Heinrich Schliemann nach hundert Jahren: Die Histo-
risierung von Mythos und Ägernis," in the very useful collection *Heinrich Schliemann
nach hundert Jahren,* ed. Justus Cobet and William M. Calder III (Frankfurt am
Main: Vittorio Klostermann, 1990). A more gently skeptical account of his life is to
be found in the introductory essay of Leo Duel, *Memoirs of Heinrich Schliemann: A
Documentary Portrait Drawn from His Autobiographical Writings, Letters and Excavation
Reports* (New York: Harper & Row, 1977). An exemplary investigation of the excava-
tion of Troy is to be found in Susan Hueck Allan, *Finding the Walls of Troy: Frank
Calvert and Heinrich Schliemann at Hisarlik* (Berkeley: University of California Press,
1999). Among the many other tellings of Schliemann's life and times is my own in
The Tomb of Agamemnon.

2. Traill, *Schliemann of Troy,* pp. 45–46.

3. Allan, *Finding the Walls of Troy.*

4. Traill, *Schliemann of Troy,* p. 78.

5. Traill, *Schliemann of Troy,* p. 83.

6. Heinrich Schliemann, *Troy and Its Remains: A Narrative of Researches and Dis-
coveries Made on the Site of Ilium and the Trojan Region* (London: John Murray, 1875),
p. 323.

7. Schliemann, *Troy and Its Remains,* p. 333.

8. Traill, *Schliemann of Troy,* p. 162.

9. Heinrich Schliemann, *Mycenae, a Narrative of Researches and Discoveries at Myce-
nae and Tiryns* (New York: Scribner's and Sons, 1880), p. 296.

10. Traill, *Schliemann of Troy,* p. 163.

11. Cited in Christiane Zintzen, *Von Pompeji nach Troja: Archäologie, Literatur und
Öffentlichkeit im 19. Jarhhundert* (Vienna: Universitätsverlag, Wien, 1998), p. 55.

12. Zintzen, *Von Pompeji nach Troja,* p. 55.

13. Heinrich Schliemann, *Ilios: The City and Country of the Trojans* (London: John
Murray, 1880), p. 3.

14. Traill, *Schliemann of Troy,* pp. 132–138. A more charitable interpretation of the
autobiography is to be found in Helmut Scheuer, "Heinrich Schliemanns 'Selbst-
biographie': Zur Gattungstypologie der Autobiographik in der zweiten Hälfte des
neunzehten Jahrhunderts," in *Heinrich Schliemann nach hundert Jahren,* ed. William
Calder and Justus Cobet (Frankfurt am Main: Vittorio Klostermann, 1990), which
suggests that the difficult process of turning from businessman to cultured archae-
ologist led Schliemann on a search for his "hidden self" (*verborgenen Ich*), p. 346.

15. Schliemann, *Ilios,* p. 1.

16. The literature on Nietzsche is so huge as to defy any sort of summary, but
there has not, to my knowledge, been any prior exploration of his Dionysian legacy
to the discipline of archaeology. My analysis is therefore based on a reading of
primary sources, supplemented by some excellent biographies such as Ronald Hay-
man, *Nietzsche: A Critical Life* (London: Weidenfeld and Nicholson, 1980); Curtis
Cate, *Friedrich Nietzsche: A Biography* (London: Pimlico, 2003); and R. J. Hollingdale,
Nietzsche: The Man and His Philosophy (Cambridge: Cambridge University Press,
1999). Lou Salomé's reminiscences gave me an invaluable glimpse of the man from
the point of view of one of his 'Ariadnes': Lou Andreas Salome, *Friedrich Nietzsche in
seinem Werken* (Frankfurt am Main: Insel Verlag, 1983), while Erich Podach's inves-
tigation of Nietzsche's Ariadne obsession was extremely helpful in its investigation

of unpublished sources: Erich F. Podach, *Ein Blick in Notizbücher Nietzsches. Ewige Wiederkunft; Wille zur Macht; Ariadne* (Heidelberg: Wolfgang Rothe Verlag, 1963). In terms of other secondary sources, the most helpful have come from the history of art. Elizabeth Cowling and Jennifer Mundy, *On Classic Ground: Picasso, Leger, De Chirico and the New Classicism, 1910–1930* (London: Tate Gallery Publications, 1990), defined a type of "Nietzschean classicism" in terms that I found inspirational for understanding the place of Knossos in artistic and literary modernism. Another catalog, this one to accompany an exhibition of Giorgio de Chirico's 'Ariadne Series', discussed Nietzsche's shaping of de Chirico's prophetic stance, the artist's lifelong pacifism, and his family's Cretan associations, thus coming closer than any other secondary source to making the connections that I have explored here: Michael Taylor, *Giorgio De Chirico and the Myth of Ariadne* (Philadelphia: Philadelphia Museum of Art, 2002).

17. Schliemann's paganism is perhaps best expressed in the design of his neo-classical-cum-neo-Homeric hero's tomb in the First Cemetery in Athens. It also manifests in his correspondence with Rudolf Virchow, where the two men invoke Athena's blessings on a regular basis. Virchow repeatedly uses variations on the phrase "May Athena be merciful to you" (*Möge Athena Ihnen gnädig sein*), for example, in Joachim Herrmann and Evelin Maass, eds., *Die Korrespondenz zwischen Heinrich Schliemann und Rudolf Virchow, 1876–1890* (Berlin: Akademie-Verlag, 1990), letter nos. 294, 399. Schliemann credits Athena with sending inspiration on a number of occasions, most characteristically for a scheme to silence one of his critics; see letter nos. 541, 585.

18. Hollingdale, *Nietzsche*, p. 48.

19. Friedrich Nietzsche, *The Birth of Tragedy and the Genealogy of Morals*, trans. Francis Golffing (New York: Doubleday, 1956), p. 26, and idem, *Werke in drei Bänden* (Dortmund: Koenemann, 1994), vol. 1, p. 27. I have included references to the German text because Golffing's translation, while it captures the sheer excitement and rhythmic exuberance of the original very well, takes rather a lot of license with it.

20. Nietzsche, *Birth of Tragedy*, p. 27, *Werke in drei Bänden*, vol. 1, p. 28.

21. Nietzsche, *Birth of Tragedy*, p. 119, *Werke in drei Bänden*, vol. 1, p. 122.

22. Nietzsche, *Birth of Tragedy*, p. 120, *Werke in drei Bänden*, vol. 1, p. 123.

23. Nietzsche, *Birth of Tragedy*, p. 95, *Werke in drei Bänden*, vol. 1, p. 96.

24. Nietzsche, *Birth of Tragedy*, p. 111, *Werke in drei Bänden*, vol. 1, p. 112.

25. Nietzsche, *Birth of Tragedy*, p. 42, *Werke in drei Bänden*, vol. 1, p. 42.

26. Nietzsche, *Birth of Tragedy*, pp. 102–103, and *Werke in drei Bänden*, vol. 1, p. 104.

27. Friedrich Nietzsche, *On the Advantage and Disadvantage of History for Life*, trans. Peter Preuss (Indianapolis: Hackett Publishing Co., 1980), p. 8, Nietzsche, *Werke in drei Bänden*, vol. 1, p. 156.

28. Friedrich Nietzsche, *The Gay Science*, trans. Josephine Nauckhoff (Cambridge: Cambridge University Press, 2001), p. 199, *Werke in drei Bänden*, vol. 2, p. 16.

29. Hollingdale, *Nietzsche*, p. 153.

30. Friedrich Nietzsche, *Ecce Homo: How One Becomes What One Is*, trans. R. J. Hollingdale (London: Penguin, 1992), p. 98, emphasis in the original.

31. There is much debate about the causes of Nietzsche's suffering. His biographers tend to offer psychosomatic explanations — as though because the scale of his torments was commensurate with the magnitude of his intelligence, there must be a

causal connection between the two. Lou Salomé herself wrote sensitively and subtly about the significance of Nietzsche's illness for his work in her *Friedrich Nietzsche in seinem Werken*. See especially pp. 42–46 in which she argues that Nietzsche's cycles of suffering and recovery were central to his philosophical outlook. There is much in his work that supports this argument, for example, the preface to the second edition of *The Gay Science*. A medical doctor has recently and persuasively argued, partly on the grounds of the childhood onset of his symptoms, that Nietzsche was suffering from a slow-growing brain tumor. See Leonard Sax, "What Was the Cause of Nietzsche's Dementia?" *Journal of Medical Biography* 11 (2003), pp. 47–54.

32. *Was bedeutet, unter der Optik des Lebens gesehn,—die Moral?* in Nietzsche, *Werke in drei Bänden*, vol. 1, p. 11. Gollfing's translation, "What kind of figure does ethics cut once we decide to view it in the biological perspective?" (p. 9), although convenient for my argument, is too anachronistic.

33. Friedrich Nietzsche, *On the Genealogy of Morality,* ed. Keith Ansell-Pearson, trans. Carol Diethe (Cambridge: Cambridge University Press, 1994), p. 25, emphasis in the original.

34. As far as I can ascertain, Nietzsche never mentioned Schliemann anywhere in his works, published or unpublished, but it is impossible that he was unaware of the famous excavations. Two of his closest friends, Jacob Burckhardt and Erwin Rohde, both engaged directly with Schliemann's Mycenaean discoveries. See Erwin Rohde, *Psyche* (New York: Harper & Row, 1966), p. 22; and Jacob Burckhardt, *Griechische Kulturgeschichte* (Stuttgart: Alfred Kroener Verlag, 1952), pp. 84–87.

35. Nietzsche, *Ecce Homo*, p. 48.

36. Nietzsche, *Ecce Homo*, p. 49, emphasis in the original.

37. Nietzsche, *Ecce Homo*, pp. 96–97, emphasis in the original.

38. There are many variations on this story, most more dramatic than this one, but for the sources of this version, see Anacleto Verrechia, "Nietzsche's Breakdown in Turin," in *Nietzsche in Italy,* ed. Thomas Harrison (Saratoga: ANIMA Libri, 1988).

39. For a more convincing diagnosis, see Sax, "What Was the Cause of Nietzsche's Dementia?"

40. Herrmann and Maass, *Die Korrespondenz zwischen Heinrich Schliemann und Rudolf Virchow: 1876–1890,* letter no. 1.

41. Traill, *Schliemann of Troy*, p. 178.

42. Marion Bertram, *Rudolf Virchow als Prähistoriker: Sein Wirken in Berlin* (Berlin: Staatliche Museen zu Berlin, 1987), pp. 12–24.

43. Malcolm Quinn, *The Swastika: Constructing the Symbol* (London: Routledge, 1994), p. 43.

44. Schliemann, *Troy and Its Remains*, p. 102.

45. Schliemann, *Ilios*, p. 348.

46. Heinrich Schliemann, *Troja. Results of the Latest Researches and Discoveries on the Site of Homer's Troy and in the Heroic Tumuli and Other Sites, Made in the Year 1882* (London: John Murray, 1884), p. xii.

47. Schliemann, *Troja*, p. 357.

48. Karl Penka, *Die Herkunft der Arier: Neue Beiträge zur historischen Anthropologie der europäischen Völker* (Vienna, 1886).

49. Quinn, *Swastika,* p. 23.

50. Otto Grabowski, *Das Geheimnis des Hakenkreuzes und die Wiege des Indogermanentums* (Berlin, 1921); Quinn, *Swastika,* p. 61.

51. Gustaf Kossinna, *Ursprung und Verbreitung der Germanen in vor- und frühge-schichtlicher Zeit*, 2 vols. (Berlin: Germanen-Verlag, 1927), quotation from p. 243.

52. Wilhelm Scheuermann, *Woher kommt das Hakenkreuz?* (Berlin: Rowohlt Verlag, 1933), p. 7.

53. Scheuermann, *Woher kommt das Hakenkreuz?* p. 20.

54. Herbert Schmidt, *Heinrich Schliemanns Sammlung: Trojanischer Altertümer* (Berlin: Georg Reimer für die Königliche Museen zu Berlin, 1902), p. 255. See also p. x for a refreshingly sober discussion of the swastika symbol as found on Trojan spindle whorls.

55. Scheuermann, *Woher kommt das Hakenkreuz?* p. 20.

56. "eine Art gegenseitigen Erkennungszeichens der Arier." Scheuermann, *Woher kommt das Hakenkreuz?* p. 7.

57. Allan, *Finding the Walls of Troy,* p. 2.

58. Ernst Meyer, ed., *Briefe von Heinrich Schliemann, gesammelt und mit einer Einleitung in Auswahl herausgegeben von Ernst Meyer* (Berlin: W. de Gruyter, 1936).

59. Meyer, *Briefe von Heinrich Schliemann*, p. 25.

60. Joseph Alexander MacGillivray, *Minotaur: Sir Arthur Evans and the Archaeology of Minoan Myth* (London: Jonathan Cape, 2000), contains a good section on Kalokairinos's excavations (pp. 91–94).

61. Arthur Bernard Cook, *Zeus: A Study in Ancient Religion* (Cambridge: Cambridge University Press, 1914), p. 478.

62. Nietzsche, *Ecce Homo,* p. 80.

63. Nietzsche, *Werke in drei Bänden*, vol. 3, p. 516, emphasis in the original.

64. Podach, *Ein Blick in Notizbücher Nietzsches*, p. 116.

65. For the best discussion in English of Weininger's work, see David Luft, *Eros and Inwardness in Vienna*.

CHAPTER TWO

1. A heroic template for the history of Minoan archaeology was set in 1949 with the publication of C. W. Ceram, *Gods, Graves and Scholars: The Story of Archaeology,* trans. E. B. Garside and Sophie Williams (London: Book Club Associates, 1971), a melodramatic best seller by a German journalist chronicling the exploits of various excavators, including Arthur Evans. Sylvia Horowitz, *The Find of a Lifetime: Sir Arthur Evans and the Discovery of Knossos* (London: Weidenfeld and Nicholson, 1981), maintained the hagiographic tradition without supplying much insight into the historical context for the rebuilding of Knossos. A slightly more scholarly, but still popular and readable, history of the excavation is to be found in J. Lesley Fitton, *The Discovery of the Greek Bronze Age* (London: British Museum Press, 1995). The pendulum has recently swung decisively away from the heroic, and the last few years have seen the publication of more critical historical work on Knossos. The curators of the Evans Archive at the Ashmolean Museum have produced some invaluable, if rather narrowly focused, publications: Ann Brown, *Arthur Evans and the Palace of Minos* (Oxford: Ashmolean Publications, 1983), idem, *Before Knossos: Arthur Evans's Travels in the Balkans and Crete* (Oxford: Ashmolean Publications, 1993); and Susan Sherrat, *Arthur Evans, Knossos and the Priest-King* (Oxford: Ashmolean Museum Publications, 2000). The most recent full-length biography of Evans is Joseph Alexander MacGillivray, *Minotaur: Sir Arthur Evans and the Archaeology of Minoan Myth* (London: Jonathan Cape, 2000), a damning account of his life and work by the

then-curator of Knossos. There is much indispensable research in the book, but it is skewed to the point of factual distortion by a profound animus toward its main protagonist, an Oedipal hatchet job neatly exemplified by the author's claim that Evans was only four feet tall (p. 34). Evans was, indeed, rather short of stature but he did make it to over five feet! Other Cretan archaeologists have engaged in a historical revisionism somewhat less nihilistic than MacGillivray's. Yannis Hamilakis, ed., *Labyrinth Revisited: Rethinking Minoan Archaeology* (Oxford: Oxbow Books, 2002), is a collection of essays mounting a "critical and historical consideration of the social production of the 'Minoan' past" (p. 4). The volume's main targets are the imperialist and nationalist contexts of Minoan archaeology, but in their zeal to condemn Evans as an archetypal British Victorian racist, the authors of the historical section sometimes fail to give due weight to the fact that the Minoans emerged in the wake of Crete's independence struggle against the Ottoman Empire. More nuanced and less denunciatory is Yannis Hamilakis and Nicoletta Momigliano, eds., *Archaeology and European Modernity: Producing and Consuming the 'Minoans'* (Padua: Botega d'Erasmo, 2006), a volume of essays based on a conference at which I was privileged to participate, which covers a range of topics from the Minoan great goddess in the context of the Victorian ideology of motherhood, to how Cretan schoolchildren today are taught about their Minoan ancestors. Still the best source for Evans's life is the family history by his much younger half-sister: Joan Evans, *Time and Chance: The Story of Arthur Evans and His Forebears* (London: Longmans, Green and Co., 1943).

2. Evans, *Time and Chance*, p. 83.

3. Evans, *Time and Chance*, p. 93.

4. Evans, *Time and Chance*, p. 94.

5. John Evans to Fanny Phelps, letter dated November 11, 1858, Evans Archive, Ashmolean Museum, Oxford.

6. John Evans to Fanny Phelps, letter dated January 14, 1859, Evans Archive.

7. See A. B. Van Riper, *Men among the Mammoths: Victorian Science and the Discovery of Human Prehistory* (Chicago: University of Chicago Press, 1993).

8. For more on Boucher de Perthes, see Claudine Cohen, *Le destin du mammouth* (Paris: Seuil, 1994).

9. Evans, *Time and Chance*, p. 101. A more vivid description of the house and person of Boucher de Perthes is contained in the reminiscences of the woman who eventually became Joseph Prestwich's wife, who was taken to visit de Perthes in 1858 by her uncle, the geologist Hugh Falconer. From Grace Lady Prestwich's *Essays Descriptive and Biographical* of 1901, we learn, for example, that de Perthes "looked a man carefully preserved: the thick brown wig was unmistakably a wig, and there was a suspicion— nay a certainty—of artificial colouring about his complexion." Grace Prestwich, *Essays Descriptive and Biographical* (Edinburgh: Blackwood and Son, 1901), p. 82.

10. Evans, *Time and Chance*, p. 102.

11. Evans, *Time and Chance*, p. 144.

12. Friedrich Nietzsche, *The Gay Science,* trans. Josefine Nauckhoff (Cambridge: Cambridge University Press, 2001), p. 120.

13. See the section "Family Life" in the John Evans Centenary Project, http://johnevans.ashmus.ox.ac.uk/evans/family.html.

14. Evans, *Time and Chances*, p. 134.

15. Ronald Burrows, *The Discoveries in Crete and Their Bearing on the History of Ancient Civilisation* (London: John Murray, 1908), p. 1.

242 Notes to Pages 56–67

16. John Tosh, A Man's Place: Masculinity and the Middle-Class Home in Victorian England (New Haven: Yale University Press, 1999), p. 105.

17. Tosh, Man's Place, p. 150.

18. Evans, Time and Chance, p. 164.

19. Brown, Before Knossos, p. 15.

20. Tosh, Man's Place, p. 174.

21. Evans, Time and Chance, p. 163.

22. For an excellent account of the intricacies of Balkan politics that gives the cynical maneuvering of the Great Powers their rightful due, see Misha Glenny, The Balkans: Nationalism, War and the Great Powers, 1804–1999 (London: Granta, 1999).

23. Arthur Evans, Through Bosnia and the Herzegovina on Foot, during the Insurrection, August and September 1875, with an Historical Review of Bosnia (London: Longmans, Green and Co., 1876), p. vi.

24. Evans, Through Bosnia and the Herzegovina, pp. 128–129.

25. Evans, Through Bosnia and the Herzegovina, pp. 308–309.

26. Evans, Through Bosnia and the Herzegovina, p. 310.

27. John McEnroe, "Cretan Questions: Politics and Archaeology, 1898–1913," in Labyrinth Revisited: Rethinking 'Minoan' Archaeology, ed. Yannis Hamilakis (Oxford: Oxbow, 2002), p. 69.

28. Evans, Through Bosnia and the Herzegovina, p. 310.

29. Evans, Through Bosnia and the Herzegovina, p. 227.

30. Evans, Through Bosnia and the Herzegovina, p. 229.

31. Arthur Evans, Illyrian Letters: A Revised Selection of Correspondence from the Illyrian Provinces of Bosnia, Herzegovina, Montenegro, Albania, Dalmatia, Croatia, and Slavonia, Addressed to the Manchester Guardian during the Year 1877 (London: Longman and Green, 1878).

32. Evans seems to have supported this solution at some point in 1877; see the excerpts from his letters to Margaret in Evans, Time and Chance, p. 205, but by the time the Austrian occupation looked like it might become a reality, he was ardently on the side of Slav nationalist resistance (p. 211).

33. Evans, Time and Chance, p. 223.

34. Evans, Time and Chance, p. 259.

35. Evans, Time and Chance, p. 312.

36. Evans, Time and Chance, p. 313.

37. Evans, Time and Chance, p. 318.

38. Arthur Evans, "Archaeological News. Krete. A Mycenaean Military Road," American Journal of Archaeology 10 (1895): 399–403.

39. Evans, "Mycenaean Military Road," p. 400.

40. Evans, "Mycenaean Military Road," p. 400.

41. Evans, "Mycenaean Military Road," p. 401.

42. Evans, "Mycenaean Military Road," pp. 401–402.

43. Evans, "Mycenaean Military Road," pp. 402–403.

44. Evans, "Mycenaean Military Road," p. 403.

45. Arthur Evans, "Archaeological News. Krete. Explorations in Eastern Crete," American Journal of Archaeology 11, no. 3 (1896): 449.

46. Evans, "Explorations in Eastern Crete," p. 456.

47. Evans, "Explorations in Eastern Crete," p. 454.

48. Arthur Evans, "The Palace of Minos," Monthly Review (March 1901): 12.

49. For contemporary reactions, see, for example, the section on de Chirico below, and also Sigmund Freud's letter to Wilhelm Fliess dated May 31, 1897, in which he describes his daughter Mathilde shedding bitter tears over the defeat of the Greeks." Sigmund Freud, *The Standard Edition of the Complete Psychological Works of Sigmund Freud,* trans. James Strachey (London: Hogarth Press, 1953–74), vol. 1, pp. 253–254.

50. One of the most detailed English-language sources for the 1897 war is the biography of Harriet Boyd, indefatigable American archaeologist, who was decorated by the Greek royal family for her service as a nurse on the frontlines: Mary Allesbrook, *Born to Rebel: The Life of Harriet Boyd Hawes* (Oxford: Oxbow, 1992). Brown, *Before Knossos,* pp. 76–84, synthesizes some valuable material from the Evans Archive at the Ashmolean about Evans's response to the situation. Theocharis E. Detorakis, *History of Crete,* trans. John C. Davis (Iraklion: Iraklion, 1994), is a one-sided account from a Cretan historian, against which may be set Ugur Mehmet Ekini, "The Origins of the 1897 Ottoman-Greek War, a Diplomatic History" (master's thesis, Bilkent University, 2006). Glenny, *Balkans,* gives an excellent history of the larger geopolitical context. See also the detailed account of the archaeological history in Philip Carabott, "A Country in a 'State of Destitution,' Labouring under an 'Unfortunate Regime': Crete at the Turn of the 20th Century (1896–1906)," in *Archaeology and European Modernity: Producing and Consuming the 'Minoans',* ed. Yannis Hamilakis and Nicoletta Momigliano (Padua: Bottega d'Erasmo, 2006).

51. Glenny, *Balkans,* p. 26.

52. Arthur Evans, *Letters from Crete* (Oxford: privately published, reprinted from the *Manchester Guardian* May 24th and 25th, June 13, 1898), quotations from pp. 24, 8.

53. Evans, *Letters from Crete,* p. 15.

54. Evans, *Letters from Crete,* p. 16.

55. Evans, *Letters from Crete,* p. 17.

56. Evans, *Letters from Crete,* p. 23.

57. Detorakis, *History of Crete,* p. 406.

58. See Carabott, "A Country in a 'State of Destitution.'"

CHAPTER THREE

1. Arthur Evans, "Knossos I. The Palace," *Annual of the British School at Athens* 6 (1900): 1.

2. See Nicoletta Momigliano, *Duncan Mackenzie: A Cautious Canny Highlander at the Palace of Minos at Knossos* (London: Institute of Classical Studies, 1999). The contrast between Evans's Knossos diary and Mackenzie's daybooks, both in the Evans Archive at the Ashmolean Museum, gives some insight to Evans's mythical archaeology. Mackenzie confined his notes to descriptions of the surface appearance of the objects that emerged, along with records of their find-spots. Evans, by contrast, seized on individual artifacts in order to bestow upon them mythological titles. One of the first finds, for example, was an object that Mackenzie described as "an earthen-ware hand-polished and incised figurine of a female without the legs but with the broken surface, where they joined the body, traceable" (Mackenzie, daybook, entry dated March 26, 1900), which Evans the same day dubbed in his diary the "Aphrodite of Knôsos!" Arthur Evans, Knossos diary, Evans Archive, Ashmolean Museum, Oxford, entry dated March 26, 1900.

3. Evans, Knossos diary, entry dated March 30, 1900.

4. Harriet Boyd Hawes, "Memoirs of a Pioneer Excavator in Crete," *Archaeology* 2 (1965): 97.

5. Evans, Knossos diary, entry dated April 13, 1900.

6. Johann Jacob Bachofen, *Das Mutterrecht: Eine Untersuchung über die Gynaikokratie der alten Welt nach ihrer religiosen and rechtlichen Natur* (Frankfurt: Suhrkamp, 1975). There is an English translation of portions of the text, but it does not include the chapter on Crete, an omission that might be explained by the fact that this section of Bachofen's book is rather thin and repetitive, focusing on a theory about the ancient laws governing parricide.

7. Lewis Henry Morgan, *Ancient Society: Researches in the Lines of Human Progress from Savagery to Barbarism to Civilisation* (New York: Henry Holt and Co., 1877).

8. Evans, "Knossos I. The Palace," p. 38.

9. Evans, "Knossos I. The Palace," p. 43, n. 1. In drawing conclusions about the organization of Minoan society on the evidence of the Mycenaean shaft graves, Evans was here the victim of his own hubris. He would never accept that the mainland culture of the Mycenaeans had its own trajectory, choosing to regard it as no more than a settlement of the great Minoan Empire.

10. Evans, "Knossos I. The Palace," p. 47.

11. Arthur Evans, "The Palace of Knossos," *Annual of the British School at Athens* 7 (1901): 94–95.

12. Arthur Evans, "The Palace of Knossos," *Annual of the British School at Athens* 8 (1902): p. 54.

13. Evans, "The Palace of Knossos" (1902), p. 65.

14. Evans, "Knossos I. The Palace," p. 47.

15. Arthur Evans, "The Palace of Knossos," *Annual of the British School at Athens* 9 (1903): 86–87.

16. Evans, "Knossos I. The Palace," p. 67.

17. Evans, "The Palace of Knossos" (1903), p. 110.

18. Evans, "The Palace of Knossos" (1903), p. 111.

19. Evans, "The Palace of Knossos" (1903), p. 111.

20. Evans, "The Palace of Knossos" (1903), pp. 111–112.

21. James George Frazer, *The Golden Bough* (London: Macmillan, 1890), p. 3.

22. Arthur Evans, "The Palace of Knossos as a Sanctuary," *Royal Institute of British Architects* 3, no. 17 (1909): 6–7.

23. Evans, *Palace of Minos*, vol. 3, pp. 75–77.

24. Evans, *Palace of Minos*, vol. 3, p. 76.

25. Friedrich Engels, *The Origin of the Family, Private Property and the State* (Harmondsworth: Penguin Books Ltd., 1985), p. 87, emphasis in the original.

26. Two excellent lives of Harrison have recently appeared: Mary Beard, *The Invention of Jane Harrison* (Cambridge: Harvard University Press, 2000), is a witty, skeptical account, intended as a corrective to the extravagant reaches of the feminist cult of Harrison, while Annabel Robinson, *The Life and Work of Jane Ellen Harrison* (Oxford: Oxford University Press, 2002) constitutes a more straightforward biography.

27. Gilbert Murray, *A History of Ancient Greek Literature* (New York: D. Appleton and Co., 1897), p. 272.

28. See Martha Celeste Carpentier, *Ritual, Myth and the Modernist Text: The Influence of Jane Ellen Harrison on Joyce, Eliot and Woolf* (Amsterdam: Gordon and Breach

Publishers, 1998); and Robert Ackerman, *The Myth and Ritual School: J. G. Frazer and the Cambridge Ritualists* (New York: Routledge, 2002).

29. Jane Ellen Harrison, *Prolegomena to a Study of Greek Religion*, third edition (Cambridge: Cambridge University Press, 1922), p. 285.

30. Harrison, *Prolegomena*, p. 497.

31. Robinson, *Life and Work of Jane Ellen Harrison*, p. 150.

32. Jane Ellen Harrison, *Themis: A Study of the Social Origins of Greek Religion*, (1926; reprint, London: Merlin Press, 1963), p. 159.

33. Harrison, *Themis*, p. 208.

34. Harrison, *Themis*, p. viii.

35. Harrison, *Prolegomena*, p. 496.

36. Arthur Evans, "Mycenaean Tree and Pillar Cult and Its Mediterranean Relations," *Journal of Hellenic Studies* 21 (1901): 99–204.

37. Christian Doll, diary, entry dated January 24, 1907, Arthur Evans Archive, Ashmolean Museum, Oxford.

38. See J. Wilson Myers, Eleanor Emlen Myers, and Gerald Cadogan, eds., *Aerial Atlas of Ancient Crete* (London: Thames & Hudson, 1992).

39. Isadora Duncan, *My Life* (New York: Boni and Liveright, 1927), p. 151.

40. James Candy, *A Tapestry of Life: An Autobiography* (Braunton: Merlin, 1984), p. 26.

41. Candy, *Tapestry of Life*, p. 26.

42. Glenny, *Balkans*: "at the start, when Austria bombarded Belgrade, and launched its invasion of Serbia, it was known briefly as the Third Balkan War" (p. 312).

43. Patrick Shaw-Stewart and Rupert Brooke cited in Michael Wood, *In Search of the Trojan War* (Berkeley: University of California Press, 1998), p. 35; Emil Ludwig cited in Glenny, *Balkans*, p. 317. There are many other examples of the same trope, see Norman Vance, "Classics and the Dardanelles Campaign," *Notes and Queries* 53, no. 3 (2006): 347–349. Contemporary reports of the Gallipoli campaign in the London *Times* often used the Homeric names for the sites.

44. Evans, *Time and Chance*, p. 368.

45. Arthur Evans, "New Archaeological Lights on the Origins of Civilization in Europe," *Science* 44, no. 1134 (1916): 400.

46. Evans, *Time and Chance*, p. 372.

47. Taylor, *Giorgio De Chirico and the Myth of Ariadne*, p. 15.

48. Giorgio de Chirico, *Memoirs of Giorgio De Chirico,* trans. Margaret Crosland (London: Peter Owen, 1971), p. 48.

49. De Chirico, *Memoirs*, p. 34.

50. Taylor, *Giorgio De Chirico and the Myth of Ariadne,* pp. 81–86.

51. Taylor, *Giorgio De Chirico and the Myth of Ariadne,* p. 83.

52. Taylor, *Giorgio De Chirico and the Myth of Ariadne,* p. 19.

53. Taylor, *Giorgio De Chirico and the Myth of Ariadne,* p. 32.

54. Taylor, *Giorgio De Chirico and the Myth of Ariadne,* p. 134.

CHAPTER FOUR

1. There has been some excellent work on the rebuilding of Knossos. On the restorations and their reception, see Alexander Lapourtas, "Arthur Evans and His Representation of the Minoan Civilisation at Knossos," *Museum Archaeologist* 22 (1995): 71–82. For a gripping yet scholarly narrative of the production and dissemination of

the fake ivory and gold figurines, see Kenneth Lapatin, *Mysteries of the Snake Goddess: Art, Desire, and the Forging of History* (New York: Houghton Mifflin, 2002). For a meticulous reconstruction of the making of the priest-king relief, see Susan Sherrat, *Arthur Evans, Knossos and the Priest-King* (Oxford: Ashmolean Museum Publications, 2000). One of the best books about Knossos is Nicoletta Momigliano, *Duncan Mackenzie: A Cautious Canny Highlander at the Palace of Minos at Knossos* (London: Institute of Classical Studies, 1999), which analyzes the life and work of Evans's site supervisor, Duncan Mackenzie, whose interpretative caution serves as an instructive contrast to Evans's more extravagant methods.

2. Arthur Evans, "Work of Reconstitution in the Palace of Knossos," *Antiquaries Journal* 7, no. 3 (1927): 258.

3. Evans, "Work of Reconstitution," p. 258.

4. Evans, "Work of Reconstitution," p. 259.

5. Evans, "Work of Reconstitution" p. 259.

6. Evans, "Palace of Knossos" (1901), p. 2.

7. Arthur Evans, "The Palace of Knossos and Its Dependencies," *Annual of the British School at Athens* 11 (1905): 23.

8. For Piet de Jong's life and times, see Rachel Hood, *Faces of Archaeology in Greece: Caricatures by Piet De Jong* (Oxford: Leopard's Head Press, 1998), pp. 225–280.

9. Jeffrey Schnapp, "Excavating the Corporativist City," *Modernism-Modernity* 11, no. 1 (2004): 89.

10. Schnapp, "Excavating the Corporativist City," p. 90.

11. In the case of Knossos, with its squat red columns, this inspiration was more ideological than aesthetic. Pastiches of Minoan and Mycenaean architecture have appeared only in recent years and are more associated with postmodern eclecticism than modernist purism in Greece. See Gere, *Tomb of Agamemnon*, p. 148.

12. Evans, *Palace of Minos*, vol. 4, p. 5.

13. David Watkin and Tillman Mellinghof, *German Architecture and the Classical Ideal, 1740–1840* (London: Thames & Hudson, 1987), pp. 171–195.

14. Hood, *Faces of Archaeology in Greece*, pp. 22–26.

15. Robin Hägg, "Bermerkungen zum Nestorring," *Schriften des deutsches Archae-ologen* 9 (1987): 57.

16. Evans, *Palace of Minos*, vol. 2, p. 755.

17. Evans, *Palace of Minos*, vol. 2, p. 755–757.

18. Evans, *Palace of Minos*, vol. 2, p. 46, vol. 1, p. 310.

19. Evans, *Palace of Minos*, vol. 1, p. 312.

20. Evans, *Palace of Minos*, vol. 2, p. v.

21. Evans, *Palace of Minos*, vol. 2, p. 45.

22. Evans, *Palace of Minos*, vol. 2, p. 756.

23. See Piet de Jong's description of the trip in Momigliano, *Duncan Mackenzie*, pp. 208–209. De Jong describes a majestic procession with Evans in the lead, followed by himself in his capacity 'as a buffer' between Evans and Duncan Mackenzie, then Manolaki the Knossos bailiff, Kronis who took care of the animals (a very handsome man in traditional Cretan dress riding a "gaily caparisoned" mule), Kosti the butler, Hassan his assistant, "and lastly a donkey which carried samples of wine collected as we went along."

24. Evans, "Archaeological News. Krete. A Mycenaean Military Road," p. 401.

25. Evans, *Palace of Minos*, vol. 2, p. 79.

26. MacGillivray, *Minotaur*, p. 279.

27. Evans, *Palace of Minos*, vol. 2, p. 22.

28. Ivan van Sertima and Rashidi Runoko, eds., *African Presence in Early Asia* (New Brunswick: Transaction, 1987), pp. 263–264.

29. [George Wells Parker], "African Origin of Grecian Civilisation," *Journal of Negro History* 2, no. 3 (1917): 337.

30. [Parker], "African Origin of Grecian Civilisation," p. 338.

31. [Parker], "African Origin of Grecian Civilisation," pp. 335–336.

32. [Parker], "African Origin of Grecian Civilisation," p. 342.

33. [Parker], "African Origin of Grecian Civilisation," p. 342.

34. [Parker], "African Origin of Grecian Civilisation," p. 344.

35. See, for example, Allesbrook, *Born to Rebel*, p. 85, in which Evans is most supportive of Harriet Boyd's ambition to dig in Crete in defiance of the American School's prohibition against women. Boyd went on to become the first woman to lead her own excavation.

36. Evans, *Palace of Minos*, vol. 3, p. 50.

37. Evans, *Palace of Minos*, vol. 3, p. 52.

38. Evans, *Palace of Minos*, vol. 3, p. 54.

39. Evans, *Palace of Minos*, vol. 3, p. 52.

40. Evans, *Palace of Minos*, vol. 3, p. 54.

41. Evans, *Palace of Minos*, vol. 3, p. 56.

42. Evans, *Palace of Minos*, vol. 1, p. 25.

43. Evans, *Palace of Minos*, vol. 1, p. 5.

44. Evans, "Mycenaean Tree and Pillar Cult and Its Mediterranean Relations," pp. 14–16.

45. Evans, "Mycenaean Tree and Pillar Cult," p. 15.

46. See Sherrat, *Arthur Evans, Knossos and the Priest-King*. The other versions of the priest-king include the restoration that contains the original fragments in the Iraklion Museum, the replica that was photographed for publication in the third volume of *The Palace of Minos*, the replica that found its way onto the south-north corridor at Knossos, and the two plaster reproductions that were made for the Ashmolean Museum, all of which position the fragments in the same relation to one another.

47. Evans, "The Palace of Knossos," *Annual of the British School at Athens* 7 (1901): 16.

48. Evans, *Palace of Minos*, vol. 4, pp. 21–22.

49. Evans, *Palace of Minos*, vol. 3, p. 176.

50. Evans, *Palace of Minos*, vol. 4, p. 31.

51. Citing the priest-king relief and the bull-leaper frescoes, one archaeologist has advocated the abandonment of the binary male-female scheme altogether for understanding Minoan depictions of gender: Benjamin Alberti, "Gender and the Figurative Art of Late Bronze Age Knossos," in *Labyrinth Revisited: Rethinking 'Minoan' Archaeology*, ed. Yannis Hamilakis (Oxford: Oxbow, 2002), pp. 98–99.

52. Jackie Wullschlaeger, *Inventing Wonderland: The Lives and Fantasies of Lewis Carroll, Edward Lear, J. M. Barrie, Kenneth Graham and A. A. Milne* (London: Methuen, 1995), p.109. Knossos surely belongs in this list as an invented Edwardian wonderland. See also Catherine Robson, *Men in Wonderland: The Lost Girlhood of the Victorian Gentleman* (Princeton: Princeton University Press, 2001). The book deals

with the figure of the girl throughout most of the nineteenth century but concludes with an acknowledgement that the ideology of boyhood took over around 1880.

53. Evans, *Palace of Minos*, vol. 3, p. 467.

54. Evans, *Palace of Minos*, vol. 3, p. 468.

55. The label on her case acknowledges that she may be a fake.

56. An excellent investigation of all the gold and ivory statuettes discussed in this section is to be found in Lapatin, *Mysteries of the Snake Goddess*. Another meticulous investigation of Minoan fakes, this time of stone goddess figurines and especially the so-called "Fitzwilliam Goddess," is Kevin Butcher and David Gill, "The Director, the Dealer, the Goddess, and Her Champions: The Acquisition of the Fitzwilliam Goddess," *American Journal of Archaeology* 97 (1993): 383–410.

57. Leonard Woolley, *As I Seem to Remember* (London: George Allan and Unwin, 1962), pp. 21–23.

58. The events recounted in this anecdote must have taken place before the publication of volume 3 of the *Palace of Minos*, in which Evans discusses the Boston goddess and the first of the boy-gods: Duncan Mackenzie was fired from his job as curator of Knossos in 1930 and the penultimate volume of *The Palace of Minos* appeared in 1931. Based on corroborative evidence from a German source, Kenneth Lapatin dates this anecdote to "between October 1923 and February 1924": Lapatin, *Mysteries of the Snake Goddess*, p. 171.

59. Evans, *Palace of Minos*, vol. 3, pp. 440–441.

60. Evans, *Palace of Minos*, vol. 3, p. 437.

61. Evans, *Palace of Minos*, vol. 3, p. 438.

62. Evans, *Palace of Minos*, vol. 3, p. 443.

63. James Candy, *A Tapestry of Life: An Autobiography* (Braunton: Merlin, 1984), p. 15.

64. Evans, *Palace of Minos*, vol. 3, p. viii.

65. Evans, *Palace of Minos*, vol. 3, p. 455.

66. Lapatin, *Mysteries of the Snake Goddess*, pp. 140–143.

67. Evans, *Palace of Minos*, vol. 3, p. 456.

68. Evans, *Palace of Minos*, vol. 3, p. 476.

69. Evans, *Palace of Minos*, vol. 4, p. 28.

70. MacGillivray, *Minotaur*, p. 284.

71. Candy, *A Tapestry of Life*, p. 21.

72. Evans, *Palace of Minos*, vol. 3, p. 440.

73. Evans, *Time and Chance*, p. 377.

74. Dörpfeld's discovery of the first Mycenaean remains around Pylos has been written out of the record at the site of "Nestor's Palace," which was excavated by Carl Blegen starting in 1939. It was not therefore possible for me to identify which of the *tholoi* in the area was the one in which the Ring of Nestor was supposed to have been found.

75. Arthur Evans, "The Ring of Nestor: A Glimpse into the Minoan after-World and a Sepulchral Treasure of Gold Signet-Rings and Bead Seals from Thisbe, Boiotia," *Journal of Hellenic Studies* 45 (1925): 1–75, quotation from p. 46.

76. Hagg, "Bermerkungen Zum Nestorring," p. 57. I reserve judgment about the ring of Nestor. Certain elements—notably the lines dividing the image into quadrants—are less delicate than the carving on other Minoan signet rings, but

other stylistic and iconographic features could easily be adduced as evidence of its genuineness.

77. Evans, "Ring of Nestor," p. 53.

78. Evans, "Ring of Nestor," p. 54. Aristotle's description of the butterfly's metamorphosis is to be found in book 5 of his *Historia animalium*. The identification of his "psyches" with cabbage white butterflies is based on the food plant of their caterpillars: "Psyches, as they are called, arise from caterpillars, which live on green-leaved plants, especially on the raphanon, or as some people say, cabbage."

79. The number is based on a count of all the works of art listed under the entry for "Psyche" in Jane Davidson Reid, ed., *Oxford Guide to Classical Mythology in the Arts* (Oxford: Oxford University Press, 1993) that appeared between 1900 and 1925.

80. John Evans to Fanny Phelps, letter dated March 6, 1859, Arthur Evans Archive, Ashmolean Museum, Oxford. Also quoted in Evans, *Time and Chance*, p. 99.

81. John Evans to Fanny Phelps, letter dated April 15, 1859, Evans Archive, Ashmolean Museum, Oxford.

82. See Lucy Goodison and Christine Morris, eds., *Ancient Goddesses: The Myths and the Evidence* (London: British Museum Press, 1998), for an excellent discussion of the archaeological case for and against the Cretan goddess.

83. Yannis Sakellarakis, *Heracklion Museum: An Illustrated Guide* (Athens: Ekdotike Athenon, 1978), pp. 60–61.

84. Yannis Sakellarakis and Efi Sakellaraki, *Archanes: Minoan Crete in a New Light* (Athens: Ammos, 1997), vol. 2, p. 659.

85. Evans, *Palace of Minos*, vol. 3, p. 80.

CHAPTER FIVE

1. Hamilakis and Momigliano, *Archaeology and European Modernity*, contains a number of excellent essays on Minoan archaeology in the context of modernism; see especially the chapters by Roderick Beaton and David Roessel. Theodore Ziolkowski, *Minos and the Moderns: Cretan Myth in Twentieth Century Literature and Art* (Oxford: Oxford University Press, 2008), unfortunately came out when the present book was already in proof stage, but constitutes a very elegant and interesting survey of the relationship between Cretan mythology and modernist art. There also exists some very good work on modernism and archaeology at sites other than Crete. Zintzen, *Von Pompeji nach Troja*, is one of the best cultural histories of Greek and Roman archaeology, showing how nineteenth-century reconstructions of the deep past were mobilized in the making of the present and the future. Her all-too-brief exploration of archaeology and modernism in the second chapter makes one wish for a twentieth-century sequel to her 'Pompeii to Troy' scheme. A special issue of the journal *Modernism/modernity*, "Archaeologies of the Modern," delineates a modernist archaeology in terms very similar to mine, pointing out its affiliations with avant-garde artistic practice and its connections to both Nietzsche and Freud': Jeffrey Schnapp, Michael Shanks, and Matthew Tiews, "Archaeology, Modernism, Modernity," *Modernism-Modernity* 11, no. 1 (2004), especially pp. 54–58. The essay on Hoffman's *Elektra* in Simon Goldhill, *Who Needs Greek? Contests in the Cultural History of Hellenism* (Cambridge: Cambridge University Press, 2002), pp. 108–177, is an insightful and often hilarious exploration of the contrast between Victorian and modernist visions of antiquity. Richard Armstrong, *A Compulsion for Antiquity: Freud*

and the Ancient World (Ithaca: Cornell University Press, 2005) situates Freud's work in the context of classical studies and makes an utterly convincing case for the deep engagement of the psychoanalytic avant-garde with the various sciences of antiquity.

2. Hugh Kenner, *The Pound Era* (Berkeley: University of California Press, 1971) p. 42.

3. T. S. Eliot, *The Sacred Wood* (London: Methuen, 1967), pp. 75–76.

4. T. J. Reed, *Thomas Mann: The Uses of Tradition* (Oxford: Clarendon Press, 1974), p. 137.

5. The function of mythology in Nietzsche's new tragic age has been brilliantly analyzed by the critic Martin Bell in his introduction to the collection of essays *Myth and the Making of Modernity*. Bell begins by lamenting the extent to which the mythical tendency in modernism has been dismissed as "intrinsically fascistic" and suggests, rather, that "it had a liberal and progressive implication which was just as intrinsic since its underlying significance was a sense of philosophical responsibility in living in a post-religious, and even post-metaphysical world." Michael Bell and Peter Poellner, eds., *Myth and the Making of Modernity: The Problem of Grounding in Early Twentieth Century Literature* (Amsterdam: Rodopi, 1998), p. 1.

6. James Joyce, *Ulysses* (New York: Random House, 1961), p. 3.

7. Joyce, *Ulysses*, pp. 7–8.

8. Joyce, *Ulysses*, p. 22.

9. Joyce, *Ulysses*, p. 7.

10. Joyce, *Ulysses*, p. 5.

11. Joyce, *Ulysses*, p. 9.

12. Joyce, *Ulysses*, p. 10.

13. Joyce, *Ulysses*, pp. 13–14.

14. Joyce, *Ulysses*, p. 27.

15. T. S. Eliot, *Selected Prose of T. S. Eliot* (London: Faber and Faber, 1975), pp. 177–178.

16. Despite the fact that Eliot left it out of his list of mythical sciences, he acknowledged archaeology's contribution to modernism. In one of his most famous essays, "Tradition and the Individual Talent," he opens with a reference to the "reassuring science of archaeology" (p. 37).

17. Klaus Fischer, *History and Prophecy: Oswald Spengler and the Decline of the West* (New York: 1989), pp. 38–39.

18. Oswald Spengler, *The Decline of the West*, trans. Charles Francis Atkinson, vol. 2 (New York: A. A. Knopf, 1970), p. 87.

19. Spengler, *The Decline of the West,* p. 87.

20. Spengler, *The Decline of the West*, p. 88.

21. Spengler, *The Decline of the West*, p. 88.

22. Evelyn Waugh, *Labels: A Mediterranean Journal* (London: Duckworth, 1930), pp. 136–137. See also David Roessel, "Happy Little Extroverts and Bloodthirsty Tyrants: Minoans and Mycenaeans in Literature in English after Evans and Schliemann," in Hamilakis and Momigliano, *Archaeology and European Modernity*, pp. 197–208.

23. Dmitri Sergeevich Merezhkovsky, *The Birth of the Gods,* trans. Natalie Duddington (London: J. M. Dent and Sons, Ltd., 1925), p. 226.

24. Roderick Beaton, "Minoans in Modern Greek Literature," in Hamilakis and Momigliano, *Archaeology and European Modernity*, p. 184.

25. Anthony Blunt, *Picasso's Guernica* (Oxford: Oxford University Press, 1969), p. 19.

26. Blunt, *Picasso's Guernica*, pp. 25–26.

27. Martin Ries, "Picasso and the Myth of the Minotaur," *Art Journal* 32, no. 2 (1972): 142–145.

28. Henry Miller, *The Colossus of Maroussi* (New York: New Directions, 1941), pp. 121–122.

29. There is a considerable literature on Freud's relationship with archaeology. Some recommended works include Kenneth Reinhard, "The Freudian Things: Construction and the Archaeological Metaphor," in Barker, *Excavations and Their Objects*; Peter Ucko, "Unprovenanced Material Culture and Freud's Collection of Antiquities," *Journal of Material Culture* 6, no. 3 (2001): 233–269; Lynn Gamwell and Richard Wells, eds., *Sigmund Freud and Art: His Personal Collection of Antiquities* (London: Thames & Hudson, 1989); John Forrester, "Mille e tre: Sigmund Freud and Collecting," in Elsner and Cardinal, *Cultures of Collecting*; Lydia Marinelli, ed., *Meine . . . Alten und Dreckigen Götter: Aus Sigmund Freuds Sammlung* (Frankfurt: Stroemfeld, 1998); and Andreas Mayer, "Objets Perdus: Matérialiser et Dématérialiser l'inconscient de Charcot à Freud," *Ethnopsy* 1, no. 2 (2001): 67–89.

30. Sigmund Freud to Wilhelm Fliess, letter dated April 7, 1901, in Sigmund Freud, *The Complete Letters of Sigmund Freud to Wilhelm Fliess, 1877–1904,* trans. Jeffrey Masson (Cambridge: Harvard University Press, 1985), p. 445.

31. Freud, *Standard Edition*, vol. 21, p. 226.

32. Freud, *Standard Edition,* vol. 2, p. 139.

33. Freud, *Standard Edition,* vol. 3, p. 192.

34. Freud, *Standard Edition,* vol. 2, p. 129.

35. Freud, *Standard Edition,* vol. 7, p. 12.

36. Muriel Gardiner, ed., *The Wolf Man and Sigmund Freud* (London: Penguin Books, 1973), p. 157.

37. Freud, *Standard Edition* vol. 23, p. 259.

38. Freud to Fliess, letter dated December 6, 1896, in Freud, *Complete Letters of Sigmund Freud to Wilhelm Fliess 1877–1904*, p. 207, emphasis in the original.

39. A useful discussion of the concept is to be found in Laura Otis, *Organic Memory: History and the Body in the Late Nineteenth and Early Twentieth Centuries* (Lincoln: University of Nebraska Press, 1994).

40. Freud, *Standard Edition*, vol. 5, pp. 548–549.

41. Freud, *Standard Edition*, vol. 23, p. 80.

42. Freud, *Standard Edition*, vol. 23, p. 91.

43. Freud, *Standard Edition*, vol. 23, pp. 70–71.

44. Freud, *Standard Edition*, vol. 23, p. 82, emphasis in the original.

45. Freud, *Standard Edition*, vol. 23, p. 83.

46. Freud, *Standard Edition*, vol. 23, p. 46.

47. Freud, *Standard Edition*, vol. 21, p. 228.

48. Yosef Hayim Yerushalmi, *Freud's Moses: Judaism Terminable and Interminable* (New Haven: Yale University Press, 1995), p. 4.

49. Peter Gay, *Freud: A Life for Our Time* (London: J. M. Dent and Sons Ltd., 1988), p. 290n.

50. Ernst Jones, *Sigmund Freud: Life and Work,* volume 3, *The Last Phase* (London: Hogarth, 1957), pp. 310–314. The situation for "responsible biologists" however,

wasn't quite so simple. For the fate of Lamarckian inheritance at the turn of the century, see Peter Bowler, *The Eclipse of Darwinism: Anti-Darwinian Evolution Theories in the Decades around 1900* (Baltimore: Johns Hopkins University Press, 1983).

51. Freud, *Standard Edition*, vol. 23, p. 100.

52. There is a small literature exclusively devoted to H.D.'s encounter with Freud, beginning with Susan Stanford Friedman, *Psyche Reborn* (Bloomington: Indiana University Press, 1981). Friedman's account led me to the archives in the Beinecke Library to confirm H.D.'s preoccupation with Minoan Crete, but nowhere in *Psyche Reborn* does Friedman herself make the connection to archaeology, assuming instead that the story of Psyche and Eros was H.D.'s only source for the Psyche symbol. Since then, however, Friedman has edited a selection of the H.D.-Bryher correspondence in which Evans is glancingly acknowledged: Susan Stanford Friedman, ed., *Analyzing Freud: The Letters of H.D., Bryher and Their Circle* (New York: New Directions, 2002). See also idem, *Penelope's Web: Gender, Modernity, H.D.'s Fiction* (Cambridge: Cambridge University Press, 1990). For other interpretations, see Dianne Chisholm, *H.D.'s Freudian Poetics: Psychoanalysis in Translation* (1992), which examines "works by H.D. in the light of Freud's psychoanalytic writings" and rereads "Freud in the light of H.D.'s revisionary psychoanalysis" (p. 2); and Claire Buck, *H.D. and Freud: Bisexuality and a Feminine Discourse* (New York: St. Martin's Press, 1991), which offers a poststructuralist analysis of H.D.'s language. Of the more recent work on H.D., Eileen Gregory, *H.D. And Hellenism: Classic Lines* (Cambridge: Cambridge University Press, 1997), stands out. Not only does this work convey some of the subtlety and erudition of H.D.'s relationship to the classics, it also captures the spirit of modernist classicism in the broader sense. Gregory's chapter "Modern Classicism and the Theatre of War," in which she evokes the classically inflected experience of the horrors of the 1914–1918 conflict, was especially important for my own understanding of the relationship of Minoan archaeology to war and peace.

53. Hilda Doolittle, *End to Torment: A Memoir of Ezra Pound* (Manchester: Carcanet Press, 1980), p. 3.

54. Doolittle, *End to Torment*, pp. 71–73.

55. Marianne Moore to Perdita Schaffner, letter dated 1921, cited in Barbara Guest, *Herself Defined: The Poet H.D. and Her World* (Garden City: Doubleday and Co., 1984), p. 4.

56. William Carlos Williams, *The Autobiography of Willilam Carlos Williams* (New York: Random House, 1951), pp. 67–68.

57. Hilda Doolittle, *Collected Poems, 1912–1944* (New York: New Directions, 1986), p. 38.

58. Louis Wilkinson, *The Buffoon* (1916), cited in Guest, *Herself Defined*, p. 45.

59. Bryher [Winifred Ellerman], *The Heart to Artemis* (New York: Harcourt, Brace and World, Inc., 1962), p. 186.

60. Phyllis Grosskurth, *Havelock Ellis: A Biography* (London: Allen Lane, 1980), p. 331.

61. Grosskurth, *Havelock Ellis*, pp. 331–332.

62. Louis Martz, *Many Gods and Many Voices: The Role of the Prophet in English and American Modernism* (Columbia: University of Missouri Press, 1998), p. 117.

63. Hilda Doolittle, *Hermione* (London: Virago, 1981), p. 216.

64. H.D. to Bryher, letter dated March 1, 1933, Bryher Archive, Beinecke Library, Yale University. I have tried to preserve H.D.'s eccentricities of spelling in my tran-

scription of the letters while correcting what appear to be typing errors. Hereafter the letters will be identified by dates in parentheses following the quoted passage.

65. Freud had self-identified in a similar way in *The Interpretation of Dreams* when he remarked that the action of the Sophocles play depicts "a process that can be likened to the work of a psychoanalysis." Freud, *Standard Edition*, vol. 4, p. 262.

66. H.D. to Bryher, letter dated March 4. "Crete-*like*" was right, as Freud had no Minoan pieces in his collection, real or fake.

67. Dilys Powell, *The Villa Ariadne* (London: Hodder and Stoughton, 1973), p. 95.

68. Evans, *Time and Chance*, p. 392.

69. Evans, *Time and Chance* p. 394.

70. Powell, *Villa Ariadne*, p. 118.

71. Callum Macdonald, *The Lost Battle: Crete 1941* (London: Free Press, 1993), p. 3.

72. Macdonald, *Lost Battle*, p. 19.

73. Macdonald, *Lost Battle*, p. 182.

74. Powell, *Villa Ariadne*, p. 150.

75. Evans, *Time and Chance*, p. 396.

CHAPTER SIX

1. The manuscript consists of a sheaf of typed pages, to which minor corrections were added by H.D. in pencil, including the crossing out of all the names and their replacement by pseudonyms—Arthur Bhaduri becomes "Ben Manisi," H.D. is transformed into "Delia Alton" (her favored nom de plume for spiritualist writings), Bryher becomes "Gareth." I have preserved the original names, and for the sake of consistency I have therefore not included any of the other penciled corrections. As with the letters in the last chapter, I have tried to distinguish between H.D.'s spelling mistakes—which I have kept in order to convey a flavor of her unpublished prose—and typos, which I have silently corrected. An annotated edition of "The Majic Ring," based on a typescript of the corrected manuscript, edited by Demetres Tryphonopolous, is forthcoming from University of Florida Press.

2. Hilda Doolittle, "The Majic Ring" (Hilda Doolittle Archive, Beinecke Library, Yale University), p. 11.

3. Doolittle, "Majic Ring," pp. 109–110.

4. Doolittle, "Majic Ring," pp. 110–111.

5. Doolittle, "Majic Ring," p. 111.

6. Doolittle, "Majic Ring," pp. 111–112.

7. H.D. uses a pseudonym for him in the original manuscript of "The Majic Ring" and so he appears as Mr. Welbeck throughout, but his real name was Pieter Rodeck. Born in 1875, he was the nephew and adopted son of the painter Lawrence Alma-Tadema, a Royal Academician famous for his lavish, archaeologically correct depictions of antiquity. Tadema had adopted Pieter when his beloved sister died. He trained as an architect and obtained an architectural studentship at the British School in Athens in the years 1896 to 1897, where he assisted with the excavations of gymnasium at Kynosarges. See David Gill, *Students at the British School at Athens* (Swansea: Ostraka Press, 2008). He was in his mid-forties at the time of the boat trip, and sounds, from H.D.'s many accounts of their flirtation, like a somewhat disappointed man, who had had a varied career involving much travel in Egypt, India, and Greece. They stayed sporadically in touch, and H.D. later said that he had married and then entered the church. The adopted son of the artist famous for

his *Victorians in Togas* (the title of a 1973 exhibition of Alma-Tadema's work at the Metropolitan Museum of Art in New York) and an architect who had worked on excavations in Greece, he was well positioned to play the role of modernist Greek god in H.D.'s psychic drama. See the annotated edition of "The Majic Ring," forthcoming from University of Florida Press, in which he appears as Mr. Van Eck.

8. Friedman, *Penelope's Web*, pp. 228–229.

9. Doolittle, "Majic Ring," p. 128.

10. Doolittle, "Majic Ring," p. 128.

11. Doolittle, "Majic Ring," pp. 130–131.

12. Doolittle, "Majic Ring," pp. 132–133.

13. Doolittle, "Majic Ring," p. 135.

14. Doolittle, "Majic Ring," pp. 135–138.

15. Doolittle, "Majic Ring," p. 140.

16. Doolittle, "Majic Ring," p. 143.

17. Doolittle, "Majic Ring," p. 144.

18. Doolittle, "Majic Ring," p. 137.

19. Freud's diagnosis, of course, linked the Cretan content of the scene, as well as H.D.'s relationship with Bryher, with H.D.'s putative mother fixation. My sub-Freudian diagnosis repudiates both these elements.

20. Doolittle, "Majic Ring," p. 212.

21. This description bears an uncanny resemblance to the island of Thera or Santorini just north of Crete. The Bronze Age city Akrotiri that flourished on Santorini before the enormous volcanic eruption that blew out the middle of the island in c. 1500 B.C. was excavated in 1967.

22. Doolittle, "Majic Ring," pp. 212–214.

23. Doolittle, "Majic Ring," p. 218.

24. Doolittle, "Majic Ring," p. 224.

25. Doolittle, "Majic Ring," p. 226.

26. Hilda Doolittle, *Collected Poems, 1912–1944* (New York: New Directions, 1986), p. 509.

27. Doolittle, *Collected Poems*, p. 510.

28. Doolittle, *Collected Poems*, p. 511.

29. Doolittle, *Collected Poems*, pp. 521–23.

30. Doolittle, *Collected Poems*, p. 540, ellipsis in the original.

31. Doolittle, *Collected Poems*, pp. 563–64.

32. Doolittle, *Collected Poems*, p. 566.

33. Doolittle, *Collected Poems*, p. 570.

34. Doolittle, *Collected Poems*, p. 570.

35. Doolittle, "Majic Ring," p. 133.

36. Doolittle, *Collected Poems, 1912–1944*, pp. 601–602, ellipsis in the original.

37. Doolittle, *Collected Poems, 1912–1944*, p. 603 italics in the original.

38. Hilda Doolittle, *The Sword Went Out to Sea (Synthesis of a Dream) by Delia Alton* (Gainesville: University Press of Florida, 2007), p. 37. The opening sequences of this spiritualist novel contain a detailed account of the end of H.D.'s occult communications with Howell and the beginning of her nervous breakdown.

39. Guest, *Herself Defined*, pp. 278–279.

40. Caroline Zilboorg, ed., *Richard Aldington and H.D.: The Later Years in Letters* (Manchester: Manchester University Press, 1995), p. 302.

41. Zilboorg, *Richard Aldington and H.D.*, p. 302.

42. Hilda Doolittle, *Tribute to Freud, Writing on the Wall, Advent* (New York: New Directions, 1974), p. xlvi.

43. H.D. was probably correct that her "political formula" would be under greater pressure in London than in Vienna: her old flame Ezra Pound was already elaborating on his anti-Semitic diatribes against usury. The introduction to the 1974 edition of *Tribute to Freud* quotes a later letter from Pound saying of her involvement with Freud, "You got into the wrong pig stye, ma chère." Doolittle, *Tribute to Freud*, p. xii.

44. Doolittle, *Tribute to Freud*, p. 126.

45. Doolittle, *Tribute to Freud*, p. 127.

46. Doolittle, *Tribute to Freud*, p. 128.

47. Doolittle, *Tribute to Freud*, p. 131.

48. Doolittle, *Tribute to Freud*, pp. 134–135.

49. Doolittle, *Tribute to Freud*, p. 139.

50. Doolittle, *Collected Poems, 1912–1944*, pp. 521–523.

51. Zilboorg, *Richard Aldington and H.D.*, p. 302.

52. For this very brief summary of Graves's extraordinary life I have relied on the three-volume biography by his nephew, Richard Perceval Graves, as well as his own autobiographical writings, supplemented by the highly recommended biography by Miranda Seymour, *Robert Graves: Life on the Edge* (New York: Henry Holt and Company, 1995). Seymour had the advantage of access to previously unexamined letters and papers, and has managed to gently disentangle some of the most persistent fictions about Graves and his circle.

53. Richard Perceval Graves, *Robert Graves: The Assault Heroic, 1895–26* (London: Weidenfeld and Nicholson, 1986), p. 63.

54. Graves, *Robert Graves: The Assault Heroic*, p. 88.

55. Robert Graves, *Goodbye to All That* (New York: Blue Ribbon Books, 1930), p. 77.

56. Graves, *Goodbye to All That*, p. 88.

57. Graves, *Goodbye to All That*, p. 261.

58. Graves, *Goodbye to All That*, p. 209.

59. Graves, *Goodbye to All That*, p. 320.

60. Graves, *Goodbye to All That*, pp. 323–324. But see Seymour, *Robert Graves*, pp. 77–92, for an account of the wedding and the marriage that emphasizes their affection for one another more than Nancy's strident feminism.

61. Graves, *Goodbye to All That*, p. 343.

62. Graves, *Goodbye to All That*, p. 367.

63. Graves, *Robert Graves: The Assault Heroic, 1895–26*, p. 298.

64. Richard Perceval Graves, *Robert Graves: The Years with Laura, 1926–40* (London: Weidenfeld and Nicholson, 1990), p. 78.

65. Graves, *Goodbye to All That*, p. 427.

66. Graves, *Robert Graves: The Years with Laura, 1926–40*, p. 294.

67. Graves's biographer Miranda Seymour suggests that a powerful incentive for the search for a spiritual narrative around which to structure his life was provided by the death of his son David in combat in April 1943. Miranda Seymour, *Robert Graves*, p. 305.

68. Graves, *Robert Graves: The Years with Laura*, p. 268.

69. Robert Graves, *Watch the North Wind Rise* (New York: Creative Age Press, 1949), p. 3.

70. Graves, *Watch the North Wind Rise*, p. 11.

71. Graves, *Watch the North Wind Rise*, p. 127.

72. Graves, *Watch the North Wind Rise*, p. 19.

73. Graves, *Watch the North Wind Rise*, p. 202.

74. Graves, *Watch the North Wind Rise*, p. 10.

75. Graves, *Watch the North Wind Rise*, p. 38.

76. Graves, *Watch the North Wind Rise*, p. 39.

77. Graves, *Watch the North Wind Rise*, p. 40.

78. Graves, *Watch the North Wind Rise*, p. 41.

79. Graves, *Watch the North Wind Rise*, p. 43.

80. Paul O'Prey, ed., *Between Moon and Moon: Selected Letters of Robert Graves, 1946–1972* (London: Hutchinson, 1984), p. 59.

81. Graves, *Watch the North Wind Rise*, p. 12.

82. Graves, *Watch the North Wind Rise*, p. 279.

83. Robert Graves, *The White Goddess* (London: Faber and Faber, 1961), p. 21.

84. Graves, *White Goddess*, p. 14.

85. Graves, *White Goddess*, p. 11.

86. Graves, *White Goddess*, p. 24.

87. Graves, *White Goddess*, p. 17.

88. In the light of the complexity of the argument, it is perhaps instructive to witness the simplicity of its first rehearsal. In 1943, Graves wrote to a friend that he had had a revelation: "[A]ll the poems that one thinks of as most poetic in the romantic style are all intricately concerned with primitive moon worship. This sounds crazy and I fear for my sanity; but it *is* so." His evidence for this? "[T]he old English ballads . . . are all composed with a sort of neurosis-compulsion for arranging things in 3s (although the stanza is a four-line one) which is the chief characteristic of the Moon Goddess—Triple Goddess—ritual." Paul O'Prey, ed., *In Broken Images: Selected Letters of Robert Graves, 1914–1946* (London: Hutchinson, 1982), pp. 315–316.

89. Graves, *White Goddess*, p. 50.

90. Graves, *White Goddess*, p. 61.

91. Graves, *White Goddess*, p. 97.

92. Graves, *White Goddess*, p. 110.

93. Despite this evidence of Graves's continued fealty to her cult, Riding herself was furious when the book came out: "the centre of his travesty had been . . . the distortion of the human wisdoms and cosmic realities that belonged to herself alone." Richard Perceval Graves, *Robert Graves and the White Goddess, 1940–85* (London: Weidenfeld and Nicholson, 1995), p. 149.

94. Graves, *White Goddess*, p. 234.

95. Graves, *White Goddess*, p. 235.

96. Graves, *White Goddess*, pp. 383–393.

97. Graves, *White Goddess*, p. 408.

98. Graves, *White Goddess*, pp. 446–447.

99. Graves, *White Goddess*, p. 458.

100. Graves, *White Goddess*, p. 458. Here Graves was probably thinking of the mental breakdown of Kit Jackson, the woman who had the great misfortune to be married to a man to whom Laura Riding had taken a fancy. Riding terrorized Jackson with a malign occult campaign and then denounced her as a witch, sending the poor woman off to the local lunatic asylum.

101. Graves, *White Goddess*, pp. 484–485.

102. O'Prey, *Between Moon and Moon*, p. 83.

CHAPTER SEVEN

1. Henriette Groegenwegen-Frankfort, *Arrest and Movement: An Essay on Space and Time in the Representational Art of the Ancient near East* (London: Faber and Faber, 1951), p. xxiii.

2. Groegenwegen-Frankfort, *Arrest and Movement*, p. xxiii.

3. Groegenwegen-Frankfort, *Arrest and Movement*, pp. 185–186.

4. Groegenwegen-Frankfort, *Arrest and Movement*, p. 199.

5. Groegenwegen-Frankfort, *Arrest and Movement*, p. 215.

6. Groegenwegen-Frankfort, *Arrest and Movement*, p. 216.

7. Carl Kerenyi, *Dionysos: Archetypal Image of Indestructible Life,* trans. Ralph Manheim (London: Routledge and Kegan Paul, 1976), p. xxiii.

8. Kerenyi, *Dionysos*, p. xxiv.

9. Kerenyi, *Dionysos*, p. 10.

10. Kerenyi, *Dionysos*, p. 12.

11. Kerenyi, *Dionysos*, p. 25.

12. Iris Murdoch, Anne McLaren, and Jacquetta Hawkes, *Women Ask Why* (London: Campaign for Nuclear Disarmament, 1962), p. 14.

13. Jacquetta Hawkes, *Dawn of the Gods* (New York: Random House, 1968), p. 60.

14. Hawkes, *Dawn of the Gods*, p. 156.

15. Hawkes, *Dawn of the Gods*, p. 128.

16. Hawkes, *Dawn of the Gods*, p. 73.

17. Hawkes, *Dawn of the Gods*, p. 76.

18. Hawkes, *Dawn of the Gods*, p. 155.

19. Hawkes, *Dawn of the Gods*, p. 161.

20. Graves, *Robert Graves and the White Goddess, 1940–85,* p. 481.

21. Elizabeth Gould Davis, *The First Sex* (New York: G. P. Putnam's Sons, 1971), p. 177.

22. Marija Gimbutas, *The Goddesses and Gods of Old Europe* (London: Thames & Hudson, 1982), p. 9.

23. Gimbutas, *The Goddesses and Gods of Old Europe*, p. 18.

24. Gimbutas, *The Goddesses and Gods of Old Europe*, p. 13.

25. One salient feature of Gimbutas's life story overlooked by her activist admirers is that she and her family took refuge in Nazi Germany when the Red Army invaded Lithuania, and she took a second Ph.D. at Tübingen University when it reopened in 1946. Her narrative of the untimely demise of "Old Europe" is the same story of the Aryan invasions so beloved of prewar German archaeologists, this time with the angels and devils reversed.

26. Riane Eisler, *The Chalice and the Blade: Our History, Our Future* (San Francisco: Harper & Row, 1987), p. 36.

27. Gimbutas, *Goddesses and Gods of Old Europe*, pp. 224–230.

28. Cheikh Anta Diop, *African Origins of Civilization: Myth or Reality* (New York: Lawrence Hill, 1989), p. 64.

29. Cheikh Anta Diop, *Civilization or Barbarism: An Authentic Anthropology,* trans. Yaa-Lengi Meema Ngemi (New York: Lawrence Hill Books, 1991), p. 3.

30. Martin Bernal, *Black Athena: The Afroasiatic Roots of Classical Civilisation*, vol. 1, *The Fabrication of Ancient Greece, 1785–1985* (New Brunswick: Rutgers University Press, 1987), pp. xii–xiii.

31. Martin Bernal, *Black Athena*, vol. 2, *The Archaeological and Documentary Evidence* (London: Free Association Press, 1991), p. 63.

32. Bernal, *Black Athena*, vol. 1, p. 2, emphasis in the original.

33. Bernal, *Black Athena*, vol. 1, p. 73.

34. Bernal, *Black Athena*, pp. 385–386. As an attempt to apply the sociology of knowledge to the discipline of archaeology, the first volume of *Black Athena* was one of the original inspirations for the present project, and I would like here to acknowledge my profound indebtedness to the spirit, if not to the letter, of Bernal's analysis.

35. Martin Bernal, *Black Athena Writes Back: Martin Bernal Responds to His Critics* (Durham: Duke University Press, 2001), p. 12.

36. Mary R. Lefkowitz, and Guy MacLean Rogers, eds., *Black Athena Revisited* (Chapel Hill: University of North Carolina Press, 1996).

37. Jacques Berlinerblau, *Heresy in the University: The Black Athena Controversy and the Responsibilities of American Intellectuals* (New Brunswick: Rutgers University Press, 1999).

38. Palmer's point was that the last palace of Knossos must have been under the rule of the Mycenaean royal family, thus transferring the credit for much of the most famous cultural and artistic products of the Minoans to their hitherto "barbaric" neighbors.

39. Leonard Palmer and John Boardman, *On the Knossos Tablets* (Oxford: Clarendon Press, 1963).

40. See Colin Renfrew's preface to his transcription of Mackenzie's Phylakopi daybooks, which praises them as "outstanding examples of systematic archaeological reasoning, produced at a time when scientific principles of excavation had not yet been established," cited in Momigliano, *Duncan Mackenzie*, p. 5. The irony of this is that Mackenzie was one of the most diehard proponents of Minoan domination over the mainland (p. 6).

41. Leonard Palmer, *A New Guide to the Palace at Knossos* (New York: Frederick A. Praeger, 1969), p. 126.

42. Palmer, *New Guide to the Palace at Knossos*, p. 128.

43. See S. Chryssoulaki, "Minoan Roads and Guard Houses—War Regained," in *Polemos: Le contexte guerrier en Égée à l'âge du Bronze,* ed. Robert Laffineur (Liège: Université de Liège, 1999), for a list of references to Alexiou's work.

44. In 1996, Lawrence Keeley, a prehistorian working on Neolithic fortifications, published a book arguing that "archaeologists of the post-war had artificially 'pacified the past' and shared a pervasive bias against the possibility of prehistoric warfare." Lawrence Keeley, *War before Civilization* (New York: Oxford University Press, 1996), p. vii.

45. Gere, *Tomb of Agamemnon,* chap. 8.

46. Chester G. Starr, "Minoan Flower Lovers," in *The Minoan Thalassocracy: Myth and Reality*, ed. Robin Hägg and Nanno Marinatos (Stockholm: Svenska Institutet i Athen, 1984), p. 9.

47. Stefan Hiller "Pax Minoica versus Minoan Thalassocracy: Military Aspects of Minoan Culture," in *Minoan Thalassocracy*, ed. Hägg and Marinatos, p. 27.

48. Sinclair Hood "A Minoan Empire in the Aegean in the 16th and 15th centuries B. C.?" in *Minoan Thalassocracy*, ed. Hägg and Marinatos, p. 33. The authors were referring to the recently publicized evidence for cannibalism and human sacrifice.

49. Chryssoulaki, "Minoan Roads and Guard Houses," p. 75.

50. Evans, *Palace of Minos,* vol. 2, p. 79.

51. Joseph Alexander MacGillivray, "The Cretan Countryside in the Old Palace Period," in *The Function of the Minoan Villa: Proceedings of the Eighth International Symposium at the Swedish Institute at Athens (6–8 June, 1992),* ed. Robin Hagg (Stockholm: Svenska Institutet i Athen, 1997), p. 23.

52. Norbert Schlager, "'A Town of Castles': An MM/LM Fortified Site at Aspro Nero in the Far East of Crete," in *Polemos: Le contexte guerrier en Égée à l'âge du Bronze,* ed. Robert Laffineur (Liège: Université de Liège, 1999), p. 176.

53. Chryssoulaki, "Minoan Roads and Guard Houses," p. 83.

54. Krzysztof Nowicki, "The Historical Background of Defensible Sites on Crete: Late Minoan III versus Protopalatial," in *Polemos: Le contexte guerrier en Égée à l'âge du Bronze,* ed. Robert Laffineur (Liège: Université de Liège, 1999), p. 193.

55. Alan Peatfield, "The Paradox of Violence: Weaponry and Martial Art in Minoan Crete," in *Polemos: Le contexte guerrier en Égée à l'âge du Bronze,* ed. Robert Laffineur (Liège: Université de Liège, 1999), p. 67.

56. Stefan Hiller, "Scenes of Warfare and Combat in the Arts of Aegean Late Bronze Age: Reflections on Typology and Development," in *Polemos: Le contexte guerrier en Égée à l'âge du Bronze,* ed. Robert Laffineur (Liège: Université de Liège, 1999), p. 324.

CONCLUSION

1. Evans, "New Archaeological Lights on the Origins of Civilization in Europe," p. 400.

{ BIBLIOGRAPHY }

ARCHIVAL SOURCES

Arthur Evans Archive, Ashmolean Museum, Oxford.
John Evans Archive, Ashmolean Museum, Oxford.
Bryher Archive, Beinecke Library, Yale University.
H.D. Archive, Beinecke Library, Yale University.

PRINTED SOURCES

Ackerman, Robert. *The Myth and Ritual School: J. G. Frazer and the Cambridge Ritualists.* New York: Routledge, 2002.

Alberti, Benjamin. "Gender and the Figurative Art of Late Bronze Age Knossos." In *Labyrinth Revisited: Rethinking 'Minoan' Archaeology,* edited by Yannis Hamilakis. Oxford: Oxbow, 2002.

Allan, Susan Hueck. *Finding the Walls of Troy: Frank Calvert and Heinrich Schliemann at Hisarlik.* Berkeley: University of California Press, 1999.

Allesbrook, Mary. *Born to Rebel: The Life of Harriet Boyd Hawes.* Oxford: Oxbow, 1992.

Armstrong, Richard. *A Compulsion for Antiquity: Freud and the Ancient World.* Ithaca: Cornell University Press, 2005.

Bachofen, Johann Jacob. *Das Mutterrecht: Eine Untersuchung über die Gynaikokratie der alten Welt nach ihrer religiosen and rechtlichen Natur.* Frankfurt: Suhrkamp, 1975.

Beard, Mary. *The Invention of Jane Harrison.* Cambridge: Harvard University Press, 2000.

Beaton, Roderick. "Minoans in Modern Greek Literature." In *Archaeology and European Modernity: Producing and Consuming the Minoans,* edited by Yannis Hamilakis and Nicoletta Momigliano, 183–196. Padua: Bottega d'Erasmo, 2006.

Beer, Gillian. *Arguing with the Past: Essays in Narrative from Woolf to Sidney.* London: Routledge, 1989.

Bell, Michael. *Literature, Modernism and Myth.* Cambridge: Cambridge University Press, 1997.

Bell, Michael, and Peter Poellner, eds. *Myth and the Making of Modernity: The Problem of Grounding in Early Twentieth Century Literature.* Amsterdam: Rodopi, 1998.

Berlinerblau, Jacques. *Heresy in the University: The Black Athena Controversy and the Responsibilities of American Intellectuals.* New Brunswick: Rutgers University Press, 1999.

Bernal, Martin. *Black Athena Writes Back: Martin Bernal Responds to His Critics.* Durham: Duke University Press, 2001.

—— *Black Athena: The Afroasiatic Roots of Classical Civilization.* Vol. 1, *The Fabrication of Ancient Greece, 1785–1985.* New Brunswick: Rutgers University Press, 1987.

———. *Black Athena.* Vol. 2, *The Archaeological and Documentary Evidence.* London: Free Association Press, 1991.

Bertram, Marion. *Rudolf Virchow als Praehistoriker: Sein Wirken in Berlin.* Berlin: Staatliche Museen zu Berlin, 1987.

Blunt, Anthony. *Picasso's Guernica.* Oxford: Oxford University Press, 1969.

Bowler, Peter. *The Eclipse of Darwinism: Anti-Darwinian Evolution Theories in the Decades around 1900.* Baltimore: Johns Hopkins University Press, 1983.

Brown, Ann. *Arthur Evans and the Palace of Minos.* Oxford: Ashmolean Publications, 1983.

———. *Before Knossos: Arthur Evans's Travels in the Balkans and Crete.* Oxford: Ashmolean Publications, 1993.

Bryher, [Winifred Ellerman]. *The Heart to Artemis.* New York: Harcourt, Brace and World, Inc., 1962.

Burckhardt, Jacob. *Griechische Kulturgeschichte.* Stuttgart: Alfred Kroener Verlag, 1952.

Burrows, Ronald. *The Discoveries in Crete and Their Bearing on the History of Ancient Civilisation.* London: John Murray, 1908.

Butcher, Kevin, and David Gill. "The Director, the Dealer, the Goddess, and Her Champions: The Acquisition of the Fitzwilliam Goddess." *American Journal of Archaeology* 97 (1993): 383–410.

Calder, William M., and David A. Traill, eds. *Myth, Scandal and History: The Heinrich Schliemann Controversy and a First Edition of the Mycenaean Diary.* Detroit: Wayne State University Press, 1986.

Candy, James. *A Tapestry of Life: An Autobiography.* Braunton: Merlin, 1984.

Carabott, Philip. "A Country in a 'State of Destitution,' Labouring under an 'Unfortunate Regime': Crete at the Turn of the Twentieth Century (1896–1906)." In *Archaeology and European Modernity: Producing and Consuming the 'Minoans',* edited by Yannis Hamilakis and Nicoletta Momigliano. Padua: Bottega d'Erasmo, 2006.

Carpentier, Martha Celeste. *Ritual, Myth and the Modernist Text: The Influence of Jane Ellen Harrison on Joyce, Eliot and Woolf.* Amsterdam: Gordon and Breach Publishers, 1998.

Cate, Curtis. *Friedrich Nietzsche: A Biography*. London: Pimlico, 2003.

Ceram, C. W. *Gods, Graves and Scholars: The Story of Archaeology*. Translated by E. B. Garside and Sophie Williams. London: Book Club Associates, 1971.

Chryssoulaki, S. "Minoan Roads and Guard Houses—War Regained." In *Polemos: Le contexte guerrier en Égée à l'âge du Bronze*, edited by Robert Laffineur, 75–83. Liège: Université de Liège, 1999.

Cobet, Justus. "Heinrich Schliemann nach hundert Jahren: Die Historisierung von Mythos und Aegernis." In *Heinrich Schliemann Nach Hundert Jahren*, edited by Justus Cobet and William M. Calder. Frankfurt am Main: Vittorio Klostermann, 1990.

Cohen, Claudine. *Le destin du mammoth*. Paris: Seuil, 1994.

Cook, Arthur Bernard. *Zeus: A Study in Ancient Religion*. Cambridge: Cambridge University Press, 1914.

Cowling, Elizabeth, and Jennifer Mundy. *On Classic Ground: Picasso, Leger, De Chirico and the New Classicism, 1910–1930*. London: Tate Gallery Publications, 1990.

Davis, Elizabeth Gould. *The First Sex*. New York: G. P. Putnam's Sons, 1971.

De Chirico, Giorgio. *Memoirs of Giorgio De Chirico*. Translated by Margaret Crosland. London: Peter Owen, 1971.

Detorakis, Theocharis E. *History of Crete*. Translated by John C. Davis. Iraklion: Iraklion, 1994.

Diop, Cheikh Anta. *African Origins of Civilization: Myth or Reality*. New York: Lawrence Hill 1989.

———. *Civilization or Barbarism: An Authentic Anthropology*. Translated by Yaa-Lengi Meema Ngemi. New York: Lawrence Hill Books, 1991.

Doolittle, Hilda. *Collected Poems, 1912–1944*. New York: New Directions, 1986.

———. *End to Torment: A Memoir of Ezra Pound*. Manchester: Carcanet Press, 1980.

———. *Hermione*. London: Virago, 1981.

———. *The Sword Went out to Sea (Synthesis of a Dream) by Delia Alton*. Gainesville: University Press of Florida, 2007.

———. *Tribute to Freud, Writing on the Wall, Advent*. New York: New Directions, 1974.

Driessen, Jan. *An Early Destruction in the Mycenaean Palace at Knossos*. Leuven: Acta Archaeologica Lovaniensia Monographie, 1990.

Duel, Leo. *Memoirs of Heinrich Schliemann: A Documentary Portrait Drawn from His Autobiographical Writings, Letters and Excavation Reports*. New York: Harper & Row, 1977.

Duncan, Isadora. *My Life*. New York: Boni and Liveright, 1927.

Eisler, Riane. *The Chalice and the Blade: Our History, Our Future*. San Francisco: Harper & Row, 1987.

Ekini, Ugur Mehmet. "The Origins of the 1897 Ottoman-Greek War, a Diplomatic History." Master's thesis, Bilkent University, 2006.

Eliot, T. S. *Selected Prose of T. S. Eliot*. London: Faber and Faber, 1975.

———. *The Sacred Wood, University Paperbacks*. London: Methuen, 1967.

Engels, Friedrich. *The Origin of the Family, Private Property and the State*. Harmondsworth: Penguin Books Ltd., 1985.

Evans, Arthur. "Archaeological News. Krete. A Mycenaean Military Road." *American Journal of Archaeology* 10 (1895): 399–403.

———. "Archaeological News. Krete. Explorations in Eastern Crete." *American Journal of Archaeology* 11, no. 3 (1896): 449–467.

———. *Illyrian Letters: A Revised Selection of Correspondence from the Illyrian Provinces of Bosnia, Herzegovina, Montenegro, Albania, Dalmatia, Croatia, and Slavonia, Addressed to the Manchester Guardian During the Year 1877*. London: Longman and Green, 1878.

———. "Knossos Diary." Ashmolean Museum, Oxford.

———. "Knossos I. The Palace." *Annual of the British School at Athens* 6 (1900): 3–70.

———. *Letters from Crete*. Reprinted from the Manchester Guardian of May 24, 25, and June 13. Oxford: Printed for private circulation by Horace Hart, 1898.

———. "Mycenaean Tree and Pillar Cult and Its Mediterranean Relations." *Journal of Hellenic Studies* 21 (1901): 99–204.

———. "New Archaeological Lights on the Origins of Civilization in Europe." *Science* 44, no. 1134 (1916): 399–408.

———. "The Palace of Knossos." *Annual of the British School at Athens* 7 (1901): 1–120.

———. "The Palace of Knossos." *Annual of the British School at Athens* 8 (1902): 1–124.

———. "The Palace of Knossos." *Annual of the British School at Athens* 9 (1903): 1–153.

———. "The Palace of Knossos and Its Dependencies." *Annual of the British School at Athens* 11 (1905): 1–26.

———. "The Palace of Knossos as a Sanctuary." *Royal Institute of British Architects* 3, no. 17 (1909): 6–7.

———. *The Palace of Minos*. London: Macmillan, 1921–1936.

———. "The Ring of Nestor: A Glimpse into the Minoan After-World and a Sepulchral Treasure of Gold Signet-Rings and Bead Seals from Thisbe, Boiotia." *Journal of Hellenic Studies* 45 (1925): 1–75.

———. *Through Bosnia and the Herzegovina on Foot, during the Insurrection, August and September 1875, with an Historical Review of Bosnia*. London: Longmans, Green and Co., 1876.

———. "Work of Reconstitution in the Palace of Knossos." *Antiquaries Journal* 7, no. 3 (1927): 258–267.

Evans, Joan. *Time and Chance: The Story of Arthur Evans and His Forebears*. London: Longmans, Green and Co., 1943.

Fischer, Klaus. *History and Prophecy: Oswald Spengler and the Decline of the West*. New York, 1989.

Fitton, J. Lesley. *The Discovery of the Greek Bronze Age*. London: British Museum Press, 1995.

Flam, Jack, and Miriam Deutch, eds. *Primitivism and Twentieth Century Art: A Documentary History*. Berkeley: University of California Press, 2003.

Forster, E. M. *Maurice*. New York: W. W. Norton, 1971.

Frazer, James George. *The Golden Bough*. London: Macmillan, 1890.

Freud, Sigmund. *The Complete Letters of Sigmund Freud to Wilhelm Fliess, 1877–1904*. Translated by Jeffrey Masson. Cambridge: Harvard University Press, 1985.

———. *The Standard Edition of the Complete Psychological Works of Sigmund Freud*. Translated by James Strachey. London: Hogarth Press, 1953–1974.

Friedman, Susan Stanford. *Penelope's Web: Gender, Modernity, H.D.'s Fiction*. Cambridge: Cambridge University Press, 1990.

———. *Psyche Reborn*. Bloomington: Indiana University Press, 1981.

Gamwell, Lynn, and Richard Wells, eds. *Sigmund Freud and Art: His Personal Collection of Antiquities*. London: Thames and Hudson, 1989.

Gardiner, Muriel, ed. *The Wolf Man and Sigmund Freud*. London: Penguin Books, 1973.

Gay, Peter. *Freud: A Life for Our Time*. London and Melbourne: J. M. Dent and Sons Ltd., 1988.

Gere, Cathy. "Inscribing Nature: Archaeological Metaphors and the Formation of New Sciences." *Public Archaeology* 2, no. 4 (2002): 195–208.

———. *The Tomb of Agamemnon*. Edited by Mary Beard, *Wonders of the World*. Cambridge: Harvard University Press, 2006.

Gimbutas, Marija. *The Goddesses and Gods of Old Europe*. London: Thames and Hudson, 1982.

Ginzburg, Carlo. "Clues: Morelli, Freud, and Sherlock Holmes." In *The Sign of Three: Dupin, Holmes, Pierce,* edited by Umberto Eco and T. A. Sebeok. Bloomington: Indiana University Press, 1983.

Glenny, Misha. *The Balkans: Nationalism, War and the Great Powers, 1804–1999*. London: Granta, 1999.

Goldhill, Simon. *Who Needs Greek? Contests in the Cultural History of Hellenism*. Cambridge: Cambridge University Press, 2002.

Goodison, Lucy, and Christine Morris, eds. *Ancient Goddesses: The Myths and the Evidence*. London: British Museum Press, 1998.

Graves, Richard Perceval. *Robert Graves and the White Goddess, 1940–85*. London: Weidenfeld and Nicholson, 1995.

———. *Robert Graves: The Assault Heroic, 1895–26*. London: Weidenfeld and Nicholson, 1986.

———. *Robert Graves: The Years with Laura, 1926–40*. London: Weidenfeld and Nicholson, 1990.

Graves, Robert. *Goodbye to All That*. New York: Blue Ribbon Books, 1930.

———. *The White Goddess*. London: Faber and Faber, 1952.

———. *Watch the North Wind Rise*. New York: Creative Age Press, 1949.

Gregory, Eileen. *H. D. And Hellenism: Classic Lines*. Cambridge: Cambridge University Press, 1997.

Groegenwegen-Frankfort, Henriette. *Arrest and Movement: An Essay on Space and Time in the Representational Art of the Ancient near East*. London: Faber and Faber, 1951.

Grosskurth, Phyllis. *Havelock Ellis: A Biography*. London: Allen Lane, 1980.

Guest, Barbara. *Herself Defined: The Poet H. D. and Her World*. Garden City: Doubleday and Co., 1984.

Hägg, Robin. "Bermerkungen zum Nestorring." *Schriften des deutsches Archaeologen* 9 (1987): 57.

Hägg, Robin, and Nanno Marinatos, eds. *The Minoan Thalassocracy: Myth and Reality*. Stockholm: Svenska Institutet I Athen, 1984.

Hamilakis, Yannis, ed. *Labyrinth Revisited: Rethinking Minoan Archaeology*. Oxford: Oxbow Books, 2002.

Hamilakis, Yannis, and Nicoletta Momigliano, eds. *Archaeology and European Modernity: Producing and Consuming the 'Minoans.'* Padua: Botega d'Erasmo, 2006.

Harrison, Jane Ellen. *Prolegomena to a Study of Greek Religion*. Third ed. Cambridge: Cambridge University Press, 1922.

———. *Themis: A Study of the Social Origins of Greek Religion*. 1926. Reprint, London: Merlin Press, 1963.

Hawes, Harriet Boyd. "Memoirs of a Pioneer Excavator in Crete." *Archaeology* 2 (1965): 94–101.

Hawkes, Jacquetta. *Dawn of the Gods.* New York: Random House, 1968.

Hayman, Ronald. *Nietzcshe: A Critical Life.* London: Weidenfeld and Nicholson, 1980.

Herrmann, Joachim, and Evelin Maass, eds. *Die Korrespondenz zwischen Heinrich Schliemann und Rudolf Virchow, 1876–1890.* Berlin: Akademie-Verlag, 1990.

Hiller, Stefan. "Scenes of Warfare and Combat in the Arts of Aegean Late Bronze Age. Reflections on Typology and Development." In *Polemos: Le contexte guerrier en Égée à l'âge du Bronze,* edited by Robert Laffineur, 320–328. Liège: Université de Liège, 1999.

Hollingdale, R. J. *Nietzsche: The Man and His Philosophy.* Cambridge: Cambridge University Press, 1999.

Hood, Rachel. *Faces of Archaeology in Greece: Caricatures by Piet De Jong.* Oxford: Leopard's Head Press, 1998.

Hood, Sinclair. "Collingwood on the Minoan Civilisation of Crete." In *Collingwood Studies,* edited by D. Boucher and B. Haddock. Swansea: R. G. Collingwood Society, 1995.

Horowitz, Sylvia. *The Find of a Lifetime: Sir Arthur Evans and the Discovery of Knossos.* London: Weidenfeld and Nicholson, 1981.

Huxley, Thomas Henry. *Collected Essays*, vol. 4, *Science and Hebrew Tradition.* London: Macmillan, 1898.

Jones, Ernst. *Sigmund Freud: Life and Work*, vol. 3, *The Last Phase.* London: Hogarth, 1957.

Joyce, James. *Ulysses.* New York: Random House, 1961.

Keeley, Lawrence. *War before Civilization.* New York: Oxford University Press, 1996.

Kenner, Hugh. *The Pound Era.* Berkeley: University of California Press, 1971.

Kenyatta, Jomo. *Facing Mount Kenya: The Tribal Life of the Gikuyu.* London: Secker and Warburg, 1938.

Kerenyi, Carl. *Dionysos: Archetypal Image of Indestructible Life.* Translated by Ralph Manheim. London: Routledge and Kegan Paul, 1976.

Kossinna, Gustaf. *Ursprung und Verbreitung der Germanen in vor- und frühgeschichtlicher Zeit.* Berlin: Germanen-Verlag, 1927.

Lapatin, Kenneth. *Lapatin, Kenneth. Mysteries of the Snake Goddess: Art, Desire, and the Forging of History.* New York: Houghton Mifflin, 2002.

———. *Mysteries of the Snake Goddess: Art, Desire, and the Forging of History.* New York: Houghton Mifflin, 2002.

Lapourtas, Alexander. "Arthur Evans and His Representation of the Minoan Civilisation at Knossos." *Museum Archaeologist* 22 (1995): 71–82.

Luft, David. *Eros and Inwardness in Vienna: Weininger, Musil, Doderer.* Chicago: University of Chicago Press, 2003.

Macdonald, Callum. *The Lost Battle: Crete, 1941.* London: Free Press, 1993.

MacGillivray, Joseph Alexander. *Minotaur: Sir Arthur Evans and the Archaeology of Minoan Myth.* London: Jonathan Cape, 2000.

———. "The Cretan Countryside in the Old Palace Period." In *The Function of the Minoan Villa: Proceedings of the Eighth International Symposium at the Swedish Institute at Athens (6–8 June, 1992),* edited by Robin Hagg. Stockholm: Svenska Institutet i Athen, 1997.

Malinowski, Bronislaw. *A Diary in the Strict Sense of the Term.* New York: Harcourt, Brace & World, 1967.

Marinelli, Lydia, ed. *Meine . . . alten und dreckigen Götter. Aus Sigmund Freuds Sammlung.* Frankfurt: Stroemfeld, 1998.

Martz, Louis. *Many Gods and Many Voices: The Role of the Prophet in English and American Modernism.* Columbia: University of Missouri Press, 1998.

Mayer, Andreas. "Objets perdus: matérialiser et dématérialiser l'inconscient de Charcot à Freud." *Ethnopsy* 1, no. 2 (2001): 67–89.

McEnroe, John. "Cretan Questions: Politics and Archaeology 1898–1913." In *Labyrinth Revisited: Rethinking 'Minoan' Archaeology,* edited by Yannis Hamilakis. Oxford: Oxbow, 2002.

Merezhkovsky, Dmitri Sergeevich. *The Birth of the Gods.* Translated by Natalie Duddington. London: J. M. Dent and Sons, Ltd., 1925.

Meyer, Ernst, ed. *Briefe von Heinrich Schliemann, gesammelt und mit einer Einleitung in Auswahl herausgegeben von Ernst Meyer.* Berlin: W. de Gruyter, 1936.

Miller, Henry. *The Colossus of Maroussi.* New York: New Directions, 1941.

Momigliano, Nicoletta. *Duncan Mackenzie: A Cautious Canny Highlander at the Palace of Minos at Knossos.* London: Institute of Classical Studies, 1999.

———. *Duncan Mackenzie: A Cautious Canny Highlander at the Palace of Minos at Knossos.* London: Institute of Classical Studies, 1999.

Morgan, Lewis Henry. *Ancient Society: Researches in the Lines of Human Progress from Savagery to Barbarism to Civilisation.* New York: Henry Holt and Co., 1877.

Murdoch, Iris, Anne McLaren, and Jacquetta Hawkes. *Women Ask Why.* London: Campaign for Nuclear Disarmament, 1962.

Myers, J. Wilson, Eleanor Emlen Myers, and Gerald Cadogan, eds. *Aerial Atlas of Ancient Crete.* London: Thames and Hudson, 1992.

Nietzsche, Friedrich. *Ecce Homo: How One Becomes What One Is.* Translated by R. J. Hollingdale. London: Penguin, 1992.

———. *On the Advantage and Disadvantage of History for Life.* Translated by Peter Preuss. Indianapolis: Hackett Publishing Co., 1980.

———. *On the Genealogy of Morality and Other Writings.* Translated by Carol Diethe. Edited by Keith Ansell-Pearson. Cambridge: Cambridge University Press, 1994.

———. *The Birth of Tragedy and the Genealogy of Morals.* Translated by Francis Golffing. New York: Doubleday, 1956.

———. *The Gay Science.* Translated by Josefine Nauckhoff. Cambridge: Cambridge University Press, 2001.

———. *Werke in drei Bänden.* Dortmund: Koenemann, 1994.

O'Prey, Paul, ed. *Between Moon and Moon: Selected Letters of Robert Graves, 1946–1972.* London: Hutchinson, 1984.

———, ed. *In Broken Images: Selected Letters of Robert Graves, 1914–1946.* London: Hutchinson, 1982.

Otis, Laura. *Organic Memory: History and the Body in the Late Nineteenth and Early Twentieth Centuries.* Lincoln: University of Nebraska Press, 1994.

Palmer, Leonard. *A New Guide to the Palace at Knossos.* New York: Frederick A. Praeger, 1969.

Palmer, Leonard, and John Boardman. *On the Knossos Tablets.* Oxford: Clarendon Press, 1963.

[Parker, George Wells?]. "African Origin of Grecian Civilisation." *Journal of Negro History* 2, no. 3 (1917): 334–344.

Peatfield, Alan. "The Paradox of Violence: Weaponry and Martial Art in Minoan Crete." In *Polemos: Le contexte guerrier en Égée à l'âge du Bronze,* edited by Robert Laffineur, 67–72. Liège: Université de Liège, 1999.

Podach, Erich F. *Ein Blick in Notizbuecher Nietzsches. Ewige Wiederkunft; Wille zur Macht; Ariadne.* Heidelberg: Wolfgang Rothe Verlag, 1963.

Powell, Dilys. *The Villa Ariadne.* London: Hodder and Stoughton, 1973.

Prestwich, Grace. *Essays Descriptive and Biographical.* Edinburgh: Blackwood and Son, 1901.

Quinn, Malcolm. *The Swastika: Constructing the Symbol.* London: Routledge, 1994.

Reed, T. J. *Thomas Mann: The Uses of Tradition.* Oxford: Clarendon Press, 1974.

Reid, Jane Davidson, ed. *Oxford Guide to Classical Mythology in the Arts.* Oxford: Oxford University Press, 1993.

Ries, Martin. "Picasso and the Myth of the Minotaur." *Art Journal* 32, no. 2 (1972): 142–145.

Riper, A. B. Van. *Men among the Mammoths: Victorian Science and the Discovery of Human Prehistory.* Chicago: University of Chicago Press, 1993.

Robinson, Annabel. *The Life and Work of Jane Ellen Harrison.* Oxford: Oxford University Press, 2002.

Robson, Catherine. *Men in Wonderland: The Lost Girlhood of the Victorian Gentleman.* Princeton: Princeton University Press, 2001.

Rohde, Erwin. *Psyche.* New York: Harper & Row, 1966.

Ross, Dorothy, ed. *Modernist Impulses in the Human Sciences 1870–1930.* Baltimore: Johns Hopkins University Press, 1994.

Sakellarakis, Yannis. *Heracklion Museum: An Illustrated Guide.* Athens: Ekdotike Athenon, 1978.

Sakellarakis, Yannis, and Efi Sakellaraki. *Archanes: Minoan Crete in a New Light.* Athens: Ammos, 1997.

Salome, Lou Andreas. *Friedrich Nietzsche in seinem Werken.* Frankfurt am Main: Insel Verlag, 1983.

Sax, Leonard. "What Was the Cause of Nietzsche's Dementia?" *Journal of Medical Biography* 11 (2003): 47–54.

Scheuer, Helmut. "Heinrich Schliemanns "Selbstbiographie": Zur Gattungstypologie der Autobiographik in der zweiten Hälfte des neunzehten Jahrhunderts." In *Heinrich Schliemann nach hundert Jahren,* edited by William Calder and Justus Cobet. Frankfurt am Main: Vittorio Klostermann, 1990.

Scheuermann, Wilhelm. *Woher kommt das Hakenkreuz?* Berlin: Rowohlt Verlag, 1933.

Schlager, Norbert. ""A Town of Castles": An MM/LM Fortified Site at Aspro Nero in the Far East of Crete." In *Polemos: Le contexte guerrier en Égée à l'âge du Bronze,* edited by Robert Laffineur, 172–77. Liège: Université de Liège, 1999.

Schliemann, Heinrich. *Ilios: The City and Country of the Trojans.* London: John Murray, 1880.

———. *Troja. Results of the Latest Researches and Discoveries on the Site of Homer's Troy and in the Heroic Tumuli and Other Sites, Made in the Year 1882.* London: John Murray, 1884.

———. *Troy and Its Remains: A Narrative of Researches and Discoveries Made on the Site of Ilium and the Trojan Region.* London: John Murray, 1875.

Schmidt, Herbert. *Heinrich Schliemanns Sammlung: Trojanischer Altertümer.* Berlin: Georg Reimer für die Königliche Museen zu Berlin, 1902.

Schnapp, Jeffrey. "Excavating the Corporativist City." *Modernism-Modernity* 11, no. 1 (2004): 89–104.

Schnapp, Jeffrey, Michael Shanks, and Matthew Tiews. "Archaeology, Modernism, Modernity." *Modernism-Modernity* 11, no. 1 (2004): 1–16.

Seymour, Miranda. *Robert Graves: Life on the Edge.* New York: Henry Holt and Company, 1995.

Sherrat, Susan. *Arthur Evans, Knossos and the Priest-King.* Oxford: Ashmolean Museum Publications, 2000.

Spengler, Oswald. *The Decline of the West.* Translated by Charles Francis Atkinson. Vol. 2. New York: A. A. Knopf, 1970.

Taylor, Michael. *Giorgio De Chirico and the Myth of Ariadne.* Philadelphia: Philadelphia Museum of Art, 2002.

Tosh, John. *A Man's Place: Masculinity and the Middle-Class Home in Victorian England.* New Haven: Yale University Press, 1999.

Traill, David A. *Excavating Schliemann.* Atlanta: Scholars Press, 1993.

———. *Schliemann of Troy: Treasure and Deceit.* New York: St. Martin's Press, 1995.

Tylor, Edward B. "The Tasmanians as Representatives of Palaeolithic Man." *Journal of the Anthropological Institute of Great Britain and Ireland* 23 (1894): 141–52.

Ucko, Peter. "Unprovenanced Material Culture and Freud's Collection of Antiquities." *Journal of Material Culture* 6, no. 3 (2001): 233–269.

van Sertima, Ivan, and Rashidi Runoko, eds. *African Presence in Early Asia.* New Brunswick: Transaction, 1987.

Vance, Norman. "Classics and the Dardanelles Campaign." *Notes and Queries* 53, no. 3 (2006): 347–349.

Verrechia, Anacleto. "Nietzsche's Breakdown in Turin." In *Nietzsche in Italy,* edited by Thomas Harrison. Saratoga: ANIMA Libri, 1988.

Watkin, David, and Tillman Mellinghof. *German Architecture and the Classical Ideal, 1740–1840.* London: Thames and Hudson, 1987.

Waugh, Evelyn. *Labels: A Mediterranean Journal.* London: Duckworth, 1930.

Williams, William Carlos. *The Autobiography of Willilam Carlos Williams.* New York: Random House, 1951.

Wood, Michael. *In Search of the Trojan War.* Berkeley: University of California Press, 1998.

Woolley, Leonard. *As I Seem to Remember.* London: George Allan and Unwin, 1962.

Wullschlaeger, Jackie. *Inventing Wonderland: The Lives and Fantasies of Lewis Carroll, Edward Lear, J. M. Barrie, Kenneth Graham and A. A. Milne.* London: Methuen, 1995.

Yerushalmi, Yosef Hayim. *Freud's Moses: Judaism Terminable and Interminable.* New Haven: Yale University Press, 1995.

Zilboorg, Caroline, ed. *Richard Aldington and H. D.: The Later Years in Letters.* Manchester: Manchester University Press, 1995.

Zintzen, Christiane. *Von Pompeji nach Troja: Archäologie, Literatur und Öffentlichkeit im 19. Jarhhundert.* Vienna: Universitätsverlag, Wien, 1998.

Ziolkowski, Theodore. *Minos and the Moderns: Cretan Myth in Twentieth-Century Literature and Art.* Oxford: Oxford University Press, 2008.

Zmigrodski, Michael. *Histoire du Suastika.* Paris: Bibliotheque Annales Economique, 1891.